# MUSEUMS AND DIFFERENCE

*Edited by Daniel J. Sherman*

INDIANA UNIVERSITY PRESS

BLOOMINGTON & INDIANAPOLIS

This book is a publication of

Indiana University Press
601 North Morton Street
Bloomington, IN 47404-3797 USA

http://iupress.indiana.edu

*Telephone orders*     800-842-6796
*Fax orders*           812-855-7931
*Orders by e-mail*     iuporder@indiana.edu

Library of Congress Cataloging-in-Publication Data

Museums and difference / Daniel J. Sherman, editor.
    p. cm.—(21st Century studies ; v. 2)
    Papers from a conference organized by the Center for 21st Century Studies and held at University of Wisconsin—Milwaukee, Nov. 14–15, 2003.
    Includes bibliographical references and index.
    ISBN 978-0-253-34946-0 (cloth : alk. paper)—ISBN 978-0-253-21935-0 (paper : alk. paper)
1. Museums—Social aspects—Congresses.   2. Museums—Social aspects—Case studies—Congresses.   3. Museum exhibits—Social aspects—Congresses.   4. Difference (Psychology)—Social aspects—Congresses.   5. Pluralism (Social sciences)—Congresses.
I. Sherman, Daniel J.   II. University of Wisconsin—Milwaukee. Center for 21st Century Studies.
    AM7.M8813    2007
    069—dc22                                                              2007020383

1   2   3   4   5   13   12   11   10   09   08

Here are plates but no appetite.
And wedding rings, but the requited love
has been gone now for some three hundred years.

Here's a fan—where is the maiden's blush?
Here are the swords—where is the ire?
Nor will the lute sound at the twilight hour.

Since eternity was out of stock,
ten thousand aging things have been amassed instead.
The moss-grown guard in golden slumber
props his mustache on Exhibit Number . . .

Eight. Metals, clay and feathers celebrate
their silent triumphs over dates.
Only some Egyptian flapper's silly hairpin giggles.

The crown has outlasted the head.
The hand has lost out to the glove.
The right shoe has defeated the foot.

As for me, I am still alive, you see.
The battle with my dress still rages on.
It struggles, foolish thing, so stubbornly!
Determined to keep living while I'm gone!

*Wisława Szymborska, "Museum"*

# CONTENTS

# ACKNOWLEDGMENTS

This book grows out of a conference by the same name organized by the Center for 21st Century Studies, University of Wisconsin–Milwaukee, on November 14–15, 2003. The Center is grateful to the Milwaukee Art Museum, which hosted the first afternoon of the conference, and to the Cultural Services of the French Embassy in Chicago and in particular Yannick Mercoyrol, then the cultural attaché in Chicago, for support in bringing speakers to Milwaukee. The conference occasioned a fruitful, lively, and civil exchange among academics and museum professionals from around the Midwest, North America, and Europe. Thanks go to the keynote speaker, Tony Bennett, and to the conference participants whose contributions for one reason or another could not be included in this volume, but whose presence was indispensable to the dialogue it seeks to further: Brooke Anderson, Annie Coombes, Robert Haywood, Anne Higonnet, Norman Kleeblatt, Régis Michel, Mark Sandberg, Christopher Steiner, and Nicholas Thomas. The conference was the last coordinated by Carol Tennessen, the Center's executive director emerita, with her usual flair, efficiency, and grace; I very much appreciate her support, and that of her successor, deputy director Kate Kramer, in all aspects of the project.

Former and current graduate project assistants at the Center, including Amity McGinnis (2004–2006), Niamh Wallace (2005–2006), Stella Lineri (2006–2007), and Scott Canevit (2006–2007), deserve thanks for their assistance with the assembly and editing of the manuscript. My thanks as well to the Center's omnicompetent office manager, Maria Liesegang, for her help with administrative and financial matters. At Indiana University Press, Michael Lundell, formerly the sponsoring editor responsible for the series 21st Century Studies, provided indispensable support at a crucial stage of the project. I would also like to acknowledge the help of editorial assistants Elisabeth Marsh

and Laura MacLeod and of Rebecca Tolen, who, taking over as sponsoring editor as the book entered production, has continued the long tradition of smooth, friendly, and professional relations between the Press and the Center.

Besides the introduction, all contributions to the volume originated as papers at the conference except those of Fitz Brundage and Ilona Katzew, whose willingness to join the project midstream I very much appreciate. The authors' thoughtfulness in reworking their texts, in most cases several times, and in adopting a sometimes unfamiliar citation style, transformed an assortment of conference papers into a book; their good cheer in doing so made the editorial process a remarkably pleasant and collegial one, and in that sense represented an apt continuation of the conference itself. I am particularly grateful to Alice Conklin, Nélia Dias, Eduardo Douglas, and Angus Lockyer for their moral support and helpful advice throughout the process.

My deepest thanks go to Ruud van Dijk, the Center's associate director for publications, on whose professionalism, unflappability, and resourcefulness I have relied throughout the project. Ruud's responsibilities include editing the manuscript for consistency, preparing it for copy editing, and compiling the index, but his contributions go far beyond this, and without him this book, if it appeared at all, would have taken far longer. Whether collating myriad drafts of an essay, laboriously reinserting references that had mysteriously gone missing, tracking down usable versions of visual material, communicating with an impressive assortment of rights-holders (once even in Dutch!), or coping with a sometimes frazzled editor, Ruud has tackled the challenges of publishing in the twenty-first century so skillfully as to make it seem easy. He and I both know it wasn't.

# MUSEUMS AND DIFFERENCE

# Introduction

DANIEL J. SHERMAN

Wisława Szymborska's brilliant poem "Museum," with its running contrasts between the objects a museum amasses and what lies frustratingly out of view—"eternity was out of stock"—suggests that museums embody nothing less than the existential difference between life and death. This book builds on Szymborska's insight, and that of a generation of scholarship, to argue not only that museums help us understand difference, but that difference offers a productive framework for understanding museums. As recent debates over nationality and citizenship suggest, difference always shadows and doubles identity, always entails a relationship between self and other.[1] For Walter Benjamin, this dynamic lies at the heart of imitation or mimesis, one of the basic ways humans articulate identity: "[man's] gift of seeing resemblances is nothing other than a rudiment of the powerful compulsion in former times to become and behave like something else. Perhaps there is none of his higher faculties in which his mimetic faculty does not play a decisive role."[2] The articulation of the relationship between self and other has informed notions of culture since that word, famously "one of the two or three most complicated words in the English language," acquired its modern multiplicity of senses in the nineteenth century.[3] As Robert Young sums up his careful genealogy of the term:

> Culture never stands alone but always participates in a conflictual economy acting out the tension between sameness and difference, comparison and differentiation, unity and diversity. . . . Culture has inscribed within itself the complex and often contradictory differences

through which European society has defined itself. Culture has always marked cultural difference by producing the other. . . .[4]

As public institutions assigned both to safeguard and to define culture, museums have always been sites for the negotiation of difference.

Alterity, "the state of being other or different" (*O.E.D. Online*), involves not only a relationship between a self and an other, but an acknowledgment that human existence itself entails such relationships. At its most basic, there is no self without an other; for the philosopher Emmanuel Levinas, "*the right of man, absolutely and originally,* takes on meaning only in the other, as the right of the other man."[5] Understood as a constantly changing set of relationships, alterity points to the instability and continuous negotiation of identity through encounters with others, to the ways self and other emerge simultaneously and recursively through the relationships between them.[6] Whatever their domain, museums, to the extent that they claim to serve a larger community or public, place the relationship between self and other, not only its representation but its very negotiation, at the heart of their practice. The heightened claims for museums' mission and purpose in recent years have if anything made these stakes more evident and more self-conscious.

If museums have, in the past quarter century, become privileged objects of inquiry in cultural studies, the centrality of difference to their institutional construction has yet to be explored in detail. At one level, scholarship on museums has both grown out of and participated in the post-structuralist critique of "an ethically unsustainable omission of the Other" in Western humanism. As Leela Gandhi notes, this critique, drawing especially on the work of Heidegger, Foucault, and Derrida, takes aim at a Cartesian subject that constructs knowledge and sustains its philosophy of identity "through a violent and coercive relationship with its omitted Other."[7] Much of the pioneering work in critical museum studies has exposed the Western museum as, effectively, this kind of Cartesian subject, but, in focusing on power, domination, and exclusion, it has tended to treat the other as absent, excluded, or misrepresented rather than examining the actual place of alterity in the operation of museums.[8] The influential museum scholar Tony Bennett has recently distinguished between approaches to museums based on ideology, which seek to look through museum operations "to decipher the modes of power that *lie behind them,*" and those based on the Foucauldian concept of

governmentality. He advocates the latter approach, which looks at museum operations "to identify how particular forms of power are constituted *there,* within those mechanisms, rather than outside or behind them."[9] Bennett's whole study, moreover, concerned with the interwoven development of evolutionary schemas, disciplines, and institutional formations such as museums, makes clear that not only power but difference is constituted *there.*

The existing critical scholarship on museums has tended to consider issues of difference within three different problematics: classification (the categories museums use to order their collections and displays and to distinguish between institutional types); museums explicitly concerned with human particularity and difference, notably natural history and ethnographic museums; and the relationship between exhibiting and colonial or imperial encounters. With respect to categories, the artificiality of the distinction between "art" and "artifact" has become a commonplace, and James Clifford's exploration of the informing assumptions and institutional consequences of this distinction has influenced much fruitful work not only in museum studies but in museum exhibitions.[10] In the introduction to the pioneering collection *Objects and Others* (1985), George Stocking observes that "not only radical critics, but establishment museologists now raise questions about the situation of non-European others along with animals and plants in museums of natural history, or their segregation from the rest of world history in museums of ethnography."[11] Although it offers important insights into alterity, Stocking's collection frames itself as a history more of a discipline, anthropology, than of museums. Similarly, in *Reinventing Africa: Museums, Material Culture, and Popular Imagination* (1994), Annie Coombes seeks to "demystify the link (in the West) between those cultural values which could be said to reside in the museum and deep-seated attachments to a concept of racial purity." But she casts her study above all as "a contribution to the work of excavating the imperial and colonial consciousness."[12] French and British collections of essays devoted to the relationship between museums and colonialism generally eschew any larger theoretical ambitions, limiting their projects to unearthing significant, but necessarily fragmentary, histories.[13] Only with Nélia Dias's essay "The Visibility of Difference" (1998) does the mutual constitution of museums and of categories of difference, in this case racial difference, come to occupy center stage.[14]

Understanding that mutual constitution as a complex historical process, but also as an active phenomenological challenge to those who work in and

on museums, is the project of this book. The use of alterity as a structuring concept entails taking the relationship between self and other as an irreducible component of cognition, desire, power, and ethics. As institutions devoted to making sense of the world, museums are inescapably constituted by, and themselves constitute (for it is an ongoing, ever-present process), difference or alterity in this broad sense. Without neglecting the differences within museum practice (categories, institutional classifications, modes of display), the volume explores difference as a larger term of analysis pointing up the conditions of possibility, occlusions, and incompleteness of such practice. In so doing, it seeks to bring together insights into the conceptual, political, and empirical bases of museum practice that have too often remained separate.

In his celebrated essay "Differance," Jacques Derrida wrote of the centrality of difference to "the thought of what is conveniently called our 'epoch': the difference of forces in Nietzsche, Saussure's principle of semiological difference, differing as the possibility of [neurone] facilitation, impression and delayed effect in Freud, difference as the irreducibility of the other in Levinas, and the ontic-ontological difference in Heidegger."[15] Derrida is here describing a moment in modernity, which is perhaps best understood as a period conscious of its own newness, its difference from the past. The beginnings of public museums in the eighteenth century both contributed to and accentuated this sense of newness: Bennett has observed that the birth of the modern museum type in the late eighteenth and early nineteenth centuries owed much to the contemporaneous emergence of a range of new historical sciences. Evolutionary series, based on time frames from the geological to the historical, remapped objects formerly classified taxonomically; at the same time, museums constituted their publics as the culmination of the evolution they placed on view.[16] Evolutionary schemas also played an important role in the elaboration of the new, anthropological notion of culture as a set of beliefs and practices common to a particular group, which Young has traced to polygenist notions of human difference that informed the nineteenth-century nexus of science and imperialism. Inasmuch as public museums figured among the institutions that sought to acculturate unlettered Europeans to the civilizing mission attributed to them, they formed a key link in the recursive loop between culture, difference, and power characteristic of modernity.[17]

By the deliberately misspelled *differance,* of course, Derrida means something other than "difference." Playing on the etymological link between the words differ and defer (the French verb *différer* combines both meanings), the philosopher uses *differance* to challenge a Cartesian philosophy based on presence or consciousness. He thus posits absence and deferral as the paradoxical basis for all meaning. "Differance," he writes,

> is what makes the movement of signification possible only if each element that is said to be 'present,' appearing on the stage of presence, is related to something other than itself but retains the mark of a past element and already lets itself be hollowed out by the mark of its relation to a future element. This trace relates no less to what is called the future than to what is called the past, and it constitutes what is called the present by this very relation to what it is not, to what it absolutely is not; that is, not even to a past or future considered as a modified present.[18]

Objects in museums constitute such traces inasmuch as they signify by standing not only for something else—an aesthetic ideal, a culture, a historical epoch, a scientific discovery or technique—but also for an imagined future. At least at the level of the individual visitor for whom they provide instruction, diversion, inspiration, or even some kind of transformation, museums always gesture toward an implied plenitude of meaning that extends beyond their boundaries.

Derrida's notion of the trace refers to Levinas, who defines it as "the presence of that which properly speaking has never been there, of what is always past" and also as the "enigma" of the other's "absolute alterity."[19] The trace, Levinas observes, "is not a sign like any other." Even when it assumes the role of a sign—when, for example, "the historian discovers ancient civilizations as horizons of our world on the basis of the vestiges left by their existence"—"the trace has this exceptional quality in relation to other signs: it signifies outside of any intention to make contact [ *faire signe*] and outside of every project of which it would be the aim." The trace, Levinas goes on, "is the insertion of space in time, the point at which the world bows toward a past and a time."[20] Beyond the resonance of this last insight with the identification of evolutionary time as key to the ordering of museums, Levinas's

understanding of the trace scarcely seems applicable to the display of objects, which conspicuously signal an intention. Yet the malleability of the categories in which museums and exhibitions place objects, from the basic art/artifact distinction to the continual production of new overarching groupings, testifies to the gap between the object-as-trace and what it ostensibly signifies. Levinas's passing reference to archaeological fantasies, moreover, offers a pertinent reminder that the pasts to which exhibited objects refer have indeed "never been present": they are fictions of a cultural imaginary.[21] One line of criticism has emphasized the unpredictability of the responses objects elicit, and has cast collections as a form of containment, a way of fixing meaning and closing it off.[22] The recalcitrance of objects, their ability to signify *outside* of any visible intention—in other words, their "absolute alterity"—grounds their attraction in both the conscious and unconscious desires of those who, with varying degrees of success, seek to make them signify.

*Différance* as trace also involves an elusive future, the point in time to which meaning is inevitably deferred. As Mary Nooter Roberts has observed, museums' acquisition of objects takes them "out of time" and places them in the "synchronic, simultaneous temporal frame of the collection." If in the abstract museums insert objects into a temporal sequence, "to say that collections and museums transform the diachronic narrative of history into a synchronic one is another way of saying they turn time into space."[23] James Clifford describes this process in a slightly different way: "Temporality is reified and salvaged as beauty and knowledge."[24] The movement Levinas describes thus comes full circle: only after inserting objects in a temporal sequence can museums spatialize time.

In their capacity as repositories of collections, museums constantly defer the completeness that collectors desire but, except in rare, narrowly delimited cases (proof coins, mint stamps of a certain country, first editions of a particular author), can never attain. The sign, as Derrida observes, is a "deferred presence. . . . the movement of signs defers the moment of encountering the thing itself, the moment at which we could lay hold of it, consume or expend it, touch it, see it, have a present intuition of it." But each object that museums and exhibitions present is *at once* the thing itself and the sign of something else: museums trouble representation by implying that the present thing (which is generally, though not always, accessible only visually) signifies only in relation to something absent. "In this way we question the

authority of presence or its simple symmetrical contrary, absence or lack."[25] Without this element of deferral, museums would not need more objects, new exhibition spaces, additional resources; without an indefinite future, their claim to serve as guardians of heritage would cease to serve any legitimating function.

When Derrida writes "we shall designate by the term *differance* the movement by which language, or any code, any system of reference in general, becomes 'historically constituted' as a fabric of difference," he adds that he intends to question the subsidiary position of such words as "historically constituted" within the philosophical tradition.[26] Through history Derrida returns to the relational dimension of alterity, and also to politics. The question remains, however, of how the framework of difference can animate the practice of critical museum studies. Here the related concepts of "the world-as-exhibition" (Timothy Mitchell) and "the museum effect" (Barbara Kirshenblatt-Gimblett) offer useful models.

For Kirshenblatt-Gimblett, "Like the picturesque, in which paintings set the standard for experience, museum exhibitions transform how people look at their own immediate environs. The museum effect works both ways. Not only do ordinary things become special when placed in museum settings, but also the museum experience itself becomes a model for experiencing life outside its walls."[27] Mitchell's "world-as-exhibition" describes "the techniques of ordering up an object-world to create the novel effect of a world divided in two: on the one hand a material dimension of things themselves, and on the other a seemingly separate dimension of their order of meaning." Although based on a claim to certainty, Mitchell notes, this binary harbors a paradox, which is that so-called reality consists only of another set of representations. In both cases, the difference *of* the museum or exhibition from "reality" offers a basis for understanding that reality in terms of alterity; for Mitchell, the world-as-exhibition depended on the structures of colonialism, "since what was to be made available as exhibit was reality, the world itself."[28] Mitchell and Kirshenblatt-Gimblett both demonstrate how a structuring concept, abstract in itself, acquires persuasive power through the exploration of concrete relationships between museums and exhibitions and the lifeworlds they represent.

Above all, an approach based on a phenomenological notion of alterity— one that takes difference as the essence of museums, and museums as the

essence of difference—must recognize that difference, like *differance,* does not exist in itself, and cannot be analyzed apart from its historical instantiations.[29] Thus the study of museums and difference encompasses the range of relationships that can be seen empirically to constitute museums. The historical configuration of alterity in museums emerges from all the people and things that give museums form: ideologies, and human actors engaging in concrete practices of collection, classification, and display, as they draw on and in turn inflect both specific knowledge formations and general relationships of power. Power builds on, constructs, and uses relations of difference, employing codes of knowledge as it does so; as Michel Foucault observed, "Relations of power are not in a position of exteriority with respect to other types of relationships (economic processes, knowledge relationships, sexual relations), but are immanent in the latter; they are the immediate effects of the divisions, inequalities, and disequilibriums which occur in the latter, and conversely they are the internal conditions of these differentiations. . . ."[30]

Thus power relations exist in a complex network both within museums—for example, the relations of different categories of museum workers, or of museum staff to trustees or other authorities—and outside them. For museums cannot exist without the media, visitors and those who claim to speak for them, and the knowledge formations and disciplines that frame their activities. Foucault's understanding of power as "manifold relationships of force," and of power relations as "both intentional and nonsubjective," provides, indeed, grounds for questioning the distinction between internal and external.[31] Such a distinction may have value as a heuristic device, but only when considered as part of a larger discursive formation that includes the "external" analyst.

This book does not aspire to comprehensiveness; too many types of difference exist in too many configurations. Rather, it offers a set of focused studies that share an inquisitive spirit and a search for complexity. In undertaking to explore the mutual constitution of museums and difference, a book with multiple authors has certain advantages: it can range more widely, speak in more than one voice, and, by addressing the topic from various disciplinary and professional perspectives, expose some of the assumptions that undergird them. In its very structure, the volume challenges one of the most pervasive of such assumptions: that museums and universities constitute *different,* if perhaps parallel, networks of relationships, and that this difference makes it impossible for scholars working in one network to understand the

other.[32] By bringing together both academics and museum-based scholars, this volume, like the conference from which it emerged, instead demonstrates the possibility of engaged, mutually respectful, and productive dialogue among scholars of museums regardless of their institutional locations. Refusing the absoluteness of singular identity claims, such dialogue acknowledges the multiple alterities in which we all participate. The volume thus replicates in the scholarly arena the many recent museum installations that have questioned, even subverted, standard categories of difference.[33]

If the preponderance of cases presented here come from the West, the authors collectively present Europe and the United States not simply as epitomes of modernity but at the same time as congeries of difference. We see, that is, the West's understanding of the world, and its modes of representing it, as inextricably intertwined in encounters, often acquisitive ones, with various others. Nor does the volume proceed through a single chronological sequence. Museums in many parts of the world today undoubtedly show greater sensitivity to issues of alterity, and to their own role in constructing categories of difference, than they have in the past. But to structure the book along a narrative of progress would obscure the pervasiveness of difference in the very constitution of museums. Thus the book offers two separate chronologies, which explore two types of relationship between museums and difference.

The essays in part 1 concern efforts to represent difference, construed in a variety of ways. The people and institutions discussed in these essays all considered, or consider, cultural difference or its human avatar, the other, to *be* representable. In this view, the very act of representing difference—of setting up objects as signs of absent entities, whether other peoples, other times, or the uniqueness of aesthetic genius—can help either to consolidate identity or to bridge difference by promoting cross-cultural understanding. In the opening chapter, Andrew McClellan traces the idealism of art museums from the beginnings of the museum age to the dawn of the twenty-first century. Difference emerges as a constitutive element of museums through the very notion that institutional practices could help aspiring others, here the working class, ascend to the ranks of those entrusted with caring for a society's most valued signs. If the heritage represented by works of art at a symbolic level bound humanity together, lack of universal appreciation of them stood for the differences of class and nation that all too often tore it apart.

McClellan concludes that the continued resonance of a universalizing aestheticized discourse with a bourgeois public effectively immunizes art museums from calls for more active social and political engagement. Certainly this discourse meshes easily with others museums may adopt when circumstances demand it, such as the strategic embrace of Kwame Anthony Appiah's cosmopolitanism in the wake of Italian and Greek demands for American museums to repatriate looted antiquities.[34]

Difference of another kind forms the subject of Ira Jacknis's essay, a diachronic account of one exhibit that encompasses a wide range of attitudes and practices in the history of American ethnographic display. More even than most museum displays, the objects related to Ishi at the University of California's Hearst Museum in Berkeley serve as traces of both a temporary presence, that of Ishi in the museum, and a permanent absence: of the culture, to this day imperfectly understood, for which he was made to stand. Thanks in large part to a popular account of Ishi's life, at one time required reading for California schoolchildren, many visitors approach these artifacts as they might objects associated with a dead celebrity: Lincoln's stovepipe hat, say, or one of Marlene Dietrich's movie costumes. This is especially ironic given that the presence at the Hearst both of Ishi and of objects related to him grew out of an ethnographic encounter framed by the influential views of Franz Boas. Boas, who had taught Alfred Kroeber, the anthropologist who brought Ishi to Berkeley, believed in the possibility of understanding the other through intensive fieldwork and participant-observation; Jacknis has elsewhere described his museology as "advocating a transfer of anthropological interest from the external form to an artifact's *meaning*."[35] His essay in this volume takes the measure of anthropology's complex, ever-changing, and ultimately ambivalent engagement with the object as signifier of difference.

The next two essays return to the uses of art as signifier of, and potential bridge between, different cultures. Angus Lockyer's examination of the Tokyo National Museum shows how Westernizing Japanese elites imported an essentially alien notion of art in the late nineteenth century in order to mold a national culture both distinct from and on the same level as Japan's counterparts on the world stage. Yet this imported conception of art could not easily accommodate elements of Japanese tradition—crafts and "folk art"—that had long occupied an important place in the national self-conception. As the Japanese national museums not only of art but also of history and ethnology

suggest, the display of "other" cultures within the paradigms of an anthropo-logical collection proved simpler than representation of important aspects of the country's own past.

Lockyer concludes his account on a positive note, discussing a recent multi-institutional collaboration that managed to break out of traditional dis-ciplinary frameworks. Nélia Dias's probing analysis of the conceptual back-ground for a new museum in Paris, in contrast, offers less ground for optimism. Her knowledgeable summary of the earlier French collections devoted to various others, French, European, and non-Western,[36] makes clear that even when informed by a humanist discourse and an emphasis on equality, such museums seek above all to affirm a paradox: the distinctness, or difference, of a French culture based on universal values. Few would contest French claims to expertise over the twinned concepts of art and civilization, yet in the hands of those responsible for the Musée du Quai Branly, these notions, supposedly the common patrimony of mankind, link up with more specifi-cally French concepts such as *laïcité* to form a barrier against the perceived threats of multi-culturalism and identity politics. Using their own notion of secularism to dismiss objections to the decontextualized display of objects sacred to Australian first peoples, French scholars re-enact a long-standing tradition of cultural primitivism that reinforces difference even as it claims to erase it.[37]

The last essay in part 1 also concerns a recent encounter between exhi-bition practices and the self-proclaimed civic values of a European nation, in this case Germany. At one level Gunther von Hagens's highly successful, if controversial, Body Worlds exhibitions, so iconic of the present moment that an imagined Miami iteration appears in the 2006 James Bond film *Casino Royale,* do not seem to have much to do with difference at all. The exhibi-tions' own publicity emphasizes their technical innovativeness and educa-tional mission; their focus on human corpses preserved in such a way as to remove all markers of individuality deprives viewers of the encounter with the face so crucial to a Levinasian ethics of responsibility to the other.[38] But in Peter McIsaac's nuanced and skillfully contextualized discussion, Body Worlds emerges as a manifestation of an old tradition of exhibitions catering to a sense of wonder or curiosity, which is itself inextricably linked to differ-ences in human body types. Moreover, like the contemporaneous phenome-non of reality television, the Body Worlds exhibitions play with pre-existing

socio-cultural differences, what Pierre Bourdieu called "distinction," in their aesthetic allusions and indeed in their veiled commentary on the entire exhibitionary complex.[39] Most seriously, as McIsaac makes clear, von Hagens, notwithstanding his self-proclaimed goal of furthering human understanding over and above cultural difference, has found himself embroiled in controversies activated by the numerous traces his Body Worlds unearth. The current German valuation of democratic openness undergirds von Hagens's claim—on a par with the art museum discourse discussed by McClellan—for the beneficial, difference-bridging effects of Body Worlds. Yet German values alone have not been able to shield Body Worlds from questions about Germany's Nazi and Communist pasts, or about the stark inequities, of which von Hagens has clearly taken advantage, that persist in the global economy. McIsaac's careful account of the differing responses to Body Worlds in the United States and Great Britain makes clear what is at stake in von Hagens's recent justification of his practices, which employs both the language of scientific research and—in a familiar gesture toward "openness"—one of the classic modalities of museum culture, the guided tour.[40]

The second part of the book, "Representing Differently," presents a number of cases that fit into a different kind of history, a story of institutions or moments that questioned the prevailing relationship between exhibitions and difference. Meta Warrick, the central figure in W. Fitzhugh Brundage's essay, refused to be confined by the conventional categories that defined her in America at the turn of the last century. An African American woman whose wealthy family and upbringing in Philadelphia had allowed her to pursue an artistic vocation, Warrick found, on returning to the U.S. after study in Paris, only limited opportunities for a sculptor of her background. Overcoming an initial reluctance to work on racially defined subjects, she accepted a commission to create dioramas on African American history at the Jamestown Tercentennial Exposition in Norfolk, Virginia, in 1907. The provisional nature of such venues gave actors from outside the mainstream the possibility to inflect and inhabit their culture. As Brundage shows, the malleability and fluidity of the diorama form allowed Warrick to go well beyond conventions established by the closest cognate, the ethnographic life groups familiar from the world's fairs of the time. Her exhibits, which Brundage painstakingly reconstructs from existing photographic evidence, in some respects fit comfortably within the discourse of racial uplift then dominant

among the African American élite. Yet in endeavoring to cover the full three-hundred-year course of African American history, Warrick made a point of confronting the complexity of black agency both before and after emancipation. And her closing dioramas of an educated and cultivated black bourgeoisie in respectable domestic settings not only made a case for full African American citizenship, they also concluded a historical narrative that insisted on the role and contributions of women. From the edges of the exhibitionary complex, Warrick anticipated by generations the critical role Cornel West has proposed for African American artists and critics.[41]

Alice Conklin's essay focuses on a time of genuine hope in museum practice, a moment when anthropologists and other practitioners of the human sciences saw changing the ways museums represented the human past as a necessary (if hardly sufficient) act of political engagement. In the genealogy of the Musée de l'Homme in Paris, the Berkeley museum discussed by Jacknis must rank as a close cousin, with Franz Boas the common ancestor, and the Musée du Quai Branly as a direct descendant. Yet the moment of the institution's foundation that Conklin explores here forms part of the history of representing differently because of the self-conscious linkage it enacted between the museum's message and its mission. Of course the museum's director, Paul Rivet, and his colleagues had to grapple with the conceptual and physical legacies of colonialism, of which the "skulls on display" of Conklin's title served as an enigmatic and somewhat disquieting trace.[42] Yet within the intellectual context of the time and with the limited means at the founders' disposal, the founding of the Musée de l'Homme, with its strongly populist orientation, stands out as a forceful statement against the hateful science of race. If the museum's early promise faded almost as quickly as the Popular Front that presided over its birth, it can hardly be an accident that members of its staff formed an early and active resistance network in German-occupied Paris.

A quick glance at the photographs accompanying the next contribution might convey the impression of yet another exhibition of Old Master paintings, albeit somewhat unfamiliar ones. But Inventing Race: Casta Painting and Eighteenth-Century Mexico attempted to offer visitors more than aesthetic satisfaction. The exhibition's curator at the Los Angeles County Museum of Art, Ilona Katzew, who shared her thoughts with me a few months after the show closed, has long been a passionate advocate for the intrinsic

interest, aesthetic and otherwise, of these remarkable paintings, which for over a century traced the complexities of racial mixing in colonial Mexico. To show them in an art museum in twenty-first-century Los Angeles, however, represented a challenge at a number of levels, beginning with museum educators and public relations officials worried about potential controversy. Thanks to Katzew's determination, the exhibition ultimately challenged visitors to regard the paintings not simply as beautiful or curious objects, but as polyvalent texts produced by a complex society both like and unlike their own. Taking on the full weight not only of difference but of the particular circumstances of its production meant resisting, not always successfully, a pervasive tendency in the media and within art museums themselves to render the strange familiar and harmless. The dossier offers readers a number of elements that help reconstruct Inventing Race: the text of the exhibition brochure and press release, photographs of the installation, two newspaper articles about the exhibition, and an edited version of my conversation with the curator. Katzew's frank account of the making of the exhibition and the responses it generated offers both encouragement and admonition to those who would follow her example.

The next essay offers another insider account of an innovative exhibition. Lissant Bolton, an anthropologist with considerable fieldwork experience in Vanuatu, came to the British Museum to take charge of a substantial but largely invisible collection of Oceanic artifacts.[43] With plans for a permanent installation of these objects on hold, Bolton found herself in charge of an exhibition of a kind quite new to the British Museum, one that broke with traditional chronological, geographical, and typological divisions. Living and Dying, Bolton explains, attempts to explore a common human condition without denying cultural difference; it tries to present remarkable objects without either fetishizing or banalizing them; it seeks to open new perspectives for visitors most of whom may be on their way to see something else. Not least important, the exhibition also moved toward greater collaboration with the makers of the objects on view than the museum has practiced in the past. The question of the control of cultural property, now much in the news, has the potential to alter relations of power and difference in museums in ways more radical than many have yet contemplated. The mixed critical response to the September 2004 opening of the National Museum of the American Indian in Washington, which

ceded a large measure of control to Indian tribes and scholars, may be a harbinger of future upheavals.[44]

The volume concludes with an essay by William Truettner, whose sensitivity to art museums' traditional privileging of the aesthetic, born of considerable experience as a curator, yields a set of bracing insights into the problems of introducing historical complexity into the standard narratives of art history.[45] His essay, which takes as its central example another kind of encounter between whites and Indians, explores the intersection of historical narrative and the politics of display. Truettner rewrites a recent exhibition catalogue's treatment of a painting, George Brush's *The Picture Writer's Story*, that at first glance testifies to a respectful as well as aesthetically masterful relationship between a white painter and an iconic Indian. Its compass extending to the silences of a major international exhibition on Art Nouveau, Truettner's essay models the kind of critical engagement with history he advocates. Most troublingly, he suggests that the discourse of quality that informs the practice of most art museums almost inevitably trumps efforts by such museums to communicate historical complexity to their audiences.

It remains unclear whether the increasingly common structural changes in museums, which generally tend to break down or recombine curatorial departments, will advance or inhibit the kinds of innovative exhibition Katzew, Bolton, and Truettner advocate.[46] Though the exhibitions differ considerably in both content and approach, Living and Dying shares at least one important feature with Inventing Race: a bracing refusal to condescend to visitors. This confidence in the visitor's ability to make his or her own sense of an exhibition has an empowering effect inasmuch as it both admits visitors' differences and refuses to be paralyzed by them. For alterity as outlined here of course has an inescapable quality; it extends well beyond museums and exhibition spaces to the dailiness of our lives and the irrecusable otherness of those around us. The ethical burden difference poses to museums as institutions is considerable, but so are the claims museums make of and for the societies and peoples they claim to serve. However museums choose to regard this burden, these essays make clear that, historically and with an eye to their ever-deferred future, they cannot escape it.

Introductions tend to offer a picture of thematic coherence, to emphasize the connecting tissue of a work rather than its disjunctions. I want to conclude, therefore, on a slightly different note, first by emphasizing the

serendipitous nature of any anthology of this kind. Ideally, the book would have covered a wider range of cases; efforts to include additional essays on museums in Africa and Latin America unfortunately proved unavailing. At a certain point, the deferral of meaning attendant on making a better book, or at least one with a greater range of cases, risks leaching into irrelevance; an editor can only hope that the volume will give rise to further inquiry along the lines it has sketched. Whatever its limitations, this book does have the merit of embracing its own differences: differences of disciplinary and professional background, differences among the authors' positions in relation to museums, differences of voice, of tone, of approach. That a civil and engaged conversation remains possible across and indeed in part as a result of these differences belies the absolute but artificial difference between insiders and outsiders posited at an earlier stage of critical museum studies and offers grounds for hope in the possibility of a mutual engagement to change museums, scholarship, and their relationship to the wider world.

## Acknowledgments

My thanks to Alice Conklin, Nélia Dias, Eduardo Douglas, and Angus Lockyer for their invaluable comments on earlier drafts; to Amity McGinnis, for her research assistance; and to Ruud van Dijk, for his editorial help.

## NOTES

1. Few formulations better sum up the fluid relationship between identity and difference than a comment reported in the title of a *Le Monde* article on the eve of the 2006 World Cup final between France and Italy: "We immigrants, we're French when we win the World Cup. But two weeks later, we're no longer French. . . .": "Nous les immigrés, on est français quand on gagne le Mondial. Mais 15 jours après . . . ," *Le Monde,* 9 July 2006, http://www.lemonde.fr/web/article/0,1-0@2-3226,36-793510@51-792240,0.html. Accessed 8 July 2006. *Le Monde* also reported persistent confusion about the national origins of members of the French team, notably those born in French overseas territories and thus French citizens from birth: "Equipe de France: amalgames et erreurs sur l'origine des joueurs," *Le Monde,* 9 July 2006, http://www.lemonde.fr/web/article/0,1-0@2-3226 ,36-793516@51-792240,0.html. Accessed 9 July 2006.

2. Walter Benjamin, "On the Mimetic Faculty," in his *Reflections: Essays, Aphorisms, Autobiographical Writings,* ed. Peter Demetz, trans. Edmund Jephcott (New York: Schocken,

1978), 333. See Michael Taussig's gloss on this passage in *Mimesis and Alterity: A Particular History of the Senses* (New York: Routledge, 1993), 19–20.

3. Raymond Williams, *Keywords: A Vocabulary of Culture and Society,* rev. ed. (New York: Oxford University Press, 1985), 87. It is worth nothing that *Keywords* contains no entries for "difference" or "alterity," though it does have one for "racial."

4. Robert J. C. Young, *Colonial Desire: Hybridity in Theory, Culture and Race* (London: Routledge, 1995), 53–54. See also Terry Eagleton, *The Idea of Culture* (Oxford: Blackwell, 2000), 1–31; like Young, whose views he broadly shares, Eagleton both acknowledges Williams's influence and departs from his analysis.

5. Emmanuel Levinas, *Alterity and Transcendence,* trans. Michael B. Smith, European Perspectives (New York: Columbia University Press, 1995), 126, emphasis his.

6. I am grateful to Angus Lockyer for this formulation.

7. Leela Gandhi, *Postcolonial Theory: A Critical Introduction* (New York: Columbia University Press, 1998), 39–40.

8. As an example, although the introduction to one pioneering volume has the subtitle "Museums and Multi-Culturalism," it takes differences among cultures as given and frames its argument with the insight that "decisions about how cultures are presented *reflect* deeper judgments of power and authority" (emphasis mine); Ivan Karp and Steven D. Lavine, eds., *Exhibiting Cultures: The Poetics and Politics of Museum Display* (Washington: Smithsonian Institution Press, 1991), 2.

9. Tony Bennett, *Pasts beyond Memory: Evolution, Museums, Colonialism* (London: Routledge, 2004), 9, emphases his.

10. James Clifford, "On Collecting Art and Culture," in his *The Predicament of Culture: Twentieth-Century Ethnography, Literature, and Art* (Cambridge, Mass.: Harvard University Press, 1988). This book more or less coincided with the influential exhibition ART/Artifact: African Art in Anthropology Collections, organized by Susan Vogel at the Museum for African Art in New York. For a permanent exhibition rethought along these lines, see Christa Clarke, "From Theory to Practice: Exhibiting African Art in the Twenty-First Century," in *Art and Its Publics: Museum Studies at the Millennium,* ed. Andrew McClellan, New Interventions in Art History (Malden, Mass.: Blackwell, 2003), 165–82. For an example of the continuing influence of these debates, see Joshua Brockman, "A New Dawn for Museums of Native American Art," *New York Times,* 20 August 2005.

11. George W. Stocking, "Essays on Museums and Material Culture," in *Objects and Others: Essays on Museums and Material Culture,* ed. Stocking, History of Anthropology 3 (Madison: University of Wisconsin Press, 1985), 4, 11.

12. Annie Coombes, *Reinventing Africa: Museums, Material Culture, and Popular Imagination* (New Haven, Conn.: Yale University Press, 1994), 2, 5. Anne Maxwell's informative study of

colonial exhibitions in roughly the same time period, with an impressive range of examples that extends from Europe to the United States and Australia, focuses on the construction of categories and identities rather than of institutions: *Colonial Photography and Exhibitions: Representations of the "Native" and the Making of European Identities* (London: Leicester University Press, 1999).

13. See, for example, Tim Barringer and Tom Flynn, eds., *Colonialism and the Object: Empire, Material Culture, and the Museum,* Museum Meanings (London: Routledge, 1998); Dominique Taffin, ed., *Du musée colonial au musée des cultures du monde: Actes du colloque organisé par le musée national des Arts d'Afrique et d'Océanie et le Centre Georges-Pompidou, 3–6 juin 1998* (Paris: Maisonneuve et Larose and Musée national des Arts d'Afrique et d'Océanie, 2000). Barringer and Flynn cast their project as filling in a gap they describe as follows: "the broader category of functional, or non-representational three-dimensional objects (whether considered as 'the applied arts', the 'decorative arts', or less restrictively as 'material culture') has largely been ignored in the context of debates about colonialism" (introduction to *Colonialism and the Object,* 3).

14. Nélia Dias, "The Visibility of Difference: Nineteenth-Century French Anthropological Collections," in *The Politics of Display: Museums, Science, Culture,* ed. Sharon Macdonald (London: Routledge, 1998), 36–52.

15. Jacques Derrida, "Differance," in his *Speech and Phenomena and Other Essays on Husserl's Theory of Signs,* trans. and ed. David B. Allison (Evanston, Ill.: Northwestern University Press, 1973), 130.

16. Bennett, *The Birth of the Museum: History, Theory, Politics* (London: Routledge, 1995), 95–96.

17. Young, *Colonial Desire,* 43–51.

18. Derrida, "Differance," 142.

19. Levinas, "Meaning and Sense" and "Enigma and Phenomenon," in his *Basic Philosophical Writings,* ed. Adriaan T. Peperzak, Simon Critchley, and Robert Bernasconi, Studies in Continental Thought (Bloomington: Indiana University Press, 1996), 63, 68–73. For Derrida's summary, see "Differance," 152. For the French sense of alterity, see Levinas, "Énigme et phénomène," in his *En découvrant l'existence avec Husserl et Heidegger,* Bibliothèque d'histoire de la philosophie (Paris: J. Vrin, 1967), 206.

20. Levinas, "La signification et le sens," in his *Humanisme de l'autre homme* (Montpellier: Fata Morgana, 1972), 60–61. I have slightly modified the translation (by Alphonso Lingis and the editors) in "Meaning and Sense," 61–62.

21. On the concept of museum fictions see Eugenio Donato, "The Museum's Furnace: Notes toward a Contextual Reading of *Bouvard and Pécuchet,*" in *Textual Strategies: Perspectives in Post-Structuralist Criticism,* ed. Josué V. Harari (Ithaca, N.Y.: Cornell University Press, 1979), 213–38.

22. See, for example, Susan Stewart, *On Longing: Narratives of the Miniature, the Gigantic, the Souvenir, the Collection* (Durham, N.C.: Duke University Press, 1994, orig. publ. 1984), especially 155–63.

23. Mary Nooter Roberts, "Do Objects Have a Life?" in *Exhibition-ism: Museums and African Art,* ed. Roberts and Susan Vogel (New York: The Museum for African Art, 1994), 48.

24. Clifford, "Objects and Selves—An Afterword," in *Objects and Others,* 241.

25. Derrida, "Differance," 138–39.

26. Ibid., 141–42.

27. Barbara Kirshenblatt-Gimblett, "Objects of Ethnography," in *Exhibiting Cultures,* 410.

28. Timothy Mitchell, "Orientalism and the Exhibitionary Order," in *Colonialism and Culture,* ed. Nicholas Dirks (Ann Arbor: University of Michigan Press, 1992), 302–303.

29. I am grateful to Nélia Dias for this insight.

30. Michel Foucault, *The History of Sexuality, Vol. 1: An Introduction,* trans. Robert Hurley (New York: Random House, 1978), 94.

31. Ibid.

32. Though typical of the response of museum professionals to academic work in critical museum studies, the assumption runs in the other direction as well. For the former, see, for example, Ivan Gaskell, review of *On the Museum's Ruins* by Douglas Crimp, *The Cultures of Collecting,* edited by John Elsner and Roger Cardinal, and *Museum Culture: Histories, Discourses, Spectacles,* edited by Daniel J. Sherman and Irit Rogoff, *The Art Bulletin* 77 (1995): 673. For the latter—a university-based scholar observing that museum professionals "have been unaware of the effects of their practices"—see Eilean Hooper-Greenhill, *Museums and the Shaping of Knowledge* (London: Routledge, 1992), 4.

33. See Chon A. Noriega, "On Museum Row: Aesthetics and the Politics of Difference," *Daedalus* 128:3 (Summer 1999): 57–81. As a university-based scholar who also organizes museum exhibitions, Noriega himself bridges the insider/outsider gap.

34. Kwame Anthony Appiah, *Cosmopolitanism: Ethics in a World of Strangers,* Issues of Our Time (New York: W. W. Norton, 2006), especially chapter 8; for the appropriation of this idea, see the comments of Philippe de Montebello, director of the Metropolitan Museum of Art, and of James Cuno, director of the Art Institute of Chicago, in "Is It All Loot? Tackling the Antiquities Problem," excerpts from a panel discussion held in New York on 6 March 2006 and reprinted in the *New York Times* annual special section on museums, 29 March 2006. Appiah also participated in the discussion.

35. Ira Jacknis, "Franz Boas and Exhibits: On the Limitations of the Museum Method of Anthropology," in *Objects and Others,* 79, emphasis his.

36. Dias is herself one of the pioneering scholars of these institutions. See, for example, her *Le musée d'ethnographie du Trocadéro (1878–1908): Anthropologie et muséologie en France* (Paris: Centre national de la recherche scientifique, 1991).

37. On primitivism as a cultural phenomenon, see, for example, Elazar Barkan and Ronald Bush, eds., *Prehistories of the Future: The Primitivist Project and the Culture of Modernism* (Stanford, Calif.: Stanford University Press, 1996); Shelly Errington, *The Death of Primitive Art and Other Tales of Progress* (Berkeley: University of California Press, 1998); Daniel J. Sherman, "Post-Colonial Chic: Fantasies of the French Interior, 1957–62," *Art History* 27 (2004): 770–805.

38. Levinas, "Meaning and Sense," especially sections 7–9, 51–64.

39. I borrow the term from Bennett, "The Exhibitionary Complex," *New Formations,* no. 4 (Spring 1988), reprinted as chapter 2 of *The Birth of the Museum.* See also Pierre Bourdieu, *La distinction: Critique social du jugement* (Paris: Minuit, 1979); in English, *Distinction: A Social Critique of the Judgement of Taste,* trans. Richard Nice (Cambridge, Mass.: Harvard University Press, 1984).

40. David Barboza, "China Turns Out Mummified Bodies for Displays," *New York Times,* 8 August 2006.

41. West's term is "Critical Organic Catalyst": see Cornel West, "The New Cultural Politics of Difference," in *The Cultural Studies Reader,* ed. Simon During (London: Routledge, 1993), 216.

42. Conklin has discussed this aspect of the museum's beginnings in "Civil Society, Science and Empire in Late Republican France: The Foundation of Paris's Museum of Man," *Osiris* 17 (2002): 255–90.

43. Bolton has published her own primary research as *Unfolding the Moon: Enacting Women's Kastom in Vanuatu* (Honolulu: University of Hawai'i Press, 2003).

44. See, for example, Elizabeth Olson, "A Museum of Indians That Is Also for Them," *New York Times,* 19 August 2004, which quotes the museum's director, W. Richard West, a Southern Cheyenne, as hoping that the "museum would achieve 'cultural understanding and reconciliation that has eluded American history from its beginnings.' " In "Who Should Tell History: The Tribes or the Museums?" *New York Times,* 21 December 2004, the reliably conservative Edward Rothstein criticizes the NMAI's cession of control to "tribal guest curators"; he writes, "the result is homogenized pap in which the collection is used not to reveal the past's complexities, but to serve the present's simplicities." Responses of Indians to the institution have generally been much more favorable; see, for example, Shauna Lewis, "Grand Opening of the Smithsonian National Museum of the American Indian," *First Nations Drum,* http://www.firstnationsdrum.com/Fall%202004/CovNMNA.htm. Accessed 7 September 2005. See also Amanda J. Cobb, "The National Museum of the American Indian as Cultural Sovereignty," *American Quarterly* 57:2 (2005): 485–506, a sensitive summary of both positions.

45. Truettner was, notably, the curator in charge of the controversial exhibition The West as America: Reinterpreting Images of the Frontier, held at his home institution, the Smithsonian's National Museum of American Art (now called the Smithsonian American Art Museum), in 1991.

46. The best-known such restructuring took place at the Museum of Fine Arts, Boston, in 1999; see Judith H. Dobrzynski, "Boston Museum's Restructuring Sows Fear Among U.S. Curators," *New York Times,* 8 July 1999. The 2006 reorganization of the Brooklyn Museum of Art has prompted comparisons with the Boston case: see Randy Kennedy, "Loss of Curators' Power Seen in Brooklyn Museum Plan," *New York Times,* 22 June 2006; Idem, "Brooklyn Museum's Plan for Its Curators Angers Organization," *New York Times,* 15 July 2006.

# PART 1 REPRESENTING DIFFERENCE

# Art Museums and Commonality

## *A History of High Ideals*

ANDREW McCLELLAN

CHAPTER ONE

In a collection of essays devoted to the subject of museums and difference, it would surely be useful to provide an overview of the ways in which museums of art and archaeology have long insisted on their importance as spaces of common aspiration, transcendent values, and mutual understanding. Needless to say, it is precisely the flattening of difference—differences of culture, class, and definitions of art across space and time—in a reductive pursuit of essential identities that recent critics of the museum have sought to explode as so many myths designed to occlude the power relations between peoples and between institutions and their publics. A generation of critics inspired by Barthes and Foucault has deconstructed the essentialism of such categories as "humanism" and "art" as contingent discursive structures serving various Western geo-political and economic interests.[1] Objects acquired by art museums are thereby defined as art and displayed for visual consumption regardless of their original context or function. Especially in large encyclopedic museums (the Louvre, Metropolitan Museum of Art, British Museum, etc.), the art of the world is laid out to give the impression of separate but equal traditions motivated by a shared desire to give visual expression to the human condition; local inflection and historical specificity, in the end, are transcended by universal impulses.

Viewed historically and critically, the rhetoric of art and humanism acti-
vated in museums is far from value-neutral and has served as a means of sort-
ing and prioritizing cultural artifacts with significant implications for how
privileged viewers have judged the cultures those artifacts are made to rep-
resent. Museum work is fundamentally about *representation,* decisive acts of
inclusion and exclusion based on criteria that are culturally and historically
specific—"always strategic and selective," in the words of James Clifford.[2]
Precisely because of the social and cultural authority vested in museums and
the apparent objectivity of what they do, museum critics strive to reveal the
strategic interests and exclusions underlying institutional policy and prac-
tices. More than an intellectual exercise, the goal of criticism is increasing
reflexivity among curators and awareness among visitors; and, to be sure,
over the past two decades significant movement has taken place within mu-
seums in the direction of greater inclusion (broader representation of cul-
tures and definition of art), accountability, and recognition of difference. But
just as museum displays are always contingent, notions of difference and
what constitutes adequate representation remain shifting targets, engaging
museums and their critics in an ongoing dialectic of critique and response,
theory and practice. Notwithstanding recent critique and a growing reflexiv-
ity among curators as a result of that critique, the rhetoric of commonality
remains a staple of mission statements and public support for museums. In-
deed, it has lately become more firmly entrenched in both quarters. The pur-
pose of this essay will be to trace the historical development of this rhetoric
in art museums and to explain its resurgence in recent years. More than
empty words fit for a fund-raising event, the rhetoric of commonality, I will
argue, has become the driving force and central justification for art museums
in an age of increasing globalism and societal fragmentation, hope and uncer-
tainty, progress and trauma.

Claims of universality have been central to the museum's identity from the
moment the dream of recreating Ptolemy's lost Library at Alexandria, or *Mou-
seion,* took hold of early modern philosophers, collectors, and kings. Known
only through scattered literary references hailing its all-encompassing collec-
tion of books and knowledge ("all the books in the inhabited world," "the
writings of all men," and so on), the *Mouseion* established a model of pleni-
tude for later museums all the more powerful because it no longer survived
to reveal its flawed contingency.[3] Reborn during the Renaissance, the ideal of

comprehensive knowledge was extended to material objects as well as books and fuelled the growth of collecting across Europe. As Krzysztof Pomian and Paula Findlen have shown, collecting became a pan-European phenomenon uniting members of different professions, social strata, and religions.[4] Typically associated with academies and seats of learning, collections became key sites in an emerging republic of letters whose allegiance to knowledge and civility transcended national borders and politics. Encyclopedic in scope and open ended in terms of social participation and potential, collections naturally took on a forward-looking dimension and were assimilated into the progressive utopianism of the Enlightenment, which is arguably still alive and well today.

We should note, however, that claims to universality in early modern collections were universally exaggerated. No collection of art or natural history aimed in fact to contain *everything* in its class; rather, collections were measured by the quality and rarity of their contents following the accepted criteria of the day. The inscription above the door to Pierre Borel's seventeenth-century cabinet qualified universality in precisely this way when it read: "a microcosm or compendium of all rare strange things."[5] In the realm of art, early attempts to determine the list of great artists, beginning with the publication of Vasari's *Lives of the Artists* in 1550, produced a good deal of consensus but also much local variation as partisan connoisseurs from different parts of Europe attempted to write native artists into the canon. The first universal art museums were really anything but; insofar as common ground could be found amidst regional inflection, the shared canon was itself highly selective in composition. A year after it opened in 1793, the Louvre stated its ambition to present an "uninterrupted sequence of the history of art"[6] but the art on display was limited to high art by male artists from the Golden Age of a select few European traditions—essentially Greco-Roman antiquity, the Italian Renaissance, and the Dutch, Flemish, and French Baroque. Within each of those schools, only the very best works by the greatest Old Masters was included. More than a century later a 1923 guide to the Louvre could proclaim: "The Louvre is the richest museum in the world. All arts and all civilizations are represented,"[7] yet the range of arts and civilizations on view had changed little since the days of Napoleon.

The advent of world's fairs, beginning in 1851, and the spread of colonialism gradually widened the European conception of art to include the applied arts and the visual culture of non-European civilizations. Following

European territorial ambitions eastward through the Mediterranean, the products of Egypt and Mesopotamia, and then India, Japan, and China, were gradually added to the canon. By the end of the twentieth century, the categories of art and culture had been extended "to all the world's peoples," as Clifford has remarked.[8] The museological terrain is still uneven in the sense that the cultural artifacts of some peoples may still be found in natural history or ethnographic museums as well as in art museums, but the drift toward greater inclusion and equal treatment of all cultures within the discursive and institutional parameters of the art world has been decisive. What allows for the assimilation of new worlds into established art museums is the guarantee that the traditional art world criteria of quality, rarity, and beauty apply consistently to everything museums display and acquire. While our museums now encourage us to view all the world's peoples as art producing, the imposition of Western aesthetic standards on non-Western objects often distorts our understanding of those objects and the cultures that produced them, as Clifford and others have argued.

Theoretically universal in scope, the Enlightenment museum also implicitly envisaged access for all. The museums built by the emerging nation states of the nineteenth century were intended to be open institutions useful to society. Public participation was an explicit desideratum of cultural policy during the French Revolution, which promoted the Louvre and other museums as engines of liberty, equality and brotherhood. Such was the Louvre's success as a state-run public attraction and model of comprehensive display that it was emulated by later art museums throughout Europe and beyond. Lingering obstacles to full access, stemming from art world elitism, racism, and economic pressures, remain to be overcome, of course, but the problems have been identified for those in authority to resolve.

The most pressing challenge facing sponsors of the art museum in modern, democratic societies was, and is, to justify the cost of their maintenance in terms of public utility. What good are art museums? In pre-Revolutionary Europe (and beyond), art had long derived its justification and patronage from service to church and court, but following the dissolution of those supports and the emergence of a secular ideology of nationhood and popular sovereignty, new uses and rationales had to be found. This constituted a significant challenge for living artists, but it also required a wholesale re-evaluation of past art. The Louvre set an important example by re-identifying art appropriated by the state

from church and crown (and eventually conquered nations) during the French Revolution as national patrimony; displayed in a royal palace turned palace of the people, the art of the past shed former meanings and became a source of communal identity and "civilizing rituals" for a newly formed citizenry.[9] Symbol of bourgeois ascendance, the museum, together with other modern institutions, aimed to disseminate bourgeois values throughout society.

But beyond civic lessons and patriotic sentiment, what good came of ordinary people looking at pictures and statues in these newly created temples of high art? While the arrangement of museum collections demonstrated the value of order and progress, individual works of art, chosen in accordance with the highest standards of taste, raised the viewer above the plane of normal existence through contemplation of the ideal. Neo-Platonic art theory had long argued as much, but during the museum age works of art acquired an enhanced transcendent potency. Propelled by Romantic philosophy, which was later popularized by museum men, social reformers, and art critics, works of art came to symbolize human creativity and imaginative freedom from the material constraints of the world, all the more when set apart from quotidian concerns in the museum. As Hans Belting has argued, the move toward this essentially modern concept of art is neatly encapsulated in the radical redefinition of the "masterpiece" after 1800. Throughout the medieval and early modern periods the term referred to a work completed in fulfillment of prescribed rules and a specific function, but during the Romantic era it came to mean the reverse, that is to say a work of art that defied conventions and external expectations, and in so doing epitomized an ideal of creative autonomy.[10] Consonant with art's withdrawal from the world, art appreciation became increasingly solitary, culminating in the isolated viewer posited by modernist theory and museums.[11] The Romantic ideal of autonomous creation had as its corollary the viewer's autonomous communion with the work of art in a space divorced from what the poet Wilhelm Wackenroder termed "the vulgar flux of life."[12] If, in the early modern era, art collections had been sites of elite sociability, from the nineteenth century they were valued increasingly as spaces for private reflection and imaginative release, as we see in William Hazlitt's reflections following a visit to the London collection of J. J. Angerstein in 1822:

> It is a cure (for the time at least) for low-thoughted cares and uneasy passions. We are abstracted to another sphere: we breathe the empyrean

air. . . . The business of the world at large, and even its pleasures, appears like a vanity and an impertinence. What signify the hubbub, the shifting scenery, . . . the folly, the idle fashions without, when compared to the solitude, the silence . . . the unfading forms within? The contemplation of truth and beauty is the proper object for which we were created, which calls forth the most intense desires of the soul, and of which it never tires.[13]

Public museums inherited this sense of beneficial separation from the outside world and became the ultimate space for art whose own value was simultaneously being redefined in opposition to practical, material concerns.

The paradoxes and losses to be negotiated in the transition to a museum culture were considerable. First, the value of many works as *national* patrimony stemmed directly from their perceived worth as the cultural heritage of mankind; it was only by appropriating what on a spiritual plane belonged to all that a country could demonstrate allegiance to European (and eventually world) civilization. This tension fueled the growth of national museums from the early nineteenth century and underlies many current disputes over ownership and restitution. Second, the broad communal access implicit in the creation of national museums worked against the demands of solitary reflection; the solitude and silence Hazlitt enjoyed in the Angerstein collection vanished once Angerstein's paintings were assimilated into London's National Gallery, for example. From the first, *amateurs* like Hazlitt have resented and avoided the crowds, complicating the museum's communal aspirations. Finally, objects in the newly charted cultural realm became useful only insofar as they lost their former utility. As Hegel argued, in attaining self-sufficiency art had been "removed to the sphere of our imagination" and was no longer essential to society, as it had been in former times.[14] Early critics of the museum, led by Quatremère de Quincy, mourned art's loss of purpose in the upheavals of the Revolution and Napoleonic wars; relocated to museums and private collections, antiquities and works of art ceded their former purpose, what Walter Benjamin called their "cult value," to become instead objects of bourgeois consumption and patriotic pride.[15]

But according to museum advocates there were also significant gains. As we see in Hazlitt's account, works of art did not lose their purpose through removal to an art gallery so much as acquire a new one as a vital source of

historical interest and contemplative pleasure. Released from previous functions, the vagaries of the market and the ambitions of collectors, "museum art" was now free to be art. Moreover it was in a public museum that the benefits Hazlitt had enjoyed as a private *amateur* could be shared by the working multitudes, who were all the more in need of beauty and inspiration owing to the dehumanizing conditions of modern capitalism. Working through each individual, society as a whole would gain relief from "low-thoughted cares and uneasy passions." As Dickens's friend Charles Kingsley said of London's National Gallery: "Picture-galleries should be the townsman's paradise of refreshment" taking the visitor "beyond the grim city-world of stone and iron, smoky chimneys, and roaring wheels, into the world of beautiful things."[16] At the heart of the modern metropolis, art museums provided an oasis of contemplation and a redemptive vision of mankind; collective toil was justified and the museum-goer returned to the workaday world ready to face its trials. Across town from the National Gallery, the Tate Gallery opened in 1897 on the site of a former prison in an area plagued with crime and dereliction. "Where once stood a building the inside of which no one wished to see," proclaimed *The Daily Graphic,* "another has risen, whose doors stand open, . . . whose cool fountain courts and cheerful galleries invite the reposeful contemplation of things of beauty."[17] The Tate's public featured a healthy cross-section of city-dwellers whose paths would not otherwise cross, from the "well-to-do citizen who was there to see some of the pictures he 'remembered years ago' " to "the nondescript individual who may have passed a few days or longer in the original building."[18] A half century later, across the Atlantic, the compensatory function of museums had lost none of its purchase. As Benjamin Gilman from Boston's Museum of Fine Arts put it,

> [Art] is a new world, of preferences, satisfactions, ideals, set beside the old indifferent or sorrowful reality. From its contemplation we come as from a respite, strengthened for that from which it has brought relief. The paradise of artistic creation is not hung in the heavens like an Olympus detached from earth, whose divinities have no thought for human kind. It has a consoling and inspiring outlook also, upon every-day reality.[19]

The need to justify the art museum was made all the more pressing following the development of the applied arts, or *Kunstgewerbe,* museum, whose *raison*

*d'être* was perfectly in accord with the values of modern industry and capitalism. London's South Kensington Museum, founded in 1857 (and renamed the Victoria and Albert Museum in 1899), was created as a direct response to the challenges and opportunities arising from the Industrial Revolution.[20] Its purpose was two-fold: on one hand, to stimulate native design and manufacture through a comprehensive display of decorative and applied arts; on the other, to provide taste and wholesome recreation to the masses who had flocked to the capital in search of work. A museum devoted to domestic objects, complete with a café (the first of its kind) and open in the evenings, would attract the people and encourage both the production and consumption of goods. Early exhibitions of royal wedding presents and featured items from the hugely popular Great Exhibition of 1851 did nothing to lessen its appeal. Within a decade of its opening, South Kensington had become the most popular museum in the world's most populous capital. Before long cities elsewhere in Europe and the United States followed its example.

In keeping with the positivist spirit of nineteenth-century capitalism, the benefits of the South Kensington Museum were concrete and quantifiable, at least in theory. Improved design could be measured in increased sales and exports; improved morality among the laboring classes, the outcome of wholesome recreation, would be reflected in decreasing rates of procreation, drunkenness, and crime. South Kensington's blend of broad appeal, economic relevance, and social reform made it a quintessentially utilitarian product of the Victorian era. In practice, the relief experienced by urban workers may have been transient at best, yet the anticipated benefits were sufficient to win the support of governments and private benefactors newly enriched by modern industry.

It is important to recognize that art museums and galleries also served the interests of industry and capitalism, but in a way markedly different from the South Kensington type. Instead of encouraging manufacture and consumption, art museums offered release from quotidian pressures and material desires, and thus fostered a calmer and more complacent citizenry and workforce (Foucault's "docile bodies"). In the words of George Godwin, chairman of the Art Union of London,

> An acquaintance with works of art gives dignity and self-esteem to the operative, a matter of no slight value as regards the stability of society,

besides making him a better workman and furnishes him with delight, independent of position, calculated to purify and exalt.[21]

John Ruskin decried modern industry and the South Kensington philosophy, yet he promoted public museums for their ability to civilize "the laboring multitude" by offering an "example of perfect order and perfect elegance."[22] Significantly, Ruskin designed a model museum of his own and placed it on a hilltop above the steel mills of Sheffield, a city described by a journalist visiting the museum as "the black heart of the grimy kingdom of industry" and a hot-bed of "trades-union terrorism."[23] Ruskin may have been naïve in imagining that the denizens of "Steelopolis" would willingly walk two miles uphill on their only day of rest to experience his vision of uplift, but his patrician faith in the softening power of the museum was widely shared.

Ruskin's contemporary, Matthew Arnold, never mentioned museums by name, yet his *Culture and Anarchy* of 1869 exerted considerable influence on museum theory and practice in the English-speaking world of the late nineteenth and early twentieth centuries. Like Ruskin, Arnold believed in the widespread dissemination of high culture, embracing not least "the raw and unkindled masses of humanity," in order to unify society and prevent anarchy. Culture—defined as the cultivation of mind and spirit through contemplation of "the best that has been thought and said"—would eventually envelop "all our fellow men" in "sweetness and light" and bring about the "general expansion of the human family." Broadly conceived, the purpose of culture was "to leave the world better and happier than we found it."[24]

For our purposes, Arnold's most radical suggestion was that culture would not only lift the downtrodden but serve as a general antidote to the creeping materialism that threatened the social fabric from within. On the eve of the Great Exhibition at Crystal Palace, Prince Albert imagined that industry would "unite the human race," but the dank slums of Dickensian London proved that raw capitalism left much to be desired.[25] For Arnold, "the unfettered pursuit of the production of wealth" had produced, on the one hand, "masses of sunken people" that society could ill afford to leave behind, and on the other, a crass new middle class blinkered by the pursuit of money and goods. "The temptation to get quickly rich and to cut a figure in the world" had become a corrosive force in advanced industrial society. In other words, the acculturation of the moneyed classes was no less a priority than

the civilizing of the poor. Rather than an end in itself, the wealth generated by modern industry should be a means to spread the "ideal of human perfection and happiness" across society.[26] It was in this spirit that wealthy captains of industry manifested their wealth even as they gave a portion of it away in support of public art museums.

The writings of Arnold and his fellow Victorians track the emergence of a popular view of art and high culture as a necessary counterbalance to the ills of modern society. Offsetting the degrading tendencies of capitalism, culture embodied "our proper humanity."[27] Without the former there would be no progress; without the latter there would be no civilization. Society needed both, hence the centrality of cultural institutions—museums, libraries, public schools, etc.—at the heart of the modern metropolis. The principle of balance took root in the United States—a booming industrial nation much in need of acculturation, according to Arnold and other foreign observers. At the World's Columbian Exposition in Chicago in 1893, for example, where North American might was showcased for the world to see, demonstrations of industry and technology surrounded a classical temple of the fine arts, which was set in splendid isolation to emphasize the complementary role of art in the new socio-economic order.[28]

Early art museums in the United States attempted to reconcile the practical utilitarianism of the South Kensington Museum and the aesthetic idealism of the public art gallery. By the early twentieth century, however, tensions implicit in the two-sided philosophy led to increased polarization both within museums and between different institutions. At Boston's Museum of Fine Arts, for example, in what has come to be known as the "Battle of the Casts," Matthew Prichard and Benjamin Gilman fought to rid the museum of its utilitarian ethos and replace it with a doctrine of high aestheticism; plaster casts, copies, and the applied arts gave way to original high art representing what Gilman described (in Arnoldian terms) as the visual equivalent to "the best that has been thought and said in the world."[29] The museum itself was rebuilt at a healthy remove from the city center to enhance separation and respite. Opposing Gilman and Prichard was John Cotton Dana, founder of the Newark Museum in New Jersey. Under Dana's guidance during the 1910s and '20s, Newark became a model of community involvement and practical relevance; in his own words, he dedicated his downtown museum to the practical interests of local citizens "and to the improvement and general efficiency of their business and work-a-day

lives."[30] Dana despised the elitism and fetishism of the art world and dismissed "gazing museums" like the MFA as the useless playthings of the privileged.

Dana's spirited attack on the elitism of high art still deserves to be reckoned with, but he was fighting a losing battle against the rising tide of Gilmanesque aestheticism, which by the 1930s had all but swept art museums clean of any remaining vestiges of utility. In part Dana's campaign failed because his assessment of the vanities of those who built art museums in their own image and interests was correct. But equally important, the rationale for museums articulated by Gilman and others indebted to Arnold came to seem increasingly pertinent, and indeed vital, in view of the disorienting pace and turmoil of modern life. Owing to the rarified tone and proto-formalist nature of Gilman's creed, we forget that he too was a populist at heart who insisted "the museum offers itself . . . not to the privileged few, but to every one." "Its task will be to offer to the whole population, old and young, the opportunity to contemplate works of art."[31] For Gilman, the museum would be useful to society, broadly conceived, by freeing art from the normal circuits of work and economic exchange in order that its aesthetic and imaginative properties could be fully enjoyed. In other words, art's utility lay precisely in its practical inutility. Echoing Gilman's views from America's industrial heartland in 1927, Blake-More Godwin of the Toledo Museum of Art reflected on the transcendent ideals that gave birth to his institution and would sustain it for generations to come. Speaking on behalf of its founding fathers, he wrote,

> They saw [the museum] as the force which could lead us out of the bondage of the commonplace; as the panacea for the great unrest; as the vital necessity for the symmetry of life; as the solution to industrial advancement and commercial supremacy. . . . Art is our precious heritage from the past. It is the best of all man knew and thought and dreamed. It is our record, the most enduring record that we have, of the ages which have preceded our own. The art of today will in its turn be our gift to posterity, and the best of it will be treasured by future generations as we treasure the best of the works of the past.[32]

Inspired by Arnold via Gilman, Toledo inaugurated an impressive tradition of public outreach based on the belief in the value of bringing beauty into the lives of ordinary people.

The compensatory value of art museums increased dramatically in the wake of World War I and the Great Depression, both of which were linked to failures within modern industrial society. Addressing students at Yale University in the first year of the Great War, the architect Ralph Adams Cram insisted: "Art is the revelation of the human soul, not a product of industrialism" and therefore stood above "the economic and industrial Armageddon that surges over the stricken field of contemporary life."[33] In a speech inaugurating the Cleveland Museum of Art in 1916, Charles Hutchinson, President of the Art Institute of Chicago, hailed art as an antidote to the materialism that had fuelled the war and as the means to "increase the happiness of future generations." Fiercely rejecting the doctrine of "art for art's sake," he insisted that art's utility had never been more apparent:

> Art for art's sake is a selfish and erroneous doctrine, unworthy of those who present it. Art for humanity and service of art for those who live and work and strive in a humdrum world is the true doctrine and one that every art museum should cherish.[34]

A year later, the critic Mariana van Rensselaer wrote that the horrors of war raised the need "to cultivate the idealistic side of human nature" and "to combat the ambitious materialism, the self-seeking worship of 'practical efficiency' which is so largely to blame for the agony of Europe and which threatens the happiness of America also."[35] She held out hope that museums would demonstrate that "material things are not all in all" and "that art, that beauty is not a mere ornament of existence but a prime necessity of the eye and the soul."[36]

In response to the massive devastation wrought by World War I, commentators furthermore emphasized art's importance as a unique document of human civilization and source of common understanding. "Art means civilization," said Cram, in a notably Hegelian view:

> Through art alone has been expressed those qualities which reach above the earth-circle, those things which are the essential elements of the race and time. . . . Through study of . . . art we are able to see into the soul of the time-spirit. . . . Through study of the philosophy of beauty and through recognition of what art signifies of any race or time, we shall come to that revision of standards which is the inevitable

precursor of a new epoch in civilization. . . . [Art is] a kind of universal solvent, a final common denominator, and before our eyes the baffling chaos of chronicles, records, and historic facts open out into order and simplicity.[37]

The idea that art manifested the soul of a people had long ago become a commonplace and a driving force behind national heritage movements across the developed world. By extension, in Cram's view, the heritage of a given people is also the heritage of humankind more generally, allowing works of art to function simultaneously as culturally specific and universal, a source of both national pride and global understanding. In both respects art warranted preservation, especially when threatened in times of strife. As the emblem of human creativity and bearer of memory, art was the antithesis of war and cataclysm.

Early recognition of the special status of cultural monuments may be found in a passage on the conduct of war in an international law treatise dating from the Enlightenment. "For whatever cause a country may be devastated," the author wrote, "those buildings should be spared which are an honour to the human race. . . . It is the act of a declared enemy of the human race thus wantonly to deprive men of these monuments of art and models of architecture."[38] A century later an American legal authority extended the class of monuments deserving protection in time of war to include "repositories" of knowledge: "By the modern usage of nations, which has acquired the force of law, temples of religion, . . . monuments of art, and repositories of science, are exempted from the general operations of war."[39] An early, unsuccessful attempt to regulate international laws and customs of war in 1874 outlawed willful damage to monuments and works of art, as did the Hague Convention of 1907, ratified by forty-one nations prior to the outbreak of World War I. Article 27 of the Convention stipulated: "In sieges and bombardments all necessary steps must be taken to spare, as far as possible, buildings dedicated to religion, art, science, or charitable purposes, historic monuments. . . ."[40]

It was against the background of the Hague agreement that the preservation of artistic heritage took on such importance during the Great War. For the first time strenuous efforts were made to spare cultural sites, including museums, and to document for propaganda purposes damage inflicted by the

enemy. Amid the carnage of a horrific war both sides claimed a love of art as if seeking absolution from some higher authority (God? Posterity?) for their sins against humanity.

As the aggressors, the Germans were particularly keen to demonstrate their high respect and responsibility for art. Despite inflicting catastrophic damage on French and Belgian monuments, including Reims Cathedral, they continued to insist that the "culture of art and war" were "the most extreme opponents conceivable, like two poles which flee from one another just as the principles of preservation and destruction."[41] Puncturing German rhetoric, the French mounted an exhibition of battle-scarred works of art at the Petit Palais in Paris in 1916 for all to see. The inspector general of French museums, Arsène Alexandre, published a catalogue of lost monuments—"many of which were cherished by the whole world"—to demonstrate to posterity that the Germans were "the enemies of humanity."[42] But looking to the future, Alexandre also hoped his book would inspire a greater respect for civilization and "association among all the human races."[43] In view of the failure of the Hague Convention to prevent the devastation of modern war, even greater cooperation and a deeper appeal to civilized values was needed:

> It was not in the name of the Hague Convention, nor the Geneva Convention, that the scholars and artists of France and the civilized world cried in protest [against the destruction of art]. . . . The laws in whose name one protested have no date . . . the laws of beauty, goodness and justice are not written in perishable words but in the hearts of individuals and the consciences of nations.[44]

It was with such sentiments in mind that the League of Nations was formed in the aftermath of the war. In 1928 in Prague the League's Committee of Intellectual Co-operation sponsored an international exhibition of popular arts, a venture that stemmed from the perceived ability of the arts to "characterize in a direct and immediate manner a people, region, and locality" and thus demonstrate "the similitude and analogies that link the members of the large human family." As one close to the event wrote, "From the assembly of these documents emerges a human aesthetic—one might even say a 'human ethic'—that rises above the specificity of national aesthetics.

Right there, at the tip of one's fingers, one has a common ground for all peoples and all times."[45] The Committee's chair, Jules Destrée, who was also the first director of the International Museum Office (created in 1926 and forerunner of the International Council of Museums, or ICOM), fervently believed that "art was one of the most effective means of establishing a solidarity of heart and mind in a world dislocated by the war."[46] A year after the Prague exhibition, the League of Nations attempted to institutionalize global understanding through the Mundaneum project, which was conceived as a

> Center for intellectual union, liaison, cooperation and coordination, . . . A synthetic expression of universal life and comparative civilization; a symbol of the intellectual Unity of the World and Humanity; An image of the Community of Nations, . . . A means of making different peoples known to each other and leading them into collaboration; An Emporium of works of the spirit. . . . The desire is: That at one point on the Globe, the image and total signification of the World may be seen and understood.[47]

The symbolic heart of the unrealized Mundaneum complex was Le Corbusier's "World Museum," designed as a square ziggurat, ancient and fundamental in form, to house "all the world's civilizations" from prehistoric times to the present. Against the background of recent turmoil, the World Museum would allow visitors to behold "the unchanging soul of humanity [in the form of] works which are, for us, immortal—works of art, unadulterated witnesses."[48] Across the Atlantic at the same time, in a lecture at the Metropolitan Museum, DeWitt Parker recommended art as the best vehicle of communication with the other:

> Art is the best instrument of culture. For art is man's considered dream; experience remodeled into an image of desire and prepared for communication. . . . Art puts us into touch with the desires of other classes, races, nations. Through art we not only know what these desires are, but we are compelled to sympathize with them; for the dream is embodied in such a way as to make us dream it as if it were our own. The barrier between one dream and the dream of another is

overcome. The understanding of other nations, which by any other path would be long and difficult, is immediate through art. . . . Even as love creates an instant bond between diverse man and woman, so does art between alien cultures.[49]

What drove these inter-war projects was the belief that the arts, by virtue of bearing the imprint of both local customs and traditions (the particular) and shared forms and aspirations (the universal), could, when juxtaposed at an exhibition or in a museum, serve at one and the same time as vehicles of patriotic sentiment and mutual understanding.

Notwithstanding the stunning failure of such initiatives to prevent the Second World War, art museums continued to be invested with the potential to heal a broken world; indeed, their perceived power to unify and assuage became more compelling than ever. Even emptied of its art, London's National Gallery symbolized the endurance of civilization by providing a stage for the lunchtime concerts of Dame Myra Hess.[50] Through waves of German bombing the music played on and select paintings were brought out of hiding on a temporary basis to give comfort and resolve to thousands of ordinary people. "This was what we had all been waiting for—an assertion of eternal values," the gallery's director, Kenneth Clark, later recalled.[51] After the war, art museums were called upon once again to body forth essential ideals that represented humankind's best hope for salvation. "The champion of man turns out to be man," declared an 1946 article in *Museum News,* "and it is in the arts that we find the mirror of human dignity, a microcosm both of order and serenity, of vitality and valor."[52] At the first meeting of the American Association of Museums after the war, the poet and Librarian of Congress Archibald MacLeish delivered a paean to the power of museums to create a better world. Rapid advances in destructive technology made ineffectual any "physical defenses against the weapons of warfare," he wrote. "There are only the defenses of the human spirit."

> The work to be done is the work of building *in men's minds* the image of the world which now exists in fact *outside* their minds—the whole and single world of which all men are citizens together. . . . What is required now is . . . communication between mankind and man; an agreement that we are, and must conduct ourselves as though we were,

one kind, one people, dwellers on one earth. . . . The world is not an archipelago of islands of humanity divided from each other by distance and by language and by habit, but one land, one whole, one earth. . . . It is precisely to their power to communicate such recognitions that the great cultural institutions of our civilization owe their influence. . . . The great libraries and the great galleries . . . demonstrate to anyone with ears to pierce their silence that the extraordinary characteristic of human cultures is their human likeness.[53]

MacLeish understood that "the conception of the gallery or the museum as the glass in which the total community of the human spirit can best be seen" had been overused to the point of being a "banal slogan of rhetorical idealism," yet he insisted that "there never was a time in human history when it was more essential to take [the] simple meaning [of that idea] and to understand it and to act."[54]

Research is still needed to discover what, if anything, the world's museums did in response to MacLeish's call to action. How typical, one wonders, was the "Wings around the World" program initiated in 1948 by the Minneapolis Institute of Art to teach high school students "the background, ideas, and cultures of the many peoples who have contributed to contemporary civilization" and "illustrate through works of art, the sociological, economic, political, and aesthetic ideals which constitute the heritage of all religious and racial groups"?[55] The most famous exhibition of post-war humanism was The Family of Man, which opened at the Museum of Modern Art in New York in 1955 and subsequently toured the world in various formats for a decade. When the tour came to an end, the exhibition had been seen by some eight million people in thirty-seven countries; the book accompanying the exhibition is still in print and has sold over three million copies.[56] The Family of Man used contemporary photographs, many by unknown photographers, to enhance its immediacy and relevance and featured images of ordinary people from around the globe engaged in universal human activities: working and playing, laughing and crying, giving birth and dying. The wall panel at the entrance read,

There is only one man in the world / and his name is All Men.
There is only one woman in the world / and her name is All Women.

There is only one child in the world / and the child's name is All Children.

A camera testament, a drama of the grand canyon of humanity, an epic woven of fun, mystery and holiness—here is the Family of Man![57]

The Family of Man was the last of a series of photomontage exhibitions curated at MoMA by Edward Steichen and dating back to World War II (Road to Victory, Power in the Pacific, Airways to Peace), but here seductive display strategies honed in the service of war were mobilized to support the common cause of life and peace. For Steichen, the exhibition was conceived "as a mirror of the universal elements and emotions in the everydayness of life— as a mirror of the essential oneness of mankind throughout the world,"[58] and thus represented "an antidote to the horror we have been fed from day to day for a number of years."[59] As a widely circulated photo exhibition and illustrated book, The Family of Man realized André Malraux's dream of museums and photography advancing the communication of universal values. In his famous post-war essay "Museum without Walls" (1951, translated into English 1953), Malraux hailed the ability of the photograph and the museum to minimize differences of scale, media, and culture in the interests of expressing instead "the mysterious unity of works of art" and their essential value as symbols of "a fundamental relationship between man and the cosmos."[60]

During the Cold War decade of the 1950s, art museums in the West supplemented the rhetoric of universal humanism by promoting art as the embodiment of freedom and creativity. When the Guggenheim opened in 1959, for example, it was described by President Eisenhower (in a letter read aloud at the opening) as "a symbol of our free society, which welcomes new expressions of the creative spirit of man."[61] During that decade, the abstract tradition celebrated by the Guggenheim gained legitimacy as the expression of bold individualism and as the antithesis of the censorship and social-realist propaganda of fascist and communist regimes.[62]

Carried along by post-war optimism and Cold War anxiety, the easy spread of humanist rhetoric in the West did not go uncontested, however. Roland Barthes attacked The Family of Man when it came to Paris in the mid-1950s for its sentimental portrayal of a generalized humanity. For Barthes, a superficial assurance that we are at bottom all the same obscured recognition of real differences that stood in the way of true understanding and justice:

Everything here, the content and appeal of the pictures, the discourse which justifies them, aims to suppress the determining weight of History: we are held back at the surface of an identity, prevented precisely by sentimentality from penetrating into this ulterior zone of human behavior where historical alienation introduces some "differences" which we shall here quite simply call "injustices."[63]

The Family of Man relied on, and bolstered, a "myth of the human 'condition'," a myth dangerous in its failure to reveal the impact of what Barthes meant by History—the realities of race, politics, gender, creed, and class—on people's lives:

> Any classic humanism postulates that in scratching the history of men a little, the relativity of their institutions or the superficial diversity of their skins (but why not ask the parents of Emmet Till, the young Negro assassinated by the Whites [lynched in Mississippi in 1955 for whistling at a white woman] what *they* think of *The Great Family of Man*?), one very quickly reaches the solid rock of a universal human nature. Progressive humanism, on the contrary, must always remember to reverse the terms of this very old imposture, constantly to scour nature, its 'laws' and its 'limits' in order to discover History there, and at last to establish Nature itself as historical.[64]

Exposing the "imposture" of humanism and redressing the injustices of "History" became in effect the motivating purpose of the social activism and critique of the 1960s, which embraced the civil rights and feminist movements, student protests on both sides of the Atlantic, and the development of critical theory in academe. In that politically charged environment, the proclaimed autonomy of art and disengaged stance of art museums struck social activists and avant-garde artists as unacceptable establishment complacency and elitism. All of a sudden the post-war tranquility of art museums was rudely disturbed by new calls for social relevance, community outreach, and heightened self-awareness. Bourgeois assumptions about public access to high culture were exploded by French sociologist Pierre Bourdieu, whose important book *The Love of Art* (1966) demonstrated that aesthetic taste and judgment were the products of class and education.[65] Backed by Bourdieu's

empirical research, activists behind the Paris riots of 1968 called for a greater democratization of culture. A year later President Pompidou announced plans for the creation of a new multipurpose cultural institution at the heart of Paris, realized as the Pompidou Center in 1977. Also motivated by the radicalized political environment, in the 1960s and '70s the first stirrings of revisionist art history began to challenge the de-politicized, formalist orthodoxy of Alfred Barr, Clement Greenberg, and their followers. Art entered a "postmodern" phase by renouncing formal purity, engaging with politics and mass culture, and "erupting" with language.[66] In the late 1960s art museums became the target of activist artists who used the visual arts as a vital medium of popular and political communication. In 1969 various radical groups—the Art Workers' Coalition (AWC), Women Artists in Revolution (WAR), and the Black Emergency Cultural Coalition (BECC)—led protests in front of New York museums against the Vietnam War and the underrepresentation of minority artists.[67] Visitors to MoMA's Information show the following year were greeted by Hans Haacke's "visitors' poll," which linked the museum and its administration (through trustee Nelson Rockefeller) to President Nixon's controversial policy in Indochina.[68]

In New York calls for action and "relevance" found a powerful voice within the museum world in Thomas Hoving, the ambitious young director of the Met. In an address to the American Association of Museums in 1968, Hoving called on his colleagues to "get involved and become far more relevant," to "re-examine what we are, continually ask ourselves how we can make ourselves indispensable and relevant."[69] Hoving then set an example of social relevance by staging the provocative exhibition Harlem on My Mind: Cultural Capital of Black America, 1900–1968. Hoving prepared the museum faithful for what was to come through the pages of the Met's *Bulletin:*

> On the eighteenth of this month [January 1969] The Metropolitan Museum of Art will open an exhibition that has nothing to do with art in the narrow sense—but everything to do with this Museum, its evolving role and purpose, what we hope is its emerging position as a positive, relevant, and regenerative force in modern society.[70]

Justifying the exhibition in advance, Hoving resurrected the commitment to "practical life" advocated by Dana and the South Kensington Museum (and

the early Met by extension)—only now practicality had to do not with industry or commerce but with politics and activism. " 'Practical life' in this day," he wrote, "can mean nothing less than involvement, an active and thoughtful participation in the events of our time."[71] Though it borrowed Steichen's familiar mass media format and was dedicated to buttressing, in Hoving's words, "the deep and abiding importance of humanism,"[72] Harlem on My Mind made the mistake of coming down from an abstract plane of global humanity to the racially charged streets of New York City in the late 1960s. Critics complained about the presence of photography in a high art museum, but surely what was most disturbing was the introduction of race and social issues where the majority of the museum's faithful constituents believed they didn't belong. Instead of respite, Hoving offered a reflection of social reality; in place of escape, hope, and resolution, he gave suffering, guilt, and uncertainty.

For the majority of Hoving's professional peers, not to mention local critics and museum-goers, what Barthes meant by *History* was unwelcome in an art museum. In an essay prompted by the exhibition, entitled "What's an Art Museum For?" Katharine Kuh answered her own question by rejecting Hoving's social justification and suggesting instead that museums "offer us islands of relief where we can study, enjoy, contemplate, and experience emotional rapport with man's finest man-made products."[73] As for the Harlem show, she concluded, "The exhibition shows us the pain, but where are the fantasies?" In the same year as the Harlem exhibition, a survey commissioned by ICOM revealed a museum-going public hostile to an overlap of art and "everyday" issues. By a clear margin, "images overtly or otherwise suggestive of catastrophe, human or social decay or other negative aspects of life" were held to be "offensive" and "out of place" in art and museums.[74]

Hoving knew Harlem on My Mind would be controversial; indeed he wanted it to be "an unusual event," "a confrontation" that would change the "lives and minds" of its viewers "for the better."[75] According to the show's organizer, Allon Schoener, he and Hoving "saw the exhibition as an opportunity to change museums," "the first step toward rethinking and expanding our concepts of what exhibitions should do."[76] Intoxicated by the radical air of the late '60s, Hoving had a messianic vision of museums on the move: "An art museum today can neither afford to be, nor will it be, tolerated as a silent repository of great treasures." "For too long museums have drifted passively

away from the center of things . . ." he told readers of the Met *Bulletin*. With his "modishly-longer hair"[77] and lingo Hoving was in touch with the vibe on the streets of New York, perhaps, but he was out of step with the conservatism of his fellow museum directors elsewhere in the country. The Harlem exhibition prompted a swift and decisive backlash in the form of a redoubled affirmation of the value of the art museum as a haven of non-political aesthetic contemplation. In the view of Hoving's antagonists (there were few supporters amongst his peers, it would seem), recent social turmoil, political instability, and war had made the art museum's function as respite from the world more relevant than ever. The chief spokesman for the disengaged museum was Sherman Lee, director of the Cleveland Museum of Art. In a speech delivered while the Harlem exhibition was still open, Lee insisted, "The art museum is not fundamentally concerned with therapy, illustrating history, social action, entertainment or scientific research. . . . The museum is . . . a *primary source* of wonder and delight for mind and heart."[78] From the marble halls of Washington's National Gallery, John Walker concurred: "I am indifferent to [the art museum's] function in community relations, in solving racial problems, in propaganda for any cause."[79] A few years later leaders of the art world, inspired by Lee and without Hoving, convened to discuss the future of the museum and definitively agreed that "Art museums should not become political or social advocates except on matters directly affecting the interests of the arts."[80]

As the dust settled after the Harlem brouhaha, museum men joined with George Heard Hamilton, director of the Clark Art Institute, in insisting that art museums were "most psychologically useful" to society by being *irrelevant* to the world outside, for it was precisely in art's removal from daily life that its "life-enhancing difference" could be felt.[81] Once it was clear that art museums were not about to follow Hoving's lead, the soothing "irrelevance" of timeless art reasserted itself in museum discourse. Witness the talk given by Otto Wittmann, director of the Toledo Art Museum, in 1974 entitled "Art Values in a Changing Society":

> In these precarious and unsettled times in which we all live, there is a great hunger for a sense of lasting significance. . . . The very nature of art and of the museums which preserve and present works of art reassures people of the continuity of human vision and thought and of the

importance of their place in the vast stream of significant developments over centuries of time. A Mayan figure in Manhattan, a T'ang figure in Toledo, even though seemingly irrelevant to our culture today, can tell us much about humanity and human relationships. . . . These silent witnesses of the past can bridge the gap of time and place if we will let them. . . . The universal truths of all art should be shared.[82]

Activism of the 1960s produced the multi-culturalism and outreach initiatives that have become the norm in museums in the decades since; in terms of programming and audience museums are now more broadly representative than they were in 1970, but a reluctance to engage in potentially polemical political discourse remains in place. A number of prominent exhibitions in recent decades illustrate the broad turn in museum policy toward what can be called a de-politicized global humanism. Take, for example, Jean-Hubert Martin's Magiciens de la Terre (Magicians of the Earth), held at the Pompidou Center in 1989. In that sprawling global survey, works by hundreds of contemporary artists from around the world, floating free of their original contexts and significations and endowed alike with what Martin called an "aura" and "magic" that set true art apart, were brought together on equal terms to further "a culture of dialogue."[83] Building on Malraux, Martin designed the exhibition to substantiate the maxim that the "multiplication of images around the world is one of the symptoms of the tightening of communication and connections . . . among the people of the planet." Having also read his Barthes and alive to the post-colonial politics of difference, Martin understood that his selection and display of objects necessarily reflected his own European perspective and obscured "the complexity of certain local situations." His intention was not to speak for other cultures, for that he realized no one can do, but to celebrate "the diversity of creation and its multiple directions." Inevitably Magicians of the Earth revealed a problematic tension at the heart of much postmodern museology: though as Martin confessed it is "difficult, if not impossible to understand the cultural reality of . . . other cultures," exposure to that which we can never fully understand will nevertheless foster appreciation, respect, and eventually dialogue. What justifies this predicament of otherness is the possibility—the hope—that the strange may be made familiar through contact mediated by the museum.

Cultural dialogue was likewise the goal of two high-profile blockbusters organized by the late J. Carter Brown in the 1990s, namely Circa 1492, staged at the National Gallery, Washington, in 1991–92 (to mark the five hundredth anniversary of Columbus's "discovery" of America) and Rings, Five Passions in World Art, organized in conjunction with the 1996 Olympic Games in Atlanta. As we might expect of such establishment events, both were uncomplicated by Martin's postmodern anxiety and both were criticized for their presumptuous (Western) visions of kindred art forms and their suppression of history. In a review of the former, Homi Bhabha exposed the hubris of Carter Brown's visual parallels between European and non-European traditions. Though celebratory and well-intentioned at eye level, the exhibition's forced cross-cultural comparisons omitted reference to the historical processes at work in 1492 that transformed, for example, Inca and Aztec ritual objects from "being signs in a powerful cultural system to . . . symbols of a destroyed culture" fit only for Western collecting and display.[84] Bhabha further lamented that the museological maneuvers characteristic of such exhibitions reduced museum visitors to "connoisseurs of the survival of Art" and unwitting "conspirators in the death of History." But for Carter Brown such concerns, had he been aware of them, would surely have seemed trivial next to art's potential to heal a tense and divided world. "What kind of a world can we look forward to?" he asked in the introduction to Rings: Five Passions in World Art.[85] "What vision, what idealism, what aspects of our nature can we look to for a world of harmony and interconnectedness?" The answer, of course, at least in part, lay in shared emotional experience revealed in and communicated by the world's art traditions:

> We must strive to integrate cultural values into a concept of the whole person and explore, with openness and sensitivity, the importance—I would say the centrality—of our emotional lives and the riches that await us in receiving, through art, affective transmissions from across great gulfs of space and time.[86]

Five years later the values of detachment and understanding took on added urgency following the 9/11 attack on the World Trade Center in New York City. Across the United States art museums offered themselves as sites of refuge and reflection. In an open letter from "The Metropolitan Museum

of Art Family to Your Family," Hoving's successor at the Met, Philippe de Montebello, wrote,

> At a time of loss and profound dislocation, art museums offer a power-ful antidote to hopelessness: their collections testify to the permanence of creative aspiration and achievement, and offer solace, affirmation, and a spirit of renewal so essential to our recovery. It remains the Met's responsibility—indeed, the very essence of its 131-year-old mission—to provide the public the opportunity to nourish the human spirit. For great art from all parts of the world can enlighten, inspire, awe, and ul-timately, help heal.[87]

In Boston, the Museum of Fine Arts offered free admission in the weeks fol-lowing 9/11. "Great works of art remind us of the enduring value of all that is best in the human spirit," said the museum's director, Malcolm Rogers. "We open the MFA's doors in hopes that these works of art . . . can provide solace and comfort at this time."[88] On the first anniversary of the terrorist at-tacks, the Met highlighted selected objects in its collection that expressed "humankind's indomitable spirit." Modeled on a "highlights tour" of the col-lection, the objects chosen on this occasion "represented every culture and every time in history" in order to "communicate the universal emotions of despair and hopè, mourning and recovery, loss and renewal."[89] The Egyptian pair statue of Memi and Sabu (ca. 2575–2465 BCE), showing a husband and wife locked in eternal communion, offered an image of undying love; a seated Buddha from the Tang dynasty (ca. AD 650) with his "idealized figure, introspective expression, and meditative posture" was the embodiment of "supernal wisdom and detachment from world affairs"; Winslow Homer's *The Veteran in a New Field* (1865) suggested survival and renewal; Matisse's *Nasturtiums with the Painting 'Dance'* (1912) combined the beauty and vitality of flowers and human movement, and so on.

In the years since 9/11 multi-cultural dialogue has become a leitmotif of art museum discourse. Witness the following pronouncement from James Cuno, an influential voice on the international museum scene: "The museum is about the world. I feel very, very strongly that the social purpose museums have is to breed greater familiarity with the rich diversity of the world's cul-tures. With greater familiarity comes greater understanding."[90] The philosopher

Kwame Anthony Appiah has lent his support to the cause. In his *Cosmopolitanism: Ethics in a World of Strangers* (2006) he encourages us to adopt a "cosmopolitan perspective," arguing that "we need to develop habits of coexistence," to "learn about people in other places, take an interest in their civilizations . . . because it will help us get used to one another."[91] Museums play an important role, he says, because "Conversations across the boundaries of identity—whether national, religious, or something else—begin with the sort of imaginative engagement you get when you read a novel or watch a movie or attend to a work of art that speaks from some place other than your own."[92]

Not surprisingly, the art of the Middle East and Asia in particular has taken on added significance in recent years. Milo Beach, former director of the Smithsonian's Sackler and Freer galleries in Washington, had this to say in an appraisal of two East-West cultural events (an exhibition on The Legacy of Genghis Khan and the "Silk Road Project" led by Yo-Yo Ma):

> Over the past decades, museums have come to play multiple roles in our lives, but surely none is more important than their ability—in the current period of international turmoil and political realignments—to connect each of us with what other people value culturally and artistically. . . . Given the internationalism of the world today, Americans deserve a rich, more balanced picture of other countries and peoples. . . . It seems clear, therefore, that the relevance and potential of museums has never been greater than it is today.[93]

Beach was writing in a U.S. newspaper for a North American audience, but the need for international understanding and exchange in our increasingly intersecting world is now broadly recognized. In 2005 a Saudi prince donated $20 million to create a new Islamic wing at the Louvre in the belief that "after 9/11, an increased appreciation of Islamic art can help bridge a cultural divide." In accepting the gift, the French culture minister said the Louvre was not simply a passive collection of objects:

> It is by now an essential instrument for the dialogue of cultures and the preservation of their diversities. In a world where violence expresses itself individually and collectively, where hate erupts and imposes its expression of terror, you dare to affirm the conviction that is yours—that

is ours—that the dialogue of peoples and cultures, the richness of patrimonies, the values of sharing are the responses of intelligence to the bitter experience of conflicts.[94]

At the same moment across the Channel in Britain, on the heels of deadly terrorist attacks in London, a Commission on African and Asian Heritage delivered a report calling on museums and school textbooks to reflect the nation's cultural diversity in the interests of greater unity. When minority culture is overlooked, it warned, "the outcome can be debilitating, leading to disaffection and disillusionment, a sense of disenfranchisement." Endorsing a more active role for museums in civic life, London's mayor said Britain's minorities must "see their achievements, contributions and historical presence reflected in our museums, archives, galleries and school textbooks."[95] In France a year later, French president Jacques Chirac sounded a similar note at the opening of the Musée de Quai Branly, devoted to non-European art: "It aims to promote among the public at large a different, more open and respectful view, dispelling the clouds of ignorance, condescension and arrogance which in the past have often nourished distrust, contempt and rejection." In short, the new museum offered "an indispensable lesson in humanity for our times."[96]

To what extent can art museums deliver on their cosmopolitan mission? We shall never know, of course, since the outcomes of such ambitions are not measurable. But what cannot be measured also can't be rejected, which leaves the ideal alive and nonetheless compelling. Even if art museums do nothing more than offer us spaces of tranquil beauty in which to dream of communion with fellow humans far removed in time and place, should we be disappointed? Barthes's critique of The Family of Man could easily be resurrected and applied to the global humanist rhetoric in circulation today, but those who would push museums in the direction of further socio-political engagement need to recognize that what Hoving meant by "active and thoughtful participation in the events of our times" is scarcely more welcome today than it was in the late 1960s. On different occasions in recent years, Philippe de Montebello has insisted that "emphasis on social activism" is out of place in museums, and that museum visitors "do not want a promulgation of their daily existence" but rather "something different, conceivably uplifting."[97] "It

is precisely by distancing the visitor from what Sartre called 'the monotonous of daily life' that we best serve that visitor."[98] Politics compromises the quality of the disengaged aesthetic contemplation that the public has come to value and that the museum's sponsors are content to pay for. For better or worse, a celebratory but de-politicized global humanism is as much as we can expect from our art museums in the years to come.

## NOTES

1. A good way into this critical literature is through recent anthologies, notably: Donald Preziosi and Claire Farago, eds., *Grasping the World: The Idea of the Museum* (Aldershot, UK: Ashgate, 2004); Bettina Messias Carbonell, ed., *Museum Studies: An Anthology of Contexts* (Oxford: Blackwell, 2004); Reesa Greenberg, Bruce W. Ferguson, and Sandy Nairne, eds., *Thinking about Exhibitions* (London: Routledge, 1996); Daniel J. Sherman and Irit Rogoff, eds., *Museum Culture: Histories, Discourses, Spectacles* (Minneapolis: University of Minnesota Press, 1994); Ivan Karp and Steven D. Lavine, eds., *Exhibiting Cultures: The Poetics and Politics of Museum Display* (Washington, D.C.: Smithsonian Institution Press, 1991); Peter Vergo, ed., *The New Museology* (London: Reaktion, 1989). Also, Eilean Hooper-Greenhill, *Museums and the Shaping of Knowledge* (London: Routledge, 1992), and Douglas Crimp, *On the Museum's Ruins* (Cambridge, Mass.: MIT Press, 1993).

2. James Clifford, *The Predicament of Culture: Twentieth-Century Ethnography, Literature, and Art* (Cambridge, Mass.: Harvard University Press, 1988), 231.

3. For a good selection of ancient references to the Museum, see Edward A. Parsons, *The Alexandrian Library* (New York: Elsevier, 1952), 98–102.

4. Krzysztof Pomian, *Collectors and Curiosities: Paris and Venice, 1500–1800* (Cambridge, UK: Polity Press, 1990); Paula Findlen, *Possessing Nature: Museums, Collecting, and Scientific Culture in Early Modern Italy* (Berkeley: University of California Press, 1994). On the Republic of Letters, see Dana Goodman, *The Republic of Letters: A Cultural History of the French Enlightenment* (Ithaca, N.Y.: Cornell University Press, 1994).

5. Quoted in Lorraine Daston and Katharine Park, *Wonders and the Order of Nature 1150–1750* (New York: Zone Books, 1998), 272; Daston and Park go on to point out, "Early modern collections excluded 99.9 percent of the known universe," concentrating instead on that which was most rare and wondrous.

6. *Décade philosophique* (thermidor-fructidor year II [1794]), 24. For the history of the Revolutionary Louvre, see my *Inventing the Louvre: Art, Politics, and the Origins of the Modern Museum in Eighteenth-Century Paris* (Berkeley: University of California Press, 1999).

7. Louis Hourticq, introduction to *A Guide to the Louvre* (Paris: Hachette, 1923).

8. Clifford, *The Predicament of Culture,* 235.

9. On the modern museum and the formation of an ideal citizenry in bourgeois society, see Carol Duncan, *Civilizing Rituals: Inside Public Art Museums* (London: Routledge, 1995), and Tony Bennett, *The Birth of the Museum: History, Theory, Politics* (London: Routledge, 1995).

10. Hans Belting, *The Invisible Masterpiece* (Chicago: University of Chicago Press, 2001).

11. See Thomas Crow, "The Birth and Death of the Viewer: On the Public Function of Art," in *Discussions in Contemporary Culture,* no. 1, ed. Hal Foster (Seattle: Bay Press, 1987), 5–7.

12. Quoted in Niels von Holst, *Creators, Collectors, and Connoisseurs,* trans. B. Battershaw (New York: G. P. Putnam's Sons, 1967), 216. The lingering influence of Romantic theory on art museums may be felt in Benjamin Gilman's insistence that "The ultimate end of every art-work is to be beheld and felt as it was wrought, and this end it fulfils whenever anyone stands before it and perceives in it the artistic content it was made to convey, enters into the soul of the artist through the gateway of his work." *Museum Ideals of Purpose and Method,* 2nd ed. (Boston: Museum of Fine Arts, 1923), 91.

13. William Hazlitt, *Sketches of the Principal Picture-Galleries in England* (London: Taylor and Hessey, 1824), 2–6.

14. Quoted in Belting, *The Invisible Masterpiece,* 20. For a materialist critique of the museum, see Crimp, *On the Museum's Ruins.*

15. For stimulating reflections on Quatremère, Benjamin, and art museums, see Daniel J. Sherman, "Quatremère/Benjamin/Marx: Art Museums, Aura, and Commodity Fetishism," in *Museum Culture,* ed. Sherman and Rogoff, 123–43.

16. Quoted in Charlotte Klonk, "Mounting Vision: Charles Eastlake and the National Gallery of London," *Art Bulletin* 82 (June 2000): 331.

17. Quoted in Brandon Taylor, "From Penitentiary to 'Temple of Art': Early Metaphors of Improvement at the Millbank Tate," in *Art Apart: Art Institutions and Ideology across England and North America,* ed. Marcia Pointon (Manchester: Manchester University Press, 1994), 22.

18. Ibid., 23.

19. Gilman, *Museum Ideals,* 95.

20. For a history of the South Kensington/Victoria and Albert Museum, see Anthony Burton, *Vision and Accident: The Story of the Victoria and Albert Museum* (London: Victoria and Albert Museum, 1999); see also Tony Bennett, *The Birth of the Museum.*

21. Quoted in Colin Trodd, "Culture, Class, City: The National Gallery, London and the Spaces of Education, 1822–57," in *Art Apart,* ed. Pointon, 38.

22. *The Works of John Ruskin,* ed. E. T. Cook and A. Wedderburn (London: George Allen), vol. 30 (1907), 53; vol. 34 (1908), 247.

23. Edward Bradbury, "A Visit to Ruskin's Museum," *Magazine of Art* 3 (1879–80): 57.

24. Matthew Arnold, *Culture and Anarchy* (New Haven, Conn.: Yale University Press, 1994), 30, 32, 34, 47.

25. Quoted in Siegfried Giedion, *Space, Time, and Architecture,* 5th ed. (Cambridge, Mass.: Harvard University Press, 1967), 246.

26. Arnold, *Culture and Anarchy,* 106–108, 128.

27. Ibid., 32.

28. Earlier, at the 1876 Fair in Philadelphia, one visitor noted "the union of two great elements of civilization—Industry, the mere mechanical, manual labor, and Art, the expression of something not taught by nature, the mere conception of which raises man above the level of savagery." Quoted in John Cawelti, "America on Display: the Worlds' Fairs of 1876, 1893, 1993," in *The Age of Industrialism in America,* ed. F. C. Jaher (New York: Free Press, 1968), 319.

29. Gilman, *Museum Ideals,* 69.

30. John Cotton Dana, *The New Museum* (Woodstock, Vt.: Elm Street Press, 1917), 12. Dana had a following among certain socially minded museum thinkers of the 1920s–40s, including T. R. Adam, Philip Youtz, and Theodore Low. For more on the inter-war debates on museum purposes and publics, see my essay, "A Brief History of the Art Museum Public," in *Art and its Publics,* ed. Andrew McClellan (Oxford: Blackwell, 2003), 1–49.

31. Gilman, *Museum Ideals,* 284; 68–69. On the place of casts in early American museums, see Alan Wallach, *Exhibiting Contradiction: Essays on the Art Museum in the United States* (Amherst: University of Massachusetts Press, 1998), 38–56.

32. Blake-More Godwin, "What the Small Museum Can Do," *American Magazine of Art* (October 1927): 528–29.

33. Ralph Adams Cram, *The Ministry of Art* (Boston: Houghton Mifflin, 1914), 83.

34. Charles L. Hutchinson, "The Democracy of Art," *American Magazine of Art* 7 (August 1916): 399.

35. Mrs. Schuyler van Rensselaer, "The Art Museum and the Public," *North American Review* 205 (January 1917): 81.

36. Ibid.: 90.

37. Cram, *The Ministry of Art,* 85, 95–96.

38. Emer de Vettel, *The Law of Nations or the Principles of the Natural Law Applied to the Conduct and to the Affairs of Nations and Sovereigns* (1758), quoted in Wojciech W. Kowalski, *Art Treasures and War* (Leicester, UK: Institute of Art and Law, 1998), 22. Following Napoleon's invasion of Italy in 1796 and his appropriation of art for the Louvre, Quatremère de Quincy objected: "dans l'Europe civilisée, tout ce qui appartient à la culture des arts et des sciences est hors des droits de la guerre et de la victoire." *Lettres à Miranda*

sur le *Déplacement des Monuments de l'Art de l'Italie (1796),* ed. Edouard Pommier (Paris: Macula, 1989), 109.

39. H. Wheaton, *Elements of International Law* (London, 1864), quoted in Kowalski, 25. Yet another text insisted, "La destruction intentionelle ou la degradation des monuments et oeuvres d'art . . . ne sont plus permises en temps de guerre et sont considérées aujourd'hui comme des actes de barbarie." M. Bluntschli, *Le droit international codifié* (Paris, 1870), 331.

40. Reproduced in Elizabeth Simpson, ed., *The Spoils of War* (New York: Harry N. Abrams, 1997), 279.

41. Paul Clemen, in *Protection of Art during War,* ed. Clemen (Leipzig: E. A. Seemann, 1919), 1.

42. Arsène Alexandre, *Les Monuments français détruits par l'Allemagne* (Paris: Berger-Levrault, 1918), 23, 1, translations my own.

43. Ibid., 5.

44. Ibid., 31–32.

45. E. Foundoukidis, "L'Oeuvre internationale de Jules Destrée dans le domaine des arts," *Mouseion* 33–34 (1936): 11. Foundoukidis was secretary to the International Museums Office. It seems the Prague exhibition was first suggested by the art historian Henri Focillon, a member of the League's Committee on Intellectual Cooperation, "who had shown that the deepest currents of civilisation turned towards popular art." *League of Nations. Committee on Intellectual Co-operation. Minutes of the Twelfth Session* (Dijon: Darantiere, 1930), 99.

46. Foundoukidis, "L'Oeuvre," 9.

47. Paul Otlet, "Mundaneum 1929," in *Oeuvre complete de 1910–1929,* by Le Corbusier and Pierre Jeanneret, 4th ed. (Erlenbach, Switz.: Editions d'architecture, 1946), 190.

48. Ibid., 192.

49. DeWitt H. Parker, *The Analysis of Art* (New Haven, Conn.: Yale University Press, 1926), 180–81.

50. In a radio broadcast in June 1941, during the worst of the bombing, Hess remarked: "I remember being told during the Spanish conflict how when Barcelona was undergoing its most agonizing moment of aerial bombardment, that outside the Concert Hall there was a queue that stretched almost to the end of the street. People felt then as people today in Britain feel now, that music with its wealth of spiritual beauty could still all the turmoil, all the hatred, all the sorrow of modern warfare." Quoted in Marian C. McKenna, *Myra Hess: A Portrait* (London: Hamish Hamilton, 1976), 150–51.

51. Kenneth Clark, *The Other Half: A Self-Portrait* (London: John Murray, 1977), 28. He also wrote: "I believe that many Londoners who remember the first year of the war will agree that the National Gallery concerts were amongst the few rewarding intervals in

their daily lives" and "an assertion of eternal values" (29). Also see Neil MacGregor, "A Pentecost in Trafalgar Square," in *Whose Muse? Art Museums and the Public Trust,* ed. James Cuno (Princeton, N.J.: Princeton University Press, 2004), 42–45.

52. Roberta F. Alford, "Popular Teaching in Art Museums," *Museum News* 23 (1 February 1946): 6.

53. Archibald MacLeish, "Museums and World Peace," *Museum News* 24 (1 June 1946): 6–7, emphasis his.

54. Ibid.

55. *Bulletin of the Minneapolis Institute of Arts* 38 (1 January 1949): 10.

56. See John Szarkowski, "The Family of Man," in *The Museum of Modern Art at Mid-Century: At Home and Abroad,* ed. John Elderfield, Studies in Modern Art 4 (New York: Museum of Modern Art, 1994), 12–37; and Christopher Phillips, "The Judgment Seat of Photography," *October* 22 (Fall 1982): 27–63.

57. Edward Steichen, *The Family of Man,* 7th printing of the 30th anniv. ed. (New York: Museum of Modern Art, 1997), 5. The text was by Carl Sandberg.

58. Ibid., 3.

59. Quoted in Mary Anne Staniszewski, *The Power of Display: A History of the Exhibition Installations at the Museum of Modern Art* (Cambridge, Mass.: MIT Press, 1998), 250.

60. André Malraux, *Museum without Walls,* trans. S. Gilbert and F. Price (New York: Doubleday, 1967), 220, 162.

61. http://www.guggenheim.org/press_releases/release_60.html. Accessed 1 May 2006.

62. Serge Guilbaut, *How New York Stole the Idea of Modern Art: Abstract Expressionism, Freedom, and the Cold War,* trans. Arthur Goldhammer (Chicago: University of Chicago Press, 1983). Also see Kirk Varnedoe, "The Evolving Torpedo: Changing Ideas of the Collection of Painting and Sculpture of the Museum of Modern Art," in *The Museum of Modern Art at Mid-Century: Continuity and Change,* Studies in Modern Art 5 (New York: Museum of Modern Art, 1995), 12–73.

63. Roland Barthes, *Mythologies,* trans. Annette Lavers (New York: Hill and Wang, 1972), 101. Barthes's essays were written between 1954 and 1956 and first published in 1957.

64. Ibid, emphasis his.

65. Pierre Bourdieu and Alain Darbel, *The Love of Art: European Art Museums and Their Public,* trans. C. Beattie and N. Merriman (Cambridge, UK: Polity Press, 1991). On Bourdieu and French cultural politics leading to the creation of the Pompidou Center, see Rebecca DeRoo, *The Museum Establishment and Contemporary Art: The Politics of Artistic Display in France after 1968* (Cambridge, UK: Cambridge University Press, 2006).

66. Mitchell, *Picture Theory,* 217, 241–79.

67. See Francis Frascina, *Art, Politics and Dissent: Aspects of the Art Left in Sixties America* (Manchester: Manchester University Press, 1999).

68. See Brian Wallis, ed., *Hans Haacke: Unfinished Business* (Cambridge, Mass.: MIT Press, 1986).

69. Thomas P. F. Hoving, "Branch Out!" *Museum News* 47 (September 1968): 15–16; on the 1960s also see Neil Harris, "A Historical Perspective on Museum Advocacy," in *Cultural Excursions: Marketing Appetites and Cultural Tastes in Modern America* (Chicago: University of Chicago Press, 1990), 82–95.

70. *The Metropolitan Museum of Art Bulletin* 27, no. 5 (January 1969): 243.

71. Ibid.

72. Preface to *Harlem on My Mind,* ed. Allon Schoener (New York: New Press, 1995). For a recent re-examination of the exhibition, see Steven C. Dubin, *Displays of Power: Controversy in the American Museum from the Enola Gay to Sensation* (New York: New York University Press, 1999), 18–63.

73. Katharine Kuh, "What's an Art Museum For?" *Saturday Review* (22 February 1969), 58–59.

74. A. Zachs, D. F. Cameron, et al., "Public Attitudes toward Modern Art," *Museum* 22 (1969): 144. These findings echoed an earlier survey by Theodore Low in the 1940s that found a marked public preference for art appreciation over "art and daily living" in educational programming at the Met: *The Museum as Social Instrument* (New York: Metropolitan Museum of Art, 1942), 24–30.

75. Preface to *Harlem on My Mind.*

76. Ibid., Schoener's introduction to the new ed.; *Metropolitan Museum of Art Bulletin,* January 1969, 244.

77. Grace Glueck, "The Total Involvement of Thomas Hoving," *New York Times Magazine,* 8 December 1968, 45.

78. Sherman E. Lee, "The Art Museum in Today's Society," *The Dayton Art Institute Bulletin* 27 (March 1969): 6, emphasis his.

79. John Walker, *Self-Portrait with Donors* (Boston: Little, Brown, 1974), xiv.

80. Quoted in Milton Esterow, "The Future of American Museums," *Art News* 74 (January 1975): 34.

81. George Heard Hamilton, "Education and Scholarship in the American Museum," in *On Understanding Art Museums,* ed. Sherman Lee (Englewood Cliffs, N.J.: Prentice Hall, 1975), 113. Also see Grace Glueck, "The Ivory Tower versus the Discotheque," *Art in America,* May–June 1971, 80–85.

82. Otto Wittmann, *Art Values in a Changing Society* (Toledo, Ohio: Toledo Museum of Art, 1974), 18–19.

83. Jean-Hubert Martin, *Magiciens de la Terre* (Paris: Centre Pompidou, 1989); all quotations come from the catalogue's preface, 8–9.

84. Homi K. Bhabha, "Double Visions," in Preziosi and Farago, *Grasping the World,* 240–41.

85. J. Carter Brown, *Rings: Five Passions in World Art* (New York: Harry N. Abrams, 1996), 17.

86. Ibid., 15, 19.

87. http://www.metmuseum.org/news/metmuseum_openletter.html. Accessed 3 October 2001.

88. http://www.mfa.org/pressroom/news/freeadmission.html. Accessed 3 October 2001.

89. http://www.metmuseum.org/September_11/curators_choices.html. Accessed 3 October 2002. Also press release of 6 September 2002.

90. *New York Times,* 29 March 2006.

91. Kwame Anthony Appiah, *Cosmopolitanism: Ethics in a World of Strangers* (New York: W. W. Norton, 2006), xix, 78.

92. Ibid., 85. The work of an earlier "cosmopolitan" philosopher, Ananda Coomaraswamy, is worth remembering. Quoting Aristotle in his 1937 essay, "What Is the Use of Art, Anyway?" Coomaraswamy reminds us, "The general end of art is man." *Christian and Oriental Philosophy of Art* (New York: Dover, 1956), 96.

93. Milo C. Beach, "Look to Museums to Bridge the Gap between Cultures," *Wall Street Journal,* 15 May 2003. A year later an article in the *New York Times* noted the upsurge in exhibitions of Islamic art in the West whose purpose was to "bridge the cultural divide." The benefits were three-fold: "the Islamic world would feel that its heritage was admired in countries that increasingly link Islam with terrorism; Westerners could look beyond today's turmoil to recognize one of the world's great civilizations; and alienated Muslim youths in Europe could identify with the glories of their Islamic roots." Alan Riding, "Islamic Art as a Mediator for Cultures in Confrontation," *New York Times,* 6 April 2004.

94. Quoted in John Tagliabue, "Louvre Gets $20 Million for New Islamic Wing," *New York Times,* 28 July 2005. Prince Alwaleed Bin Talal Bin Abdulaziz Al-Saud also hopes the new Islamic wing "will assist in the true understanding of the true meaning of Islam, a religion of humanity, forgiveness and acceptance of other cultures." *New York Times,* 3 August 2005.

95. Quoted in Alan Riding, "London Sees Political Force in Global Art," *New York Times,* 4 August 2005.

96. Quoted in Alan Riding, "Imperialist? Moi? Not This French Museum," *New York Times,* 22 June 2006.

97. Quoted in Judith Dobrzynski, "Hip vs. Stately: The Tao of Two Museums," *New York Times,* 2 February 2000.

98. Philippe de Montebello, "Art Museums, Inspiring Public Trust," in *Whose Muse?*, ed. Cuno, 166. Earlier in the essay he states: "information about works of art [should not] be distorted for political or other ends, including, as is increasingly prevalent, for marketing reasons" (152). As Cuno's collection of essays makes clear, the biggest perceived threat to the autonFomy of the art museum today lies in the museum's growing reliance on commerce and corporate influence.

# "The Last Wild Indian in North America"

## *Changing Museum Representations of Ishi*

IRA JACKNIS

The California Indian man known to us today as "Ishi" is one of the most famous individual Native Americans of all time. Yet, in a profound historical irony, we do not even know his true identity. Following Native Californian custom, he refused to divulge his personal name, and so, instead, he was referred to by the word that meant "man" in the language of his people, the Yahi. The Yahi, the southernmost group of Yana-speakers, lived in the valleys and foothills east of the upper Sacramento River. A small group at contact, their numbers declined precipitously through the nineteenth century due mainly to systematic attempts by the settlers to eliminate them. Ishi, born probably about 1860, spent most of his life in hiding with his family, avoiding the assaults of whites invading the Yahi homeland, the Deer Creek valley area of Tehama County. In the fall of 1908, his family was contacted by a party of surveyors, but no sign of them was found again until Ishi walked into the nearby town of Oroville on 29 August 1911. All the members of his family, along with the rest of the Yahi, appear to have perished. Ishi's notoriety has come from the belief that he was the last Native American to have lived a "traditional" life, apart from the invading society.

Within days Ishi was taken to the University of California Museum of Anthropology, then in San Francisco, where he lived for the next four and

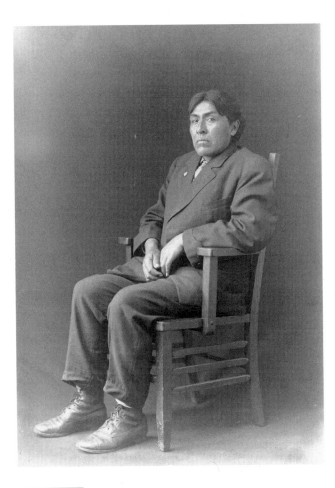

Figure 2.1. Formal portrait of Ishi. Photograph by the Camera Club, fall of 1911. *Phoebe A. Hearst Museum of Anthropology (PAHMA), UC Berkeley, neg. no. 15-5414. Courtesy of the UC Regents.*

a half years. At the museum, Ishi was employed as a live-in janitor as well as a demonstrator of Yahi culture. Here he collaborated with Alfred L. Kroeber (1876–1960), professor of anthropology at the university and director of its anthropology museum, and Thomas T. Waterman, instructor and museum curator, as well as Dr. Saxton Pope, Ishi's physician, who developed an interest in archery from his friend. Together they worked to document the culture of Ishi's Yahi ancestors.

After Ishi's death from tuberculosis on 25 March 1916, the anthropologists who knew him recorded their findings in university publications. However, Ishi's life was gradually forgotten until 1961, when Theodora Kroeber (1897–1979), Alfred's second wife, published *Ishi in Two Worlds: A Biography of the Last Wild Indian in North America*.[1] Since then the general public has maintained a deep and abiding fascination with the subject of Ishi, embodied in best-selling books by Mrs. Kroeber and others, and in essays, plays, poems, paintings and sculptures, films, and musical compositions. His life has become particularly familiar to California school children, who often study his story in fourth-grade social studies classes. In recent years, he has returned to the news with the search for his brain, which had been removed in an autopsy, and its eventual repatriation in the summer of 2000 to members of the Yana community for reburial with the rest of his remains.

Despite this wealth of cultural representation, somewhat surprisingly there has been virtually no critical study of the surviving corpus of objects created by Ishi and since re-presented by their primary repository—the Phoebe A. Hearst Museum of Anthropology (founded in 1901 as the University of California Museum of Anthropology, and known from 1959 to 1992 as the Robert H. Lowie Museum).[2] This essay seeks to address Ishi's "museum career." It summarizes and characterizes Ishi's original production, in association with the university anthropologists, of ethnographic objects: primarily artifacts and photographs, but including also sound recordings and texts.[3] This initial collecting is then contrasted with the subsequent rich history of museum representations of the Ishi story, principally in a succession of exhibits at the Hearst Museum. This allows us to highlight a shift in anthropological rhetoric from cultural salvage to intercultural domination and resistance. The story also raises enduring issues for the museum's preservational mission across cultural and temporal differences.

One could hardly choose a better case study in which to examine the dynamics of museum anthropology and cultural difference than the story of Ishi. Anthropology is by definition based on issues of cultural difference, and therefore, by extension, so are the museums devoted to the subject. What gives the story of Ishi such narrative and analytic power is that it is so personalized and relatively well documented, in contrast to the more usual collective and meager documentations. Making the case even more acute is the fact that for Ishi and the Yahi almost all the documentation of a single culture

rests on one man and his representations. Conceptions of difference are chal-
lenged when the terms of contrast are so reduced. This account addresses
both the poetics and politics of difference: the content and modes of the
representation as well as the power relationships that have created them.

## Original Inscription

When Ishi was discovered, Alfred Kroeber was completing a decade of in-
tensive fieldwork and research on California Indian cultures. In this effort,
he was carrying out the mission and methods of his mentor, Franz Boas
(1858–1942). The German-born anthropologist was then transforming the
discipline in America with his critique of cultural evolutionism. Instead of
its value-laden progressivism, Boas advocated a more culturally relative ap-
proach based on intensive participant-observation fieldwork. After earning
his doctorate with Boas at Columbia in 1901, Kroeber began his professional
career in California.

As California Indian cultures were then little known among anthropolo-
gists, Kroeber was attempting to describe their basic features and geograph-
ical distributions. Working within a Boasian salvage paradigm,[4] he believed
that it was necessary to recover and present as much information as possible
in order to leave for future humanity a record of the diverse cultures that had
once existed. Because those in aboriginal North America lacked written lan-
guages, Boas and Kroeber adopted a multimedia model of ethnography.[5] In
addition to written field notes and texts in native languages, Kroeber col-
lected artifacts, took photographs, and made sound recordings.[6]

Beginning in 1901 (and announcing it officially in 1903), Alfred Kroeber
implemented a survey of Californian archaeology and ethnology which at-
tempted to collect artifacts and other ethnographic objects from every abo-
riginal culture once residing within the state's borders. He summarized this
research in his *Handbook of the Indians of California* (1925), accompanied by a
map of tribal territories. According to Kroeber, the *Handbook*'s goal was "to
reconstruct and present the scheme within which these people in ancient and
more recent times lived their lives. It is concerned with their civilization—at
all events the appearance they presented on discovery, and whenever possible
an unraveling, from such indications as analysis and comparison now and then
afford, of the changes and growth of their culture."[7]

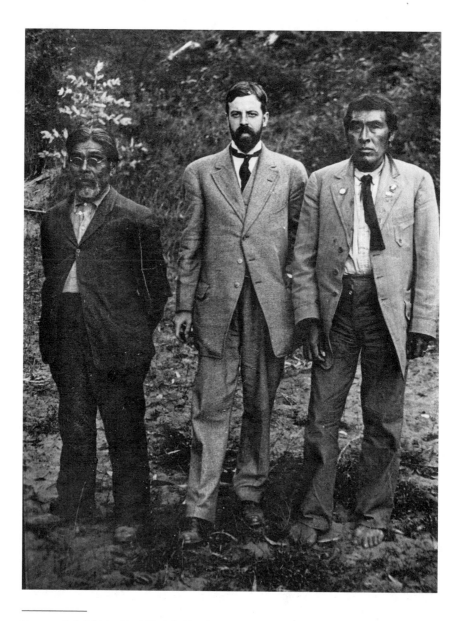

FIGURE 2.2. Ishi (*right*), Alfred L. Kroeber (*center*), Sam Batwi (*left*). Outside the University of California Museum of Anthropology, San Francisco; photograph by Louis J. Stellman, September 1911. *PAHMA neg. no. 13-944. Courtesy of the UC Regents.*

Until Ishi appeared in 1911, however, the Yahi represented a blank, unknown region. The Yahi, who appeared to have been untouched by Western culture, were thus a key source for the reconstruction of the aboriginal cultures of California. It soon became clear that Ishi was alone, and Ishi thus succumbed to the many tropes of extinction, such as "vanishing" and the "last of," evocative of the dodo or the last passenger pigeon. Although it was true that Ishi was "the last Yahi Indian," his ties to a larger Native Californian community were overlooked and obscured.

### Ishi's Body

Although no longer extant and thus not an ethnographic object per se, Ishi's body was on display during his years at the UC Museum of Anthropology. While Ishi lived at the museum, he was often behind the scenes, working as a janitor and watchman. There were times, however, when he was on public display. In fact, his arrival at the museum came just a month before the public opening of the exhibit galleries, and he was quite a sensation during the ceremonies. Usually on the weekends, especially during his first months, Ishi performed songs and demonstrated crafts.

Ishi, of course, was not the only native person on public view in turn-of-the-century America. The most common venues for the display of live humans were the many world's fairs and Wild West shows, but there were two famous cases of native individuals displayed in cultural institutions: the family of the Greenland Inuit boy Minik at the American Museum of Natural History and the Pygmy man Ota Benga at the Bronx Zoo, both in New York.[8] Thinking of these cases of coercion, many have criticized Kroeber's actions. Yet, when Ishi was given a choice of whether to stay at the museum, he replied, "I wish to stay here where I now am. I will grow old in this house, and it is here I will die."[9] There were not many viable options at the time. His status, as with all Native Americans, was defined by federal legislation as that of a ward of the U.S. government, especially as the Yahi had signed no treaties. As a practical matter, living unassisted in a white community would have been virtually impossible, given his difficulty in communicating. The principal alternative would have been to live with some other Yana or other Native Californians. By 1911, there were about a dozen elderly Yana-speakers; others with Yana ancestry had intermarried into dispersed Pit River and Wintu communities. The principal deterrent to this

solution at the time would have been his lack of kin ties and his difficulties in earning a living.

After his death, Ishi's body was cremated along with some of his personal possessions. His ashes were placed in a Pueblo Indian pot from the collection and interred in a mausoleum in Colma, just south of San Francisco. As he was a ward of the state without kin, the museum no longer had any responsibility for him. However, an autopsy had been performed against Kroeber's wishes, and after a review by the doctors his brain was given to the museum, where Kroeber found it on his desk when he returned from a sabbatical. As he had no desire to keep it, he sent it to Aleš Hrdlička at the Smithsonian, which maintained a comparative collection of brains.[10]

## Artifacts

The Hearst Museum preserves a relatively small collection of artifacts associated with Ishi. The 210 catalogued entries now extant fall into two major categories: objects associated with Ishi's last household in the Deer Creek area (43 items) and objects made by Ishi in the museum (152 items), in addition to 15 objects attributed to Ishi and probably made by him in the museum. Most were accessioned between 1910 and 1915, but a few came in as late as 1981. About three-quarters of the collection is related to hunting in some way: 91 arrow or spear points of obsidian and glass (plus 7 unfinished items), 36 arrows, 7 bows, and 2 quivers. In addition to arrow-making tools, other objects include baskets, mortars and pestles, deer and bear skins, fur blankets, hair nets, fish nets, salmon spears and nets, fish hooks, fire drills, and raw materials, as well as Euro-American items (a spoon, a saw, a cloth bag, and a hat) found in Ishi's camp.

The objects associated with Ishi's last Yahi household are the earliest, of both production and collection. They consist of three accessions collected in the Deer Creek area of Tehama County by Thomas T. Waterman, by Alfred L. Kroeber and Waterman, and by John and Merle Apperson, and acquired by the museum in 1910, 1914, and 1914, respectively.[11] Each of these accessions occurred under distinct circumstances. As noted, in November 1908 a team of surveyors discovered a group of Indians, presumably Ishi and his family, at their camp site near Deer Creek. They frightened away the family and removed many of their belongings. In 1909, Kroeber sent out museum assistant Thomas T. Waterman to search for signs of the Yahi group. Waterman

visited the site and collected some of the remaining objects in the camp, now abandoned. In 1914, Waterman and Kroeber, accompanied by Ishi, Saxton Pope, and Pope's son, collected further items from the site. While Ishi was initially reluctant to go, he eventually agreed, and by all accounts even enjoyed his experience. Just before leaving the area, Kroeber purchased from John and Merle Apperson the collection of Yahi objects that they had taken in 1908. John was a local rancher who had served as a guide for the surveying party of 1908; his son Merle had accompanied him.

Most of the Ishi collection consists of objects made by Ishi for the museum, items "made for hire," in today's terminology. Ishi, who was paid a salary for his services as a custodian, made the objects at the museum with materials supplied by the anthropologists. The records are not specific as to what extent his artifact production came under the scope of his official duties, but given the understandings of the time, it probably did. Ishi had a good opportunity to see what Kroeber and his associates did in a museum, and all available evidence suggests that he did understand that he was making these items for eventual preservation there. For example, "he was accustomed to seeing them [tools made in the museum] on exhibit in museum cases, to having people look at them behind glass. . . ."[12] Moreover, almost all of these items were accessioned during his lifetime. These new objects included arrow points, arrows, a quiver, fishing nets, hair nets, fishing spears and spear points, fish hooks, and fire drills. Many, if not most, of the objects that Ishi made in the museum were never used, and some were unfinished. One exception, however, is the tool kit that he used to produce stone arrow points.

In considering this array of diverse objects, it is useful to review the "how" of collecting (the identity and motivations of the collectors, or the politics) as well as the "what" (the categories and status of the artifacts, the poetics). Objects from Ishi and his extended Yahi family were obtained by three kinds of people: the museum anthropologists, local residents of Deer Creek, and friends and acquaintances of Ishi's in San Francisco. While the anthropologists desired them for cultural documentation, both of the other groups valued the artifacts as souvenirs of a remarkable individual. Ishi's objects were acquired according to four basic modes. First, there were the direct gifts from Ishi. Second, there was commissioning for a payment, with supplied materials. (Significantly, the museum did not accession any of Ishi's body, even though it had a comparable collection of Native Californian

skeletons. It is clear that Kroeber considered Ishi a personal friend and not a scientific specimen.) Third, both the surveyors and Waterman took objects without payment, the former by frightening the owners, and the latter by collecting from an abandoned site. In the final form of transaction, a confiscated collection was subsequently purchased.

Some of the museum's catalogue cards for the Waterman and Apperson accessions describe these objects as "stolen."[13] All evidence indicates that Ishi's family had no more use for the few objects that Waterman found at their camp (such as parts of their home). The motivations for the earlier "collecting" by John and Merle Apperson are less defensible. They seemed to have taken these objects partly as souvenirs or booty, and partly as material evidence of the Yahi band, whose existence had not been conclusively demonstrated up to that time. The family justified the removal by pointing out that the Yahi had taken objects from their homes. According to Eva Marie Apperson, her father-in-law John Apperson and her brother-in-law Merle had second thoughts about their actions and returned to the Yahi camp with the intention of returning the confiscated items.[14] But there was no further sign of the family, and the Appersons retained the objects. Kroeber's purchase of the Apperson haul is an interesting and debatable transaction. In one sense, he was buying stolen property. In this case, however, there seemed to be no one other than Ishi to whom the objects could be repatriated, and in his new life at the museum, Ishi would have no use for them. Unfortunately, by this time, any possible harm to the Yahi band had already been done; furthermore, the objects were—and still are—of immense significance to ethnographic science as a representation of more-or-less "traditional" Yahi culture. We have no evidence that Ishi objected to Kroeber's purchase of these items.

To what extent can the museum's Ishi collection represent Yahi culture? Many people think that the Hearst Museum must have a lot of Ishi material. While more than 200 items may seem like a lot coming from one man and his immediate family, they do not form much of a basis for representing an entire culture. In fact, most of the collection consists of small stone arrow points and the raw material to make them. Of the approximately 186 objects that Ishi made there, about 128 were stone and glass projectile points. As a male in a gendered Native Californian culture, this is the kind of artifact production that Ishi would have known best. Conspicuously absent, however, is the iconic object type for California Indians—basketry. While the museum

has a few Yahi baskets found in Ishi's last camp, most of its Yana baskets are from the northern groups and were collected in 1907 by linguist Edward Sapir. Not only does this make for a somewhat limited exhibit, it severely distorts the reality of traditional Yahi culture.

Almost everyone has been interested in Ishi's objects as testimony of a pre-contact, "wild" cultural state. The corpus, however, as suggested by its differing modes of acquisition, falls into two distinct clusters: the items Ishi made at the museum and the objects from his last camp. As a rule, Kroeber avoided signs of acculturation in his artifact collecting. As he explained to a trader, "The requirements of our Museum make it most desirable that we should obtain old pieces that have seen use." But he was willing to accept re-productions, which he described in his inventories as "models."[15] Models were essentially what Ishi made in the museum, although he did use some of them in demonstrations. Clearly, Yahi objects were so rare that even commissions were better than nothing. Many, however, reveal significant signs of innovation and culture-contact. Nowhere is this better seen than in Ishi's projectile points. Stimulated by his new setting and freed of the need to hunt for his own food, Ishi created beautiful, long points from glass, so long that they would have been non-functional.[16] In addition to glass, he eagerly made use of cotton string for fish nets, commercial paint for his arrows, glue for his arrows, and even metal for some arrow points. His cultural curiosity extended to the fabrication of an English-style quiver, undoubtedly suggested by Pope, completely different from the kind he had used in Deer Creek.

While seemingly more aboriginal and "authentic," some of the objects from Ishi's last camp tell a different story. They indicate that Ishi had stopped being a "stone age Indian" well before coming to live in San Francisco. He and his family were using arrow points made from glass, fish spear points from iron nails, and denim bags and hats, along with metal spoons and saws.[17] These Yahi did their own collecting, finding objects abandoned or sometimes stealing them. As a kind of "holocaust" survivor, Ishi lived his entire life in a state of cultural adaptation and change. Alfred Kroeber was certainly aware of this, as he was of other Native Californian innovations,[18] but given his salvage agenda, he needed first to demonstrate distinctive Yahi cultural patterns.

Like all the specimens in an anthropology museum, once accessioned, Ishi's objects have been made to represent the culture of their maker, erasing the distinctive histories of their production, use, and collection.

## Photographs

As an object of intense public interest, Ishi, unsurprisingly, was the subject of many, many photographs. Especially during his first weeks and months in Oroville and San Francisco in 1911, newspaper photographers created many staged images. In them, Ishi was dressed up in skin clothing that was unknown to the Yahi. Somewhat more documentary seems to have been about 1,500 feet of film shot in 1914 and 1915 by the California Motion Picture Company. Unfortunately, because of its fragile nitrate film stock all copies of the film seem to have disintegrated, leaving only some stills. There are relatively few candid photographs that show Ishi as he appeared in daily life, and unfortunately their makers are often not clearly identified.

Of the approximately 300 photographs of Ishi in the museum's collections, about 150 were taken during the most extended of Ishi's photographic sessions, a trip back to Ishi's homeland in May 1914. Of this total, 121 were taken by Alfred Kroeber and the remainder by Saxton Pope. With his interest in archery, the physician focused on Ishi using his bow and arrow. The principal subjects of the Ishi collection are landscapes (of the Deer Creek area), Ishi constructing and using traditional artifacts at the museum and in Deer Creek (hunting, fishing, fire-making, bow- and arrow-making), and portraits.

Kroeber's pictures involve several kinds of ethnographic fiction.[19] For instance, one lengthy series of images depicts the hunting of a deer and its subsequent skinning and butchering. However, contemporary accounts reveal that this scene was faked, evidently for the benefit of the camera. According to Pope, on this trip Ishi was not able to bring down a deer with his bow and arrow, so the carcass being treated must have been shot with a rifle.[20] Even more critical, in almost the entire body of Deer Creek photos, Ishi is shown in minimal dress, usually a skimpy loincloth that seems to bear no relation to traditional Yahi dress.[21] We know that once he had come to live in San Francisco, Ishi preferred to wear shirts, trousers, and shoes, just like the white people around him. Anyone looking at the pictures might have thought that s/he was seeing a truly untouched aboriginal, a "Stone Age" Indian. If Ishi had ever lived this way, he certainly did not by 1914. Because that stage was now unavailable to the camera it had to be recreated. This salvage orientation marked Kroeber's artifact collecting and indeed all of his ethnography.

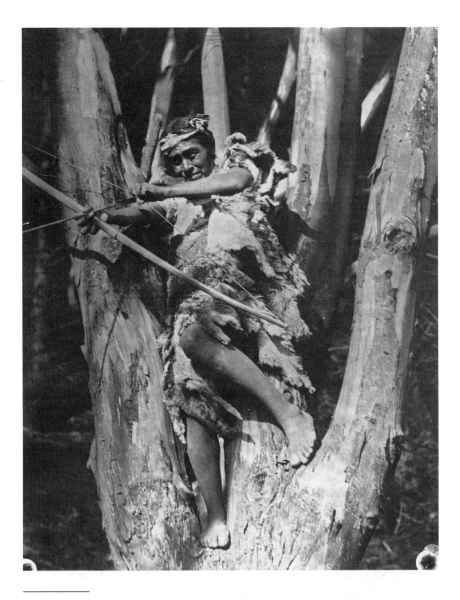

FIGURE 2.3. Ishi, with a bow and arrow, in a posed photograph, wearing fictive costume. Outside the University of California Museum of Anthropology, San Francisco; by unknown photographer of the *San Francisco Call*, September 1911. *PAHMA neg. no. 13-953. Courtesy of the UC Regents.*

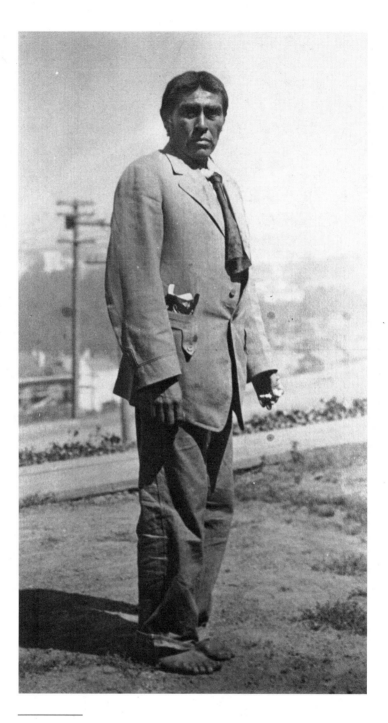

FIGURE 2.4. Ishi in a candid photograph. At the University of California, Berkeley; photographer unknown, fall 1911. *PAHMA neg. no. 15-16827.*
*Courtesy of the UC Regents.*

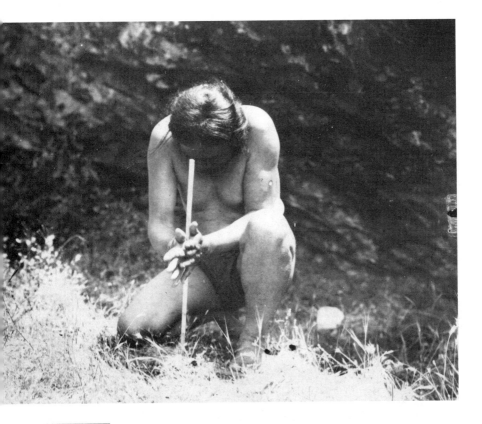

FIGURE 2.5. Ishi, wearing a loincloth, making fire with a fire drill. Deer Creek, Tehama County; photograph by Alfred L. Kroeber, 14 May–2 June, 1914. *PAHMA neg. no. 15-5763. Courtesy of the UC Regents.*

Ironically enough, when taking pictures of people, Kroeber usually showed his native subjects as they were, in all their acculturated clothing. With Ishi in 1914, he made an exception.[22]

Like the artifact collectors, the different photographers produced different kinds of pictures for different motives. However, just as all the collectors were motivated by the mission of salvage, so most—although not all—of the photographers were dedicated to the task of cultural re-creation in the face of Ishi's now transformed appearance. Tellingly, the principal exception seems to have been those candid images made by local residents of various sorts—that is, not by professional photographers or anthropologists, both of whom shared a common agenda rooted in Ishi's "primitive" state.

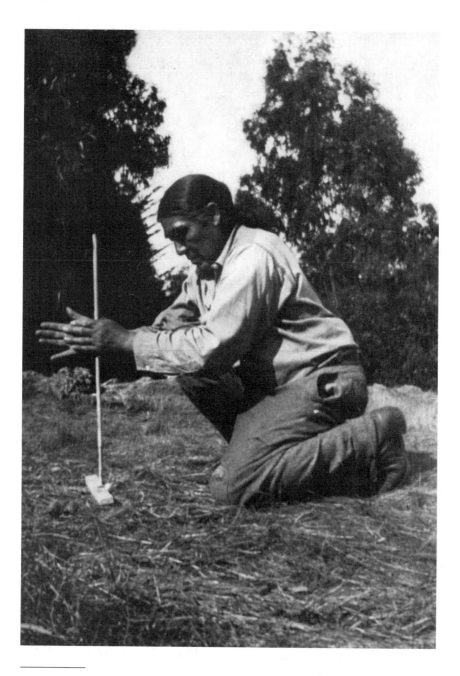

FIGURE 2.6. Ishi, wearing a shirt and trousers, making fire with a fire drill. Outside the University of California Museum of Anthropology, San Francisco; photograph by Saxton T. Pope, ca. 1911–15. *PAHMA neg. no. 15-6275. Courtesy of the UC Regents.*

Thus we see that issues of difference were central to the Ishi story from the beginning. There was a tension embodied in the original inscriptions, caught between two versions of Yahi culture. Kroeber's desire to document a vanished pre-contact state meant that he had to suppress signs of acculturation that existed in front of his eyes (in Ishi's use of metal, glass, and cloth objects and in Ishi's new clothing). Kroeber treated one version as the authentic, even when he had to take active means to create this authentic condition (in the photographic posing and reconstruction) while he hid or ignored the other. As the decades wore on, however, these contradictions became more apparent.

## The Revival of Representations

In today's world, where Ishi seems ever-present at the Hearst Museum, it is difficult to conjure a time when he was barely known. Yet, after Ishi's death, the memory of him gradually faded. Reportedly, Alfred Kroeber found the death of Ishi very painful and tended to avoid discussing him. In his summary *Handbook of the Indians of California,* Kroeber spends about a page considering Ishi under the section on the Yahi.[23] The most complete contemporary treatment by people who knew Ishi was a series of short papers published in a professional series with limited distribution.[24] Ishi's artifacts were even more hidden. Because the UC museum had no public exhibits during the decades after it moved back to the Berkeley campus in 1931, Ishi's objects went unseen.[25]

As noted, his revival began with the work of Theodora Kroeber, who ironically never knew Ishi.[26] In a second marriage for both husband and wife, she had married Alfred in 1926. She began the research and writing in the late 1950s, late in both of their lives, and by the time her book was published, her husband had been dead for about a year. She was greatly encouraged and assisted by Robert F. Heizer, a UC archaeologist and ethnohistorian. As a student of Kroeber's, he had intended to write such a book, but he turned over his files to her once she began her work. While Alfred supplied information and read over the completed manuscript, he, too, did not direct her writing. *Ishi in Two Worlds: A Biography of the Last Wild Indian in North America* was published in October 1961 with an initial print run of 4,000 copies, but the press rushed into print thousands more copies, partly in response to the publication

of a condensed version in *Reader's Digest,* which had a circulation of 13 million.[27] The book has gone on to sell over one million copies, becoming one of the University of California Press's all-time best-sellers.

Thomas Buckley has given us an excellent critique of the complex similarities and differences in the presentations of Ishi by the two Kroebers.[28] Briefly, from her husband Theodora Kroeber derived a view of cultural survivals, portraying Ishi as an untouched "stone age Indian." Departing from him, however, she recounted a story of genocide and holocaust, an interest shared with her colleague Robert Heizer. Although well-written and compelling, much of the book is a kind of historical fiction. With very limited sources, Theodora Kroeber resorts to cultural recreation for the first part of the book, describing Ishi's life before 1911. And, as Orin Starn points out, she tends to put the best light on Ishi's relationships with the anthropologists.[29]

In 1964, Theodora Kroeber published a children's version of the book.[30] It is notable that in the years since there have been more children's books on Ishi than serious scholarship aimed at adults, further magnifying the role of Mrs. Kroeber's book. In 1979 Robert Heizer and Theodora Kroeber published *Ishi, the Last Yahi: A Documentary History,* an anthology of most of the original written sources on Ishi.[31] Most of the illustrations were from Lowie Museum collections. The discovery and repatriation of Ishi's brain stimulated a new literature, including the recent anthology edited by Alfred and Theodora's sons, Karl and Clifton Kroeber, and the account by anthropologist Orin Starn, who had located Ishi's brain.[32]

In a strange kind of historical resonance, just as Ishi had arrived a month before the opening of the original UC anthropology museum, so was Theodora Kroeber's book about him published soon after the January 1960 opening of the museum's new building. Despite its greatly expanded exhibition space, the museum felt that a series of small, topical, and rotating exhibits was preferable to permanent installations. One of these early themed displays was devoted to Ishi, presenting most of the surviving artifacts and photographs for the first time in decades. Although the museum also preserved Ishi's sound recordings and some written documentation, these visual and tangible ethnographic representations lay at the heart of its mission of scholarly research and public education.

## Hearst Museum Exhibits

The Hearst Museum's new Ishi exhibit proved to be critical in the museum's own representations of Ishi and cultural difference. The curator of this display was Albert B. Elsasser, a Heizer student who worked as a research anthropologist at the museum with special responsibility for the exhibit programs. Elsasser was close to the Kroebers, also collaborating with Theodora Kroeber and Heizer in later publications.[33] From surviving files, it appears that the various incarnations of the Ishi exhibit did not change substantially until a decade after Theodora Kroeber died and Elsasser retired, both in 1979.[34]

The first exhibit on the subject at the newly named Lowie Museum was Ishi: The Last Survivor of a Californian Indian Tribe, characterized as "an exhibition in honor of Theodora Kroeber's successful book."[35] In fact, the label copy for the exhibit and most of its successors were taken directly from Mrs. Kroeber's book, which had appeared only three months before. In addition to a sampling of artifacts, there were many photographs, publications, and newspaper reproductions concerning Ishi and his life at the museum after 1911. On display from 13 January to 12 March 1962, the exhibit drew more than twelve thousand visitors, quite a large crowd for a two-month show. The popular exhibit then traveled to the State Indian Museum in Sacramento, which had lent twenty-five specimens from its J. McCord Stilson Ishi collection.[36]

In late 1965, the Ishi exhibit was put on display again "in response to countless requests from the general public."[37] The following year it traveled again, this time to the Junior Museum of the Palo Alto Recreational Department. And again it played to large crowds, the Palo Alto director reporting that "the Ishi exhibit set an all-time attendance record, amounting to an increase of 500% over the average daily attendance recorded during the same period the previous year."[38]

The Ishi exhibit was revived a decade after its first incarnation as Ishi, the Last Survivor of a California Indian Tribe.[39] This 1972 exhibit was quite similar to the 1961 version, although it appears to have been larger and more ambitious in design. Again it contained direct quotations from Theodora Kroeber, but it also seems to have contained some briefer paraphrases. The focus on Mrs. Kroeber's narrative was literal: one case included copies of her book, plus relevant Ishi numbers from the professional series University of California Publications in American Archaeology and

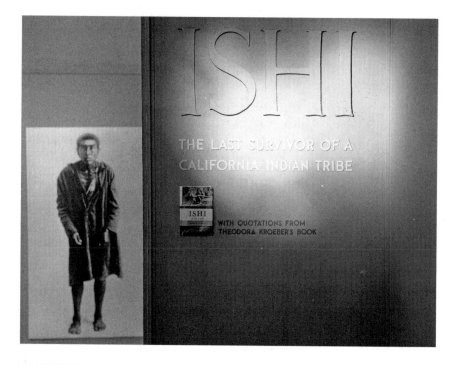

Figure 2.7. Ishi exhibit, 1962 version, curated by Albert Elsasser, "Entrance." Phoebe A. Hearst Museum of Anthropology, UC Berkeley; photograph by Eugene R. Prince. *PAHMA. Courtesy of the UC Regents.*

*Ethnology.* Most of the objects and photographs were the same; the pictures and contemporary news clippings were presented in giant photomurals. As the museum had few Yahi baskets, the display included a selection from their northern Yana neighbors.

Although details are vague, it appears that some version of this Ishi exhibit was displayed through most of the 1970s; several were entitled simply The Story of Ishi. For the September 1974 version, there was a new, shorter text, accompanied by the usual stock of objects. While the exhibit ends with Pope's affectionate characterization of Ishi as a basically patient and cheerful individual,[40] one final label remarked, "Ishi's story, that of a survivor of an Indian group decimated by the policies of an intruding group and by local ignorance and hostility, is a familiar one not only from the history of this country but throughout the world."

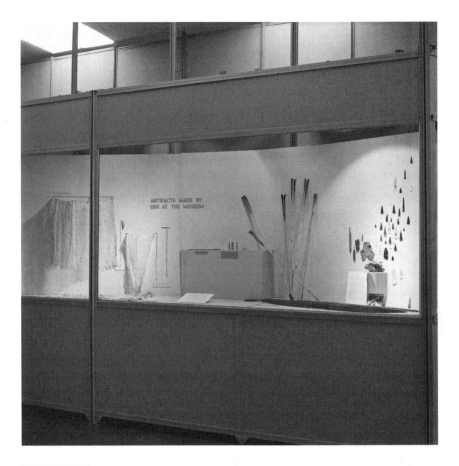

FIGURE 2.8. Ishi exhibit, 1966 version, curated by Albert Elsasser, "Artifacts Made by Ishi in the Museum." Phoebe A. Hearst Museum of Anthropology, UC Berkeley; photograph by Eugene R. Prince. *PAHMA neg. no. 15-20153. Courtesy of the UC Regents.*

During the late 1970s the museum removed the Ishi display, only to be met with constant complaints.[41] The museum often encountered frustrated and sometimes angry visitors who had come long distances to see the poignant objects that they had read about in Theodora Kroeber's compelling book. Not wanting to disappoint them if they had come from places as distant as Germany, the staff would take them downstairs into the restricted collections area. Obviously, this burden could not be indefinitely sustained, so it was decided to present some Ishi exhibition permanently.

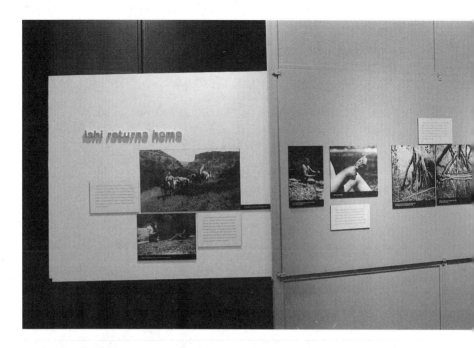

Figure 2.9. Ishi exhibit, 1972 version, curated by Albert Elsasser, "Ishi Returns Home." Phoebe A. Hearst Museum of Anthropology, UC Berkeley; photograph by Phillip Chan. *PAHMA. Courtesy of the UC Regents.*

Beginning about 1981, the museum decided to display its Ishi collection at least during the summers. Using a side gallery devoted to teaching exhibits during the academic year, the entire space was completely devoted to Ishi. During the school year, they kept as much of it on view as possible, usually about one-third.[42] The organizer was education specialist Martha Muhs. No real curation was involved, however, as the original label and photo panels prepared by Albert Elsasser were recycled. Some linking and contextual passages, approved by museum anthropologist Frank A. Norick, were added. The exhibit was structured chronologically. According to Muhs, the museum tried to be "low profile," sticking close to Mrs. Kroeber's version, telling the Ishi story without much editorial comment.

The first new—and non–Theodora Kroeber—version of the Ishi exhibit was curated by anthropology graduate student Susan Berry. Simply called Ishi, the new display opened in May 1990 but was on view for only

about nineteen months (through the end of 1991), after which the gallery was closed for reinstallation. For what was intended to be a definitive and comprehensive exhibit on Ishi, Berry wrote completely new labels. In the end, they were not too different from the Kroeber-Elsasser version. Nevertheless, there was an important change in perspective. A socialist, Berry was angry about the Ishi story, regarding it as an episode of cultural exploitation. Her final section on "Ishi, the Symbol" discusses for the first time alternative and competing views of Ishi's significance.[43] Also included was a section curated somewhat independently by research archaeologist M. Steven Shackley. Following his new research (published in 2000), he prepared a small section on Ishi's stone tool technology. In it, Shackley showed the distinctiveness of Ishi's work and its resemblance to some neighboring styles.

Another Ishi exhibit followed very shortly. Soon after being hired as a curator in the summer of 1991, I had the opportunity of producing a completely new version to coincide with a Berkeley meeting of the California Indian conference. Because of the conference's significant native participation, it was decided to substantially rethink and revise the exhibit as Ishi and the Invention of Yahi Culture. During its long run (6 October 1992–30 September 2001), the display was moved several times. Each successive version became smaller and more condensed, although the same basic narrative was maintained. After an introduction and a section on the Yahi and their life during the late nineteenth century came the two principal components: one case of thirteen artifacts used by Ishi in his last home before 1908, and one containing eleven of the objects that he made in the museum. The exhibit also included, virtually unchanged, Shackley's section on Ishi's arrow points (thirty-eight points and tools). The display was supplemented with thirteen photographs and graphic panels focusing on Kroeber's visual recreations of the 1914 trip. The presentation concluded with a panel, "Ishi as Romantic Narrative," dealing with the interpretation of Ishi's life since his death.[44]

Motivated by the theories of anthropologists Victor Turner and Roy Wagner, and drawing upon linguist Leanne Hinton's new research on Ishi's tales and Shackley's on projectile point style, I sought to highlight Ishi's adaptation and innovation.[45] Stressing the personal and creative aspects of culture, I treated Yahi culture not as a static and finite thing, but as a complex web of meaning, generated by individuals as they extend received wisdom to meet

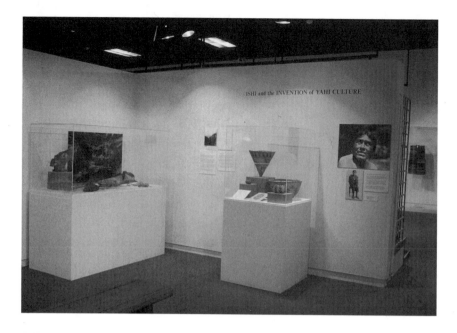

FIGURE 2.10. Ishi exhibit, 1992 version, curated by Ira Jacknis, view of first half. Phoebe A. Hearst Museum of Anthropology, UC Berkeley; photograph by Eugene R. Prince. *PAHMA. Courtesy of the UC Regents.*

changing circumstances. Specifically, I found Ishi's "invention" in his stone tool production (longer, non-functional, made of glass instead of obsidian) and his use of materials such as commercial glue, paints, and cotton string. Invention also meant that Alfred and Theodora Kroeber were creatively combining their ethnographic sources with their theoretical perspectives, as seen for example in the archaism of Alfred's 1914 photography.

In order to install a comprehensive centennial exhibition, the Ishi display was dismantled and the artifacts placed into a new, permanent Native California Cultures gallery, opened in early 2002. Unlike every Ishi exhibit up to that time, this was intended to dissolve the special status of Ishi and place his objects into the context of the rest of California Indian material culture. Because it employed a visible- or study-storage format, items were placed densely on glass shelves with minimal labeling, as in a museum storeroom. While this has some benefits, such as allowing a much greater number of displayed objects, the loss of interpretive labels and photographs has greatly frustrated

visitors. Just as the museum disappointed visitors when it had no Ishi exhibit, visitors who have come to know him from the many books and films want to see a large, expansive display. The museum is adding more interpretation to meet these desires.

Although Ishi material has most often been presented as a subject in its own right, it has at times been incorporated into larger displays. A selection of Ishi's arrow points was included in the Hearst Museum's centennial exhibition, A Century of Collecting (2002–2003). They clearly belonged in any review of the museum's highlights, as they had in the Treasures of the Lowie Museum exhibition (1968), which coincided with the museum's seventy-fifth anniversary and the university's centennial. Some arrow points were also included by installation artist Fred Wilson in his exhibition Aftermath, which used objects from the Hearst Museum and was presented in the University Art Museum (2003). Wilson felt that they were appropriate for a display that explored the results of wars.

A look at the range of exhibit titles—from "The Last Survivor of a California Indian Tribe" through "The Story of Ishi" to "Ishi and the Invention of Yahi Culture"—shows how far museum attitudes had changed. That said, the story of Ishi as told by Theodora Kroeber and relayed by Albert Elsasser endured for almost three decades; and even alternative versions resembled each other, due partly to a limitation of resources, but primarily to a limitation in original sources.

## Photographs and Films

Apart from artifacts, the Hearst Museum has had many other dealings with Ishi materials. The most widely distributed of these have been the photographs, which have been used extensively in every book, exhibit, and film about Ishi. The original glass plate and nitrate film negatives were copied to safety film in the mid-1960s. In the last few years, the museum's entire collection of original Ishi negatives has been digitized—along with the rest of the California ethnographic photographs—for the Museums and On-line Archives of California (MOAC), a project of the state-sponsored California Digital Library.[46] Somewhat like visible storage, this website offers access to complete collections with relatively little interpretation, although that can be added later.

Not all the Ishi pictures were included, however. For practical and legal reasons, this project was restricted to field photos that the museum itself had

produced and for which it had original negatives. Thus it did not include many of the Ishi pictures taken by news photographers in San Francisco for which the museum did not have the reproduction rights. Significantly, many of these depicted Ishi in Western clothing, in San Francisco. Many of these images were poorly documented. In researching them it was possible to determine some of their provenances, most particularly that of a very famous picture of Ishi standing with Alfred Kroeber and Sam Batwi, a Northern Yana interpreter who was present during Ishi's first weeks at the museum (fig. 2.2). The image had been widely reproduced without proper identification of its authorship or ownership. It now appears to have been taken by the local journalist Louis Stellman, with the original negative in the California State Library, Sacramento. More important, people have felt very free to crop out one or more of the subjects, usually Batwi but sometimes even Kroeber. By thus radically re-visioning the historical facts, they helped romanticize Ishi, making him seem even more alone and out of context than he really was.

Although Theodora Kroeber was primarily a writer, her books—as well as the museum exhibitions—were opportunities to represent Ishi visually. The original edition of *Ishi in Two Worlds* (1961) was actually rather well illustrated: 62 images on 32 pages of photos, bound into a central portfolio. More pictures were available, however, some of which were presented in the first exhibit, whose press release called attention to its inclusion of "unpublished photographs." This would have been the effective beginning of Ishi's visualization, as there really was no large-scale public distribution of Ishi photographs until the publication of the deluxe edition of Kroeber's book (1976) along with the few relatively short films that had been made. The new edition contained 101 black and white photographs and engravings, 30 color plates, and 9 original maps and drawings. All the books, films, and exhibits about Ishi have drawn from this relatively small pool of images.[47]

Films were another visual representation of the Ishi story.[48] The only museum production was an unfinished film directed by Samuel A. Barrett.[49] Barrett had been awarded the UC department's first doctorate in anthropology (1908). Although he was a curator at the Milwaukee Public Museum when Ishi was discovered, he saw Ishi several times on visits to San Francisco.[50] After a career in Milwaukee, he returned in the late 1940s to his alma mater, where he served as research associate. His projected Ishi film was part of a larger project to film American Indians, carried out between 1960 and

1965. Funded by the National Science Foundation, it was sponsored by the Berkeley anthropology department, with the resulting films and artifact collections going to the museum. Harking back to his training under Kroeber, Barrett was motivated by cultural salvage.

Barrett had been planning a film on Ishi as early as 1961, but he did not get a chance to film the subject until mid-June of 1962.[51] There are three surviving sequences for Ishi and Deer Creek: landscape and environment (1,050 feet), something called "Ishi in Deer Creek Canyon" (1,800 feet), and the family of Mountain Maidu Marie Potts, wearing traditional-style Maidu costumes, re-enacting Yahi culture (2,000 feet).[52] These scenes included putting partly finished baskets and materials in a stream, hanging and removing strips of meat and fish over a grill, eating cooked salmon, girls playing with dolls, instruction in winnowing, playing the grass game, top-spinning, a musical string, arrow-flaking, fire-making, basket-making, clay doll–making, and digging bulbs.

The full projected scope of Barrett's film and the reasons that it was not completed are uncertain. From the surviving footage, it seems that he was attempting a filmic version of Theodora Kroeber's book, combining a historical fiction of Ishi's life before 1911 with a historical documentary on his life at the museum. The project most likely foundered because of the substantial problems of reconstruction that it posed, problems that began with Kroeber and his staged 1914 photographs. Barrett's powers of cultural re-creation were considerable, but even he could not overcome the extreme poverty of sources, especially human ones, for the Yahi. When he had reconstructed Kwakiutl or Pomo culture, in those cases there were some living representatives who maintained some of the culture.[53]

All the other Ishi films were independent productions, but as the principal repository of Ishi material the Hearst Museum has often offered substantial assistance.[54] Of these films, the most important and the one making the greatest use of museum resources was *Ishi, The Last Yahi*, directed by Jed Riffe.[55] This is not the place for a comprehensive discussion of the various Ishi films,[56] but one might note that the Riffe film relies less on recreation and more on the devices of historical documentary pioneered by Ken Burns. As in the exhibits of the 1990s, there is more of a recognition of the coevalness of Ishi and the anthropologists, to use a term popularized by Johannes Fabian;[57] they shared a historical world, one that can be evaluated and critiqued by those in the present.[58]

Other than its continuing exhibit, the Hearst Museum itself has produced very few representations of Ishi.[59] In 1972, it published a short pamphlet reprinting two of Alfred Kroeber's accounts in the popular press.[60] And in the same year, it produced four slide sets, containing fourteen images, evidently in conjunction with the revised exhibit. Two posters were released: a small one in black and white for the first exhibit, and a larger one depicting Ishi swimming, probably for the 1972 version.[61] It is probably only a matter of time before the surviving Ishi objects make their appearance in the digital realm, transforming further the so-called Stone Age Indian.

### Ishi's Remains

There was one final kind of Ishi documentation—his physical remains. Again, it would take us too far afield to recount the lengthy process by which some Yana descendants had the brain repatriated and reburied with his ashes in 2000.[62] Ironically, however, the remains and the brain were some of the few Ishi objects that the Hearst Museum did not control. Although the museum was accused by some of hiding the facts, the Hearst Museum had never accessioned the brain, or any other parts of Ishi's body, into its collections and thus had no record of the brain's whereabouts. The controversy over the brain greatly magnified the public's already enormous interest in Ishi.

### Conclusion: The Shapes of Ishi's Memory

Since his arrival at the University Museum of Anthropology in 1911, Ishi has been an important part of its history. He came just as Alfred Kroeber was completing his first decade at the museum, the period of virtually all of his California fieldwork and collecting. The Yahi objects relating to Ishi filled an important gap in what became the world's largest and most comprehensive California Indian collection. In 1931 the museum moved back to the Berkeley campus, and the fading of Ishi's memory coincided with the decades when the museum had no public exhibits. Although Ishi had been something of a public attraction during the years 1911–16, his fame exploded upon the publication of Mrs. Kroeber's book. During the 1960s and early 1970s, the Hearst Museum greatly expanded both its collecting and its public presentation through exhibits.[63] This was also a time of substantial growth for American anthropology.

The museum's Ishi exhibits were installed during a period of vast social upheaval and redefinition. It was the age of the Civil Rights movement and the war in Vietnam, as well as Native American political challenges. Among the more important symbolic events were the nineteen-month Indian occupation in 1969–71 of the former federal penitentiary on Alcatraz Island in San Francisco Bay, visible from Ishi's museum home, and the establishment in 1970 of the American Indian Movement as a national organization. These actions called into question the previous political and conceptual place of Native Americans, and it is not surprising that a story of genocide and survival would resonate with the public.

By the time of the new exhibits of the 1990s the Native American situation had changed substantially. California Indian culture was undergoing a revival, documented in the magazine *News from Native California*,[64] and the museum's collections were now governed by federal repatriation legislation of the Native American Graves Protection and Repatriation Act (NAGPRA), passed in 1990. The story of Ishi had shifted to his relationship to a now-vibrant California Indian culture, set against assertions of cultural continuity and sovereignty.

These changes strike at the very heart of the mission of the Hearst Museum, indeed of all museums. By their nature, these institutions must confront ambiguities of difference, both temporal and cultural. As Franz Boas envisioned, rightly so in this case, the objects in museums and the texts in archives remain the principal—and sometimes the only—documentation of vanished cultures. Accordingly, the public looks to these institutions as places for permanence and continuity. Beyond their scholarly roles, however, museums are also in the education—if not the entertainment—business, and as the world around them changes, their interpretations must also change, or they will be seen as increasingly irrelevant and incapable of telling the stories that society demands. As cultural and conceptual interfaces, they are continually challenged by the general public and native communities alike.

At the Hearst Museum, the Ishi story is like a hit song for some singers; it is what the public wants and repeatedly asks for, and the institution denies it at its own peril. While museums may need to keep certain objects always on display, they do not have to maintain the interpretations that surround them as did the Hearst Museum for so long. As other case studies have pointed out,[65] in addition to the mission of artifactual preservation, another reason for

conservative, unchanging exhibits can be real pragmatic factors such as museums' often limited resources.

Museums of anthropology must also specifically confront the problem of cultural difference. In Ishi's case, what culture are we talking about? Who and what exactly were the Yahi? While the Kroebers regarded Ishi as the last representative of a distinct people they called the Yahi, recent scholarship has pointed to the similarities between this group and their more northern Yana relatives.[66] Linguists have noted the mutual intelligibility of the various dialects of the Yana language,[67] and the Smithsonian decided that the Redding Rancheria and Pit River Tribe were sufficiently related to Ishi to accept his repatriated brain.[68] Issues of cultural classification, like other taxonomic determinations, will always be debatable (splitters vs. lumpers), but historical changes have brought into question the certainties of former times. While Ishi was almost certainly the last Yahi, the categorical status of this assertion may not be as compelling as his immense public persona suggests.

In seeking to understand the story of Ishi and the Yahi one continually comes up against the problem of the limited sources. With minor exceptions, there is essentially only the one Yahi collection at UC Berkeley. When one adds to the objects the sound recordings, the photographs, and the texts (mostly held by the Bancroft Library), one realizes that the University of California preserves the direct evidence for most of what we will ever know of the Yahi people. Yet, as Franz Boas maintained more than a century ago, only large collections can allow us to determine what is typical and what is unique about a culture.[69]

In a system of difference, to what can these Yahi objects be compared? In addition to the ethnographic material discussed here, there are Yahi archaeological collections in the Hearst Museum as well as a small collection of Ishi-related material at the California State Indian Museum, Sacramento. There are also several small private collections, some representing objects obtained from local residents of the Deer Creek area,[70] and others deriving from Ishi's time in San Francisco, when he gave arrows and stone points to visitors.[71] The Peabody Museum at Harvard preserves a modest collection of Yana baskets, as does the Hearst. Baskets are usually the most commonly preserved object type from Native California, and it is likely that there are other collections. But any material from the Yahi, especially the non-basket items such as bows and arrows, nets, clothing, fire drills, etc., is extremely rare.

Related to this is the relatively small component of Ishi's life—and Yahi culture, in general—for which we have first-hand documentation. Most tellings of his story focus on what we know of Ishi's life at the museum, 1911–16, supplemented with the meager accounts of the Yahi during his lifetime. While there has been some attempt to get new facts into consideration,[72] the state of discourse on Ishi consists largely of the manipulation of a small stock of objects and facts. Even more critical is the museum's limitation to mute objects, such as artifacts and photographs. While some of the artifacts may be direct expressions of Ishi's thought, they largely derive their meaning from comparison with other sets of objects. The photographs that have so informed our historical picture of Ishi in books, exhibits, and films were not self-portraits but produced by a host of photographers with varying motivations. A more personal perspective may be revealed by Ishi's sound recordings (preserved in the museum) and his oral dictations (preserved in the Bancroft Library). For only in them do we hear Ishi's own voice, in both the literal and metaphorical senses.

All these visual media cannot directly reveal to us the rich world of thought and belief, accessible only through language (as Franz Boas maintained in 1907).[73] While this problem can be overcome for most cultures, for the Yahi it is almost impossible. Frequently overlooked is the fact that Ishi and his anthropologist friends had tremendous problems in communicating. Despite their best efforts, Kroeber and Waterman, and even Sapir, were not able to understand much Yahi, and Ishi was reluctant to learn much English. Therefore, most of what we know about Ishi, or think we know, has been attributed to him or even just guessed at. Theodora Kroeber's book, especially in its first half dealing with Ishi's pre-1911 life, is full of historical fiction. The words preserved in the wax cylinders and dictated texts are all the more significant as they are in Ishi's own words, in his native language, despite the great difficulties of translation.

Anthropologist Edward Bruner has suggested that all ethnography embodies narrative strategies, and that for Native America there has been a shift over the twentieth century from a story of vanishing cultures to accounts of survival and resistance.[74] The museum interpretation of the Ishi story has moved through three such stages. Alfred Kroeber focused on survivals of a vanishing pre-contact culture. After a gap, Theodora Kroeber laid the groundwork of a view of cultural resistance, with her attention to culture contact

and, indeed, genocide. This insight was extended and broadened into the concept of cultural invention, which stresses agency and creativity. This includes a more self-conscious historicism, embodied in the new historical research of myself, Orin Starn, and even the Kroeber sons.

All these interpretations, however, do not replace one another; instead they are superimposed in a complex layering of challenge and response. Ishi, and Yahi culture as a whole, must always be seen according to multiple—and valenced—points of view: native as well as non-native; in the past, present, and future. As this essay has suggested, we will never find a definitive rendition of Ishi and Yahi culture. Nevertheless, the Hearst Museum will surely continue to tell his story.

## Acknowledgments

This summary essay is based on the cumulative research and curation on Ishi that I have carried out since coming to the Hearst Museum in the summer of 1991. I am naturally indebted to my many colleagues, but for special assistance I would like to single out Burton Benedict, Thomas Buckley, Grace Buzaljko, Victor Golla, Leanne Hinton, Virginia Knechtel, Karl and Clifton Kroeber, F. Alexander Long, Malcolm Margolin, Martha Muhs, Sheila O'Neill, Eugene Prince, Jed Riffe, M. Steven Shackley, and Barbara Takiguchi.

## NOTES

### Abbreviations

acc.      accession

AR        Annual Report of the Robert H. Lowie Museum of Anthropology, University of California, Berkeley, for the Academic Year Ending in June 30

HMA      Phoebe A. Hearst Museum of Anthropology, University of California, Berkeley

1. Theodora Kroeber, *Ishi in Two Worlds: A Biography of the Last Wild Indian in North America* (Berkeley: University of California Press, 1961).

2. The principal exceptions are Shackley's article on Ishi's stone tool technology, and my recent essay on Ishi's sound recordings. M. Steven Shackley, "The Stone Tool Technology of Ishi and the Yana of North Central California: Inferences for Hunter-Gatherer Cultural Identity in Historic California," *American Anthropologist* 102, no. 4 (2000): 693–712. Cited as reprinted in *Ishi in Three Centuries,* ed. Karl Kroeber and Clifton Kroeber (Lincoln: University of Nebraska Press, 2003), 159–200; Ira Jacknis, "Yahi Culture in the Wax Museum: Ishi's Sound Recordings," in *Ishi in Three Centuries,* ed. Kroeber and Kroeber, 235–74.

3. While not pursued rigorously here, my analysis of Yahi ethnographic inscriptions is generally derived from Clifford Geertz, "Thick Description: Toward an Interpretive Theory of Culture," in his *The Interpretation of Cultures: Selected Essays* (New York: Basic Books, 1973), 3–30. I have applied and extended this approach in my research on the history of anthropological representations (especially in visual and sonic modes), embodied in my essays cited below.

4. Regna Darnell, *And Along Came Boas: Continuity and Revolution in Americanist Anthropology* (Amsterdam: John Benjamins, 1998).

5. Ira Jacknis, "The Ethnographic Object and the Object of Ethnology in the Early Career of Franz Boas," in *Volksgeist as Method and Ethic: Essays on Boasian Ethnography and the German Anthropological Tradition,* ed. George W. Stocking, Jr., History of Anthropology vol. 8 (Madison: University of Wisconsin Press, 1996), 185–214.

6. In addition to the artifact and photograph collections, the Hearst Museum preserves all the sound recordings that Ishi made. Ishi's original sound recordings comprise 148 wax cylinders (about five hours and forty-one minutes) by Waterman, Kroeber, and musician William F. Kretschmer, recorded in San Francisco between September 1911 and April 1914. These consist of mythological texts, narrative accounts, and music (for full descriptions and analysis, see Jacknis, "Yahi Culture in the Wax Museum").

7. Alfred Kroeber, *Handbook of the Indians of California* (Washington, D.C.: Bureau of American Ethnology, Bulletin no. 78, 1925), v.

8. Rachel Adams, "Ishi's Two Bodies: Anthropology and Popular Culture," in *Ishi in Three Centuries,* ed. Kroeber and Kroeber, 18–34; Jace Weaver, "When the Demons Come: Retro(Spectacle) among the Savages," in *Ishi in Three Centuries,* ed. Kroeber and Kroeber, 35–47.

9. Theodora Kroeber, *Ishi in Two Worlds: A Biography of the Last Wild Indian in North America,* deluxe, illus. ed. (Berkeley: University of California Press, 1976), 228.

10. Kroeber and Kroeber, eds., *Ishi in Three Centuries;* Orin Starn, *Ishi's Brain: In Search of America's Last "Wild" Indian* (New York: W. W. Norton, 2004).

11. The Hearst Museum accession numbers for these collections are Waterman (399), Kroeber and Waterman (477 B), and the Appersons (483).

12. T. Kroeber, *Ishi in Two Worlds,* deluxe ed., 216.

13. The status of such statements is moot. The catalogue cards in question were clearly filled out decades later, in the 1960s, although based on earlier documentation in ledgers. The author and authority of these statements are not indicated. No original documentation refers to "stealing," but clearly this is an arguable value judgment.

14. Eva Apperson, *We Knew Ishi* (Red Bluff, Calif.: Lithograph Co., 1971), 53, 56.

15. Quoted in Ira Jacknis, "Alfred Kroeber as Museum Anthropologist," *Museum Anthropology* 17, no. 2 (1993): 28; cf. Diana Fane, "The Language of Things: Stewart Culin

as Collector," in *Objects of Myth and Memory: American Indian Art at The Brooklyn Museum,* by Diana Fane, Ira Jacknis, and Lise M. Breen (Brooklyn: The Brooklyn Museum of Art, in association with University of Washington Press, Seattle, 1991), 26–27.

16. The Yahi had no tradition of such extreme styles, although they were present in the burials of neighboring tribes (Shackley, "Stone Tool Technology" [2003], 177–79). Ishi's points, however, were unprecedented, even longer than those. An example of one of Ishi's extra long arrow points, made of clear glass, is Hearst Museum specimen cat. no. 1-19487.

17. Cf. Starn, *Ishi's Brain,* 244.

18. A. Kroeber, *Handbook,* vi.

19. Ira Jacknis, "Alfred Kroeber and the Photographic Representation of California Indians," in "The Shadow Catcher: The Uses of Native American Photography," ed. Ira Jacknis and Willow Powers, special issue, *American Indian Culture and Research Journal* 20, no. 3 (1996): 23–25.

20. Saxton T. Pope, "Yahi Archery," *University of California Publications in American Archaeology and Ethnology* 13, no. 3 (1918): 128.

21. Jerald Jay Johnson, "Yana," in *California,* ed. Robert F. Heizer, vol. 8, *Handbook of North American Indians,* ed. William C. Sturtevant (Washington, D.C.: Smithsonian Institution, 1978), 367.

22. Jacknis, "Alfred Kroeber and the Photographic Representation": 23.

23. A. Kroeber, *Handbook,* 343–44.

24. Pope, "Yahi Archery"; Pope, "The Medical History of Ishi," *University of California Publications in American Archaeology and Ethnology* 13, no. 5 (1920): 175–213; Edward Sapir, "The Position of the Yana in the Hokan Stock," *University of California Publications in American Archaeology and Ethnology* 13, no. 1 (1917): 1–34; Sapir, "Yana Terms of Relationship," *University of California Publications in American Archaeology and Ethnology* 13, no. 4 (1918): 153–73; Sapir, "The Fundamental Elements of Northern Yana," *University of California Publications in American Archaeology and Ethnology* 13, no. 6 (1922): 215–34; Thomas T. Waterman, "The Yana Indians," *University of California Publications in American Archaeology and Ethnology* 13, no. 2 (1918): 35–102.

25. Surviving documentation does not allow us to determine whether any of Ishi's artifacts were displayed in the San Francisco museum after his death in 1916 and before 1931. As most of the collections were generally on display in a kind of visible storage, one assumes that they were, especially while he was still remembered.

26. In her freshman anthropology class with T. T. Waterman in 1915, Theodora Kracaw heard much about the Yahi man, but due to his ill health she was never able to meet him before his death (Clifton Kroeber, personal communication, October 2003); cf. Theodora Kroeber, "Timeless Woman: Writer and Interpreter of the California Indian World," interview

conducted by Anne Brower, 1976–78 (Berkeley: Regional Oral History Office, Bancroft Library, University of California, 1982), 30.

27. Press clipping, Ishi exhibit file, HMA.

28. Thomas Buckley, " 'The Little History of Pitiful Events': The Epistemological and Moral Concerns of Kroeber's Californian Ethnology," in *Volksgeist as Method and Ethic: Essays on Boasian Ethnography and the German Anthropological Tradition,* ed. George W. Stocking, Jr., History of Anthropology vol. 8 (Madison: University of Wisconsin Press, 1996), 289–94.

29. Starn, *Ishi's Brain,* 60.

30. Theodora Kroeber, *Ishi, Last of His Tribe* (Berkeley, Calif.: Parnassus, 1964).

31. Robert F. Heizer and Theodora Kroeber, eds., *Ishi, the Last Yahi: A Documentary History* (Berkeley: University of California Press, 1979).

32. Kroeber and Kroeber, eds., *Ishi in Three Centuries;* Starn, *Ishi's Brain.*

33. Theodora Kroeber, Robert F. Heizer, and Albert B. Elsasser, eds., *Drawn from Life: Californian Indians in Pen and Brush* (Socorro, N.M.: Ballena, 1977).

34. Most of the surviving exhibit files relate to the 1962 and 1972 versions. Unfortunately, the files for the post-1972 versions are spotty, with the exception of the Ishi and the Invention of Yahi Culture version. It is very telling, though, that the museum seems to have put records for most versions of the exhibit in one undated folder, clearly implying a sense of timeless truth.

35. AR 1962: 8.

36. James McCord-Stilson in Chico had a collection that included some of the Yahi material taken by the surveyors in 1908. In 1933 McCord-Stilson lent this collection to the State Indian Museum in Sacramento, which purchased it from his heirs in 1935. Richard Burrill, *Ishi in His Second World: The Untold Story of Ishi in Oroville* (Chester, Calif.: Anthro Co., 2004), 263.

37. AR 1966: 15. At the Hearst Museum, 30 October 1965–22 February 1966. As the museum often did, it advertised the Ishi exhibit with two small displays in outdoor cases: an exhibit announcement and a photograph, both presented in November of 1965. The Anthropology Library, in the same building, displayed copies of Theodora Kroeber's publications on Ishi, along with some photographs of Ishi (AR 1966:17).

38. AR 1967: 15. In Palo Alto, 17 October–17 December 1966. This popular exhibition was scheduled to be lent to the Oakland Public Museum in connection with the opening of its new building in late 1968 (AR 1966: 15), but there is no sign that it ever was.

39. Revived Ishi exhibit, 21 April 1972–4 February 1973. This exhibit was accompanied by corridor case displays devoted to *Publications to Which Ishi Contributed* (installed 28 June 1972). And on 4 August 1971, the film *Ishi in Two Worlds* (written, directed, and produced by Richard C. Tompkins, 1967) was shown. Later exhibits were similarly advertised.

40. T. Kroeber, *Ishi in Two Worlds,* deluxe edition, 248.

41. Information on the Ishi exhibits of the 1980s is based primarily on an interview with Hearst Museum education specialist Martha Muhs and registrar Joan Knudsen, 13 October 2003.

42. During its 1986 incarnation (30 May–15 August), the exhibit was given the old title of *Ishi: The Last Survivor of a California Indian Tribe.*

43. Susan Berry's interpretation was documented in a four-page pamphlet produced for the exhibit: *Ishi* (Berkeley: Lowie Museum of Anthropology, University of California, 1990).

44. Although created independently, the versions of Berry and Jacknis were somewhat similar. Both used an excerpt from Ishi's narrative on arrow-making, derived from the linguistic research of Leanne Hinton and her students, and both included Shackley's new research. Most importantly, by 1990, both were reacting against the acontextual romantic fascination with Ishi.

45. Roy Wagner, *The Invention of Culture,* rev. and expanded ed. (Chicago: University of Chicago Press, 1981); Herb Luthin and Leanne Hinton, "The Days of a Life: What Ishi's Stories Can Tell Us about Ishi," in *Ishi in Three Centuries,* ed. Kroeber and Kroeber, 318–54.

46. "Yahi," *Guide to the California Ethnographic Field Photographs, 1900–1960,* http://www.oac.cdlib.org/findaid/ark:/13030/kt4q2nb0qt. Accessed in spring 2006.

47. Ishi enthusiast Richard Burrill has managed to publish additional images, drawn mostly from the local ranching community around Deer Creek; Richard Burrill, *Ishi Rediscovered* (Sacramento: Anthro Co., 2001).

48. Not counting the vanished early newsreels, the principal films on Ishi include two documentaries: *Ishi in Two Worlds* (Richard Tomkins, producer/director, 1967) and *Ishi, the Last Yahi* (Jed Riffe and Pamela Roberts, producers/directors, 1992), and two fiction features: *Ishi, Last of His Tribe* (Jim Summers, director, for NBC, 1978) and *The Last of His Tribe* (Harry Hook, director/producer, for HBO, 1992). See James A. Freeman, "Ishi, the Last American: Review Essay," *Visual Anthropology* 7 (1995): 249–59.

49. Ira Jacknis, "Visualizing Kwakwaka'wakw Tradition: The Films of William Heick, 1951–1963," in "Ethnographic Eyes: In Memory of Douglas L. Cole," *BC Studies,* special issue, ed. Wendy C. Wickwire, nos. 125/126 (2000): 99–146.

50. Samuel A. Barrett, review of *Ishi in Two Worlds,* by Theodora Kroeber, *American Anthropologist* 64 (1962): 391.

51. Albert B. Elsasser to William H. Olson, 7 December 1961, 1962 Ishi exhibit folder, HMA.

52. Among the key original camera rolls were no. 829 (15 September 1962) and no. 831 (16 September 1962), shot at Dog Bar, near Colfax, California; all are preserved in the Hearst Museum archives. The cinematographer was William Heick (cf. Jacknis, "Visualizing Kwakwaka'wakw Tradition").

53. With a motive of pre-contact representation, visual recreation is present through-out the history of ethnographic film and photography, including Edward S. Curtis's work with Native Americans as well as that of pioneer filmmaker Robert F. Flaherty among the Canadian Inuit, Samoans, Irish peasants, and Louisiana Cajuns. Ilisa Barbash and Lucien Taylor, *Cross-Cultural Filmmaking: A Handbook for Making Documentary and Ethnographic Films and Videos* (Berkeley: University of California Press, 1997), 331–34.

54. For example, for his film *Ishi in Two Worlds* (1967) Richard C. Tomkins borrowed 24 of Ishi's projectile points, a plaster face mask, 7 tape recordings of his songs, and 372 neg-atives. Museum technician Grover S. Krantz demonstrated obsidian pressure-flaking (AR 1966: 18).

55. Jed Riffe and Pamela Roberts, producers/directors, *Ishi, the Last Yahi,* 16 mm. film/video, color, 57 minutes (Berkeley: Center for Media and Learning, University of California Extension, 1992).

56. See Ira Jacknis, " 'Ishi, the Last Yahi,' film by Jed Riffe and Pamela Roberts," *Visual Anthropology Review* 10, no. 2 (1994): 84–86; Freeman, "Ishi, the Last American."

57. Johannes Fabian, *Time and the Other: How Anthropology Makes Its Object* (New York: Columbia University Press, 1983).

58. In addition to his artifacts and photographs, Ishi's sound recordings have been pre-served and re-presented. In fact, because of the intense interest in Ishi, his sound record-ings, originally on wax cylinders, have been the most copied and remastered in the Hearst's entire recordings collection (Jacknis, "Yahi Culture in the Wax Museum," 255–58). Ishi's recordings were not made available to the general public until the mid-1970s, when, as part of a sampler series on California Indian music, the museum produced its first collection of Ishi recordings, sold to the public on a 25.5 minute cassette tape. In 1992, a new version was prepared by Bernie Krause, a local environmental sound artist. In conjunction with the Riffe film, Krause digitally remastered and restored twelve songs and narrative excerpts for a 34.5 minute cassette tape. Bernie Krause, ed., *Ishi: The Last Yahi,* Music and World Series, mono WSC 1604 (San Francisco: Wild Sanctuary Communications, 1992).

59. In recent years, at least, the Hearst Museum's reticence in producing Ishi-related products has been purposeful, due to its sensitivity to the charge of exploiting or profiting from Ishi. If the museum were so inclined, it could sell many, many kinds of Ishi products, given the great public interest in his story.

60. Albert B. Elsasser, ed., *The Mill Creek Indians and Ishi: Early Reports by A. L. Kroeber* (Berkeley: Robert H. Lowie Museum, University of California, 1972).

61. Ishi was also the subject of a "teaching kit." These boxes containing books, sample artifacts, photographs, and the like, could be borrowed by elementary school teachers for use in the classroom.

62. Cf. Kroeber and Kroeber, eds., *Ishi in Three Centuries;* Starn, *Ishi's Brain.*

63. Ira Jacknis, "A Collection of Collections: The Phoebe A. Hearst Museum of Anthropology, UC Berkeley, 1901–2001," manuscript, forthcoming in *Strange Bedfellows: Anthropology in University Museums, Institutes, and Departments,* ed. Donald McVicker, Mary Frech McVicker, and Elin Danien.

64. Malcolm Margolin, ed., *News from Native California* (Berkeley, Calif.: Heyday Books, 1987–).

65. Cf. William W. Fitzhugh, "Ambassadors in Sealskins: Exhibiting Eskimos at the Smithsonian," in *Exhibiting Dilemmas: Issues of Representation at the Smithsonian,* ed. Amy Henderson and Adrienne L. Kaeppler (Washington, D.C.: Smithsonian Institution Press, 1997), 206–45; Ira Jacknis, " 'A Magic Place': The Northwest Coast Indian Hall at the American Museum of Natural History," in *Coming Ashore: Northwest Coast Ethnology, Past and Present,* ed. Marie Mauzé, Michael E. Harkin, and Sergei Kan (Lincoln: University of Nebraska Press, 2004), 221–50.

66. Buckley, "The Little History of Pitiful Events," 293; Starn, *Ishi's Brain,* 70.

67. Victor Golla, "Ishi's Language," in *Ishi in Three Centuries,* ed. Kroeber and Kroeber, 208.

68. Stuart Speaker, "Repatriating the Remains of Ishi: Smithsonian Institution Report and Recommendation," in *Ishi in Three Centuries,* ed. Kroeber and Kroeber, 73–86.

69. Franz Boas, "The Occurrence of Similar Inventions in Areas Widely Apart," *Science* 9 (1887): 485–86. Reprinted in *The Shaping of American Anthropology, 1883–1911: A Franz Boas Reader,* ed. George W. Stocking, Jr. (Chicago: University of Chicago Press, 1974), 63.

70. Cf. Burrill, *Ishi Rediscovered.*

71. There were other Ishi-related objects that were formerly in the museum. In her book (*Ishi in Two Worlds,* deluxe edition, 102–104), Theodora Kroeber indicates that the museum still owned two baskets (collected by Frank D. Norvell in 1885) and one bag containing an arrow-making outfit (collected by Darwin B. Lyon in 1889). While these items had been deposited in the museum in September of 1914 (acc. 490) by Lyon, they were never catalogued and were returned to the lender in October 1939. All are now in the Kelly-Griggs House Museum, Red Bluff, California (Burrill, *Ishi Rediscovered,* 31–32).

72. Shackley, "Stone Tool Technology"; Burrill, *Ishi Rediscovered;* Jacknis, "Yahi Culture in the Wax Museum."

73. Franz Boas, "Some Principles of Museum Administration," *Science* 25 (1907): 921–33.

74. Edward M. Bruner, "Ethnography as Narrative," in *The Anthropology of Experience,* ed. Victor W. Turner and Edward M. Bruner (Urbana: University of Illinois Press, 1986), 139–55.

# National Museums and
# Other Cultures in Modern Japan

ANGUS LOCKYER

The Tokyo National Museum (Tokyo Kokuritsu Hakubutsukan; hereafter
Tōhaku) sits in a recessed position of prominence at the northernmost end
of Ueno Park, the nerve center of Japanese national culture. Passing
Maekawa Kunio's Tokyo Metropolitan Festival Hall, Le Corbusier's National
Museum of Western Art, and the National Science Museum on the right, and
Maekawa's largely subterranean Tokyo Metropolitan Art Museum on the
left, one comes upon a sprawling complex of five oddly contrasting build-
ings, which together make up Tōhaku. Josiah Conder's original main build-
ing, of 1882, was destroyed in the Great Kanto Earthquake of 1923, but the
French-influenced Hyōkeikan still stands to the left of the main courtyard. It
was built in the first decade of the century by Conder's student Katayama
Tōkuma in honor of the wedding of the crown prince, although it is not now
used for exhibition. The Honkan, the "new" main building at the top of the
main courtyard, by Watanabe Jin, embodies the stylistic schizophrenia of the
early 1930s. The "oriental" tiled roofs sit awkwardly on top of a heavy, largely
unadorned façade, and for much of its life the building has been criticized for
the poor light in which it shows its numerous holdings of objects officially
designated as National Treasures and Important Cultural Properties. To its

right, Taniguchi Yoshirō's 1968 Tōyōkan is a more convincing marriage of international modernism with the Japanese past, displaying the East Asian art and antiquities of which the main building's Japanese exhibits are to be seen as the culmination. Japanese archeology, the local ground for the latter, from the Paleolithic through the eighteenth century, is housed on the first floor of the Heiseikan special exhibition hall, built in 1993 to commemorate the wedding of a later crown prince. Finally, in 1999, thirty years after his father's commission, Taniguchi Yoshio completed an extraordinary new building behind the Hyōkeikan to house the seventh- and eighth-century treasures from the Hōryūji temple near Nara which by most accounts constitute the oldest collection in Japan, an aesthetic quintessence that establishes arche for and gives identity to the remainder of the Tōhaku collection.[1]

Together with its counterparts in Kyoto and Nara, Tokyo's predecessors as capitals of the archipelago, Tōhaku is a convincing home for the national patrimony, storing and displaying the cream of the Japanese artistic crop, together with the domestic and regional stock from which it emerged. It stands confidently alongside the national museums of other cultures, which stockpile the cultural capital with which the modern state can invest its claims of cosmopolitan significance and national distinction. Unlike that of its Euro-American counterparts, however, and as the above description may suggest, Tōhaku's assurance has been hard-won. The architectural miscellany gives some sense of the labor that has been required to establish the museum's own credentials and the awkward authority of the tale it tells about the Japanese past.

This paper tries to specify the nature of this awkwardness by comparing Tōhaku to the two other Japanese national museums that deal in culture: the National Museum of Japanese History (Kokuritsu Rekishi Minzoku Hakubutsukan, more accurately translated as the National Museum of History and Folk, hereafter Rekihaku); and the National Museum of Ethnology (Kokuritsu Minzokugaku Hakubutsukan, hereafter Minpaku). All three are in the culture business: collecting, storing, and exhibiting artifacts (rather than specimens), and thereby producing a particular place for and representation of Japan within the story they tell about the past. This work also implies the regulation of difference, both within the nation as it is put on display, and between it and the others against which it is compared.

In what follows I sketch briefly the reasons why the three museums

made the choices they did in exhibiting their permanent collections, and the consequences of these choices for their representation of both Japan and other cultures. The model at Tōhaku and Rekihaku has been historical, following the modern museology of the West, which famously subordinates space to time, reads difference as evolution, divorces art and artifact, and thereby finally complements the imperial self with a colonial other.[2] In the Japanese context, I would argue, the work has carried less conviction, albeit with no less problematic implications. At Tōhaku, Japanese art has been removed from the contexts that animated it and entombed as national treasure in an imperial mausoleum. Minpaku downplays the importance of authenticity and advocates comparison between cultures, but insists nonetheless that the latter should be understood in isolation, as discrete, organic, and largely ahistorical entities. Rekihaku has done more to acknowledge the extent to which the Japanese past has changed over time, often as a result of continental exchange and domestic multiplicity, but continues to rehearse an irreducible essence of the Japanese folk. In all cases Japanese uniqueness is avowed, but in none is there any convincing way of bringing the story into the present.

Space does not permit a detailed anatomy of the museum collections as they exist today, nor a patient genealogy of the evolution through which they have reached this point. Instead, I will suggest why the permanent collection of each museum takes the form that it does and the consequences of that form for the objects processed thereby, highlighting the limitations imposed by official mandates and adopted models, and enabling comparison between the Japanese case and other examples. Given this presentist bias, it is also important to note how the institutions have begun to provide a space within which their own practice can be interrogated and a new museology might emerge. Various such initiatives have been apparent in recent years. I end the paper with a 1997 special exhibition at Minpaku which emphasized the extent to which the "traditional" cultures on display in the main galleries were themselves the products of particular moments of cultural exchange. Rather than an imperial narrative that reaffirms through distancing the distinction of the modern nation, it suggested the gradual emergence of an alternative, self-referential exercise that triangulates a contingent national identity in terms of its looking at, and being looked at by, other cultures.

## The Birth of the Museum

When Japanese observers first went to the West in the 1860s, they needed new words with which to describe the museums, exhibitions, and other institutions of visual culture that were so numerous in Europe and America. This was not because public display was unknown during the Tokugawa, or Edo, period (1600–1868).[3] The commercialization and urbanization of early modern Japan gave rise to a variety of venues wherein culture and industry were put on display, affording a claim of native precedents for later practices of exhibition.[4] There were obvious distinctions, however, between these indigenous practices and those of the foreign institutions. Not only were the objects on display radically different from those in Japan: the iron and steam of modern industry was immediately evident as the source of Euro-American wealth and power; oil paint and figurative sculpture suggested ways of showing and seeing that would have radical consequences for artistic practice in Japan. But the institutions themselves were unprecedented. The vast scale and universal pretensions of international exhibitions dwarfed the familiar fairs of Edo, Nagoya, and the other cities of Tokugawa Japan. Similarly, the permanence, comprehensiveness, and public nature of the museums betokened something new.

The word invented to describe the latter novelty was *hakubutsukan,* literally "hall of diverse objects." It first appeared in 1860, to describe the patent office in Washington, D.C., in the diary of the translator for a mission dispatched by the Tokugawa government to ratify the commercial treaties between Japan and the United States.[5] Subsequent missions adopted the same designation for all kinds of museums, a usage which was standardized in 1866 with the publication of the encyclopedic *Seiyō Jijō* (Conditions in the West) by Fukuzawa Yūkichi, who thereby cemented both his own reputation and the place of museums among the categorically Western things to which Japan might aspire.[6] Following the overthrow of the Tokugawa shogunate in 1868, the new Meiji government too was quick to see the potential of public exhibition.

As the model of the patent office might suggest, however, art was not immediately uppermost in the newfound enthusiasm for museums. Tōhaku today dates its birth to an exhibition in 1872 at Yushima Seidō, a Confucian shrine become educational secretariat, but this was intentionally a promiscuous

jumble of old and new, natural and man-made, more similar to the earlier product fairs than to a modern museum. Early museum policy combined personnel, principles, and practices from diverse Edo-period precursors, with conflicting preferences for a variety of foreign models.[7] Diversity and predilection were quickly subordinated, however, to the more pressing imperatives of industrial promotion, as advocated by Sano Tsunetami, who had used his earlier experience in building a modern navy for his domain as a springboard into the new government.[8]

For Sano, exhibitions and museums had a central part to play in the national pursuit of wealth and power.[9] Like Tanaka and Machida, although in a different delegation, he had visited Europe in 1867 to attend the Paris Exposition Universelle, but the lessons he drew from the experience were somewhat different. His model was not botanical or Bloomsbury, but rather the work of industry visible at the then South Kensington Museum, today's Victoria and Albert. With this and the 1873 Vienna Welt-Ausstellung in mind, he became a fierce advocate for the transformative potential of exhibition in the drive to industrialize. At home, by "training the eye" (*ganmoku no kyō*) of an as yet unenlightened populace, industrial exhibitions and their permanent cousins would encourage the improvement of native industry and thereby promote a stream of export goods. Exhibited abroad, such goods could help correct a yawning balance-of-payments deficit.[10] Sano's vision was rapidly adopted by his boss, Ōkubo Toshimichi, ascendant in the 1870s and then busily building his Home Ministry into the prime mover in industrial promotion.[11] In 1873, the nascent museum was placed under the jurisdiction of the secretariat for the Vienna exhibition and moved to Uchiyamashita-chō, close to the present-day Imperial Hotel. In 1875, the secretariat itself was wound down and the museum transferred to the Home Ministry. The early phase of exhibition policy culminated with the first Domestic Industrial Exhibition in 1877 in Ueno Park, which was followed by a new museum building on the same site, completed in time for the second Domestic Industrial Exhibition in 1881.[12]

It was only gradually that Tōhaku as we see it today emerged from these earlier preoccupations, through a gradual process of both ideological and institutional differentiation. The first step was the transfer of the museum into the jurisdiction of the Ministry of Agriculture and Commerce in 1880, soon followed by its move to Ueno in March 1882. The transfer and the move

coincided with the beginning of a reconsideration of, if not a backlash against, what was now seen as the earlier indiscriminate welcome afforded to Western civilization and enlightenment, in combination with a reevaluation of things Japanese.[13] For the museum, this meant a turn away from industrial promotion and toward cultural preservation. The shift gained institutional direction through the appointment as director of Kuki Ryūichi, who had earlier earned his civilizational spurs under the tutelage of Fukuzawa. Its intellectual justification came via Kuki's close association with Ernest Fenollosa, recently arrived from Massachusetts to teach political economy and philosophy at the Imperial University, as well as his acolyte Okakura Kakuzō. Together Fenollosa and Okakura were beginning their advocacy (and acquisition) of what they identified as Japanese tradition, which they would soon turn to highly profitable account back in Boston.[14]

Although its new ministerial overlord was the heir of Ōkubo's insistence on industry, already by 1884 the museum's four main priorities were governed by culture: to preserve antiquities (aided by its right of first refusal on any temple or shrine dispositions); to encourage the progress of arts unique to Japan; to collect objects not yet represented in its collections; and to promote exchanges of objects with foreign institutions.[15] The trend was reinforced by the ongoing creation of a splendid Japanese monarchy, intended as a counterweight to the popular insurgence and constitution-making that marked the early 1880s, as well as an equivalent to the royal families and national traditions that buttressed contemporary European states and their burgeoning empires.[16] The transfer of the museum to the jurisdiction of the Imperial Household Ministry in 1886 and its renaming as the Imperial Museum (Teikoku Hakubutsukan) in 1889 effectively constituted the various objects on display as a single art lineage, identifying the cultural diversity therein as a national patrimony with which to buttress the monarchy's claims of unbroken continuity and equality on the international stage.[17]

The first stage of this redefinition culminated in 1900, with a further renaming of the institution as the Imperial Household Museum and the publication, in French, of the first history of Japanese art, as a catalogue to accompany Japan's participation in that year's Paris Exposition Universelle. The catalogue was the work of Okakura and Kuki, with the assistance of the museum staff. It built on Okakura's development over the previous decade of a periodization of Japanese art. Its canon was incarnated in the form of

"national treasures" whose identification and research, enabled by a Diet law of 1897, was now the museum's priority.[18] The *Histoire de l'art du Japon* was translated into Japanese in 1901, although it took another two decades before its periodization was realized in the galleries, replacing the previous displays by genre and displacing Tōhaku's lingering pretensions to being a universal survey museum. The last link with natural history was also finally broken in the 1920s, when the destruction of all the buildings except the Hyōkeikan in the Great Kanto Earthquake provided the opportunity for both the transfer of the zoological, botanical, and mineralogical specimens to what is now the National Museum of Science and the construction of today's "new" main building.

## The Problem with Japanese Art

What emerged from this process, however, was a very particular story of Japanese art, embodied in a museum very different from the institutions with which it might be compared. Tony Bennett has noted that, in the European context, it was possible for national museums to adopt wholesale the iconographic programs of earlier royal and aristocratic collections.[19] Given the Japanese comparison, it is possible to broaden the claim about the various elements that produced a space of representation wherein a viewer might identify with the forces of civilization. These elements included the perceived evolution of pictorial and sculptural media toward an ever more realistic depiction of the world; religious, historical, portrait, and landscape genres delineating the space and time in which, and the actors through whom, a providential destiny had been realized; and the massing of such objects in galleries, reiterating and rendering permanent their lessons. The forces of civilization thus presented, of course, were inflected through the rendering of history as a national narrative. Combined with its provision of a space of emulation, wherein hypothetically universal access afforded the possibility of social mingling and aspiration, and of regulation, whereby the bodily experience of being in the museum required the viewer to measure himself or herself against the social and aesthetic models on display, the institution as a whole could function as an instrument of liberal governance, producing a voluntarily self-regulating citizenry that would be willing to put itself on the side of power.[20]

In late-nineteenth-century Japan, however, the iconographic program itself—together with supporting media, genres, and display practice—was missing. The priority was not the production of a liberal subject but rather the invention of a national aesthetic, through which the new state might acquire historical integrity and which might therefore support the other institutional and ideological creations underwriting the state's claim to a putative equality with the West.[21] "Japanese art history," therefore, as Mimi Yiengpruksawan has observed, "developed as a function of the Japanese state."[22] Okakura was central to this development, identifying the particular genius that enabled Japan both to represent Asia as quintessence (or museum) and to mark itself apart, capable of adaptation where India and China no longer were.[23] Periodization worked "to integrate stylistic and aesthetic evolution with historical development," assuming "a continuous history held in common by all cultural producers from ancient times through the present." The whole was anchored by its association with the unbroken imperial line, in whose possession a number of representative masterpieces could be found.[24] Translated into the Imperial Household Museum, the resulting history of art was realized as a series of galleries, identified by periods whose name was taken from the ruling house (some of them military rather than imperial) or its capital city.

None of this, however, had much to do with the previous practice of Japanese art. It is a commonplace that museums remove objects from the contexts within which they have been produced and consumed. In the Japanese case, however, the rupture was particularly stark. Aesthetic contemplation was hardly unknown in pre-modern Japan, but fine art as a category introduced novel distinctions, requiring a divorce between labor and appreciation.[25] Older identifications had emphasized the mastery of material, tools, and practice required to participate in a particular activity: ink and brush, wood and chisel, clay, metal, ivory, tea. Fine art, on the other hand, prompted the search for objects that could meet the representational challenge posed by European painting and sculpture, and required a divorce from other media that were gradually relegated to various categories of craft.[26] The latter might well suffice to satisfy early export demand, but would soon be consigned to the indigenous pre-history of an industrial present; fine art alone could guarantee the authenticity, distinction, and therefore endurance of Japanese tradition. Until recently, the split was still visible in the main building at Tōhaku, where national time unfolded from Asuka through modern

on the second floor, largely in terms of sculpture and painting, over the applied and decorative arts on the first floor below.

The break was even more startling in terms of the ways in which the museum proposed that objects now be seen. To generalize across the range of situations in which pre-Meiji Japanese "art" was acquired, used, and appreciated is quixotic at best, but some broad characterizations and preliminary distinctions are possible. At the most general level, an object was governed by considerations of context and occasion that militated against any easy translatability or permanent display. Religious artifacts, which formed the large part of the early Tōhaku collection, did not denote an invariant truth, authorized by a single godhead, but called on a manifold unseen world, anchored and choreographed through the specificity of local practice.[27] Spiritual power was frequently mediated through indigenous deities with links to the immediate environment.[28] When this was not the case, Buddhist icons did their work through configuration and siting that turned universal potential to particular ends. Temple guardians and other visible markers might indicate a transition into sacred space, but access was often regulated, visibility governed by considerations of hierarchy and calendar: some icons on permanent, but often restricted, recessed, and therefore indistinct display; some unveiled annually or even more occasionally; and the most potent never revealed. The forced separation of Shinto and Buddhism following the events of 1868 and the resulting wave of destruction visited on Buddhist artifacts enabled the classification of distinct religious traditions, prompted the cataloguing and conservation of what could now be seen as an artistic heritage under threat, and gives some indication of the temporal ruptures necessary in order to bring Tōhaku into being.[29] The insistence of Okakura and Fennollosa on seeing the Guze Kannon, until then the hidden central icon of Hōryūji temple and subsequently the guardian spirit for Okakura's identification of Japanese tradition, reveals the curatorial violation required to overcome spatial distinctions, to secure an artifact for the museum, and thereby to traduce the irreducible *genius* of a singular *locus* as the representative icon of a national tradition.[30]

A similar logic, diversity, and reticence were evident in the networks of commission, use, and exchange governing more secular objects. Here the multiplicity of contexts, practices, and artifacts refuses a full accounting. Given their status and importance in defining the art to which both Okakura and

Tōhaku were dedicated, however, it is useful to note that graphic media were often designed and deployed in the service of allusion rather than representation, conjuring associations rather than identifying presence, and displayed as part of an environment in which they had no necessary priority, or even independent status.[31] A hand scroll might narrate the key scenes from a religious life or a classical tale, but would likely interleave image and text, assuming the dense layers of reference that informed both and inviting solitary or companionable un-rolling and raveling rather than static contemplation and general access. A hanging scroll might depict mountains and water, but the landscape might well be Chinese if not imagined, and the scroll itself might be displayed only occasionally, subject to considerations of season, company, and mood, as well as the other objects with which, from its alcove, it was to set the scene.[32] It took somewhat longer for such artifacts to enter the galleries, thereby materializing the full range of Okakura's canon, and their transfer hardly required the salvage operation necessary for religious icons, but their conversion to the cause of representation, to establish both parity with and distinction from European models, required a similar dislocation from existing site and practice.

These initial attempts to identify, collect, and display Japanese art of course left vast numbers of Japanese artifacts unaccounted for, and therefore fertile fields for subsequent intellectuals and collectors to harvest. Wealthy industrialists around the turn of the century began to rediscover tea as an occasion for the elaboration of corporate networks and social status, assembling collections and holding salons wherein they could afford to overcome some of the divisions between fine and applied arts, observer and object that the museum had established, and objects might thereby take on a life unavailable within its walls and cases.[33] In the 1910s and '20s Yanagi Muneyoshi, the leading intellectual light of what would become the *mingei* (folkcraft) movement, identified the pre-industrial everyday lives of commoners and the objects produced for them by unknown craftsmen as the endangered source for an alternative national aesthetic.[34] In both cases, the discoveries subsequently spawned their own institutions, in private art museums and folkcraft museums throughout the archipelago, but over time the aesthetics and objects also made their way into the national collections, overlaying though never restructuring the foundational chrono- and typo-logies. Perhaps the most jarring such episode was the urgent embrace of the Japanese sword immediately following

the Asia-Pacific War in order to save it from the demilitarizing clutches of the Occupation, and its subsequent requisite transfiguration from martial signifier and family heirloom to aesthetic object and national heritage.[35]

Even as collection and display evolved, therefore, objects continued to be incorporated into collections by being detached from historical moment and local context and then classified according to the existing schema. At the most general level, museumification has produced the twin dislocations of Japanese art from its continental context and modern Japan from its own past. For the first, it is enough to underscore the extent to which the discoveries of Japanese art in the late nineteenth and early twentieth centuries were premised on the misrecognition of regional exchange as a national past. The ceramics that formed the bulk of the European export trade during the early modern period, which excited official encouragement and Western Japonisme during the late nineteenth century, and from which Okakura and his associates therefore distinguished Japanese fine art, were the product in the most recent instance of the dragooned importation of Korean ceramic artists during Toyotomi Hideyoshi's doomed invasions of the peninsula in the late sixteenth century. The Hōryūji sculpture, on which Okakura seized as the founding moment of a distinctive Japanese aesthetic and which therefore enabled the possibility of a national history, was also, most likely, Korean.[36] The unknown craft, which Yanagi identified as the enduring soul of the Japanese people against the finer pretensions of Japanese art, could still be seen most clearly in Japan's colonial peripheries.[37] (In this, Yanagi was replaying the preference of Sen no Rikyū for Korean Ido rice bowls as the favored utensil for what became formalized as the tea ceremony.) Tōhaku had and has space for Asian others, as aesthetic predecessors in the national galleries devoted to Korea and China, and/or archaeo-ethnological others as empire expanded.[38] But the discovery and display of Japanese art has made it hard for self and others to occupy the same historical time or gallery space.

The narrative institutionalized at Tōhaku, moreover, has had the effect of divorcing Japan's past from its present. The institutional premises of territorial integrity and historical continuity are at odds with the wholesale transformation of artistic practice that followed the events of the middle of the nineteenth century: modern Japanese art had to wait until the 1950s for its own national museum.[39] The institutional divorce of modern art from its

predecessors is of course a global, rather than uniquely Japanese, phenomenon, and it is beyond the scope of this paper to explore the evolution of modern artistic practice in Japan, but the extent to which Tōhaku fails to provide a history within which modern art could take its place raises questions about its status as the authority on the Japanese past.

## Civilization, Comparatively

The question of how to link past to present is a persistent problem also at the National Museum of Ethnology (Minpaku) and the National Museum of Japanese History (Rekihaku), both of which came into being in the wake of the economic growth and surplus of the 1950s and '60s. As post-war institutions, both make a conscious break with pre-war narratives of national history and culture, shifting the emphasis from imperial continuity and elite representation to local contexts and commoner lives. Repudiating the classification and chronology embedded in the galleries of Tōhaku has enabled an exploration of the diversity within the Japanese past and some acknowledgment of the extent to which that past is itself the artifact of a larger regional history. At the same time, in both museums the pre-modern past provides the authentic ground for Japanese people and culture, against which modern experience can only be deviant and fragmentary.

Minpaku today traces its own history back to 1935, when Shibusawa Eizō and others began planning an ethnology museum. These plans came to nothing, however, and the official history begins in earnest in 1964, when five scholarly organizations joined to petition the Ministry of Education for a national ethnological research museum.[40] The driving force behind the museum, however, was Umesao Tadao, an ecological scientist turned ethnographer who in 1957 had emerged as a public intellectual with a pioneering article, "Introduction to an Ecological View of Civilization," based on ethnological fieldwork in Central and South Asia.[41] By the mid-1960s Umesao was building on this initial statement to develop a comparative theory of civilization, and therefore a new understanding of Japan's place in world history, while simultaneously becoming one of the leading commentators on the contemporary transformation from industrial to information society (jōhō shakai), as well as the possible shapes of society to come. In the latter role, he was also one of a group of five intellectuals in the Kansai area (Kyoto, Osaka,

and Kobe) who promoted and helped plan the Osaka Expo (World's Fair) of 1970, which would explore and promote questions about contemporary developments. Umesao himself saw the Expo site as the ideal place for a museum of ethnology, which might materialize his understanding of civilization and thereby Japan's distinctiveness. Umesao was the first director-general of the museum, serving from its foundation in 1974 through its opening in 1977 to his formal retirement in 1993, and his vision of Japan in the world frames the permanent exhibition at Minpaku to this day.[42]

Umesao understands civilization as a complex formed by human beings, their material artifacts, institutions, and culture, which is determined in the first instance by the relationship between communities and their environment. Within the old world, he sees a fundamental distinction between the patterns governing the development of the civilizations of the continental empires (China, India, the Islamic world, and Russia) on the one hand and those of Japan and western Europe on the other. The former were exposed to waves of destruction emanating out of the dry region that cuts diagonally through Asia, Africa, and Europe, and thus their development was driven externally, making it impossible to "mature sufficiently to allow mounting internal contradictions to work themselves out through revolutionary change."[43] The latter, by contrast, were blessed by both a temperate climate and sufficient distance from the disruption and were therefore able to develop in accordance with their own internal logic, passing through the stages, such as feudalism, necessary to reach the capitalist present. Japan, therefore, was fundamentally different from its continental neighbors. While it had inherited "much from Chinese civilization . . . these components . . . were not the ones that formed the foundation of our modernization. Rather it was the special ecological environment that became the basis for the development of a civilization entirely different from the classical continental empires."[44]

This model of discrete civilizations forms the basic premise for the permanent exhibit at Minpaku, a round-the-world tour that begins in Oceania before moving through the Americas, Europe, and Africa, and then West, Southeast, Central and North, and East Asia, to culminate in Japan. On the ground, the geographical circuit downplays Umesao's more polemical claims about the similarities between Japan and western Europe. Rather than the implicit hierarchy of Tōhaku, the museum makes an explicit attempt to treat civilizations equally, enabling a comparative perspective between artifacts.

The inclusion of the developed world and, more pointedly, Japan itself makes a striking difference from most other ethnological collections.[45] The same leveling impulse extends to the artifacts themselves. From the start, Umesao was insistent on an omnivorous collection policy, arguing that in order to present a thorough account of everyday life, objects should be representative rather than quintessential, "trash" rather than "treasures."[46] The exhibits for each region thus combine rural and urban, old and new, rather than privileging a particular way of life as a normative ideal.

Capacious as it is, however, the exhibit as a whole also places severe restrictions on the ways of seeing the artifacts on display. The model allows for variation within a region, grouping similar tools together so that visitors can form an image of the diversity within the whole.[47] But the whole is insisted on, downplaying both exchange across space and change over time in favor of a timeless cultural integrity. Early migration and influence between regions is acknowledged, but ongoing relationships are more difficult to see. The museum's acquisitions are restricted to objects pre-dating the introduction of plastics, but in effect the world on display is pre-industrial. As Yoshida Kenji, one of Minpaku's researchers, has noted:

> the exhibits emphasize the individual, separate nature of regional cultures and their own, unique values, embodying the cultural relativism advocated by cultural anthropology from the beginning of the twentieth century . . . [but also] marked by [its] characteristics and problems. One of the problems of the Minpaku collection is that by looking for characteristics specific to regional cultures, and so tending to collect artifacts used in "traditional" life, until very recently there have been no collections or exhibitions of contemporary objects, which have been created with advancing globalization. Especially in the permanent exhibition, created when Minpaku opened, this results in a portrayal of the cultures of the various peoples of the world as if they were unchanging and static.[48]

Given these premises, recent transformations can only be seen as depredation, the civilizations on display under threat: "The nomadic way of life is slowly dying out because the conditions supporting it have disappeared."[49] In the Japanese case, "many objects associated with traditional . . . lifestyles

have been disappearing in the last few years." The museum insists, however, that they "can still be found on the fringes of contemporary life" and were used "until quite recently . . . on an everyday basis," and that thus with careful discernment "we can appreciate underlying motifs in Japanese culture that are difficult to perceive in modern society."[50] In the absence of a more explicit acknowledgment of how the cultures on display are themselves the product of particular circumstances, the reasons for this difficulty and, more broadly, the relationship between culture and history must remain obscure. As at Tōhaku, although for different reasons, there is no way in the permanent collection of bringing the story up to the present.

## Fragmented Folk

In comparison to art and ethnology, history took longer to put on display. Rekihaku finally opened in 1983, thirty years after an initial petition by three of the five organizations that would later petition for a separate ethnology museum. It was only in 1966, however, that the cabinet accepted a proposal to establish a museum of history and ethnology, as one of a number of projects commemorating the one hundredth anniversary of the Meiji Ishin. Even then, the project required over fifteen years of planning, a large part of which was taken up by a debate over the basic plan for the permanent exhibits. The first plan had emphasized a chronological exposition of Japanese history, unfolding the story of the nation through the ages and complementing it with sub-exhibits on particular themes, ethnological exhibits of traditional lifeways, archaeological displays, and outdoor exhibits of traditional housing and the like. By the end of 1978, however, this plan had given way to a rather different model. Rather than a textbook narrative, the museum would stage a series of themes, chosen from subjects of current research and ongoing debate among historians, which would enable visitors to understand the multiple perspectives available on the past and the open-ended nature of our relationship to it.

Throughout the museum, the emphasis was to be on *minshū seikatsu-shi* (literally, the history of the everyday life of the people), which would both be easier to display through objects than political or intellectual history and presumably have greater appeal to the public. The exposition of these themes was to be explicitly interdisciplinary, not only incorporating the findings but also respecting the distinct methodologies of archaeology, ethnology, and

other disciplines. The choice and development of themes was allocated to project teams, to include both museum staff and external specialists. The first themes to emerge from this process included early state formation, the question of Japanese feudalism, and the like, but also laid heavy emphasis on commoner life and culture, for example counterposing peasant movements to the *daimyō* (military overlords) who are the usual staple of fifteenth- and sixteenth-century political history.[51]

The choice of approach and themes needs to be understood in the context of broader developments within Japanese history at the time. Both conservative and progressive historians in the post-war period agreed on the need to look beyond the "dark valley" of the 1930s and excavate a viable national past on which to build a reformed present. For both, the Meiji period, following the arrival of the West in 1853 and the fall of the Tokugawa shogunate in 1868, was the starting-point for such a recovery. (Hence the one hundredth anniversary of the inauguration of the modern state was not the incidental occasion but the genetic endowment of the museum.) But they differed on its significance. While conservative commentators extolled Meiji for its achievements of economic modernization and national autonomy (downplaying for the most part the colonial empire to which these led), one group of progressive historians sought in Meiji the last gasp of popular resistance to the depredations of industrial capitalism and the impositions of an authoritarian state.[52] These were the chroniclers of *minshūshi* (people's history), led by Irokawa Daikichi.[53]

Following the lead of Yanagita Kunio and other ethnologists in the early twentieth century, the *minshūshi* writers sought traces of what they believed to be an authentic, but now vanished, Japan in the communal life of pre-modern communities and the sensibility and self-expression to which these gave rise. For Irokawa, this commoner voice had found its last expression in the freedom and popular rights movement (*jiyū minken undō*) of the late 1870s and early 1880s, which had demanded a new constitution based on popular sovereignty and universal suffrage. In this view, the suppression of this movement by the Meiji state had broken Japan's connection with a living past and thereby enabled the deviation toward authoritarianism, empire, and finally war. And the recovery of these voices, promising the restoration of an indigenous democratic tradition, found expression at Rekihaku. Irokawa served as the main academic consultant for the museum's initial plans, and

the assumptions of *minshūshi* continue to provide the broad parameters for the permanent exhibits.

This vision of history has enabled a more complex narrative of the Japanese past than that visible at Tōhaku. Where the latter insists on the unilinear unfolding of an original endowment, Rekihaku proposes a polyphonal, often conflictual vision. Where art tends to divide by hierarchy and classification, separating devotional icon from vernacular screen from military uniform despite their common origins in the same historical time, space, and perhaps also class, history would rather establish links, suggesting relationships between apparently discrete material objects. The basic exhibition policy at Rekihaku, moreover, has allowed the emphasis within this dialectical view of the past to shift, a potential that has been realized in the years since the museum was established. Irokawa's work on people's history has been supplemented by others, perhaps most noticeably Amino Yoshihiko, whose account of the non-agrarian population of medieval Japan has broadened into a wholesale revision of the standard narratives of Japanese history; there is now a broad recognition of the ways in which Japan as a nation is itself an artifact of the modern state system and in which the pre-modern archipelago was defined through its maritime interactions with the continent.[54]

The permanent exhibition today repeatedly connects turning points within the national past to broader regional influences. Thus the arrival of rice from China nearly 2,000 years ago prompted a transformation toward more complex agricultural communities and the emergence of the social hierarchies and religious practices that preceded the formation of the early state. That Yamato State in turn depended heavily on continental imports, and the intermediation of maritime communities between Japan and Korea, in establishing its own hegemony. In the fourteenth and fifteenth centuries, Chinese imports of technology and printing, among many other goods, enabled a revolution in architectural practice and intellectual life, a trade that continued throughout the Edo period, when Japan used to be thought of as "closed." Similarly, the most recent special exhibition, The Interaction in Medieval East Asian Sea, insists that "since ancient times, the seas of Asia have linked one region with another and, as sites for the mutual exchange of people, objects, culture and technology, they became a cradle of history, serving as a driving force for the reforms that brought new eras." The point is illustrated with screens depicting the various activities associated with this trade, as well as the ceramics, some

of them salvaged from wrecks, that formed the bulk of the trade and provided the requisite materials for the emerging tea culture. The exhibition suggests that the Portuguese and other Europeans arrived in the sixteenth century as initially marginal figures in what was already a thriving regional market, and it was only after this encounter that interchanges "gradually became confined to a national framework." The somewhat pointed moral of the story is therefore that "the maritime regions of East Asia during the Middle Ages . . . together formed a world that was not connected by the usual confluence of national borders and countries."[55]

At the same time, the arguments and assumptions that have enabled the open-ended exploration of history beyond the nation in the pre-modern world have also stymied a convincing engagement with the connections between it and the modern period, and the dynamics of the latter. The first three galleries of the permanent exhibition, devoted to the pre-modern, culminate in a fourth exploring the world of Japanese folk custom and belief, an acknowledgment of the influence of ethnology driving both the initial calls for the museum and the premises of people's history itself. But here history comes to a halt. The archipelago is disaggregated into different environments, within which tradition is seen to endure without any exploration of why or how. In the urban landscape, people seek consolation from unspecified "anxieties and conflicts" through religious beliefs and practices that "may seem old-fashioned at first glance . . . but quietly live on," echoing Irokawa's search for local practice that can endure unchanged through modern transformations. Agricultural, mountain, and fishing villages are characterized by enduring symbioses between human community and natural environment without any acknowledgment of how both, and the relationship between them, have been transformed in the recent past through industrialization, depopulation, and environmental degradation, for example.[56] Ethnology here operates as reassurance and prophylactic against the corrosions of time, which must come after cultural authenticity has been established.[57]

In accounting for the modern, however, the insistence by Irokawa and others that the imperatives of industry and empire have distorted the history of people's everyday lives, translates into a fragmented presentation, with agency drained from the archipelago and developments driven by influences from an unspecified elsewhere. The fifth and final gallery opens with the "civilization and enlightenment" of the late nineteenth century, which was

promoted by the government, but also encouraged the commoners in the demand for rights; the installation, however, ignores the way in which the movement was shaped by both state and subjects, rather exploring its effects through the uneven transformation of commoner lives. Industrialization is seen through the eyes of a female employee, the development of Hokkaido is acknowledged to have caused suffering to the Ainu, and the mass culture of the 1920s is juxtaposed to the welfare problems exposed by the Great Kanto Earthquake. There is no exploration of how these transformations are connected, however, nor any mention of how modernization proceeded and modernity was forged through both industry and empire, domestic transformation and colonial advance. Nor, finally, is there any suggestion of what followed the first talkies, how the story might come up to the present. At the National Museum, Japanese history stops with the birth of popular entertainment in the 1920s in Café Ultra, a cabaret in Asakusa, the traditional and modern center of commoner Tokyo.[58]

### Images of Other Cultures

It would be too easy, and misleading, to leave the story there. It should be no surprise to learn that the permanent collections of national museums still bear the traces of their nineteenth- or twentieth-century governing assumptions and that history therefore comes up short. As noteworthy is the extent to which the museums have recently begun to provide space within which to develop a very different understanding of self and other, past and present, as they question the premises of their own operation and formulate the basis of a quite new and different museology. A recent reinstallation in the main building at Tōhaku has begun to overcome the divorce between fine and other arts, to reintroduce ethnographic materials, and to explore the broader social fields within which art history itself emerged. Special exhibitions are complemented at Rekihaku with an active lecture and conference schedule, exploring the politics of displaying both past and present. There are also plans to inaugurate a permanent exhibit on the twentieth century, beginning in 2008. There is no space to explore the full range of initiatives here, but to give some sense of the shifts underway, let me end by introducing the special exhibition held at Minpaku from September 1997 to January 1998 to commemorate the twentieth anniversary of its opening.

The exhibition was a distinctive three-way collaboration between Minpaku, the Setagaya Art Museum (a contemporary art museum in Tokyo, to which the exhibition subsequently transferred), and the British Museum in London. It aimed to place Japan in comparative perspective with Africa and Oceania, and so destabilize the perspective from metropolis outwards (whether Japanese or British), as well as the primordial distinction between high (civilized) art and ethnographic (primitive) object on which the division of labor and various narratives of all the national museums in part rest. The exhibition began with a time tunnel of thirty sets of three photographs, tracing a temporal regression from contemporary rush hours in Kyoto, Fiji, and Ghana to the moment at the turn of the last century when people throughout the world seem to have begun simultaneously to brandish umbrellas. The first room then took up the story by recreating the way in which the three regions were displayed in the British Museum circa 1910, plunging the visitor back into a world of overflowing exhibit cases, minimal labeling, and the catholic collection habits of late Edwardian Britons. Benin bronzes were the property of ethnographic collections but, importantly, Japanese art had already been divorced from arms and armor, endorsing Okakura's work to establish equivalency. The second room reversed the gaze, showing how the three "traditional" cultures had incorporated elements of Western culture into their own cultural practices, whether in Fante battle standards in Ghana, coconut palm copies of elaborate English hats in Polynesia, or frock coats in early Meiji. The third room marked a gradual differentiation between the three cases, noting how the Western way of seeing Africa and Oceania was gradually adopted within Japan, as the latter acquired its own industry and empire. The easy separation of modern self from still primitive other was brought up short, however, in the final room, which emphasized again the simultaneity of and active translation between contemporary cultures. All-in-one kiosks from a Japanese rail station, the London Underground, Accra, and New Guinea underlined the extent to which convenience is a global good. African coffins, New Guinea battle shields, Japanese puri-kura, and contemporary Western art revealed the extent to which any cultural production relies on transgressing the boundaries between self and other, art and ethnography.

One exhibition alone was of course not enough to break down these walls. The exhibition does, however, suggest a way out of the double bind in which history has found itself, in Japan and elsewhere. By exploring, in the

words of its curator, how "the West, Africa and Oceania, and Japan have looked at each other during the modern age" and investigating "the traces left by these intersecting gazes in the form of objects and photographs," the exhibition suggested not only the extent to which these identities have historically been constituted by difference, however much a national history might wish to pretend otherwise, but that collapsing the distinction between art and other objects might be one way to begin writing a new history that allows us to see this.[59] This kind of self-estrangement, through a familiarization with difference, is perhaps work for national museums in the years to come.

## Acknowledgments

Thanks to Yoshida Kenji for an early invitation and ongoing advice, to Dan Sherman for unflagging encouragement and meticulous editing, and to Tim Clark, Sarah Teasley, and Alice Tseng for close reading and excellent suggestions. Following Japanese usage, Japanese names are written with the family name first, followed by the given name: thus Taniguchi Yoshio rather than Yoshio Taniguchi. In the notes, Japanese names are written as they appear in publication.

## NOTES

1. For introductions to Tōhaku, see Ōsumi Akiko, "Tokyo Kokuritsu Hakubutsukan Hyaku-Ni-Jū nen no Rekishi," *Gekkan Bunkazai* 349 (1992): 6–13 (hereafter "Rekishi"); Ōsumi Akiko, "Tokyo National Museum," in *Nihonga, Transcending the Past: Japanese-Style Painting 1868–1968*, ed. Ellen P. Conant (Saint Louis, Mo.: Saint Louis Art Museum, 1995), 90–91; and, of course, the museum's newly redesigned website: Tokyo National Museum, "Museum Map," http://www.tnm.go.jp/en/guide/map/index.html, and "History of the Tokyo National Museum," http://www.tnm.go.jp/en/history/12.html. Both accessed 1 July 2004.

2. The model rests therefore on a division of cultural labor. Art museums have traditionally undertaken a self-description of Western civilization, adumbrating universal truths through an evolutionary account of individual genius. Natural history, ethnology, and other "evolutionary" museums, on the other hand, were charged with the care of those objects deemed to be outside history, the products of unindividuated groups and the domain of synchronic sciences. Between them they could thereby provide a space of representation for the imperial state and of emulation for its national subjects. The two sides of Central Park, metropolitan identity marked off against imperial ethnography, thus neatly reveal the two-sided coin of the modern museological project. Tony Bennett, *The Birth of the Museum: History, Theory, Politics* (London: Routledge, 1995) and *Pasts beyond Memory: Evolution, Museums, Colonialism* (London: Routledge, 2004).

3. The Tokugawa period takes its name from the ruling family of the last of three military governments, or shogunates, that governed Japan from the late twelfth century. Edo, present-day Tokyo, was initially their military headquarters and became the largest city in the world by 1700. The Tokugawa family, government, and period were preceded by the Kamakura (1185–1333), named after the town that was the headquarters for the shogunate headed by the Minamoto house, and the Muromachi (1336–1573), named after a southern part of Kyoto, the emperor's capital, that was the headquarters for the Ashikaga shogunate. Following the fall of the Tokugawa and the revolution that "restored" monarchical rule, modern time was told and the past organized by reign, hence Meiji (1868–1912), Taishō (1912–26), Shōwa (1926–89), and Heisei (1989–present).

4. Collection itself, whether of cultural artifacts or natural history, tended to be a private affair. Nonetheless, temples frequently "unveiled" their treasures to the public at *kaichō,* a useful opportunity to generate income from belief; entrepreneurs exploited the new urban demand for diversion, and often the spaces and crowds afforded by temple and shrine unveilings and festivals, to stage the miraculous and marvelous at *misemono,* literally "showing things"; and natural historians, building on Chinese traditions of medicinal herbology and their own practice of scholarly meetings, broadened their remit at *bussankai* to collect and display products (*bussan*) that might benefit the health not only of individuals but of the body politic. See Peter Kornicki, "Public Display and Changing Values: Early Meiji Exhibitions and Their Precursors," *Monumenta Nipponica* 49, no. 2 (1994): 167–96. For the links between *kaichō* and *misemono,* see Nam-Lin Hur, *Prayer and Play in Late Tokugawa Japan: Asakusa Sensoji and Edo Society* (Cambridge, Mass.: Harvard University Press, 2000). For *misemono,* see Andrew L. Markus, "The Carnival of Edo: *Misemono* Spectacles from Contemporary Accounts," *Harvard Journal of Asiatic Studies* 45, no. 2 (1985): 499–541. For the argument that these can be understood as the precedents for modern practices of exhibition, see Shiina Noritaka, *Zukai Hakurankaishi* (Tokyo: Yūzankaku, 2000), 17–40, and Umesao Tadao, "Keynote Address: The Comparative Study of Collection and Representation," in *Japanese Civilization in the Modern World, XVII, Collection and Representation,* ed. Tadao Umesao, Angus Lockyer, and Kenji Yoshida, Senri Ethnological Studies 54 (Osaka: National Museum of Ethnology, 2001), 1–9.

5. Shiina, *Zukai Hakurankaishi,* 41; Umesao, "Keynote Address," 9.

6. *Fukuzawa Yūkichi Zenshû* (Tokyo: Iwanami Shoten, 1958), vol. 1, 26–27. On Fukuzawa, see Carmen Blacker, *The Japanese Enlightenment: A Study of the Writings of Fukuzawa Yukichi* (Cambridge, UK: Cambridge University Press, 1964).

7. The personnel included Tanaka Yoshio, who had supplemented an early training in herbology and natural history with close observation of the Jardin des Plantes in Paris, as well as Machida Hisanari, who used the example of the British Museum to buttress his advocacy for the historical preservation of religious sites and artifacts, then under attack

in a wave of anti-Buddhist campaigns. For Tanaka, see Angus Lockyer, "Japan at the Exhibition, 1867–1970" (Ph.D. diss., Stanford University, 2000), 79–82, and Murasawa Takeo, *Kindai Nihon o kizuita Tanaka Yoshio to Yoshikado* (Tokyo: Tanaka Yoshio Yoshikado Kenshôkai, 1978).

8. For Sano, see Yoshikawa Ryuko, *Nisseki no Sōshisha Sano Tsunetami* (Tokyo: Yoshikawa Kōbunkan, 2001).

9. In the 1870s, the tasks confronting the still unformed state were often neatly summarized in a series of four-character syllogisms. In order to escape the semi-colonial fate by then overtaking China, Japan would have to become a "rich country, with a strong army" (*fukoku kyōhei*). In order to generate the requisite riches, the government would have to "increase production and promote industry" (*shokusan kōgyō*). And in order to accomplish any of this, the country as a whole would have to embrace what is usually translated as "civilization and enlightenment" (*bunmei kaika*), but which implied the wholesale rejection of the now discredited customs and practices of the past, in favor of opening what in retrospect seemed to have been a closed country to the improving influence of the West.

10. Lockyer, Japan at the Exhibition, 90–95.

11. For Ōkubo, see Lockyer, Japan at the Exhibition, 95–98, and Sasaki Suguru, "Bunmei kaika no seiji shidō: Ōkubo Toshimichi o chūshin ni," in *Bunmei Kaika no Kenkyū*, ed. Hayashiya Tatsusaburō (Tokyo: Iwanami Shoten, 1979), 78–111.

12. Ōsumi, "Rekishi" and "Tokyo National Museum."

13. For the general context here, see Kenneth B. Pyle, *The New Generation in Meiji Japan: Problems of Cultural Identity, 1885–1895* (Stanford: Stanford University Press, 1969).

14. For Kuki, see Tsukasa Ryōichi, *Baron Kuki Ryūichi* (Kobe: Kobe Shinbun Shuppan Sentaa, 2003); for Okakura, see Kakuzo Okakura, *The Ideals of the East: The Spirit of Japanese Art* (Rutland, Vt.: Tuttle, 1970), F. G. Notehelfer, "On Idealism and Realism in the Thought of Okakura Tenshin," *Journal of Japanese Studies* 16, no. 2 (1990): 309–55, and Victoria Weston, *Japanese Painting and National Identity: Okakura Tenshin and his Circle* (Ann Arbor: Centre for Japanese Studies, University of Michigan, 2004); and for Okakura and Fenollosa, see Stefan Tanaka, "Imaging History: Inscribing Belief in the Nation," *Journal of Asian Studies* 53, no. 1 (1994): 24–44, and Karatani Kōjin, "Japan as Museum: Okakura Tenshin and Ernest Fenollosa," in *Japanese Art after 1945: Scream against the Sky,* ed. Alexandra Munroe (New York: Harry N. Abrams, 1996), 33–39.

15. Shiina, *Zukai Hakurankaishi,* 88.

16. Takashi Fujitani, *Splendid Monarchy: Power and Pageantry in Modern Japan* (Berkeley: University of California Press, 1996).

17. Ōsumi, "Rekishi" and "Tokyo National Museum." Thanks to Alice Tseng for clarifying the significance of developments in the 1880s.

18. Mimi Yiengpruksawan, "Japanese Art History 2001: The State and Stakes of the Research," *Art Bulletin* 83, no. 1 (2001): 114.

19. Bennett, *The Birth of the Museum,* 36.

20. Ibid., 24.

21. For the broader project, see among many others Marius B. Jansen and Gilbert Rozman, *Japan in Transition: From Tokugawa to Meiji* (Princeton, N.J.: Princeton University Press, 1986).

22. Yiengpruksawan, "Japanese Art History 2001": 114.

23. For Japan as museum, see Karatani, "Japan as Museum," and Stefan Tanaka, *New Times in Modern Japan* (Princeton, N.J.: Princeton University Press, 2004), 168–92.

24. Yiengpruksawan, "Japanese Art History 2001": 114.

25. Kitazawa Noriaki, *Me no Shinden* (Tokyo: Bijutsu Shuppansha, 1989); Kinoshita Naoyuki, *Bijutsu to iu Misemono: Aburae Chaya no Jidai* (Tokyo: Heibonsha, 1993); and Satō Dōshin, *'Nihon Bijutsu' Tanjō: Kindai Nihon no 'Kotoba' to Senryaku* (Tokyo: Kōdansha, 1996). Thanks to Tim Clark for pointing out that Japanese art did not require the importation of Western concepts in order to exist, but rather that the neologisms encouraged a gradual restructuring, perhaps even a simplifying, of what was already a highly sophisticated aesthetic discourse and practice.

26. Satō Dōshin, *Meiji Kokka to Kindai Bijutsu: Bi no Seijigaku* (Tokyo: Yoshikawa Kōbunkan, 1999).

27. For two examples, see Donald F. McCallum, *Zenkōkji and Its Icon: A Study of Medieval Japanese Religious Art* (Princeton, N.J.: Princeton University Press, 1994), and Mimi Hall Yiengpruksawan, *Hiraizumi: Buddhist Art and Regional Politics in Twelfth-Century Japan* (Cambridge, Mass.: Harvard University Press, 1998).

28. For a recent introduction to the phenomenon, see Mark Teeuwen and Fabio Ramelli, eds., *Buddhas and Kamis in Japan: Honji Suijaku as a Combinatory Paradigm* (London: Routledge, 2003).

29. For the separation and the consequences of its aftermath for Buddhism, see James Ketelaar, *Of Heretics and Martyrs in Meiji Japan: Buddhism and Its Persecution* (Princeton, N.J.: Princeton University Press, 1990); for Shinto, see Helen Hardacre, *Shinto and the State, 1868–1988* (Princeton, N.J.: Princeton University Press, 1989).

30. Tanaka, "Imaging History," 24–25. At the same time, the fragility of many of the artifacts placed some constraints on their mobility. Thanks to Alice Tseng for pointing out that the Imperial Museums in Kyoto and Nara were built in the 1890s in order to alleviate the need to take icons all the way to Tokyo.

31. For the variety of ways in which allusion was mobilized in early modern visual media, see Alfred Haft, "A Study of Mitate in the Edo Period" (Ph.D. diss., SOAS, University of London, 2005).

32. For a short introduction to the moment in the fifteenth century when this aesthetic complex crystallized, see Donald Keene, *Yoshimasa and the Silver Pavilion: The Creation of the Soul of Japan* (New York: Columbia University Press, 2003).

33. Kumakura Isao, "The Tea Ceremony and Collection: The Prehistory of Private Art Museums," in *Japanese Civilization,* ed. Umesao et al.; Christine Guth, *Art, Tea, and Industry: Masuda Takashi and the Mitsui Circle* (Princeton, N.J.: Princeton University Press, 1993).

34. Soetsu Yanagi, *The Unknown Craftsman: A Japanese Insight into Beauty* (Tokyo: Kodansha International, 1972); Lisbeth Kim Brandt, "The Folk-Craft Movement in Early Showa Japan, 1925–1945" (Ph.D. diss., Columbia University, 1996); and Yuko Kikuchi, *Japanese Modernisation and Mingei Theory: Cultural Nationalism and Oriental Orientalism* (London: Routledge, 2004).

35. Kinoshita Naoyuki, "From Weapon to Work of Art: 'Sword Hunts' in Modern Japan," in *Japanese Civilization,* ed. Umesao et al.

36. Tanaka, "Imaging History."

37. Brandt, "Folk-Craft Movement."

38. Ainu and Ryukyuan materials were part of the collection from the 1870s, Taiwanese were added from the 1890s, ancient Korean and Chinese expanded following the First World War, and Micronesian artifacts formed the centerpiece of a Southern Culture Exhibition in the Hyōkeikan in 1942, following the transfer of the permanent exhibition to the new main building. Yoshida Kenji, " 'Tōhaku' and 'Minpaku' within the History of Modern Japanese Civilization: Museum Collections in Modern Japan," in *Japanese Civilization,* ed. Umesao et al.

39. "The History of The National Museum of Modern Art, Tokyo," http://www.momat.go.jp/english/history.html. Accessed 2 July 2004.

40. The organizations were the Folklore Society of Japan, the Japanese Association of Ethnology, the Anthropological Society of Nippon, the Japanese Society of Ethnology (from 2004 the Japanese Society of Cultural Anthropology), and the Japanese Archaeological Association. The first three had also been the petitioners in 1953 for what would eventually become Rekihaku. National Museum of Ethnology, *Survey and Guide 2004–2005,* http://www.minpaku.ac.jp/english/aboutus/2004_all.pdf, 3. Accessed 4 July 2004.

41. Already in 1964, the article had been chosen as one of the eighteen most "influential in shaping Japan's postwar thought" by the *Chūō Kōron,* perhaps the leading public opinion journal, in whose pages it had admittedly first appeared. By 1996, the 1967 book that followed the original article came fourth in a survey of fifty-eight leading intellectuals of the ten best books of any genre published in the twentieth century, ahead of texts by Doi Takeo and Nakane Chie that are much better known in the West. The 1967 book has now been translated into English as *An Ecological View of History: Japanese Civilization in World Context* (Melbourne: Trans Pacific Press, 2003).

42. Umesao's own account of the creation of the museum can be found in a series of interviews, collected as Umesao Tadao, *Minpaku Tanjō* (Tokyo: Chūō Kōronsha, 1978).

43. Umesao, *Ecological View,* 56.

44. Ibid, 166–67. Umesao's development of these ideas began from the question of Japanese modernization, which preoccupied intellectual debate at the time. Unlike the dominant progressive position, however, which he saw as overly preoccupied with the recent wartime past and in thrall to Marxist analysis, he did not assume that modernization had failed, due to differences between Japan and western Europe, but rather that it had succeeded, precisely because of the similarities between his two old-world zones.

45. "All cultures are treated equally by the museum, since our policy is to regard cultural differences as exemplifying the wealth of cultural diversity rather than to judge them in terms of superiority or inferiority." "An Introduction to the Exhibits," in *Guide to the National Museum of Ethnology* (Osaka: National Museum of Ethnology, 1991).

46. Yoshida Kenji, " 'Tōhaku' and 'Minpaku.' "

47. Ibid.

48. Ibid.

49. *Guide to the National Museum of Ethnology,* 153.

50. Ibid., 170.

51. Kokuritsu Rekishi Minzoku Hakubutsukan, *Kokuritsu Rekishi Minzoku Hakubutsukan Jūnen-shi* (Sakura: Kokuritsu Rekishi Minzoku Hakubutsukan, 1991), 127–33. The full list of themes was as follows: in the ancient period, "the appearance of the Japanese people," "the emergence and development of farming," "*kofun* and their society" (ancient tombs, dating from the end of the third to the early sixth century), "the *ritsuryō* state" (the earliest state in the archipelago, from the mid-seventh to the tenth century), and "court culture"; in the medieval period, "east and west Japan," "popular life and culture," "*daimyō* (military overlords) and *ikki* (peasant movements)," and "Japan in the age of exploration"; and in the early modern period, "the Japanese feudal system," "everyday life in village society," "the formation of cities," and "foundations for modernity: the establishment of a popular cultural sphere."

52. For a general overview of post-war historiography, see Carol Gluck, "The Past in the Present," in *Postwar Japan as History,* ed. Andrew Gordon (Berkeley: University of California Press, 1993), 64–95.

53. For introductions to *minshūshi,* see Carol Gluck, "The People in History," *Journal of Asian Studies* 38, no. 1 (Nov. 1978): 25–50, and Takashi Fujitani, "Minshushi as Critique of Orientalist Knowledges, *Positions* 6, no. 2 (Fall 1998): 303–322. Two works by Irokawa have been translated into English: *The Culture of the Meiji Period,* trans. Marius B. Jansen (Princeton, N.J.: Princeton University Press, 1985), dealing with the freedom and popular rights movement and the establishment of the emperor system; and *The Age of Hirohito: In Search of Modern Japan,* trans. Mikiso Hane and John Urda (New York: Free Press, 1995).

54. See Amino Yoshihiko, "Emperor, Rice, and Commoners," in *Multicultural Japan: Palaeolithic to Postmodern,* ed. Donald Denoon, Mark Hudson, Gavan McCormack, and Tessa Morris-Suzuki (Cambridge, UK: Cambridge University Press, 1996), 235–45, and Amino Yoshihiko, "Deconstructing 'Japan,'" *East Asian History* 3 (June 1992): 121–42.

55. National Museum of Japanese History, "Special Exhibition. The Interaction in Medieval East Asian Sea: Maritime Commerce, Ports and Sunken Ships," http://www.rekihaku.ac.jp/e_news/index91/index.html. Accessed 3 July 2004.

56. National Museum of Japanese History, "Gallery 4: The World of Japanese Folk Customs and Beliefs," http://www.rekihaku.ac.jp/e_zyoosetu/no4/index.html. Accessed 3 July 2004.

57. For a parallel case, see Daniel J. Sherman, "'Peoples Ethnographic': Objects, Museums, and the Colonial Inheritance of French Ethnography," *French Historical Studies* 27, no. 3 (2004): 669–703.

58. National Museum of Japanese History, "Gallery 5," http://www.rekihaku.ac.jp/e_zyoosetu/no5/index.html. Accessed 3 July 2004. For a fictional introduction to the Asakusa of the 1920s, see Yasunari Kawabata, *The Scarlet Gang of Asakusa* (Berkeley: University of California Press, 2005). For the area's Tokugawa-period history, see Nam-Lin Hur, *Prayer and Play in Late Tokugawa Japan: Asakusa Sensōji and Edo Society* (Cambridge, Mass.: Harvard University Press, 2000).

59. Kenji Yoshida, "'Images of Other Cultures' in Museums," in *Ibunka e no Manazashi: Dai-Ei Hakubutsukan to Kokuritsu Minzokugaku Hakubutsukan no Korekushon kara,* ed. Kenji Yoshida and John Mack (Tokyo: NHK Saabisu Sentaa, 1997), 42.

# Cultural Difference and Cultural Diversity
## *The Case of the Musée du Quai Branly*

NÉLIA DIAS

Difference in all its forms—cultural, temporal, geographical, and physical—is a central issue in museums regardless of their nature—ethnographic, historical, artistic, archaeological, or scientific. So one may ask, why does difference play such a central role in museums and what are the links between museums and difference? To what extent does difference require the act of seeing, and particularly those privileged spaces of visibility such as museums? And if the title of this volume were *Museums and Diversity,* what would the implications be? Is diversity as closely linked to visual display as difference?

Difference, and especially cultural difference, presupposes a relationship to the extent that the mental operation of establishing a difference consists of putting in relation two or more things and proceeding with comparison. The comparative exercise underlying the study of cultural difference implies somehow a model or a norm that determines the constitution of objects of difference and of otherness. This comparative perspective is somehow absent in the notion of cultural diversity, which presupposes cultural variability. Thus, if cultural difference requires classification and comparison, cultural diversity operates at the level of the inventory and of the particular.

As institutions primarily dedicated to the display of cultures, ethnographic museums are confronted with the issues of cultural diversity and

cultural difference. But although these issues are currently acknowledged, museum professionals and anthropologists rarely discuss them. Moreover, cultural diversity has become such a common notion that it does not seem to require any further discussion. But are the notions of cultural difference and cultural diversity equivalent, or do they presuppose distinct conceptions of otherness? And could it be that these notions have specific contents according to national traditions? My paper, focused on the French context, attempts to explore the notions of cultural difference and cultural diversity by examining the creation of a new museum in Paris, the Musée du Quai Branly, which opened in June 2006.

Like all new institutional foundations, the creation of the Musée du Quai Branly has given rise to heated debates among anthropologists, art historians, and curators. Dedicated to the display of cultural diversity, this new museum explicitly aims to be distinct from an ethnographic museum—thus its name, reflecting its own geographical location and not any specific ethnographical focus—as well as from the embracing view of the study of man—incorporating physical anthropology, ethnology, and prehistoric archaeology—pioneered long ago by the Musée de l'Homme.

The specificity of the Musée du Quai Branly lies in two traits. First, it focuses on non-Western cultures, thus excluding European ones, which have been relegated to the new Musée des Civilisations de l'Europe et de la Meditérranée, scheduled for completion in 2012 in Marseille. Far from being surprising, the absence of European collections within the Quai Branly is the *logical* consequence of viewing European societies as rich in complexity and dynamic, in short as civilizations, as opposed to non-European ones, deemed culturally homogeneous and static. Second, its agenda explicitly stresses the equality of cultures (with the consequent denial of cultural hierarchy) on the one hand, and the defense of French republican values, namely citizenship and *laïcité,* on the other. There are no allusions to cultural difference in this project, as if this very notion was incompatible with the supposedly universal values of French republicanism. To what extent does the recognition of cultural differences constitute a threat to the French conception of a unitary republic? The acknowledgment of cultural differences seems to be a problematic issue in France, as though it might lead this country along the Anglo-Saxon road of *identity politics.* In the words of the Constitution, the French republic is indivisible, and public opinion perceives separate communities as automatically leading to divisions. Thus

the problem is to reconcile the increasing ethnic diversity of French society within the assimilationist tradition. Museums and schools, as state-financed institutions, have since the nineteenth century played a central role in the republican integration of citizens; the challenge facing these institutions nowadays is their responsiveness to changes within French society.

Like the current politics of immigration in France, debates over values such as cultural diversity in the museum world reflect, among other things, the complex and still largely unacknowledged legacy of colonialism on contemporary French society. Although the French imperial enterprise took disparate forms and had widely varying effects in different eras and parts of the world, its long-standing imbrication with scientific inquiry, visual representation, and the acquisition of material objects has played an important role in shaping many museum collections and institutional structures. Collecting as a knowledge project was made possible by and through the social and political control of the overseas territories. The Musée d'Ethnographie du Trocadéro increased its collections throughout the second half of the nineteenth century thanks to French colonial expansion and the role played by administrators, travelers, and missionaries in gathering objects for the museum.[1] The close links between colonialism and the practice of collecting were still prevalent in the late 1930s, as Alice Conklin has pointed out: "the colonies could clearly provide rich harvests because conditions for collecting by any French citizen were most bountiful where the French flag flew."[2] This colonial legacy even unacknowledged pervades current French debates on the role assigned to the new Musée du Quai Branly as a space devoted to cultural diversity.

In sharp contrast to English-speaking countries, where issues of cultural diversity and of multi-culturalism have been and continue to be widely debated, in France the discussion is quite recent and essentially consists of demonstrating the peculiarity of the French approach to this topic. Book titles such as Tzvetan Todorov's *Nous et les Autres: La réflexion française sur la diversité humaine* and Jean-Loup Amselle's *Vers un multiculturalisme français* clearly express the supposed French specificity. Much of the debate on the issues of cultural difference and cultural diversity has been conducted by sociologists such as Alain Touraine and Michel Wieviorka, and by philosophers like Tzvetan Todorov.[3] Surprisingly, French anthropologists have disregarded this issue, with some exceptions such as Louis Dumont and Jean-Loup Amselle.[4] This is not particular to French anthropology. As Terence Turner has pointed out,

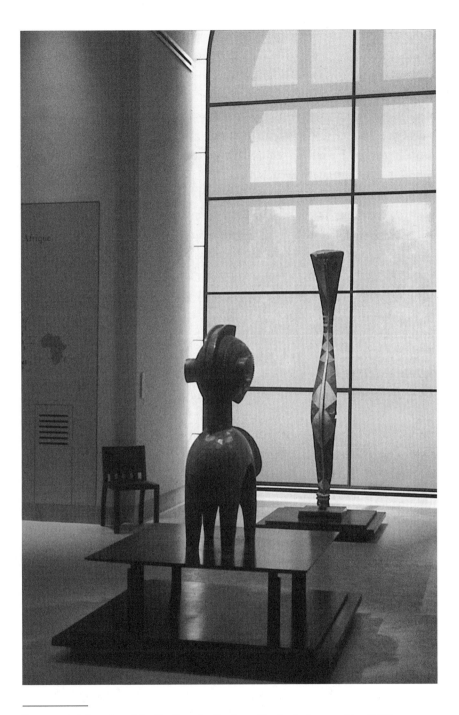

Figure 4.1. Interior of the Pavillon des Sessions, Musée du Louvre, May 2000.
*Photograph: Daniel J. Sherman. Architecture: Jean-Michel Wilmotte. By permission of the Musée du Quai Branly.*

anthropologists have been quite neglected by the "new academic speciali-
zations in 'culture', such as cultural studies, and by academic and extra-
academic manifestations of 'multiculturalism.' "[5]

Examining the notions of cultural difference and cultural diversity not in
abstract terms but rather in a particular field provides a good example of
how concepts can shape practices, in this case museum practice. My argu-
ment is that, far from being equivalent, cultural diversity and cultural differ-
ence are quite distinct in French usage. This is not a minor semantic quarrel;
cultural diversity and cultural difference refer, in the French case, to distinct
ways of conceiving alterity and its place within the nation. On the museolog-
ical level, French debates on cultural diversity are shaped by concerns about
"*l'égalité des cultures,*" a concept translated as "equivalence of cultures." What
is at stake in this notion is the assumption that all cultures can be put on an
equal footing through the choice, made by Western connoisseurs, of their
masterpieces and of their most representative objects. In other words, equiv-
alence of cultures presumes that art is the best way of approaching cultural
diversity. Why is France so eagerly attached to the defense of the equivalence
of cultures, first at the Pavillon des Sessions at the Louvre (inaugurated in
April 2000 as a precursor to the Quai Branly), then at the Musée du Quai
Branly itself? To what extent does this recent interest in equivalence of
cultures—equality of human creations as well as equality of works—reflect a
decreasing concern for cultural difference? Can equality, particularly equality
of cultures, be made compatible with the acknowledgment of cultural differ-
ences? Before analyzing the particular case of the Musée du Quai Branly, it is
important to keep in mind how the issues of cultural difference and cultural
diversity have shaped discursive formation as well as museological practices in
France. I will focus briefly on two previous institutional settings, the Musée
d'Ethnographie du Trocadéro and the Musée de l'Homme, which provided,
over the course of a century, models for displaying otherness in accordance
with the anthropological conceptions of their times.

## Visualizing Racial and Cultural Difference at the Trocadéro

The first French ethnographic museum, the Musée d'Ethnographie du Tro-
cadéro (MET), was founded in Paris in 1878 in the wake of the Universal Ex-
hibition of that year.[6] Primarily dedicated to ethnography, this institution

embodied evolutionist notions of difference, physical as well as cultural. The issue of difference became a theoretical issue in the new field of anthropology, at this time seeking disciplinary autonomy, and museums played a central role as spaces dedicated to the visualization of difference. Like other ethnographic museums of this time, the MET aimed to display human difference, particularly racial and cultural difference, and the development of human civilization through the linkage of race and progress. It is worth noting that the conception of a physical difference—that is, of a *natural* inequality between human groups—was developed not by conservatives but by liberal anthropologists committed to the secular values of the French Third Republic. The fact that these "natural differences" were proclaimed in large public and democratic arenas, museums, was not considered contradictory to republican egalitarianism.

By displaying side-by-side non-European objects and European ones, in other words "primitive" and popular artifacts, the MET attempted to make visible the differences—in the light of evolutionary theory—between nineteenth-century urban European cultures and "others," primitive or peasant. The assumption that non-European cultures as well as traditional European ones were different from and inferior to French (urban) culture was based on the supposed universalizing dimension of French civilization. Thus the apparent paradox inherent to the MET: it displayed cultural difference at the same time that the Third Republic's politics were aimed, both externally (through colonialism) and internally (through civic education), at eradicating such difference.

With the advent of the Third Republic, France's cultural expansionism turned in the direction of the colonial world in order to spread a secular mission, the *mission civilisatrice*. "The notion of a civilizing mission," argues Alice Conklin, "rested upon certain fundamental assumptions about the superiority of French culture and the perfectibility of humankind. It implied that France's colonial subjects were too primitive to rule themselves, but were capable of being uplifted."[7] This mission had a domestic counterpart; it paralleled the effort to create a unitary culture in France from the 1880s on. This task was complicated by the diversity of languages, ethnic groups, and religious practices, and realized only through political will. As Herman Lebovics notes, "struggles about what was France and who spoke for the French people tended initially to be claims for hegemonic domination rather than

proposals for inclusion. Culturally, national unity took the form of a popula-
tion assimilated to a common civilization, which was from the late nine-
teenth century classical in its content and republican in its prescriptions."[8]
Thus, far from constituting a threat to national unity and to the unity of
French culture, the display of French regional cultures at the MET sought to
reveal the difference between them and metropolitan culture.

The MET did not need to display urban French culture; it was implied on
every wall in the categories used for depicting alterity. In the exhibition room
dedicated to France, religious objects were labeled as "amulets," "curiosities,"
and "superstitious things" and thus depicted as remains of traditional beliefs
deemed to disappear with the spread of rational thought. Cultural difference
was one of those concepts constructed in order to make alterity intelligible
and visible; this notion presupposed the principle of incommensurability of
cultures and the assumption of a hierarchy between cultures. The other was at
the same time different *and* inferior, a conception that would be called into
question by the 1920s.

## Racial Equality and Dignity at the Musée de l'Homme

The transformation of the MET into the Musée de l'Homme in 1937 consti-
tuted a turning point both in the perception of alterity and in the content of the
discipline associated with its analysis. Dedicated to the study of humankind as a
whole, this museum aimed at combining physical anthropology, ethnology, and
prehistoric archaeology. For Paul Rivet (1876–1958), the Musée de l'Homme's
first director, committed democrat and opponent of racist theories, the mu-
seum's mission consisted of making visible the conception of the unity of hu-
mankind. Arguing in favor of a generally monogenist position, Rivet asserted
that the diverse human types had originated from a single species. In contrast to
his predecessors, who emphasized racial difference, Rivet sought to demon-
strate racial equality, although, as Jean Jamin has aptly pointed out, he never se-
riously questioned the very category of race.[9] It would seem that the urgency of
the fight against racist theories prevailed over the need to rethink the notion of
race. Thus, the Musée de l'Homme was assigned the cultural and scientific role
of defending racial equality in order to challenge current prejudices.

With the accent placed on the pluralist conception of culture and on the
rejection of racial hierarchies and biological determinism, the Musée de

l'Homme was explicitly promoting cultural relativism. Moral and intellectual differences between peoples were no longer regarded as indicators of inherited cultural capacity, but rather as the result of diverse cultural experiences. By focusing on how distinct cultures had evolved different constellations of values and models of social organization, the Musée de l'Homme's directors were arguing for the complexity of non-Western societies. The acknowledgment of the complexity of non-Western societies parallels the denial of their supposed "primitiveness." As Daniel Sherman notes,

> Both Mauss and Rivet rejected the term 'primitive' to describe indigenous peoples living in French-controlled territories. Mauss wrote that none of these peoples could accurately be called 'primitive', in the sense of pre-historic; most were 'archaic' or 'proto-historic.' Rivet preferred to avoid evolutionary schemas altogether, noting that the people ethnographers would encounter in the French empire 'are as far, perhaps even farther, from their origins as we; it is just that their civilization has evolved in a different direction from ours'.[10]

Marcel Mauss's rejection of the term "uncivilized peoples" on theoretical grounds dates back to his inaugural lecture as professor of the *histoire des religions des peuples non civilisés* (history of the religions of uncivilized peoples) at the École pratique des Hautes Études (Paris) in 1901.[11]

Although proclaiming racial equality and defending the complexity of non-Western societies, French ethnologists did not seek to promote the equivalence of cultures (*égalité des cultures*).[12] For them the rejection of racial hierarchy did not entail the denial of cultural hierarchy: races exist on an equal basis, but their cultural achievements cannot be put on an equal footing. On the contrary, far from advocating the equivalence of cultures, French ethnologists were instead concerned with the dignity of human beings and societies, which is quite a distinct concern. The stress on dignity has to be considered from a dual perspective: on the one hand, the recognition of cultural variety in the spirit of relativism, and therefore of the legitimacy and possibility of alternative cultural forms; on the other, the refusal of racial hierarchy. In his close analysis of the notion of dignity, Charles Taylor points out how the modern notion of dignity, "used in a universalist and egalitarian sense," refers to "dignity of human beings," or citizen dignity. As a concept

"compatible with a democratic society" it contrasts with the notion of honor, which "is intrinsically linked to inequalities." "With the move from honor to dignity," argues Taylor, "has come a politics of universalism, emphasizing the equal dignity of all citizens." Moreover, "the politics of equal dignity is based on the idea that all humans are equally worthy of respect."[13]

To advocate that "all humans are equally worthy of respect"—the basis for the politics of equal dignity—and to defend "the equal value of human potentials" is one thing; it is something else to proclaim the "equal value of what they have made of this potential." In other words, and as Taylor has perceptively demonstrated, this last assumption leads to the recognition of "the equal value of different cultures." French ethnology in the 1930s stressed racial equality and the equal worth of human societies; only in the 1990s would French curators come to defend the equal worth of certain material productions, in this case aesthetic ones, in the name of the equivalence of cultures.[14]

During the 1930s, French ethnologists used the concept of dignity without explaining its content. Mauss argued in 1931 that "indigenous arts are relatively just as worthy (*dignes*) as many of ours."[15] The term dignity is frequently associated with the notion of respect, as the following quotation by the ethnologist Jacques Soustelle, a Mexican specialist at the Musée de l'Homme, clearly demonstrates: "We show that there were and that there exist different civilizations more or less perfect in some respect or other, but all equally capable of practical or aesthetic invention; the museum that we wished to build is nothing more than a tableau of the collective efforts of humanity, under all climates, on all continents, an effort which has everywhere produced works worthy of respect."[16] Soustelle's words are significant because on the one hand they point out the equal value of human potentials regardless of the differences in terms of civilization, and they outline a respect for the material results of this potential (*des oeuvres dignes de respect*), on the other. But this French ethnologist carefully avoids speaking about the equal worth of the works. In other words, during the 1930s the main concern was still the erasure of racial inequality and the recognition of human dignity.

Although stressing the dignity of human societies, French ethnologists discarded the controversial issue underlying the notion of dignity, that of equal rights. As several historians of French colonialism in Africa have pointed out, French colonial authorities adopted at the same time a politics of assimilation—with the possibility of African subjects eventually becoming

French citizens—and a politics of association, "predicated," as Conklin argues, "upon respect for indigenous cultures, and administration through preexisting native political structures."[17] In parallel, a form of colonialist politics (association) and a disciplinary knowledge (ethnology) both emphasize the equal worth and the dignity of cultures. At stake is respect for an assumed difference of (colonized) cultures both from a cognitive point of view and in colonial policy. As Benoît de l'Estoile has recently pointed out, displaying the diversity of cultures and races was at the core of the 1931 Exposition Coloniale in Vincennes; for Maréchal Lyautey, the chief organizer of this Exposition, "the more one got to know them ['native races'], the more their supposed inferiority was redefined as difference."[18]

French ethnologists during the 1930s argued for the diversity of non-European societies; the latter were not simpler, just different. Thus the notion of difference connoted not inferiority but rather complexity. By refusing to use terms such as "inferior" and "uncivilized," French ethnologists aimed at stressing the dignity of all human societies and peoples. Their insistence on fundamental respect for cultural difference among human societies was based on what anthropologists in the 1930s were already calling cultural relativism. Although they provided an essentializing vision of culture, it was to the end of defending a diversity of human value orientations.

In the metropolitan context, ethnologists disregarded France's diverse cultures in the name of the unity of French society. The focus on France's cultural particularities goes back to the 1930s in the wake of the 1937 World's Fair in Paris. In that period, as Shanny Peer has pointed out, "the cultural pluralism embodied in the diverse provincial cultures came to be embraced as quintessentially French: national authorities desired to recuperate and recast provincial folk traditions as a cultural bulwark against a new menace: that of mechanical, standardized, industrial civilization."[19] Once absorbed by the French nation, "the diverse cultures of provincial France were proudly reclaimed as France's national patrimony in 1937."

In other words, cultural variety was conceived as constitutive of the French nation, in the sense that it was somehow equivalent to regional diversity. Georges-Henri Rivière, former assistant director of the MET and director of the Musée des Arts et Traditions Populaires (ATP), founded at the same time as the Musée de l'Homme, "acknowledged," as Sherman notes, "that France encompassed considerable regional variety, not only in languages but

in physical types. Yet his plan for the Galerie culturelle treats these variations as background, asserting that 'French unity can be understood only in historical and cultural terms.' "[20] French ethnologists tended to assume that social differences were much more important than cultural differences. The eradication of the social differences of traditional French society would pave the way for the gradual elimination of cultural differences and, consequently, of cultural hierarchies. This was the conception asserted by Rivière when he referred to "a world that was no longer split into educated and popular strata and where humankind, finally, would reclaim its worth (*dignité*)." Herman Lebovics argues that in "ascribing differences in social power and in the valuation of high and popular culture to class differences, Rivière celebrated the elimination of the barriers between high and popular culture as the predictable consequence of the further democratization of French society."[21]

From the 1930s to the 1990s the Musée de l'Homme continued faithfully to exhibit cultural diversity, largely without renovating its installations or labels. The cultural diversity displayed at the Musée de l'Homme was somehow an outdated diversity, without reference to the changes that occur within one and the same culture. At the ATP the situation was quite similar; the image of France there was of a rural country characterized by a regional diversity that functioned as a sort of guarantee against globalization. Needless to say, French cultural diversity as presented at the ATP was conceived as a harmonious assemblage of diverse regional cultures with little or no reference either to the overseas territories or to immigrants from former French colonies. In both cases, the impulse for a radical transformation of these institutions came from the political sphere rather than from the ethnological community. Prior to the 1990s few French ethnologists cared about or reflected on ethnographic museums. When the French government decided to separate the Musée de l'Homme's collections to create a new institution, the Musée du Quai Branly, renowned ethnologists such as Louis Dumont and Jean Rouch, whose careers were linked wholly or in part to the museum, were the fiercest opponents of this project.[22] These two ethnologists defended the legacy of the 1930s in the name of an embracing conception of the study of man and its underlying humanistic dimension. Thus, only at the end of the 1990s did French ethnologists mobilize to discuss museological matters, although they did not question the notion of cultural diversity and the role of the museum in a multi-cultural society.

## The Musée du Quai Branly Project

The project of creating a new museum in Paris goes back to 1996 and was intended as a sort of cultural legacy of Jacques Chirac's presidency.[23] Since François Mitterrand was associated with what were called *les grands travaux*—the Louvre extension, the Bibliothèque Nationale de France, and the Bastille Opera house, to name just a few—Chirac also wanted to inscribe his name in enduring monuments.

Placed under the double direction of the Ministry of Culture and the Ministry of Instruction and Research, the Musée du Quai Branly has had, since its inception, two directors: a museological director, Germain Viatte, former director of the Musée National d'Art Moderne (Centre Beaubourg), and a scientific director whose real title is *directeur de l'enseignement et de la recherche*. The anthropologist Maurice Godelier, a specialist on New Guinea, occupied this scholarly position from 1997 until his resignation in 2002, when he was replaced by another anthropologist, Emmanuel Désveaux, a specialist on Ojibwa Indians; since early 2005 Anne Christine Taylor has been the research director of this museum. The specificity of the Musée du Quai Branly lies in the fusion of two substantial collections, those of the Musée de l'Homme and those of the Musée National des Arts d'Afrique et d'Océanie (this means that it will contain a huge number of objects: more than 300,000), and in its focus on non-European cultures; European objects will be on display during temporary exhibitions.

This new museological project has given rise to growing discussions among anthropologists, art historians, and curators centered mainly on the issue of art *versus* ethnography and incidentally on the absence of European collections. However, less attention has been paid to the underlying political and moral values associated with this new institution. The indifference of the French anthropological community toward museums may provide a partial explanation for this lack of attention; another reason might be the relative absence of French anthropological debate on topics related to contemporary social and cultural questions, a matter left to sociologists and philosophers.[24] Thus, an analysis of the new museum project can provide some tools for understanding French conceptions of cultural difference and cultural diversity. Rather than providing a history of the museological project, my goal here is to stress the four dimensions—cultural diversity, citizenship, *laïcité,* and equivalence of cultures—that both underlie the project and shape its very contents.

## Cultural Diversity and Universalism

The Musée du Quai Branly is explicitly conceived in radical opposition to the Musée de l'Homme, in both its intellectual goals and its civic mission. As Emmanuel Désveaux, the former research director of the Musée du Quai Branly, stressed in an interview with *Le Monde,* the Musée de l'Homme is dedicated to the display of the natural history of man, whereas Quai Branly focuses on the cultural history of man.[25] The contrast between these two institutions is, according to this anthropologist, accentuated by their supposedly antagonistic frameworks: the Musée de l'Homme was conceived of as a "museum of human evolution" in contrast to the Musée du Quai Branly, which has as its main purpose to show "the plurality, the diversity of cultures."[26]

Yet the history just outlined casts doubt on this supposed incompatibility between a museum embedded in evolutionism (thus old-fashioned) and a new institution devoted to cultural diversity. In fact, the issue of cultural diversity was at the core of the Musée de l'Homme project, which refused categorically to use evolutionism as a theoretical framework. If there is a significant difference between the two institutions it resides in the close relationship at the Musée du Quai Branly between cultural diversity and the stress put on art as a common denominator across societies.[27] Désveaux reiterates the importance of the aesthetic dimension within the new museum. In his view, art constitutes one of the best ways of showing the diversity of cultures. This assumption is based on the premise that "in our own culture, [art] is a value widely appreciated and a matter of consensus." This last statement is obviously highly questionable due to its ethnocentric presuppositions. Although Désveaux recognizes that the question of the universality of art is still open, he argues that art, being a "substitute for religion," allows a "respectful approach, a non-discriminatory one, to non-Western cultures."

Why does art have to be the vehicle *par excellence* for recognizing cultural diversity? Far from accepting the possibility of alternative cultural expressions, the Musée du Quai Branly tends somehow to limit the field of cultural diversity to one supposed universal form, the artistic one. Undoubtedly market value plays a central role in the redefinition of non-Western objects as art objects and has an impact on the choice of the objects to be displayed.[28] Since 1998, the Musée du Quai Branly has been acquiring objects from private collectors and auction houses; the amount for acquisitions

allotted to the museum was 150 million French francs (23 million euros).[29] One of the most expensive pieces, a statue from New Ireland, "has been purchased for 18 million French francs" (2.7 million euros) from a private collector and is now on display at the Pavillon des Sessions.[30]

By omitting physical anthropological and prehistoric collections, the Musée du Quai Branly intends to take a strictly "culturalist approach," devoid of any biological reference.[31] The separation of the biological from the cultural implies the end of an encompassing conception of anthropology and the affirmation of an autonomous cultural sphere defined strictly in aesthetic terms. Yet, the choice of a supposed neutral designation for the museum, that is, a geographical location (the Quai Branly), was aimed both to overcome the art/ethnography dichotomy and to elude the very question of the status of the objects on display.[32] It is worth noting that several names were suggested for this new institution: Musée des Arts Premiers (Museum of Early Art), conveying the sense of so-called primordial arts equated with non-European ones, Musée des Arts et des Civilisations, or Musée de l'Homme, des Arts et des Civilisations, leaving open the question of to what extent art could be distinct from culture and from civilization. It would be inaccurate to say that the Musée du Quai Branly will center exclusively on the arts; by combining the aesthetic dimension with cultural contextualization, this museum attempts to overcome the boundaries between form and function. A quite similar procedure informs the display at the Pavillon des Sessions; before leaving the exhibition galleries, visitors have access to an interpretive space with interactive consoles providing information about social and cultural context. Yet by spatially as well as conceptually separating objects from societies, the Pavillon des Sessions relegates anthropological and historical data to the status of interpretative complements.[33]

The display of cultural diversity has been one of the aims of ethnographic museums since the end of 1920s, and some of the issues discussed by Désveaux, as well as his use of the notion of cultural diversity, are deeply embedded in what he designates as "classic ethnology." As Désveaux explicitly asserts, the notion of cultural diversity cannot be separated from the concept of difference: "Cultural diversity only exists though difference. If we have begun to better understand the 'other,' it is because we have grasped his culture in its totality, its continuity, its coherence, according to its own value."[34] But

FIGURE 4.2. *Above left:* Musée du Quai Branly, January 2007: north (Seine) façade. *Photograph: Daniel J. Sherman. By permission of the Musée du Quai Branly.*

FIGURE 4.3. *Below left:* Musée du Quai Branly, January 2007: south (Rue de l'Université) façade. *Photograph: Daniel J. Sherman. By permission of the Musée du Quai Branly.*

FIGURE 4.4. *Above:* Musée du Quai Branly under construction, January 2006: future shop and offices with Australian ceiling paintings from Rue de l'Université. *Photograph: Daniel J. Sherman. By permission of the Musée du Quai Branly.*

does this mean that the concept of cultural diversity can still be used without critical analysis? And can it be dissociated from its underlying assumptions, such as the notions of respect and dignity? Gyan Prakash has emphasized, in a paper on museums, the importance of scrutinizing the "notions of cultural and human diversity that have framed the representation of difference." In his view, " 'the orders of the West' cannot be undone by turning away but by re-visioning the organization of cultural difference."[35]

Far from being a neutral term, cultural diversity is embedded in theoretical presuppositions. Two points are worth making, the first concerning the distinction between cultures and civilizations, a distinction institutionalized with the creation both of an "exotic" museum dedicated to cultural diversity and of a non-exotic museum devoted to European and Mediterranean civilizations. It is worth noting that one of the names for the museum in Marseille was "Musée des civilisations de la France et de l'Europe."[36] Why is diversity essentially linked to cultures and not to civilizations? Museums nowadays tend to choose their names based on abstract terms such as "cultures," "societies," and "civilizations," in contrast to nineteenth-century museums named according to knowledge formations. Second, the concern for human and cultural diversity echoes a wider concern about "ecological" issues—climatic diversity, bio-geographical diversity, and natural diversity. In travel literature throughout the nineteenth century the transition from the diversity of peoples to natural diversity occurred frequently; depictions of religious beliefs, social practices, and forms of political organization were preceded by detailed descriptions of the varieties of flora and fauna. The assumption of close links between natural diversity and cultural diversity is reenacted at the Musée du Quai Branly. The museum building, conceived by the architect Jean Nouvel, is surrounded by a large garden (18,000 sq. meters) designed by the landscape architect Gilles Clément. Large magnolias and cherry trees as well as other kinds of vegetation mask the museum's façade in order to embed the building "in a little bit of nature, a museum in the trees."[37] The overlap between cultural diversity and natural diversity seems to follow from the contents of the Musée du Quai Branly. Until 2002, the Musée National des Arts d'Afrique et d'Océanie occupied three floors of the Palais Dorée, the basement of which contains an aquarium.

## Museum Citizenship

Like its predecessor, the Musée de l'Homme, the Musée du Quai Branly aims to promote civic values, namely republican values. According to Germain Viatte, director of the museological project since its inception, the new museum is first of all an institution devoted to the spread of republican values such as respect for the law, citizenship, and *laïcité*.[38] As a legal principle, *laïcité*, a term only imperfectly translated as "secularism," is closely linked to the issue of equal rights. It presupposes the unity of the Republic composed of citizens and is based on three assumptions: freedom of conscience, equality of citizens, and a universalist concern for the public interest.[39] In addition to proclaiming that the Musée du Quai Branly is first of all a republican institution, based on secular principles, Viatte ascribes a particular mission to this institution, to be a tool for citizenship:

> The museum is conceived as an instrument, a tool that facilitates knowing and exploring, displaying and disseminating the resources in its care. This vision is founded on a strong consciousness of the institution's responsibilities concerning heritage and culture and the people who will come into possession of those resources. It is connected to the notion of respect and sharing. This institution is part of [*s'inscrit dans*] the institutions of the Republic, in its respect for law and laïcité. . . . It is an instrument of citizenship for our own society among the multiple components of the Republic.[40]

Why is citizenship one of the most cherished values at the Quai Branly? The conception of museums as civic spaces which all citizens have the right to enter without discrimination goes back to the mid-nineteenth century, as Tony Bennett and Glenn Penny have pointed out.[41] But what is at stake in the French case is not the conception of a museum as a civic space but rather its mission in relation to citizenship.

The notion of citizenship implies the sense of belonging to a nation and the idea of a public space based on common interests; to be a citizen requires a principle of inclusion, what is known in France as the "republican contract." The French nation has since the Revolution been conceptualized around abstract, universalistic, and voluntaristic principles of citizenship, rather than

on the particularistic, ethnically based notion of nationhood. This may help to explain why the recognition of cultural particularities is, in theory, in conflict with the universalism inherent to republican values, for such recognition entails discriminating between citizens rather than treating them as equals. Elements such as a common language and shared values were deemed to strengthen a common sense of citizenship. As Herman Lebovics has pointed out, "French republicanism interpreted the logic of the nation-state as requiring that political boundaries approximate cultural ones, or more exactly, that to share in the life of the nation one had to be a part of *the* national culture. This imperative of unity, then, required the French state to concern itself deeply with cultural life of its citizens in the areas of language and aesthetics."[42]

The founding text of the modern French nation, the Declaration of the Rights of Man and the Citizen of 1789, in its very title asserts the right not just of the person but also of the citizen. Its first article specifies that "Men are born and remain free and equal in rights. Social distinctions can be based only on public utility."[43] In other words, peculiarities of religion, language, or ethnicity are excluded as leading to invidious distinctions, something that the current French Constitution reasserts. The French model stems from the Revolutionary ideal, which enshrines the equal rights and obligations of citizens as individuals—thus the tensions between the rights of the individuals and the recognition of cultural specificities.

French scholars have barely called into question the republican model of integration. For example, the anthropologist Jean-Loup Amselle, in the preface to the second edition of *Vers un multiculturalisme français,* notes a contradiction between natural rights or the rights of man and the acknowledgment of cultural difference. In his view, the recognition of a multiplicity of ethnic groups within the French territory offers ideal conditions for the development of racism. It follows, argues Amselle, that the only response to the risk of "segmentation of the population" lies in the republican model of integration, in spite of its faults.[44] We find here the assumption that recognition of ethnic diversity and cultural specificities will necessarily destroy the nation. Sociologists such as Michel Wieviorka have tried to overcome the issue of universalism versus communitarianism. According to Wieviorka, instead of setting social equality and difference against each other, it is important to bring them together; one of the ways to combine equality and difference is

through "the encounter of cultures." Museums, particularly museums containing non-Western objects, are privileged places for such an encounter of cultures.[45] Even if some scholars explicitly admit the failure or the difficulties of the republican model of assimilation and the gap between republican ideals and everyday practices, this does not mean that they are willing to admit the existence of separate communities. For Wieviorka, democracy implies both the recognition of cultural diversity and the acknowledgment of a dominant culture.[46] This sort of compromise is, in his view, the only way to preserve republican values.

The accent the Quai Branly's directors place on citizenship has an underlying premise, the defense of secularism; as Viatte states, "France's position is at once universalist and secular (laïque)."[47] As state-financed institutions, museums, like schools, have the job of forming citizens; this is why both types of institution are expected to apply the principle of secularism. The increasing ethnic diversity of French society, and the growing concern by non-Western peoples about the way they were and are represented in ethnographic museums, require new responses from museums professionals. Conscious about the implications of representing alterity in the new millennium, French curators turn to the republican legacy in order to find answers to disturbing questions.

**Laïcité as a Museum Value**

According to Article 2 of the French Constitution enacted in 1958, France is conceived as an "indivisible, secular, democratic and social Republic. France guarantees (assure) the equality of all citizens under the law without distinctions in terms of origin, race or religion. It respects all beliefs (croyances)."[48] In other words, the very conception of the French republic implies the denial of religious distinctions and respect for all beliefs, leaving aside the question of the content of those beliefs. The separation of the French state from the church goes back to the early twentieth century, more precisely to the law of 9 December 1905; this law capped the process of secularization, which has its roots back in the 1880s with the Goblet and Ferry laws concerning laïcité in schools.[49] As a result, no religion can be privileged; religious practice and beliefs belong to the individual sphere and cannot interfere with the public domain. Under this principle, equality before the law for all citizens, regardless

of their private beliefs, is supposed to be guaranteed by barring religious institutions and values from the public arena.

Leaving aside the juridical definition of *laïcité* as well as its philosophical basis, I will focus here on its museological implications.[50] Due to the secular character of the French state, museums are conceived as republican, democratic, and secular spaces; as a result, they cannot transmit any particular religious message or privilege one confession to the detriment of others. To what extent is the museum's mission as an institution providing lessons of citizenship compatible with its supposed neutrality regarding values, namely religious values? Of course, neutrality in a secular state is equivalent to "confessional neutrality" and does not mean neutrality in relation to values; far from expressing moral relativism, the "confessional neutrality" of the secular state is based on values such as universalism, reason, and justice, to name a few.[51]

The defense of *laïcité* is, according to Viatte, one of the principles inscribed in the Quai Branly, along with citizenship and universalism. This concern with secularism has attracted a great deal of attention from the organizers of the Musée du Quai Branly's project, at least in part as a way of avoiding controversial issues such as the display of objects sacred to particular cultures and the right of native populations to have a voice in representing the meaning of objects they claim as their heritage. Implicitly acknowledging the potential of museums as political minefields for the expression of cultural and religious particularities, the Quai Branly's curators endorse the supposedly universalist values of French republicanism.

The defense of *laïcité* raises two questions: first, does the concept mean that all religions are equal and equally treated in terms of museum display? Second, does it entail an equal treatment of religion and other modes of depicting reality, such as science? In an interview with the French journal *Le Débat,* Maurice Godelier asserts that "for us, in Republican France, all religions are true; any religion could show up in the museum as the only true religion, the other ones being false."[52] By asserting, in the spirit of Emile Durkheim, that all religions are true, and that therefore no one deserves special treatment within the museum, Godelier moves from the juridical sphere to the domains of anthropology and philosophy. The notions of truth and falsehood allow Godelier to argue that within the space of the museum all religions are true, apparently a cultural relativist stance. In fact, however, his position has more to do with the defense of republican principles than with

cultural relativism, the excesses of which he criticizes as "hyper-relativism." If from an anthropological perspective it is possible to assert that "all religions are true," the same assertion transposed into the sphere of the museum, conceived as a secular space, is problematic.

If the Quai Branly's message stresses that all religions are true, it does not follow that the museum considers religious conceptions equivalent to other ways of apprehending reality, such as scientific ones. Denying hierarchy among religions, by considering them all equal, does not mean that religion and science have equal value. The Musée du Quai Branly is not a museum "in which we would assert that all discourses on objects and societies are equivalent, that is, can be equally true."[53] In other words, within an institution devoted to education not all theories deserve equal attention; scientific discourse obviously has pre-eminence over other discourses. This applies to schools as well; the latter, conceived as secular spaces, are deemed to transmit a universal knowledge.[54]

Godelier's defense of science is grounded in his criticism of "discourses" that consider "scientific knowledge as just a form of Western ideology." This last position is, he believes, "an intellectual error" and "a cultural aggression"—in sum, pure "demagogy." Although recognizing that his own position will prompt criticism in the U.S. and Canada, Godelier attempts to explain the reasons underlying the questioning of Western knowledge. It is a reaction, he argues, of "peoples uprooted (déracinés) and humiliated" to find their own roots and to forge a new identity; a reaction that gives these people the right to see themselves as equals to those who have uprooted them.[55] This last phrase is worth noting. By emphasizing how the issue of equality between Western and non-Western peoples is central to these questions, Godelier stresses that the real problem is not in judging the correctness of competing beliefs; on the contrary, it has to do with the equal worth of cultures, a problem that the philosopher Charles Taylor has discussed at length. By pointing out how the politics of difference "can end up making everyone the same," Taylor notes that "the presumption of worth imagines a universe in which different cultures complement each other with quite different kinds of contribution. This picture not only is compatible with, but demands judgments of, superiority, in a certain respect."[56] Désveaux asserted that it would "not be judicious to build a discourse on collections based solely on autochthonous claims"; the latter are not only instable but also incompatible one with another and with the current state of scientific knowledge.[57]

The defense of museums as secular spaces was the object of a debate in anthropology raised by the exhibition Marc Couturier: Secrets, held in 2001 at the Musée National des Arts d'Afrique et d'Océanie. This exhibition, curated by an artist, Marc Couturier, presented sacred aboriginal objects, such as *tjurunga,* to visitors. An Australian anthropologist, John E. Stanton, criticized the exhibition on the grounds that it attested to the "overwhelming insensitivity of French museum curators with regard to the knowledge and beliefs of other cultures."[58] Secrets provided, argued Stanton, a good "example of cultural arrogance," and he invited French museums to adopt the cultural politics of the U.S., Canada, and Australia to avoid perpetuating "the condescending practices of the past." Two French anthropologists and specialists on New Guinea, Brigitte Derlon and Monique Jeudi-Ballini, defended the exhibition. One of their arguments centered on the principle of museums as "secular spaces." Arguing that the museum's main function is to display its collections to the public, it follows, according to Derlon and Jeudy-Ballini, that sacred objects from non-European societies as well as from European ones, presented with respect, should be made visible to visitors.[59] The refusal to exhibit sacred objects in a museum is contradictory, argue Derlon and Jeudi-Ballini, with its role as a secular space. Moreover, this refusal can lead to the adoption by the museum's curators of other societies' signs of belief, a position which, according to the two anthropologists, ends up making sacred the other's sacredness. One may argue that in the museum space the only values that can be sacred are republican values.

### Equality of Cultures, or toward the Erasure of Difference

The Pavillon des Sessions, dedicated to the display of masterpieces from the world over, was deemed a sort of precursor of the Musée du Quai Branly.[60] Containing a small number (around 120) of non-Western objects, mainly sculptures, chosen for their formal qualities, the Pavillon des Sessions was conceived as a space of recognition of arts from non-Western cultures; moreover, the entry of these objects into the Louvre was considered an acknowledgment of the equality of human creations. On that occasion, Godelier, Stéphane Martin (director of the agency responsible for building the Quai Branly museum), and Viatte continually stressed that displaying non-Western objects at the Louvre demonstrated France's openness toward the other. At

the same time they insisted on the underlying dimension of this gesture: the denial of a hierarchy of the arts. In other words, even if some of the objects at the Pavillon des Sessions had already been displayed at the Musée de l'Homme or at the Musée National des Arts d'Afrique et d'Océanie, they were not displayed as merely art objects; being at the Louvre gives them the cachet of *art*.

As Viatte explicitly noted, the Pavillon des Sessions is the result of a political decision. There was a political will to assert symbolically the equivalence of cultures, and its recognition by France through its most prestigious cultural institution, the Louvre museum.[61] Needless to say, the equivalence of cultures is based on the equal worth not of all their material productions but only of their masterpieces. Moreover, the assumption of artistic equality is based on the presupposition that art is a universal value intrinsic to human behavior. In other words, equivalence of cultures is somehow restricted to a specific category of objects, art objects. As Godelier states, "By this gesture [inclusion in the Louvre] all of humanity's masterworks and, with them, the societies that created them become equal. Their presence in the same space demonstrates once and for all that there is no progress in art and that no society has a monopoly on human creation."[62] Note here the move from equality of the masterpieces to the equality of societies. A similar assumption appears in a panel near the exit of the Pavillon des Sessions; it says that the Musée du Quai Branly's main goal is to demonstrate that "there is no hierarchy among the arts, and no hierarchy among peoples." The denial of the hierarchy of arts and the rejection of the idea of progress in art are both grounded in classic and canonical examples of art in the West, painting and sculpture; moreover, non-Western objects are submitted to the same canonical criteria that art historians apply to Western art, such as the notion of creation and of the creativity of individual artists.

Désveaux has reiterated the notion of equivalence of cultures at the core of the new museum. Arguing that the aesthetic dimension could be a sort of vehicle for an "anti-evolutionistic message," he claimed, in the name of the equivalence of cultures, that a reliquary from Zaire is worth the same as a Romanesque capital.[63] The common denominator of objects as diverse as reliquaries, masks, and a Romanesque capital is the act of removing them from their "original" context, in other words expropriation, and the act of appropriation by the institution of the museum.[64]

The equivalence of cultures finally has implication for the concept of human dignity. Godelier as well as Désveaux points out that there is "no progress in art." Posing this dictum as the central message of the Quai Branly makes it possible, according to Désveaux, to place "all societies on an equal footing. The moral advantage is considerable." And he adds: "to privilege the presentation of an artistic production goes in the direction of the representatives of these cultures, who will therein find their dignity anew."[65] The assumption here is that the elevation of non-Western objects to the status of art objects presupposes the elevation of peoples identified with them. In contrast with the Musée de l'Homme's message of equal dignity of peoples and consequently, to paraphrase Charles Taylor, of the equal value of all humans' potentials, the Musée du Quai Branly adopts the reverse position; it maintains that it is the equality of creations, and especially of artistic creations, that paves the way for the equality of peoples and societies. In other words, through art all societies have equal status because art, as a common denominator, can transcend cultural barriers and establish a "dialogue between cultures."

Why do human dignity and societies' dignity have to be expressed through art? Are there no other ways of expressing human dignity besides works of art? And to what extent does the stress in equality of artistic creations contribute to erase cultural particularities? Charles Taylor has rightly cautioned against the "presumption of equal worth." As Taylor notes, "The peremptory demand for favorable judgments of worth is paradoxically—perhaps one would say tragically—homogenizing. For it implies that we already have the standards to make such judgments. The standards we have, however, are those of North Atlantic civilization. And so the judgments implicitly and unconsciously will cram the others into our categories."[66] French cultural politics in museums contribute nonetheless to this same homogenizing process, by valorizing art as a feature common to all cultures. This amounts to the erasure of cultural differences and helps provide, as Sally Price perceptively notes, "an aestheticized vision of cultural difference."[67]

### Concluding Remarks

The Musée du Quai Branly is part of a larger enterprise to redesign the museum landscape in France. In addition to the Musée des Civilisations de l'Europe et de la Méditerranée in Marseille, other museum projects are under

discussion: the foundation of a department of Islamic arts at the Louvre, the renovation of the Musée de l'Homme,[68] and the creation of a museum of immigration. These museum projects can be regarded as complementary to the Musée du Quai Branly in the sense that they incorporate geographical areas (Europe), topics (relationships between nature and culture), and social groups (immigrants) that Quai Branly leaves out. At stake in those projects is the desire to solve sensitive political and social issues through culture—the conviction that art and culture can bring together peoples, ethnic groups, and nations, and become the new magical bond. Through objects, museums attempt to palliate government policies and social exclusions. The claim that "there is no hierarchy among the arts, and no hierarchy among peoples" obscures the inequality of the relationships between France and non-European peoples. Thus the role ascribed to museums: to exonerate society for its failure to deal with peoples and cultures whose objects are in museums devoted to cultural diversity.

French debates on cultural difference and cultural diversity are to a certain degree molded by the tension between the acknowledgment of cultural particularities and the defense of republican universalistic values. Republican thought privileges the rights of citizens and demands that differences be ignored. It seems clear that the republican model of integration can exist only through political will; the tendency to direct politics into the cultural sphere helps to explain the role ascribed to museums as schools of citizenship. And it is in the context of a growing social and civic crisis—high unemployment, failing schools, questions of identity and social mobility, and the growing alienation of the young, especially in immigrant communities—that museums are quite paradoxically called to fulfill the republican legacy.

The case of the Musée du Quai Branly makes clear the problematic nature of the relationships between museums and difference. By trying to take into account both cultural diversity and human universals, the Musée du Quai Branly has put itself in the position of refusing to acknowledge cultural difference. The quest for a common denominator across societies, in this specific case the aesthetic dimension, cannot but erase cultural particularities. Undoubtedly, as Sherman has commented, the combination of "the national and the universal does not always come easily, and, more important, it often involves competing definitions, appropriations, and unequal relations of power."[69] The criticism of universalism goes back to the late 1940s; in 1947

the executive board of the American Anthropological Association (AAA) elaborated a Statement on Human Rights submitted to the United Nations. "How can the proposed Declaration be applicable to all human beings, and not be a statement of rights conceived only in terms of the values prevalent in the countries of Western Europe and America?" was one of the questions raised.[70] Since the late 1940s, anthropologists have positioned themselves in opposition to universal values, such as "human rights," questioning the applicability of those rights to non-Western contexts. But the problem of making respect for cultural traditions compatible with respect for individual rights has not yet been resolved.[71]

The focus of the Musée du Quai Branly's organizers on common features overriding cultural differences has an underlying agenda. They seek to avoid essentializing the concept of culture and thus reducing it, to quote Turner, "to a tag for ethnic identity and a license for political and intellectual separatism."[72] The constraints on recognizing the ethnic diversity of French society within museums are not merely institutional but historical and political. Ironically, the political refusal to admit separate communities goes with the institutional acceptance of separate museum projects. The department of Islamic arts at the Louvre is distinct from the Pavillon des Sessions; the Musée du Quai Branly will not deal directly with people from former French colonies, who will be melded into a museum of immigration with other waves of immigrants coming from Europe during the early nineteenth century. Yet there is a significant absence in this larger effort to redesign the museum landscape in France: the relationship between French culture and the cultures of colonized peoples. Whether the Musée du Quai Branly will pave the way for such a relationship remains to be seen.

## NOTES

Unless otherwise attributed, all translations are the author's own.

1. Nélia Dias, *Le musée d'ethnographie du Trocadéro (1878–1908): Anthropologie et muséologie en France* (Paris: Éditions du Centre National de la Recherche Scientifique, 1991).

2. Alice L. Conklin, "Civil Society, Science and Empire in Late Republican France: The Foundation of Paris's Museum of Man," *Osiris* 17 (2002): 284.

3. Alain Touraine, *Pourrons-nous vivre ensemble? Égaux et différents* (Paris: Fayard, 1997); Michel Wieviorka, *La Différence* (Paris: Editions Balland, 2001); Idem, ed., *Une société frag-*

*mentée? Le multiculturalisme en débat* (Paris: La Découverte, 1996); Idem, ed., *La différence culturelle: Une reformulation des débats* (Paris: Balland, 2001); Tzvetan Todorov, *Nous et les autres: La réflexion française sur la diversité humaine* (Paris: Editions du Seuil, 1989).

4. Louis Dumont, *Essais sur l'individualisme: Une perspective anthropologique sur l'idéologie moderne* (Paris: Seuil, 1983); Jean-Loup Amselle, *Vers un multiculturalisme français: L'empire de la coutume* (Paris: Flammarion, 2001, orig. pub. 1996).

5. Terence Turner, "Anthropology and Multiculturalism: What Is Anthropology that Multiculturalists Should Be Mindful of It?" in *Multiculturalism: A Critical Reader,* ed. D. T. Goldberg (Oxford: Blackwell, 1997), 406–407.

6. On this museum see Dias, *Le musée d'ethnographie du Trocadéro.*

7. Alice L Conklin, *A Mission to Civilize: The Republican Idea of Empire in France and West Africa 1895–1930* (Stanford, Calif.: Stanford University Press, 1997), 1.

8. Herman Lebovics, *Mona Lisa's Escort: André Malraux and the Reinvention of French Culture* (Ithaca, N.Y.: Cornell University Press, 1999), 29.

9. Jean Jamin, "Le savant et le politique: Paul Rivet 1876–1958," *Bulletin de la Société d'Anthropologie de Paris* 3–4 (1988): 277–94.

10. Daniel J. Sherman, "Peoples Ethnographic: Objects, Museums, and the Colonial Inheritance of French Ethnology," *French Historical Studies* 27, no. 3 (2004): 678.

11. Marcel Mauss, "L'enseignement de l'histoire des religions des peuples non civilisés à l'Ecole des hautes études. Leçon d'ouverture," *Revue de l'histoire des religions* 45 (1902): 35–55.

12. The term ethnology was chosen during the late 1920s to designate the science of synthesis, encompassing physical anthropology, ethnography, and prehistoric archaeology.

13. Charles Taylor, "The Politics of Recognition," in *Multiculturalism and "The Politics of Recognition,"* ed. A. Gutmann (Princeton, N.J.: Princeton University Press, 1992), 41.

14. In this respect I cannot but disagree with Alice Conklin's argument that "Rivet used both bones and objects to try to convince the public of the equality of all peoples and cultures" (see Conklin, "Civil Society": 255). Later in her article she states that the museum's directors "sought to communicate . . . results that proved the equality of all peoples and cultures, if not their equal degree of civilization" (289). As I have pointed out, it is necessary to distinguish between equivalence of cultures (*égalité des cultures*) and the "equal degree of civilization."

15. Marcel Mauss, "Les Arts Indigènes," *Lyon Universitaire,* April–May 1931, 2.

16. Soustelle, quoted in Conklin, "Civil Society": 279.

17. Conklin, *A Mission,* 187.

18. Benoît de L'Estoile, "From the Colonial Exhibition to the Museum of Man: An Alternative Genealogy of French Anthropology," *Social Anthropology* 11, no. 3 (2003): 341–61.

19. Shanny Peer, *France on Display: Peasants, Provincials, and Folklore in the 1937 World's Fair* (Albany, N.Y.: SUNY Press, 1998), 143, 196.

20. Sherman, "Peoples Ethnographic": 698.

21. Herman Lebovics, *True France: The Wars over Cultural Identity 1900–1945* (Ithaca, N.Y.: Cornell University Press, 1992), 170.

22. Louis Dumont's manifesto "Non aux arts premiers" was published in *Le Monde,* 25 October 1996. Through committees, manifestos, and manifestations, the film-maker Jean Rouch was among the first and the fiercest opponents of the break-up of the Musée de l'Homme.

23. On this new museum and its links with the Pavillon des Sessions, see Nélia Dias, "Esquisse ethnographique d'un projet: le Musée du quai Branly," *French Politics, Culture and Society* 19, no. 2 (2001): 81–101; Idem, "Une place au Louvre," in *Le Musée cannibale,* ed. M.-O. Gonseth, J. Hainard, and R. Kaehr (Neuchâtel: Musée d'ethnographie, 2002), 15–30; Élise Dubuc, "Le futur antérieur du Musée de l'Homme," *Gradhiva* 24 (1998): 71–92.

24. It is interesting to note that the recent debate around the headscarf mobilized philosophers, sociologists, and political analysts. The recent book by the anthropologist Jean-Pierre Dozon, *Frères et sujets: La France et l'Afrique en perspective* (Paris: Flammarion, 2003), provides a good example. Throughout the 350 pages of the book, focused on the historical relations between France and its former African colonies from the early nineteenth century until 1960s, there isn't a single allusion to the contemporary situation of African immigrants in France.

25. Emmanuel de Roux, "Le musée du quai Branly rejette Darwin," *Le Monde,* 19 March 2002, 31.

26. Ibid.

27. Emmanuel Désveaux, "Le musée du quai Branly au miroir de ses prédécesseurs," *Ethnologies* 24, no. 2 (2002): 219–227.

28. For the relevance of the trade in tribal art in the new French museological creations, see Raymond Corbey, "*Arts premiers* in the Louvre," *Anthropology Today* 16, no. 4 (2000): 3–6.

29. Emmanuel de Roux, "Le musée des arts premiers pousse-t-il le prix des œuvres à la hausse?" *Le Monde,* 20 March 2001, 27.

30. Corbey, "*Arts premiers*": 5.

31. De Roux, "Le musée du quai Branly."

32. Nélia Dias, "Ethnographie, arts, arts premiers: la question des designations," *Arquivos do Centro Cultural Calouste Gulbenkian* 45 (2003): 3–13.

33. Benoît de L'Estoile, "From the Colonial Exhibition to the Museum of Man: An Alternative Genealogy of French Anthropology," *Social Anthropology* 11, no. 3 (2003): 341–61; L'Estoile, "Le musée des 'arts premiers' face à l'histoire," *Arquivos do Centro Cultural Calouste Gulbenkian* 45 (2003): 41–61.

34. Quoted in de Roux, "Le musée du quai Branly."

35. Gyan Prakash, "Museum Matters," in *The End(s) of the Museum / Els Límits del museu* (Barcelona: Fundació Antoni Tàpies, 1996), 65.

36. Michel Colardelle, "Que faire des Arts et Traditions populaires? Pour un musée des Civilisations de la France et de l'Europe," *Le Débat* 99 (1998): 113–18.

37. See *La Lettre,* Musée du Quai Branly, February 2002.

38. Germain Viatte, "La muséologie au Musée du Quai Branly," *Arquivos do Centro Cultural Calouste Gulbenkian* 45 (2003): 25.

39. Henri Pena-Ruiz, *Qu'est-ce que la laïcité?* (Paris: Gallimard, 2003), 128.

40. Viatte, "La muséologie au Musée du Quai Branly": 25.

41. Tony Bennett, *The Birth of the Museum: History, Theory, Politics* (London: Routledge, 1995); Glenn Penny, "Municipal Displays: Civic Self-Promotion and the Development of German Ethnographic Museums, 1870–1914," *Social Anthropology* 6 (1998): 157–68.

42. Lebovics, *Mona Lisa's Escort,* 29.

43. Declaration of the Rights of Man and of the Citizen, trans. Keith Michael Baker, in *The Old Regime and the French Revolution,* ed. Baker, vol. 7 of *University of Chicago Readings in Western Civilization* (Chicago: University of Chicago Press, 1987).

44. Amselle, *Vers un multiculturalisme,* vii.

45. Wieviorka, *La Différence,* 214.

46. Ibid.

47. Quoted in Krzysztof Pomian, "Arts et Civilisations: un musée à définir, un musée pour les arts exotiques, entretien avec Germain Viatte," *Le Débat* 108 (2000): 82.

48. "La France est une République indivisible, laïque, démocratique et sociale. Elle assure l'égalité devant la loi de tous les citoyens sans distinction d'origine, de race, ou de religion. Elle respecte toutes les croyances."

49. For a well-documented and lucid approach to this question see the recent and useful book by Henri Pena-Ruiz, *Qu'est-ce que la laïcité?* Pena-Ruiz rightly points out the distinction between laïcité and secularization, and the specificity of the French definition of laïcité as part of the Republican contract.

50. For a detailed and well-documented discussion of these issues, see Henri Pena-Ruiz, *Philosophie de la Laïcité* (Paris: PUF, 1999) and *La Laïcité pour l'égalité* (Paris: Fayard, 2001).

51. Pena-Ruiz, *Qu'est-ce que que la laïcité?,* 186.

52. Krzysztof Pomian, "L'anthropologue et le musée: Entretien avec Maurice Godelier," *Le Débat* 108 (2000): 93.

53. Pomian, "L'anthropologue": 94.

54. On the question of *laïcité* in schools, see Pena-Ruiz, *Qu'est-ce que laïcité?,* chapter 11, "L'enseignement laïque."

55. "[Q]ui leur donne droit de se penser comme les égaux de ceux qui les ont déracinés."

56. Taylor, "The Politics of Recognition," nn. 41, 71.

57. "Ainsi, par exemple, s'il nous paraît important d'en tenir compte, nous ne pensons pas judicieux de construire un discours autour des collections qui réponde exclusivement aux revendications des autochtones. Car celles-ci s'avèrent instables, peu compatibles les unes avec les autres, ni d'ailleurs avec l'état des connaissances scientifiques." In Désveaux, "Le musée": 225.

58. John E Stanton, "Sur l'exposition Marc Couturier: Secrets," *Gradhiva* 30–31 (2001–2002): 199.

59. Brigitte Derlon and Monique Jeudy-Ballini, "Le culte muséal de l'objet sacré," *Gradhiva* 30–31 (2001–2002): 203–211.

60. Corbey, "*Arts premiers.*"

61. Pomian, "Arts et civilisations": 80.

62. Maurice Godelier, "Unir Art et Savoir," *Connaissance des Arts,* H.S., 149 (2000): 55.

63. "Une écorce peinte aborigène rivalise avec un masque de la côte Nord-Ouest, qui lui-même vaut un reliquaire du Zaïre, qui à son tour vaut un chapiteau romain, etc." Désveaux, "Le musée": 226.

64. On this double process of expropriation and appropriation, see the introduction by George W. Stocking to *Objects and Others: Essays on Museums and Material Culture* (Madison: University of Wisconsin Press, 1985), 3–14.

65. De Roux, "Le Musée du Quai Branly," 31.

66. Taylor, "The Politics of Recognition," 71.

67. Sally Price, "Cultures of the World à la Française," *American Anthropologist* 103, no. 4 (2001): 1174.

68. Focused on the biological and the cultural dimensions of the human species, the Musée de l'Homme intends also to explore the relationships between human societies and nature. On the project of refurbishing this museum, see Jean-Pierre Mohen, ed., *Le nouveau Musée de l'Homme* (Paris: Odile Jacob, 2004).

69. Daniel J. Sherman, personal communication to the author, November 2003.

70. Executive Board, American Anthropological Association, "Statement on Human Rights," *American Anthropologist* 49 (1947): 539–43.

71. For a good account of the discussion on individual and group rights, see Kwame Anthony Appiah, *The Ethics of Identity* (Princeton, N.J.: Princeton University Press, 2005), chapters 3 and 4; and Michael Ignatieff, *Human Rights as Politics and Idolatry* (Princeton, N.J.: Princeton University Press, 2001).

72. Turner, "Anthropology," 209. This author carefully distinguishes "critical multiculturalism" from "difference multiculturalism."

# Gunther von Hagens's Body Worlds

*Exhibitionary Practice, German History, and Difference*

PETER M. McISAAC

In June 2004, the California Science Center in Los Angeles premiered Body Worlds, a German anatomy exhibition with the stated goal of educating the public on health issues. This ambition turned on showing something never seen before: over two hundred specially prepared human specimens, some twenty-six of them lifelike, posed, whole human corpses. In spite of the potential for Body Worlds to shock and even offend visitors, specially preserved and arranged human corpses were something museum staff believed the U.S. public could not afford to miss. As Science Center President Jeffrey N. Rudolph argued, "I honestly believe it's the exhibit with the strongest impact of any that I've ever seen. One of the unique things about museums in general is that we show authentic things, things that are real. In this case it's something that is very close to us, that has impact for our own bodies."[1] Unusual for its explosive subject matter as well as for its supposed similarity to living bodies, the California show also offered a story that seemed to further increase its fascination, legitimacy, and historical uniqueness. Having been seen by some fifteen million visitors in Europe and Asia paying between twelve and nineteen dollars per ticket, Body Worlds was, even before its U.S. debut, the most visited, and also maybe the most profitable, traveling exhibition in history. Although the level of controversy seems lower in the

U.S., Body Worlds has arguably also been one of the most controversial of such exhibitions. From these and many other perspectives, Body Worlds seems unlike any other exhibition that has come before it.

This essay seeks to analyze modalities of difference, particularly notions of historical difference, engendered by Body Worlds as exhibition. In what follows, I work from the premise that many of the key terms underwriting Body Worlds' success and appeal are constructed by exhibitionary techniques. Approaching Body Worlds as a mode of exhibitionary knowledge production elucidates the practices, techniques, and discourses that cast displays as producing and/or enforcing ruptures vis-à-vis past epochs and traditions. An important symptom of these ruptures is a sense of progress and change, which the exhibition valorizes as part of its contribution to public enlightenment. My approach is divided into four parts. In part one, I analyze Body Worlds' engagement with traditions of art and anatomical imaging as a lead up to an analysis in part two of the show as an exhibition. In the third, I probe the exhibition's use of concepts of tolerance and authentic self-exposure as a means of signifying its allegiance to democratic values, which, in part four, I situate with respect to the German discursive fields that shaped the exhibition's construction and reception in its first seven years.

Study of the German context cannot be neglected, for several reasons. First, Body Worlds' main organizers, Dr. Gunther von Hagens and his wife, Dr. Angelina Whalley, grew up and were trained in post-war East and West German society and institutions. Body Worlds' impact has, second, been especially well documented and felt in Germany; it ran in more German-speaking cities and over a longer time span (1997–2004) than in any other country, and no other country has seen such fierce and sustained controversy about it. The intensity of German controversy has partly to do with the legacies of the Holocaust, which inform debates on medical ethics and political values in some ways unique to Germany and in some ways that are universal. Important to my argument is the notion that conscious affirmations of "democratic" principles are simultaneously inscribed with impartially or irrationally articulated rejections of Germany's problematic past. Seen in this way, Body Worlds offers visitors the opportunity to stake out differences between today's Germany and past authoritarian epochs in both reflective and irrational, ritualistic ways, not only dispelling myths and taboos, but also inscribing new taboo zones in discourses of German identity. Body Worlds was

created when German understandings of how the past and present relate to each other were shifting, which in turn affects "democratic" concepts such as tolerance, human dignity, and personal autonomy. It is not surprising that German cultural discourses having to do with race, the symbolism of showing corpses in public, and the valences of incorporating dissent into exhibitions affect interpretation of the show. At the same time, many of the reasons that Body Worlds resonates with German visitors, such as thrill-seeking and obsession with embodiment, are shared by visitors the world over, as becomes clear when looking at the show's reception in Great Britain. In this regard, it is highly significant that Body Worlds presents its bodies as exemplars of universal medical and Enlightenment principles, valid for all cultures. Yet the universal claims made by organizers are informed by the experience they bring to each subsequent venue, a point that becomes especially clear when casting a brief glance at the U.S. staging of the show. Overall, then, this essay is about what it means for universalized bodies to be shown for the purpose of public enlightenment at the millennium, with a non-exclusive emphasis on the German intellectual framework.

## Body Worlds: A Renewed Dialogue between Art and Anatomy

The Body Worlds exhibitions had their public debut in 1996 and have shown nearly continuously ever since, most often in an environment of intense debate in which one of the few things the opposing sides can agree on is that nothing like Body Worlds has never been seen before. For supporters, the public exhibition of corpses becomes a mass medium for an unparalleled democratization of medical knowledge and for confronting our mortality in a groundbreaking, modern way. Tissues preserved using von Hagens's techniques, which he calls "plastination," are capable of being shaped as the polymers harden, allowing corpses to be presented in free-standing poses and with organs expanded in space. Because they are dry and odorless, preserved tissues look alive and tend not to induce the feelings of disgust and revulsion common to the presentation of tissues in alcohol and formaldehyde. Plastination revolutionizes internal anatomy for lay audiences, revealing organ systems and the effects of cancer, heart disease, and behaviors such as smoking in innovative and creative ways. For organizers and supporters, Gunther von Hagens's pioneering spirit produces social benefits in the truest sense of the

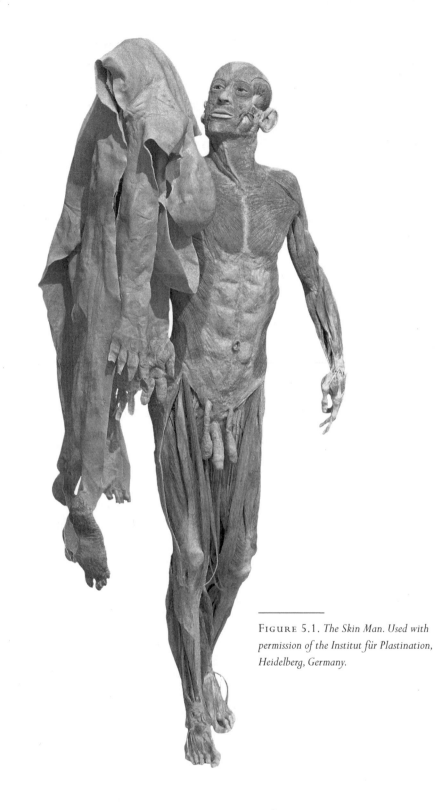

FIGURE 5.1. *The Skin Man. Used with permission of the Institut für Plastination, Heidelberg, Germany.*

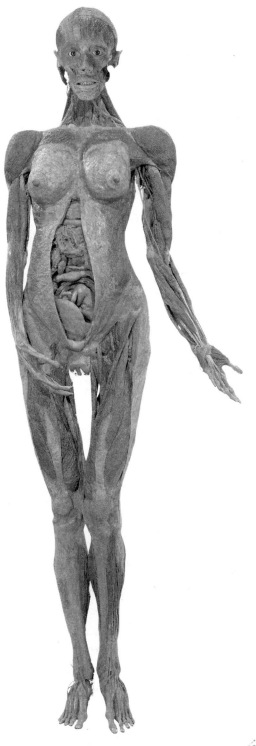

FIGURE 5.2. Posed female figure.
*Used with permission of the Institut für*
*Plastination, Heidelberg, Germany.*

Enlightenment, increasing knowledge and shattering taboos and superstitions that inhibit human progress.

Of course, not everyone regards Body Worlds as a welcome innovation or a contribution to public enlightenment. Most everywhere it has shown, Body Worlds has generated controversy about its permissibility and the actual benefits of displaying plastinated human corpses. Instead of popular science, many critics see a sensational freak show, its gruesome qualities underscored by Gunther von Hagens's eccentric persona and the sometimes bizarre poses of his specimens. Body Worlds especially disturbs religious groups, for whom the lurid public spectacle of human corpses violates human dignity and respect for the dead. The fact that Body Worlds is a private, for-profit undertaking raises hackles still further: its commercial orientation conflicts with its proclaimed public service and the altruism behind donors' leaving their bodies to science. Moreover, it is not even clear that all of von Hagens's specimens were obtained from willing and consenting adults. Allegations have persisted that von Hagens trades in a global black market for body parts and has procured bodies from prisoners, the homeless, and the mentally ill in Russia and China, heightening concerns that the ethical grounding of the show is anything but sound. Like supporters, critics and skeptics of Body Worlds feel that it represents something unprecedented in history, but for them, Body Worlds represents a new social low.

The heavy criticisms and stark polarization produced by the exhibition have tended to drive admission numbers higher.[2] Yet visitors also come because comprehending the human body is a core problem for a host of artistic, scientific, and scholarly projects at the beginning of the twenty-first century. In medicine, imaging technologies such as MRI, CAT scans, and ultrasound continue to open new vistas on the body, enabling improvements in the research, diagnosis, and treatment of disorders and bringing about changes in how we view issues such as reproduction. High-profile undertakings such as the Visible Human Project, a high-resolution digital rendering of entire male and female corpses for virtual anatomical simulations, couple advanced imaging with the networked dissemination of data, changing the place of the cadaver in fields ranging from the study of anatomy to the simulation of surgical techniques.[3] Meanwhile, a whole spectrum of medical and quasi-medical practices, from genomics, implants, and cosmetic surgery to piercing, tattoos, exercise, and dieting, promise to allow the alteration of the

body as much for aesthetic as for health purposes. And for a variety of political, philosophical, and aesthetic reasons, contemporary artists and scholars are also reassessing conceptions of the body in light of new configurations of medicine and aesthetics and prevailing currents in philosophy. Though attention is rightly paid to the ethical and human rights issues these conceptions raise, a significant part of this complex work attempts to uncover and/or expose conceptions of the body generally lost to medical non-specialists since the end of the nineteenth century, imbuing contemporary projects with a kind of exhibitionary logic. Indeed, by interrogating earlier medical practices in their work (thus prompting us to reconstruct those contexts), artists such as Kiki Smith, Damien Hirst, Cindy Sherman, and John Isaacs, to name only a few, remind us that the history of bodily representation is punctuated with rich exchanges between medicine, aesthetics, and metaphysics.[4] In part because it, too, attempts to expose eras when illuminating the body promised to shed light on the mysteries of existence, Body Worlds resonates with contemporary cultures that are obsessed with embodiment and expecting to find significance in the exposed human body.

It is not possible here to offer more than a cursory treatment of anatomical imaging since the Renaissance. Medical, artistic, and religious imaginary contents have often overlapped in the anatomical study of the human figure, in both the physical dissection of the body and the representation of its structures. In the Renaissance, artists such as Michelangelo and Leonardo da Vinci are reported to have consulted with anatomists as well as, in da Vinci's case, even dissecting cadavers alone.[5] Informed by the practices and conventions established by Renaissance artists and anatomists, representations aimed to convey their fidelity to anatomical structures and at the same time reveal the (beautiful) body as "divine machine," a creation whose proportions, symmetries, and intricacies manifest God's design.[6] To persuade viewers of their fidelity and relationship to the divine, anatomical figures had to appear against backdrops and in poses implying movement and life.

By the time other media and techniques had developed after 1700, medical, artistic, and religious imaginaries had also shifted. Artists working in seventeenth- and eighteenth-century anatomy schools in Bologna, Florence, and France used colored waxes to model human organs and bodies with a lifelike, three-dimensional appearance. These masters' task required working from large numbers of corpses, meaning that a single model was a highly

detailed composite derived from as many as two hundred different bodies.[7] Sculpting in wax allowed the creation of some figures that could be disassembled layer by layer to reveal the position of organ systems, anticipating techniques and metaphors of transparency later employed in "visible human" figures made from glass during the nineteenth and twentieth centuries.[8] As in the Renaissance, the unprecedented detail of the whole-body wax models was supported by poses and contexts that heightened their lifelike realism. In the eighteenth century, however, artists used the prevailing tropes of Baroque saints and classical figuration to secure insights into the meaning and pathos of life, death, and the afterlife.[9]

As in previous epochs, the development of technological media such as photography, cinema, and X-rays, together with the professionalization of art and medicine, led to new configurations of medical, aesthetic, and cultural imaginaries. Public autopsies were discontinued as the dissection of bodies became the purview of medical specialists. At the same time, a kind of professional facticity can be detected in nineteenth- and twentieth-century uses of traditional media, for instance in the woodcuts of Gray's *Anatomy,* that seems to banish any sense of theatricality from the presentation of the dissected body.[10] Yet, as Lisa Cartwright's scholarship on medical films demonstrates, the seemingly objective, scientific uses of technological apparatus to image and flay the moving body are informed by modernist aesthetic conventions of visuality on the one hand and gender-specific morality on the other.[11] Even in an age purporting to have diminished the spectacle and drama of opening the body, powerful aesthetic, ethical, and emotional investments accompany medical dismemberment.

With respect to traditions of art and anatomy, Body Worlds seeks to advance a twofold claim to innovation. On the one hand, it portrays itself as an unprecedented anatomical imaging technology that surpasses even the most sophisticated apparatus of the twentieth century. On the other, it seeks to expose the ruptures in tradition wrought by enlightened medical practice. With respect to the first point, it is productive to think of plastination and its arrangement in von Hagens's exhibition environment as a medical imaging technology that illustrates the body with high precision, verisimilitude, and three-dimensional materiality. The display techniques used in Body Worlds enable a visualization of the body "from the inside out," so to speak, revealing the tight relationships of internal structures and systems within the body and their relationship to external

form. From the preparation of the specimen to its placement in the exhibition environment, the technologies and techniques aim to provide a vision and experience of bodies as they "really are." "Plastination gives rise to this visual materiality," von Hagens writes, "making the internal body authentically perceptible in three dimensions."[12] Though Body Worlds' concept of authenticity is by no means simple, the techniques employed in the show are supposed to introduce almost no distortion with respect to living bodies.

## Body Worlds as Popular Science Exhibition: The Return of a Nineteenth-Century Mass Medium?

Calling the display of plastinates a medical imaging technology reveals how it represents an advance over previous anatomical traditions and existing medical imaging technologies such as X-rays, magnetic resonance imaging (MRI), computer simulation, and ultrasound. As von Hagens writes, "Plastinates are dry, odorless and precise all the way down to the microscopic range. They can be flexible, hard and even transparent. This makes them the most natural and lasting permanent specimens since the advent of anatomy."[13] No other technology, neither the two-dimensional electronic techniques nor more traditional glass and wax models, can offer the combination of fine resolution, material presence, and three-dimensionality of plastination.[14] In other words, plastination has historical and traditional predecessors and even competitors, but no equal in any respect when it comes to rendering the human body visible: Body Worlds represents both the culmination of anatomy and the "cutting edge" of medicine.

Yet though the vision might seem new, Body Worlds' cutting-edge status is constructed through exhibitionary techniques that are in fact familiar and relatively conventional. The insistence on the exhibition's uniqueness frames the entire show in the form of the technological prehistory that one hears on the acoustiguide or reads in the opening chapters of the exhibition catalogue. The technical apparatus of plastination is likewise prominently displayed and explained at shows. That visitors seem not to question its uncomplicated claims to exhibitionary innovation is perhaps more an indication that the decoding of exhibitions is by now second nature to broad swaths of the general public than of Body Worlds employing groundbreaking techniques. As the otherwise awkward title "Body Worlds" can help us see, von Hagens's display technologies at core offer a fairly conventional "colonizing of reality," to

paraphrase Timothy Mitchell.[15] Indeed, after a century or more of Western-
ers seeing the world as "colonized reality," one of the more remarkable fea-
tures about Body Worlds is that its exhibitionary methods seem
unremarkable. One of the signatures of nineteenth-century technology exhi-
bitions was the construction of the present cultural moment in terms of
progress relative to the techniques, technologies, apparatus, and beliefs of
earlier epochs. In presenting itself as a technological advance, Body Worlds
recalls this quintessentially nineteenth-century exhibitionary mode.

The exhibitionary rhetoric exerts itself most forcefully in the way par-
ticular specimens reveal and make things visible. Von Hagens's specimens
tirelessly present the effects of behaviors such as smoking on the heart and
lungs. The installations devote special attention to the appearance and place-
ment of advanced medical devices such as pacemakers and prosthetic joints.
With respect to these installations, it is useful to consider a point made by
Ludmilla Jordanova, who has observed that medical museums traditionally
tend to enact what she calls "double representation."[16] With this term Jor-
danova describes how a discovery made or represented through the tech-
niques or theories of a researcher is literally re-presented to be discovered
anew, most usually by a layperson.[17] In Jordanova's terms, von Hagens might
be seen as transmitting the message to visitors, "this is how the body works
because my theory and technology say it works this way."[18] Thus, von Hagens
"trumps" and encompasses all medical technology with his creations and dis-
plays, which he inscribes at the apex of an order of things produced by his
exhibition. The view prevails that von Hagens's technological vision has for-
ever changed the way we can look at our bodies and mortality, enforcing a
rupture between the present and the past.

Organizers claim that a significant aspect of plastination's technological
superiority resides in its seeming ability to vanish. According to von Hagens,
most imaging technologies detract from our ability to apprehend the bodies be-
fore us because the performance of the technology tends to draw attention
above all to itself, making the mediating technology in some sense the "mes-
sage." In contrast, plastination achieves its effects while tending toward imper-
ceptibility. Thus, in the rhetoric of Body Worlds, "it is the body itself that
fascinates, not new means of reproducing and mapping" it through virtual tech-
nologies.[19] Yet despite plastination's differences from other technologies, it
seems disingenuous, even misleading, to assert that the technology is also not

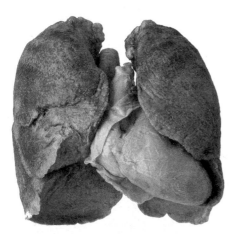

FigURE 5.3. Smoker's lung. *Used with permission of the Institut für Plastination, Heidelberg, Germany.*

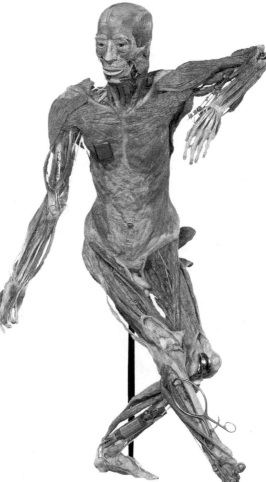

FigURE 5.4. *Dancer,* showing prostheses and implants. *Used with permission of the Institut für Plastination, Heidelberg, Germany.*

FIGURE 5.5. Hip replacement. *Used with permission of the Institut für Plastination, Heidelberg, Germany.*

somehow part of Body Worlds' message. Each version of the exhibition explains the respective technological processes in a special installation. Catalogues and Web presentations likewise dedicate significant attention to the technology, reminding us not to forget its invisible operations.[20] Moreover, visitors are regularly reminded of what they would encounter were the technology not employed, finding leitmotifs such as, "plastination stops decay and shriveling so completely that the inside of the body ceases to be an object of disgust. No smell disturbs the viewing."[21] Paradoxically, the very absence of certain aesthetic and sensory conditions confirms the presence of the technology.

Another way of expressing the relationship of the vanishing technology to the authentic bodies on display is in terms of a realism guaranteed by certain exhibitionary conventions. As has been discussed, many of the functions of Body Worlds turn on the claim to authenticity and the material reality made of the bodies on display.[22] Because of both the particular techniques of plastination and traditional anatomical conventions, the materiality of the bodies and the illusion enhanced by framing devices are so intertwined that they cannot be meaningfully separated. This becomes clearer by noting that plastination is carried out on bodies, organs, and tissues immediately following death, with material to be plastinated placed in a cold acetone bath that allows the removal

of water and soluble fats without damaging the remaining tissues.[23] After the object is transferred to a vacuum chamber, the acetone is driven out and replaced with polymers under vacuum.[24] Since up to 70 percent of the human body is water, roughly the same amount of a plastinated specimen will be polymer, leading von Hagens to argue for some legal purposes that the traditional legal definition of corpse does not apply.[25] Even for von Hagens, then, the "real" is not as straightforward as it might seem. More important, however, when objects are taken from the vacuum chamber, they do not retain the original shape they once had. Rather, von Hagens observes that they are but a "little pile of materiality" that has to be positioned and posed as the polymers harden so that they can be made to resemble the living body.[26]

The fidelity of Body Worlds to living bodies does not result solely from plastination's ability to arrest decay. Both medical and aesthetic considerations go into the construction of the pose. On the one hand, the pose must ensure that nerves, blood vessels, and organs can be seen or envisioned in their "proper" places.[27] The authority for medical accuracy stems in part from von Hagens's traditional medical training and experience as an anatomist, and partially from his more contested assertions that he is a "Professor" and that he has some affiliation with the medical faculty of Heidelberg.[28] Von Hagens also makes regular use of a collection of twenty thousand historical anatomical images as he shapes his plastinates.[29] Together with measures such as the removal of identifying features of the face, the preservation of the confidentiality of the donors' names, and the removal of nearly all skin, this reconstruction of the body according to a culturally and historically significant body of anatomical representation advances the notion that the bodies on display are *exemplary bodies*.[30] Individual differences in organ structure, disease, or pathology can accordingly be explained in terms of *universal medical norms*. This claim to exemplarity and universality is crucial for the claim that the exhibition belongs in an Enlightenment program of teaching and learning.

At the same time, the process of rendering bodies "universal" renders conventional visual markers of racial and ethnic difference difficult to perceive. Instructive in this regard are the views of anthropologist Uli Linke, who views Body Worlds' bodies as unequivocally German:

> Presented without reference to personal biography or cause of death, the plastinated specimens perform a symbolic function: The corpses are

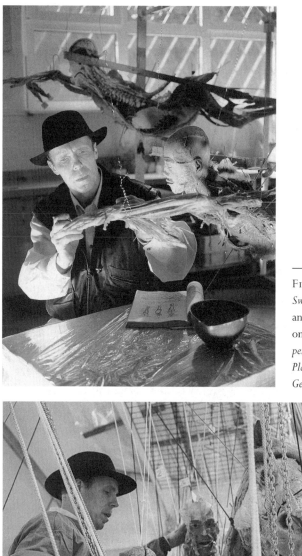

FIGURE 5.6. Positioning *Swimmer*. Note the anatomical reference book on table. *Used with permission of the Institut für Plastination, Heidelberg, Germany.*

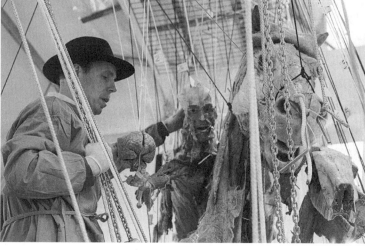

FIGURE 5.7. Positioning *Horse and Rider*. *Used with permission of the Institut für Plastination, Heidelberg, Germany.*

aesthetized [sic] in such a way as to suppress evocations of violence, victimhood, or history. Regarded as 'anatomical artworks' (Andrews), artistic 'statues' (Roth), the displays successfully evade comparisons with Nazi medical experimentation or eugenics and racial hygiene. Indeed, the refurbished corpses are plastinated *German* bodies. . . . In this exhibition of human anatomy, German ideals of the national body are inscribed onto the corpses by a medical gaze that is preoccupied with images and representations of gender and race.[31]

For Linke, Body Worlds' specimens secure their "Germanness" with the whiteness of their skin, the open display of sex differences, and the bodies' athletic postures, reinforced by the absence of pained expressions and clear markers of racial difference.[32] Reminding the reader that the specimens are, indeed, "plastinated *German* bodies," Linke fallaciously concludes that the show cannot evoke thoughts of Nazi medical experimentation and racial hygiene, presumably because Germans invariably locate themselves on the side of the historical perpetrators. But Linke assumes that the universal requires that there really is something like a more or less homogenous German body whose qualities exist prior to plastination (if the medical gaze works the way Linke claims, need the bodies be German?). In fact, von Hagens plastinates bodies of a wide range of ethnic origins. For years, he has recruited donors in a multi-cultural German society and has obtained corpses from global sources (including Russia and China), meaning that the de facto presence of racially and ethnically diverse bodies in the shows cannot be ruled out. What the erasure of these differences means depends of course on the assumptions made by individual viewers, but as Linke's reading shows, Body Worlds' universalizing construction of the body is too easy for Germans to perceive as abstract and white. One may wonder whether Body Worlds would have the same resonance in Germany if visitors had to consider that tolerance in multi-cultural societies also means accepting a wide range of bodily and cultural differences.

In addition to employing universals, the exhibitionary use of poses and the anatomical tradition underscores the production of a sense of enlightened progress. Many of the controversial poses of von Hagens's figures are quotes from historical anatomical drawings and specimens from Western anatomical traditions. Whereas the so-called *Skin Man* of Body Worlds [fig. 5.1]

is attributed to Juan Valverde's Renaissance drawing of a man flaying himself to reveal his muscles, the *Horse and Rider* specimen refers to Honoré Fragonard's *The Cavalier of the Apocalypse,* created with metal alloys and varnish.[33] Similarly, von Hagens's homage to body donors in the form of a praying skeleton recalls William Cheselden's *Side View of the Skeleton.*[34] In the London show, large reproductions of the quoted sources were regularly placed behind the plastinates. Though this mode of display clearly attempts to legitimize Body Worlds by assembling a positively valorized tradition around its objects, von Hagens's strategy can also be read as showing his exhibition to be a culminating moment in the traditions of anatomical display. As Stuart Jeffries points out, "[von Hagens] hankers after the heady days of the Renaissance and the three centuries thereafter, when anatomists and artists explored the workings of the human body as never before and made their workings public at anatomical theatres. . . . Von Hagens regards the dissection arenas that opened in Padua in 1594 and Leiden in 1597 as predecessors of his Body Worlds exhibition."[35] Picking up from his predecessors, von Hagens presents their two-dimensional illustrations and approximating models as strides toward the ultimate goal of preserving human bodies and our knowledge of them without distortion. In this view, Valverde's drawings, Cheselden's engravings, and Fragonard's metal and varnish figures simultaneously represent incremental advances in knowledge and unfulfilled desires, as if each document and specimen articulated an anatomist's vision of what material bodies would look like were the limitations of decay overcome.[36] Much as architectural blueprints anticipate a finished building, von Hagens's technological innovation enables these latent visions to be translated into manifest, material form. Progress, marked according to the ability of a method to maintain the fidelity of a specimen's appearance to living bodies in three dimensions and for all time, is thus expressed in terms of overcoming nature and as a temporal vector of refinement.

Shaping the pose allows the displayed bodies to appear convincingly real and break certain taboos, particularly prohibitions on the encounter with dead bodies and mortality. At stake in doing away with obsolete taboos is nothing less than the viewer's "bodily emancipation." For a variety of reasons, von Hagens and his supporters often claim that modern Western societies have increasingly tended to remove the processes of death and dying from public view, either banning their viewing outright, sanitizing them, or relegating

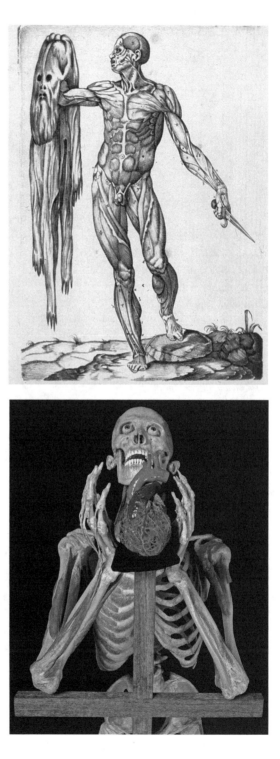

FIGURE 5.8. Muscle-man holding flayed skin, by Juan Valverde. *Juan Valverde, Anatomia del corpo humano (Rome: Ant. Salamanca, et Antonio Lafreri, 1560). Property of Duke University Medical Center Library, Trent Collection, History of Medicine Collections, Durham, N.C.*

FIGURE 5.9. Praying skeleton. *Used with permission of the Institut für Plastination, Heidelberg, Germany.*

FIGURE 5.10. *Side View of the Skeleton,* by William Cheselden. *Reprinted from William Cheselden,* Osteographia of the Anatomy of the Bones, *Philadelphia:WB Saunders, 1968, plate 36, with permission of Elsevier Inc. Property of Duke University Medical Center Library, History of Medicine Collections, Durham, N.C.*

them to the purview of specialists (medical pathology, funeral homes). What experience people in Western societies have of death is most often not first-hand and material, but rather mediated through films, television, and photographs.[37] There are a variety of arguments as to why mortality tends to be obscured in to-day's society, ranging from religious strictures to public health considerations (quick burial to prevent the spread of disease) to biological-evolutionary notions about why the sight of death and decay produces aversion. Yet, as these arguments go, it is unclear whether the prohibition is life-affirming or, in a highly modern society, any longer acutely necessary.[38] As von Hagens put it once in an interview, "there are certain taboos in our society that we need to survive. We do not need others, although we think that we do."[39]

Though von Hagens has challenged taboos, at least notionally, by questioning the assumption that "a dead body should not be funny and one

should not laugh about it," he is seldom very articulate about which precise taboos can or should *not* be overturned in light of his exhibition.[40] The argumentation usually turns on the more general notion that with technologies such as plastination, the time has come to subject all our fears of death and dying to the scrutiny of reason. Such scrutiny does not take place in a straightforward manner, because the question of death is highly emotionally charged from practically any standpoint and prevents the immediate application of reason. To prevent feelings of mourning, disgust, or fear from being triggered, a lifelike pose is sought that contains certain elements of humor, fantasy, and creativity. As von Hagens sees it, "Mourning inhibits learning and causes people to zone out. I therefore attempt to make the whole body plastinates [look] as life-like as possible. Freed from the taint of disgust, a life-like, integral anatomy becomes possible that allows the viewer to be fascinated by its authenticity [Echtheit]. . . . When the plastinate 'plays chess' or 'rides,' death is introduced into life in a downright humorous way."[41] Breaking the stranglehold of irrational taboos requires not merely a confrontation with death, but that bodies look alive, real, and at times, amusing.

Requiring bodies to appear "real" entails highly specific arrangements and displays. Von Hagens writes: "It became obvious that the instructive effect of anatomical representations is substantially influenced by the total aesthetic effect of the whole body specimens. . . . Thus I try to have the specimen appear as lifelike as possible."[42] Despite having begun with real human corpses, "correct" anatomical positioning on its own does not ensure a resemblance to real human form. An overall aesthetic effect is necessary to produce a lifelike illusion.[43] Crucial for Body Worlds is that the instructive effect and its particular aesthetic components are anchored in each other much as picture and frame reciprocally determine their respective effects. The aims of this technique go beyond deception. As von Hagens observes, "expanded whole body plastinates are successful when the arrangement causes the viewer to put the expanded fragments back into their original positions, to close the body back up before one's mental eye in a practically involuntary way. As a result, a mental animation of the expanded whole body plastinates arises in the eye of the viewer that intensifies the impression the plastinates make."[44] As plastinates such as *The Witch* demonstrate, the arrangement of certain tissues often coincides with representational conventions suggesting that the figure has only momentarily stopped while carrying

out some larger process.[45] In this figure, tendons and muscles of the calf have been drawn backwards like the parallel lines used in comics to indicate a figure in motion—in this case, flying. The impression of bodily wholeness and integrity seeks specific emotional and rational registers: viewers are to experience fascination, wonder, awe, and humor as they ponder the complex functionality of the body's organs and tissues and the fragility of the human organism. This is one way to understand von Hagens's claims that the educational potential of his shows can be achieved only through the "fascination of the real."

As staged in German exhibitory contexts (later stagings, particularly in the U.S., alter this), the Body Worlds exhibition constructs conditions that engender a reciprocal movement or oscillation between incommensurable opposites or poles. This oscillation has to do, to my mind, with shifts in the modes of collecting and collections-based knowledge production that have taken place since the Enlightenment. Curiosity and wonder inhered to Renaissance and Baroque collections such as *Wunderkammern,* furthering what was considered knowledge in those periods. As Katharine Park and Lorraine Daston stress with regard to early modern theories of wonder, "to register wonder was to register a breached boundary, a classification subverted. The making and breaking of categories—sacred and profane; natural and artificial; animal, vegetable and mineral; sublunar and celestial—is the Ur-act of cognition, underpinning all pursuit of regularities and discovery of causes."[46] Collections of wondrous objects were especially effective in overturning basic assumptions.[47] But with the Enlightenment, scientific status began to hinge on the establishment of visually identifiable notions of order and classification over and against perceptions of wonder, curiosity, and the spectacular.[48] Consequently, writes Susan A. Crane, "curiosity is no longer sufficient grounds, nor a satisfactory object, for museum collecting; plenitude is no longer representative of a worldview but of disorder; and persistent interest in curiosities now relegates the collector to the status of dilettante."[49]

The dominance of the new paradigm did not mean the total elimination of curiosity, wonder, or the spectacular. Rather, they tended to be subject to dynamics of repression and the return of the repressed. Carla Yanni puts it nicely when she writes, the "theatricality of displays stayed with museums: a ghost from Baroque Italy, it trailed the display of natural objects well into the nineteenth century, when professional museum keepers shunned spectacle

FIGURE 5.11. *The Witch. Used with permission of the Institut für Plastination, Heidelberg, Germany.*

and theatrics."[50] The perception of an opposition between dispassionate rational pursuits and the inspiration of most kinds of emotion led natural history collections in the nineteenth and twentieth centuries to dampen much of their emotional appeal as strongly as possible so as to enhance scientific legitimacy.[51] Recent developments such as scientific "edutainment," according to Stephen Asma, promote rather than suppress a sense of movement between the incompatible poles.[52] Since von Hagens has increasingly invoked

the edutainment paradigm as a way of clarifying his own purposes in his exhibitions, it is worth examining how the "real" in Body Worlds resides in an oscillation between the material and illusory, between detached observation and emotional effects.[53]

In Body Worlds, such an oscillation is pronounced in and inseparable from the particular environment that enhances the effects of both poles. Such a context can be viewed as a kind of exhibitory framing that enhances some details and inhibits others, shaping the narratives that can be constructed on the basis of the objects and their environment. While in North America Body Worlds has, for reasons I will discuss in a moment, been presented only in established science museums, European showings nearly always took place in "popular," non-scientific venues such as tents, old train stations, former breweries, and a Hamburg sex museum, situating their experience outside the realm of officially codified educational institutions. Immediate installations also shape visitors' narratives. Von Hagens makes this apparent when he explains how he produces a lifelike effect: "the illusion of animation can even be amplified through a particular preparation of the face, an emotional pose, typical accoutrements such as accessories, clothing, tools and the creation of an exhibition space that is familiar to the viewer, such as a workplace or open nature."[54]

In Body Worlds, props and proper placement in the display environment—often a garden-like setting—use aesthetics to enhance the lifelike illusion. But authenticity also amplifies the exhibition environment. In Cologne, for instance, an itinerary through the exhibition started with presentations of individual organs and organ systems and thin sections of bodies. These are precisely the types of plastination that von Hagens began with when his attention was still focused on strictly professional applications of his methods.[55] As some anatomists have written, they are in fact the specimens with the most direct professional value.[56] The path moved on to increasingly interpretive and posed figures, culminating in the most notorious ones such as *The Lasso Thrower, The Fencer,* and *The Chess Player.* Along the way, medical students were available to confirm information presented through the specimens as accurate and true to the body as understood by medical science. At the very end, visitors were also reminded of the provenance of the displayed specimens with cards that gave them the chance to donate their bodies to the Institute for Plastination, an act that provides special opportunities to verify just how "real" everything is. In June 2003, some 650 of the over 5,500 future Body Worlds donors received a guided tour of the facilities in

Heidelberg "in order to make human anatomy [still] more palpable."[57] One of the "highlights" of this event was the opportunity for the son of one donor to witness and inspect his deceased father's transformation into a kind of eternal life as an exhibit with near-perfect fidelity to the bodily trappings of the being who once inhabited them.[58] Publicizing donors' ability to go "behind the scenes" also promotes plastination and display as transparent processes with nothing to hide, offering a vantage point from which to authenticate the workings of the exhibitionary apparatus.

By strengthening the effects of both poles, as was done in Europe, the exhibition intensifies the oscillation that can take place there. For this reason, it can be said that the Body Worlds is as real as it is completely staged. Bending itself both to instructive viewing and to idle gawking, it is at once, and inseparably, scientific and aesthetic. If viewer perceptions are to span opposing notions, widely divergent and indeed polarized readings might be expected.[59] Moreover, since even otherwise well-informed visitors to Body Worlds are unlikely to reflect much about how exhibition techniques mediate knowledge, structure their experience, and perhaps even confirm their expectations, the exhibition only reinforces an already powerful component of museal display's cultural operation. A polarization of views among European visitors was not the only predictable outcome in this instance, and in the end it does not matter whether von Hagens sought this effect intentionally. For a for-profit show, the promotion of oscillating views is a museal effect that helps ensure a high public profile and continued public interest, especially when fed to media outlets that also tend to polarize positions in their reporting.[60] It is thus significant that the vestibule in which visitors waited to buy tickets for the London show displayed newspaper articles debating the show's merits. The strongly pro and contra nature of those articles created an expectation that every visitor would probably come down on one side or the other.

With regard to oscillation and visitor polarization, marked shifts accompanied the exhibition's transplantation to the North American context, with von Hagens and his staff anticipating how the audience would respond to the show and affect its profitability. In light of the different cultural expectations and sensibilities, what worked to sensationalize the show and maximize oscillation in Germany and Britain needed adjustment in North America. As organizers wrote upon taking leave of Europe following the last installation in Frankfurt,

FIGURE 5.12. *The Biker.* Note props and backdrop. *Used with permission of the Institut für Plastination, Heidelberg, Germany.*

FIGURE 5.13. Sliced sections of male and female corpses. *Used with permission of the Institut für Plastination, Heidelberg, Germany.*

FIGURE 5.14. *The Fencer. Used with permission of the Institut für Plastination, Heidelberg, Germany.*

The traveling exhibition Body Worlds is about to go long-term to the USA; there the cards are going to get reshuffled. Much of what we have thus far learned will be useful to us there. And many things that were easy in Germany will cause us problems in the US. [We expect] that the nakedness of the exhibition will be more controversial in a relatively prudish America than it was in Germany, [while] the successful ability to finance the exhibition on our own will be attacked less out of jealousy, but will instead be recognized as an independent achievement.[61]

Drawing on their sense of what they had learned about the European response to the show, organizers addressed their concerns about American

prudishness by ensuring that exhibitions took place in recognized educational venues such as the Science Museum of Minnesota and the Denver Museum of Nature and Science. Beyond the sense of propriety associated with the surrounding venues, reinforced at each subsequent exhibition, von Hagens had an ethics commission sign off on the appropriateness of the show before its Los Angeles and Cleveland debuts.[62] He also made sure that his exhibition is presented as part of a larger slate of offerings (a "combi-ticket") that typically includes the BBC IMAX documentary *The Human Body*.[63] These legitimizing strategies have led to a much less controversial North American reception than might have been the case had the European practices been continued. Indeed, it is remarkable that at a time when the U.S. religious right seized on any case that seemed to violate the sanctity of the body before or after death (such as the debate on Terry Schiavo's right to die), religious leaders have largely seen fit to endorse or ignore Body Worlds.[64] Having employed techniques that tone down the tendency to polarize visitor response, the show probably attracts less controversy and fewer visitors than it had in Europe but avoids offending a large constituency whose opposition might, if aroused, possibly jeopardize the whole North American enterprise. In light of how the show has been situated with respect to German discourses of democracy, von Hagens's unwillingness to become a test case for democratic tolerance in the United States becomes very conspicuous.

But whether one thinks of the European or North American responses to the show, it is worth asking why Body Worlds and its "fascination of the real" seem to have a particular appeal at the beginning of the third millennium. Body Worlds comes onto the scene at a time when technology in general, and medical technology and research in particular, are beginning radically to alter people's relationship to corporeality and to death. On the one hand, genetic engineering and other medical advances are promising to extend life for ever larger periods of time, changing how we perceive our existence in time.[65] On the other hand, computers and other electronics are rendering the body and the subject less necessary for everyday transactions and even communicative interaction with other people. Either way, there is a tendency for philosophical and cultural positions to be situated less and less in the past and future, with positions rooted in a temporal present (or "out of time") coming instead to the fore.[66] As Fredric Jameson has recently argued,

"the reduction to the present can thus also be formulated in terms of a reduction to the body as a present of time."[67]

This sense that the body is the only potentially lasting aspect of our existence is the source of both exhilaration and anxiety, and is manifest in the rise of the "cult of the body" (discernible in tattoos, piercing, bodybuilding, fitness, and plastic surgery) and the end of the traditional subject. These developments are an enabling condition of Body Worlds in two ways. First, the material body and the temporality of its decay can be made visible, indeed worth saving, only once they have passed into a kind of obsolescence. Yet in contrast, the exhibition attracts many visitors for its ability to hold out the metaphysical promise of eternity and immortality expressed through a particular materialization of the body. Many visitors pledging their bodies to von Hagens find it comforting that after death, their bodies will not be "eaten by worms" or "turned off like a computer screen." Some even see themselves "functioning" after death, in that others will learn about anatomy and health and potentially admire them for their splendid bodies, the lives they lived (represented by bodily traces), and/or the contribution their donation represents to science and humanity. With at least some donors and visitors, being on view seems to confer a particular sense of importance and value in and of itself. Recent statements and the very organization of the shows have reinforced this sense that value derives from being shown. The London installation saw the prominent addition of two new plastinates, respectively holding out liver and heart in sacrifice (see, for instance, fig. 5.9), both explicitly dedicated to the memory of those who have donated their bodies to Body Worlds.[68] Yet the eternity that the exhibition can deliver is, crucially, never one's own. The exhibition reinforces an imaginary notion of the body as a totality that provides the capacity "to organize the world without participating in it."[69] Even those who donate their bodies to the plastinator can only have fantasies, based on their experience of viewing the bodies of others, about what it will be like to have their dead bodies placed on view for others to look at.[70]

## Tolerance, Self-Exposure, and the Allegiance to Democratic Values?

An important dimension to Body Worlds is how it stages its own relationship to critical voices and the debates about it. Practically every aspect of the show's construction and promotion has seemed predicated on presenting

itself as a mode and model of enlightened liberation and tolerance. On one level, a vision of von Hagens himself is at stake in the exhibition, through which he presents himself as a guarantor of these values. Whereas the express desire to break taboos and crush superstitions is a part of this vision, another dimension couches plastination in terms of an at times personal struggle for democratic freedoms. Originally a citizen of the German Democratic Republic (GDR), von Hagens spent twenty-one months in an East German prison in the late 1960s for an abortive attempt to escape to the West. Von Hagens was one of the many East German prisoners in those years released to the West in exchange for financial compensation from the West German government. Arriving in West Germany in 1970, von Hagens resolved to make the most of his newly won freedoms and to pursue his ideas and dreams to the bitter end. He recalls in the exhibition catalogue that his thoughts on the day he invented plastination in 1977 centered on these political notions. In contrast to his wavering about whether to flee the GDR, in the West he embraced a "clear decision this time in favor of uncertainty, which is always an opportunity at the same time."[71] In his narrative, von Hagens stylizes himself as someone who has felt the struggle for democracy on his own body and as someone whose integrity deserves to be trusted. Specifically commenting on the relationship of von Hagens's biography to the significance of the show, Bazon Brock, a prominent German art historian, validated the exhibition's mythmaking on the basis of its maker's positive qualities. As Brock notes, "authenticity is established when one goes to jail for one's convictions."[72]

Authenticity in Brock's sense means refusing to hide in the face of controversy or danger, and it is through figures of brave self-exposure and openness that von Hagens's refusal intersects with the logic of Body Worlds as exhibition, on the one hand, and certain tropes of post-war German democracy, on the other. With respect to the former, von Hagens's endorsement of plastination's "uncertainty" inflects the technique as an embrace of knowledge that obligates its discoverer to expose his knowledge and the resulting burdens. Von Hagens would betray more than himself were he to suppress either the display of authenticated bodies or the slings and arrows of criticism that display has provoked: the presentation of critiques in the open visitor guest book is thus integral to a Body Worlds exhibition predicated on authenticity. In turn, the notions of self-exposure and openness resonate with long-established, post-war tropes of German democracy signaling the workings of a government

committed to antiauthoritarian principles, particularly in architecture and art exhibitions. The glass dome of Norman (Lord) Foster's renovated Reichstag that permits ordinary citizens to stand above and "oversee" the parliamentary chamber of the Bundestag is only the latest iteration of tropes of transparency and citizen empowerment found around the world in the anti-monumental, modernist glass and steel façades of West German government buildings.[73] In these buildings, acts of exhibition complement these architectural tropes, with over thirty-three million dollars having being set aside to procure and commission art by Sigmar Polke, Gerhard Richter, Hanne Darboven, Jenny Holzer, and Christian Boltanski.[74] Some artists, among them Hans Haacke and Thomas Schütte, refused commissions, seeing in them an attempt to co-opt art for political purposes and a papering over of the decades in which the German state had manipulated art exhibitions for ideological purposes, from the interventions of Emperor Wilhelm II around 1900 and the Nazis' "degenerate art" exhibits in the 1930s to the promotion of artistic programs by both East and West in the Cold War.[75] Though the exhibition of art in state buildings cannot be seen as either strictly perpetuating or rupturing these traditions, the government intends its embrace of contemporary art to represent its commitment to democratic openness, tolerance, and critique of authority. For the German government as for von Hagens, authenticity is won by ostentatious self-exposure.

Because plastination is thoroughly intertwined with von Hagens's story of integrity and authenticity, his narrative also locates Body Worlds subtly but squarely within the parameters of "democratic science," giving the impression that von Hagens implicitly disavows certain traditions. As Thomas Assheuer noted in the weekly *Die Zeit,* "If one did not know [that von Hagens had been imprisoned in the GDR for attempting to escape], one might believe that his necromania had come from the vaults of East German socialist science. It was notorious for its will to knowledge and for its slavish obedience [*Kadavergehorsam,* lit. "obedience until death"] with respect to progress. It resolutely believed that humanity could be delivered from myths and the fickleness of nature as well."[76] One only needs to recall the medical abuse of GDR athletes in the name of attaining enlightened socialism to have a sense of the destructive forms this science could take.[77] Since von Hagens began studying medicine as a member of the Socialist party in Jena three years before his decision to leave the GDR, his current project may not be as divorced

from socialist science as von Hagens's personal narrative or Assheuer's analysis imply.

True, von Hagens claims that his experience of party hypocrisy disabused him of any desire to remain in the GDR.[78] Yet he has set up massive plastination facilities in Kyrgyzstan and China, which, as globalized business ventures, offer him lower operating costs and less stringent regulations than in Europe, and connections he can exploit since he grew up in an East Bloc country. As he explained in an interview with Didi Tatlow, "I grew up in East Germany, and I really feel very at home in China. . . . It almost reminds me of my childhood. Little things, like the cups they use in hospitals. Also, I know how to deal with Communist Party secretaries. I know I'll get someplace with them."[79] Recent evidence that von Hagens's Dalian facility had accepted the bodies of executed Chinese prisoners casts doubt on the notion that Body Worlds can be readily dissociated from socialist science. Indeed, Assheuer's point about the abuses of enlightenment progress underscores the fact that the relationship between science and the attainment of democratic freedoms and protections is not automatic, particularly in light of twentieth-century German history. Before the GDR, the Nazis also sought to "enlighten" its populace about good bodily health (always linked to notions of racial hygiene) by using transparent, gendered anatomical models that traveled within Germany and abroad; they also carried out horrendous medical experiments on victims of the Holocaust in the name of "science."[80] Though real and meaningful distinctions might well be made between science in von Hagens's program and the respective GDR and Nazi eras, von Hagens's concepts of enlightenment, progress, and democratization might have been more extensively substantiated and argued in the exhibition.

The notions of enlightened tolerance practiced in the exhibition are also inscribed in the exhibition by implementing, with modifications, the traditional technique of the visitor guestbook. Both in the exhibition and on the Web, a whole spectrum of visitor comments is available for view. The over 70,000 comments visitors have made indicate that exhibition-goers feel a need to communicate with show organizers and other visitors.[81] However, the large numbers also mean that what can be viewed at any one time is a selection. Prior to 2003, Body Worlds seemed to go out of its way to select the widest possible range of opinion for placement on the Web, with the show openly displaying passionate criticisms of its undertakings. Until recently it

was possible to read a variety of strongly voiced opinions, including Christian Wetter's vehement attacks on "the pseudo-science of the show" and a German woman's wondering why von Hagens "has not yet been prosecuted."[82] Strongly held views in favor of the shows were also presented. But as evidence began to surface that von Hagens was receiving unwillingly donated bodies from Russian and later Chinese prisons, critics damningly referred to him as "Dr. Frankenstein" or a modern-day Josef Mengele. Changing his tactics, van Hagens began to lash out at critics who associated the show with Nazism. In light of revelations in February 2005 that von Hagens's father had served with the SS in Poland, personal as well as social taboo zones may be converging. Also revealing are comments made by von Hagens's wife and exhibition co-organizer, Dr. Angelina Whalley, in an article in Singapore's *Life!* magazine (also posted on the Body Worlds website):

> "If it's Dr. Frankenstein, it's okay," says Whalley, 43, the medically-trained director of the Institute for Plastination in Heidelberg. But she takes offence at comparisons to Nazi concentration-camp doctor Josef Mengele, who conducted grisly experiments on inmates. "We are always open to any criticism and we accept that. But if it's pure maliciousness, of course, it's something we cannot accept."[83]

Reserving the right to reject outright critiques it deems "malicious," Body Worlds' presentation of opposing views has diminished, with positive assessments and general references to the show's controversy replacing explicit criticisms. Nevertheless, visitors are still prompted to share their views before reading those of others, giving the impression that the show's promoters continue to tolerate, if not welcome, opposing viewpoints. What can be seen as a commitment to the democratic value of tolerance on one level welcomes controversy on another, translating, as several commentators have noted, into increased visitor numbers and better business.[84]

### Body Worlds and Discourses of Democracy:
### A German Obsession?

When asking why the commitment to democratic values has such resonance in the German reception of Body Worlds, the centrality of democratic values

in German debates should be stressed. For supporters and detractors alike, nothing less than full commitment to democratic values proclaimed in the German Constitution has been at stake in this exhibition. This is the case even when the bulk of their arguments are presented in discourses other than law, such as art history, medicine, history, or philosophy. Supporters point to the fundamental right of well-informed, mature citizens to decide what happens to their bodies before and after death. In this view, a democratic state should on principle not prevent von Hagens from applying his methods to their corpses since there is no public health risk after plastination. Also stressed is an intention to equip ordinary citizens with previously privileged medical knowledge and thus better control of their own bodies. Detractors maintain that the right to proper burial (*Bestattungszwang*) and the protection of human dignity (*Würde des Menschen*), cornerstones of the post-Holocaust Constitution, are being violated for base, money-making spectacle.

Underscoring that democracy is in fact what is principally at stake in the German evaluation of this exhibition, Franz Josef Wetz and Brigitte Tag, the editors of the first scholarly essay collection on Body Worlds, explain that their volume is motivated by their perception that the debate on the show had failed to function in a democratic manner. For them, Germany has still not moved far enough away from certain "painful experiences of history," a reference to both the Holocaust and, to a lesser extent, the authoritarian GDR.[85] Among other things, these regimes of course prohibited open debate and critical opposition. Wetz and Tag model a democracy whose operation implicitly disavows authoritarian eras whenever it is invoked, precisely because it entails a constant renewal of traditions under the scrutiny of reason and toleration of opposing views. Like Wetz and Tag, I wish to regard practices and discourses related to democracy in terms of how they enforce differentiations between present freedoms and past oppression.

A focus on the relationship of democratic structures to past authoritarian eras is a productive approach to the German debates about the exhibition. For one thing, the discursive fault lines and the cultural commonplaces with respect to German democracy have been undergoing shifts and redefinition since the fall of the Berlin wall and German unification, meaning that the status and health of German democracy occupy the forefront of many discussions. In recent years, German politicians have felt compelled

to remind their constituents of their historical burdens. As Socialist politician Thorsten Meyerer explained in 2001,

> That is the lesson of Auschwitz-Birkenau, of Majdanek and Treblinka, of Sobibor, Belzek and Chelmno: that one is not only responsible for what one does, but rather also for that which one allows to happen. . . . True, not everyone looked the other way [in the Nazi era]. There was resistance from communists, unions and social democrats, from church groups and individuals such as Dietrich Bonhoeffer. Even in a dictatorship it was possible to decide in favor of humanity over inhumanity. How much simpler must it be for us, living as we do in a free-democratic constitutional state, to stand up and make it clear to Neo-Nazis that society will not accept it when human dignity is breached.[86]

Much like Wetz and Tag, these politicians were articulating anxieties about the condition of Germany's democracy, though the conscious, not to mention conscientious, discussion of the health of German democracy speaks more to its relative strength rather than its fragility.

At the same time, however, there were causes for concern following German unification in 1990. In 1999 alone, some ten thousand right-wing attacks on Turks, Jews, and historical monuments took place across Germany. In 2000, the number had risen to an estimated fourteen thousand.[87] In these same years, a newly united Federal Republic began to debate whether the time had come for Germany to act more like a "normal" nation in spite of having anything but a "normal" past. The contentiousness of the debates on topics ranging from the wisdom of transferring the federal capital from Bonn to Berlin, the appropriateness of having German military forces serve in Kosovo and Afghanistan, and the building of a Holocaust memorial to the victims of National Socialism demonstrated that German society could not simply turn away from the legacies of the Nazi past.[88] But it has also become clear that other parameters of that engagement were and are also shifting—for instance, in the growing public debates on formerly taboo topics such as German suffering at the hands of the Allies in the Second World War, or in Botho Strauss's and Martin Walser's protests of the political, ethical, and aesthetic burdens borne by Germans with respect to the legacies of the Nazi past and the Holocaust.[89]

Because they turn on the valences and cultural functions of what it has meant to Germans to see images of bodies and corpses in public since 1945, the terms of Walser's protest are worth examining. As Walser put it in a 1979 essay, "One glance at an Auschwitz picture suffices and everybody admits at least to himself: we are not finished with this. Regardless of what you do with this, you cannot delegate it."[90] It is worth recalling that one of the strategies employed by the Allies after the Second World War to impress upon Germans the magnitude of the crimes committed in the Holocaust was to require them to view piles of corpses in concentration camps such as Buchenwald or in photographs.[91] By 1998, the time he gave his (in)famous speech in Bremen's St. Paul's Church, Walser had apparently tired of having to confront images of corpses on a regular basis, and he articulated a desire to be able to look away or escape from those images and, by implication, the Nazi past.[92] Such a looking away should no longer be frowned upon, Walser argued, because, for one thing, the treatment of the Nazi past via images of corpses had by 1998 become little more than an empty ritual, and, for another, Germans had in fact already learned enough from the past.[93] Though it is eminently possible to take issue with Walser, I would, for now, like to stress two things. First, the emergence of his position makes it clear that the taboo zones defining the relationship of the culture and politics of the Berlin Republic to the Nazi past were shifting, with new fault lines emerging on the question of whether Germans had "learned enough from the past." Second, the public presentation of images of corpses and bodies in Germany is charged in particular ways.

The particularity of the German context can be clarified by taking a look at the reception of Body Worlds during its London showing from 21 March 2002 to 9 February 2003. As when it appeared in Germany, Body Worlds provoked intense controversy in Britain, with the media not hesitating to sensationalize the public presentation of corpses as a "Victorian freak show." As in Germany, opposition came in particular from religious leaders who maintained that von Hagens showed disrespect toward the dead and from various groups objecting to the commercialization of the human body. Nonetheless, the show touched different nerves in Britain. Much of the controversy in the UK swirled around specifically British concerns regarding the public display of bodies and the rights of patients. For one thing, Body Worlds spoke to the work of contemporary British artists such as Damien Hirst, Marc Quinn, Rick Gibson, and Anthony Noel Kelly, each of whom

linked art and anatomy by aestheticizing human and animal body parts in provocative and sometimes illegal ways.[94] Since early 2001, the British public had also been reeling from the Alder Hey Report, an account of how, in the 1980s and 1990s, a pathologist, Dr. Dick van Velzen, had secretly harvested organs from over eight hundred dead children in a Liverpool hospital without obtaining proper parental consent. The Alder Hey Report inflamed the public, igniting fears of modern-day body snatching and impropriety among medical practitioners.

Body Worlds was readily associated with the Alder Hey scandal, partly because parents of the Alder Hey children prominently attacked the exhibition and partly because von Hagens and his corpses resonated with the images of the body-snatching mad scientist, particularly after von Hagens performed a public autopsy live before paying and television audiences.[95] Insofar as this performance was the first public autopsy in Britain since the Anatomy Act was passed in 1832 (it was also his first anywhere), it seemed calculated to violate specifically British taboos and sensibilities.[96] In response, the British press anointed von Hagens "Dr. Frankenstein," likening him to the fictional doctor inspired by the body snatchers of the early nineteenth century.[97] Allegations that von Hagens had illicitly received bodies of prisoners, the homeless, and the mentally ill from an anatomical institution in Novosibirsk fed associations with anatomical horrors of the British past and present.[98]

In the British reception of the show, issues of legality and democratic values had a resonance distinct from that in earlier German debates. The government responded unenthusiastically, delaying approval of the show while determining whether it violated the 1832 Anatomy Act, whether it presented a public health risk, and, in the case of the public autopsy, whether von Hagens had the proper licenses to dissect a human corpse.[99] When the Health Ministry eventually ruled that no existing statute outlawed the show, several MPs threatened legislation against any and all public displays of corpses.[100] Although nothing came of these efforts, von Hagens and his German supporters protested what they regarded as politicians' undemocratic and un-British attitudes, in the process saying as much about their views of democracy as the British political climate. A defiant von Hagens stated, "I won't be stopped. I am in a democratic country here [in the UK] and can do anything permitted by law. I am appalled at [their threat of imprisoning me]."[101] German philosopher Franz Joseph Wetz complained, "I'm astonished and irritated that this exhibition has run into such

big obstacles in the UK, where liberalism originated."[102] Officials had, to be sure, failed to embrace Body Worlds, but in the end, Wetz's vision of populist democracy seems to have prevailed: Britons were largely left to decide for themselves what to think about von Hagens's project. In a rash of articles and letters to the editor, supporters lauded the show for democratizing medical knowledge and enlightening the public, while opponents railed against the commercial, sensationalized aspects of the presentation.[103] For all the polarization, few commentators saw the health of British democracy at stake in the show.[104]

Not so in Germany, where the show was interpreted along the shifting fault lines demarcating the authoritarian past and the democratic present. Stefan Ruzowitzky's film *Anatomy*, the most successful German film of 2000, helps position Body Worlds on Germany's changing cultural and political terrain, notably with respect to the legacies of the Nazi past. *Anatomy*, starring *Run Lola Run*'s Franka Potente, capitalizes on and interprets Body Worlds in terms of medical ethics and Germany's Nazi past. Set in the anatomical institute in Heidelberg where von Hagens developed plastination, the film operates in the genre of Gothic horror, making it primarily about the return of the repressed and the uncovering of disavowed history and experience.[105] As such, *Anatomy* depicts the efforts of Potente's character Paula Henning to expose a secret medical society that murders medical students and others with rare diseases in order to produce innovative, unprecedented anatomical specimens. The secret medical society, known as the Anti-Hippocratic League for its conducting research without regard for patient well-being, maintains continuities with experiments carried out by physicians in the Nazi era. In the film, those experiments take the form of victims being injected with a chemical (promidal) that arrests decay and permits dissection and shaping of their living bodies as their tissues harden and die. As Paula learns, the chemical and techniques were developed by her grandfather in order to perform radical anatomical research in the Nazi era, making its legacies an inescapable part of her family and scientific heritage. As Ruzowitzky puts it, "we tried to get across the idea that . . . the foundations of this modern university building lie in the past, a somewhat evil past at that. When we scratch at the surface of modern technological medicine we reveal the sins of our forefathers."[106] By emphasizing the ongoing use of promidal to further illicit research, the film suggests that the institute's spectacular displays of human anatomy are the

immediate heirs to Nazi practices, with lucrative contracts from pharmaceutical companies and international prestige driving present-day "anti-Hippocratic" practices in anatomy and medicine.

The film's commentary is unmistakably directed at von Hagens's Body Worlds. Prominent scenes take place in a collection of anatomical specimens, which sports skulls, organs suspended in spirits, and freestanding figures in poses taken straight from Body Worlds. When a student asks, moreover, whether the last are merely models, he is told, "No, [they are] genuine human specimens, plastinated [*plastiniert*]. All the water and fat is sucked out of the tissue. They'll keep forever."[107] As Ruzowitzky notes, a "big coup in terms of props was our hall of anatomical specimens. The specimens are what the film is all about, really. They were inspired, of course, by that Body Worlds exhibition which is such a big hit these days."[108] Though the plastinated specimens are easily exploited to support the film's presentation of horror and gruesome images, it is significant that they result from and continue to provoke violence and crime. Standing before the plastinated remains of her former roommate Gretchen, Paula realizes that the removal of identifying facial features—a key means by which Body Worlds specimens are universalized—works only to erase evidence of murder. The cutting away and arrangement of tissue and the contorted poses characteristic of plastinates are thus interpreted as markers of violence and torture. Even more crucially, the bodies on display are presented not as freely donated gifts to science, but as the victims of scientists who disregard basic ethical tenets.

In leveling the charge that universalizing his bodies conceals a crime, the film joins a series of critics who have accused von Hagens of shady dealings and body snatching, faulting him in particular for refusing to present documentation to establish that he obtained his bodies legally and ethically.[109] These allegations reached a fever pitch in 2004, when *Der Spiegel* uncovered evidence that von Hagens's facility in China had accepted the bodies of executed Chinese prisoners. Though von Hagens relinquished the bodies and has not (yet) been convicted of any crime, the episode made it harder for him to continue exhibiting in Europe. In contrast to critical interventions such as *Der Spiegel's*, however, the film does not shy away from linking these concerns about Body Worlds directly to the dubious practices of the Nazi era. Body Worlds serves as the vehicle for suggesting that modern medicine is accompanied by abuses we would prefer to believe ended in 1945. In this view, the

exhibition represents not a triumph of enlightened science, but rather its horror-inspiring abject.

Anatomy's association of Body Worlds with Nazi medicine garnered criticism because for many, such a topic seems inappropriate for an entertainment film. The scene in which Paula's professor Grombek explains the afterlife of the National Socialist medical practices to her occurs in the basement chambers of the Anti-Hippocratic League (predictably enough, the chambers are the foundation of the medical faculty). As Ruzowitzky notes,

> the scene is meant to give the intellectual context, to show that it's not all about going at people with knives. . . . In this scene, [the Professor] talks about the Anti-Hippocrates in the Third Reich. For some reason, people objected to this. They did not think Mengele and the medical experiments of the Third Reich should be mentioned in a "light" movie like this. I found that a bit odd. I'd be more critical of the movie if it sidestepped the issue. How can you make a movie in Germany about medical ethics and not mention the medical experiments of the Nazi era?[110]

The nature of these objections raises two points. First, the film's view of Body Worlds as heir to Nazi science was not the basis of the objection per se, as it might have been if public perceptions of the exhibition saw no possible association of von Hagens's exhibition with Nazi practices. Second, since unification, the legacies of the Holocaust have increasingly been relegated to "serious" art forms and discourses.[111] Anatomy's violation of this expectation points to the constraints, social as well as discursive, that limit German discussions of the Holocaust.

Andreas Nachama's case further clarifies these discursive limits, showing how Body Worlds inscribes discursive taboo zones with respect to the Nazi past. Nachama, the President of the Jewish Community in Berlin, explained in an interview that the Jewish Community had refrained from mounting an official protest of Body Worlds, because its pronouncements are readily associated with Holocaust issues and the weight of Auschwitz.[112] But Nachama expressed his personal reservations about Body Worlds, stating that the exhibition was "possibly the logical consequence of what happened in the twentieth century. Then there was no barrier to [what could be done] to living human beings, human bodies by the millions were burned to ashes or turned into

soap by murderers, lampshades were made out of human skin . . . These people deserve to be buried because their earthly existence has ended. They should not be exhibited as a commodity."[113] Christian churches have made similar points about the right to proper burial, the protection of human dignity, and the commodification and instrumentalization of the body in the show without provoking ire.[114] The significant difference between their critiques and that of Nachama is the association of the exhibition with the Holocaust. Yet for von Hagens and a few subsequent critics, this association seemed to violate an unspoken rule.

Rather than take the critique in stride, as he has tended to do with respect to the Christian organizations, von Hagens lashed out at Nachama with an open letter in the *Frankfurter Rundschau*. Differentiating his shows from Nazi science on the sole grounds that his subjects donated their bodies willingly— an argument von Hagens can no longer easily make in light of the Chinese scandal—von Hagens concluded that his exhibition represented "the opposite of the horror of mass murder and the piles of corpses in German concentration camps."[115] Pointing out that he is a "historically aware German, who has visited both Dachau and Buchenwald," von Hagens warned Nachama that his critique tended to trivialize the Holocaust and the suffering of its victims, and "damages the reputation of the Jewish Community as a moral institution that is to be taken seriously."[116] Even giving von Hagens the benefit of the doubt, his disproportionately angry defense is based on evidence that only indirectly acquits his show of any relationship to the Holocaust, if it does so at all. By invoking Dachau and Buchenwald in particular, von Hagens appeals to a ritual that remains meaningful only when it does not foreclose the possibility of future critical self-examination, a capacity for which von Hagens seems to lack. His response suggests that a taboo is violated when the Holocaust is mentioned in the same breath as his show.

In discussions of Body Worlds, both for and against, that avoid mentioning the Holocaust, the German Constitution does the "work" of anchoring the argument in a way that seems not to exceed certain discursive limits. Though the Constitution is just one step removed from the Holocaust, that level of displacement demarcates a taboo zone that can be crossed only in particular circumstances. Reinforcing discursive separations from the Nazi era would seem to be one crucial factor in why both sides in the debate over Body Worlds come back again and again to the German Constitution and

what German legal principles permit. The invocation of the Constitution can of course be rhetorically complex, even within a single argument. Nonetheless, invoking the Constitution forces an opponent to run the risk of violating at least its spirit, a tricky maneuver not least because such a violation can appear to be ambiguous with regard to past totalitarian eras. The reenactment of political breaks with respect to Nazi and GDR pasts underscores the notion that German democracy exists in some registers as a ritual avoidance of the past, even several decades after the founding of the Federal Republic. Seen this way, the ritual "work" done by the Constitution takes the form of an affirmative gesture toward "democratic values" even as it forestalls open scrutiny of the past.

Traditions can be renewed in a democracy through a critical exercise of reason coupled with an implicit rejection of earlier non-enlightened, non-democratic traditions. While critical renewal of traditions is enlightened, the actualization of a rejection does not necessarily occur only on a rational level, and thus it can be seen as ritual. Historically, techniques of exhibition have been extremely well equipped to transmit a sense of culture as rupture with the past, thus emphasizing claims to uniqueness, innovation, and progress. In his analysis of nineteenth-century World Expositions and smaller popular exhibitions, Tony Bennett contends that they "located their preferred audiences at the very pinnacle of the order of things they constructed. They also installed them at the threshold of greater things to come."[117] Body Worlds' multiple claims to originality, progress, and the breaking of taboos share much with their nineteenth-century brethren. Body Worlds might therefore be serving German democracy not only in a straightforward, educational fashion, but also by calling forth a ritual affirmation of values antithetical to those of the National Socialists and to a lesser extent the GDR. Precisely because Body Worlds operates in a discursive realm whose terms are decisively "beyond" the Holocaust, visits to the show are prone to enforce a sense of difference with respect to the Nazi and GDR pasts. This occurs in the sense of rupture provoked by plastination, as well as in the propensity of the exhibition to generate polarized interpretations. Ultimately, the urgent appearance of democracy at this juncture, in a practice that confirms Germans' perceptions of cultural progress, emerges with a certain logic, even as the exhibitionary apparatus that underwrites those perception hails from another era.

## NOTES

I am grateful to Evelyn Preuss, Peter Pfeiffer, and Vanessa Agnew for their comments on earlier versions of this essay. I am especially indebted to Daniel J. Sherman for his insightful critiques.

1. Quoted in Diane Haithman, "Exhibition on the Human Body Gets under People's Skin," *Los Angeles Times,* 26 June 2004.

2. See Stuart Jeffries, "The Naked and the Dead," *Guardian,* 19 March 2002, http://education.guardian.co.uk/higher/arts/story/0,9848,670045,00.html. Accessed 15 June 2004.

3. See Thomas J. Csordas, "Computerized Cadavers: Shades of Being and Representation in Virtual Reality," in *Biotechnology and Culture: Bodies, Anxieties, Ethics,* ed. Paul E. Brodwin (Bloomington: Indiana University Press, 2000), 173–92; see also Lisa Cartwright, "A Cultural Anatomy of the Visible Human Project," in *The Visible Woman: Imaging Technologies, Gender and Science,* ed. Paula A. Treichler, Lisa Cartwright, and Constance Penley (New York: New York University Press, 1998), 21–43.

4. See Deanna Petherbridge, "Art and Anatomy: The Meeting of Text and Image," in *The Quick and the Dead. Artists and Anatomy,* ed. Deanna Petherbridge and Ludmilla Jordanova (Berkeley: University of California Press, 1997), 7–99; see also Martin Kemp and Marina Wallace, *Spectacular Bodies: The Art and Science of the Human Body from Leonardo to Now* (Berkeley: University of California Press and Hayward Gallery, 2000), 158–207.

5. Petherbridge, "Art and Anatomy," 10. According to Petherbridge, da Vinci had contact with the anatomist Marcantonio della Torre, while Michelangelo worked with Realdo Columbo.

6. Kemp and Wallace, *Spectacular Bodies,* 22–30.

7. On the Baroque tropes used by artist Gaetano Giulio Zumbo, see Marta Poggesi, "The Wax Figure Collection in 'La Specola' in Florence," in *Encyclopaedia Anatomica: Museo La Specola Florence* (Cologne: Taschen, 1999), 20–22. On eighteenth-century tropes, see Petherbridge, "Art and Anatomy," 90–95.

8. See Rosmarie Beier and Martin Roth, *Der gläserne Mensch, eine Sensation: Zur Kulturgeschichte eines Ausstellungsobjekts* (Stuttgart: G. Hatje, 1990).

9. Kemp and Wallace, *Spectacular Bodies,* 61.

10. Ludmilla Jordanova, "Happy Marriages and Dangerous Liaisons: Artists and Anatomy," in *The Quick and the Dead,* ed. Petherbridge and Jordanova, 101.

11. Lisa Cartwright, *Screening the Body: Tracing Medicine's Visual Culture* (Minneapolis: University of Minnesota Press, 1995), 90–98.

12. Gunther von Hagens, "Gruselleichen, Gestaltplastinate und Bestattungszwang," in *Schöne neue Körperwelten: Der Streit um die Ausstellung,* ed. Franz Josef Wetz and Brigitte Tag

(Stuttgart: Klett-Cotta, 2001), 60. All translations of this and other German texts are mine unless otherwise indicated.

13. Von Hagens, "Gruselleichen," 42.

14. Von Hagens's valorizations of anatomical traditions are also held by commentators having nothing to do with his exhibitions. See for instance Kemp and Wallace, *Spectacular Bodies,* 32–68, particularly 61–63.

15. Timothy Mitchell, *Colonising Egypt* (Berkeley: University of California Press, 1991), 2–25. For a generalization of Mitchell's term in the history of scientific display, see Sharon Macdonald, "Exhibitions of Power and Powers of Exhibition: An Introduction to the Politics of Display," in *The Politics of Display: Museums, Science, Culture,* ed. Sharon Macdonald (New York: Routledge, 1998), 13.

16. Ludmilla Jordanova, "Museums: Representing the Real?" in *Realism and Representation,* ed. George Levine (Madison: University of Wisconsin Press, 1993), 258.

17. Jordanova, "Museums: Representing the Real?" 258. See also Macdonald, "Exhibitions of Power," 10.

18. Jordanova, "Museums: Representing the Real?" 258.

19. Von Hagens, "Gruselleichen," 60.

20. Gunther von Hagens, "Anatomie und Plastination," in *Prof. Gunther von Hagens' Körperwelten: Die Faszination des Echten* (Heidelberg: Institut für Plastination, 2000), 22–28. See also http://www.koerperwelten.de/en/plastination.asp. Accessed 31 December 2003.

21. Von Hagens, "Gruselleichen," 23.

22. As Bazon Brock has observed, the creation and presentation of plastinates operates on a double claim to authenticity. See Bazon Brock, "Bildende Wissenschaft," in *Prof. Gunther von Hagens' Körperwelten,* 272.

23. Klaus Tiedemann, "Möglichkeiten und Grenzen des Plastination," in *Schöne neue Körperwelten,* 22.

24. Tiedemann, "Möglichkeiten und Grenzen," 21; Von Hagens, "Gruselleichen," 42.

25. The situations I have in mind had to do with the importing of specimens into foreign countries. See von Hagens, "Gruselleichen," 81–82. Von Hagens refers to the television report "Die Leichenshow in Basel. Eine Wanderausstellung an den Grenzen von Recht und Moral," ed. Harold Woetzel (Stuttgart: Südwestrundfunk, 2000), which pointed up the ambiguity of these issues. See also Axel W. Bauer, "Plastinate und ihre Präsentation im Museum—eine wissenschaftstheoretische und bioethische Retrospektive auf ein Medienereignis," in *Prof. Gunther von Hagens' Körperwelten,* 228.

26. Von Hagens, "Gruselleichen," 42.

27. Von Hagens, "Gruselleichen," 59–60.

28. These latter claims have been questioned in a court case. "Plastinator will sich weiter Professor nennen," *Der Spiegel,* 25 September 2003, http://www.spiegel.de/wissenschaft/mensch/0,1518,267150,00.html. Accessed 31 December 2003.

29. Von Hagens, "Gruselleichen," 47.

30. See Tony Bennett, *The Birth of the Museum: History, Theory, Politics* (New York: Routledge, 1995), 95–96. Susan A. Crane argues that the Enlightenment paradigm deployed history as a means of differentiating the curious, strange, and freakish from significant "witnesses" and "monuments." Susan A. Crane, "Curious Cabinets and Imaginary Museums," in *Museums and Memory,* ed. Susan A. Crane (Stanford: Stanford University Press, 2000), 75.

31. Uli Linke, *German Bodies: Race and Representations after Hitler* (New York: Routledge, 1999), 10. Original emphasis. Linke cites Edmund L. Andrews, "Anatomy on Display," *New York Times,* 7 January 1998, and Jürgen Roth, "Body Counts," *Konkret* 4 (1998): 51.

32. Linke, *German Bodies*, 10, 29–30.

33. Juan Valverde, *Anatomia del corpo humano* (Rome: Ant. Salamanca, et Antonio Lafreri, 1560). An image of Fragonard's specimen is available at: http://www.vet-alfort.fr/Fr/musee/Site_Fr/index2.htm. Accessed 12 June 2004.

34. William Cheselden, *Osteographia, or the Anatomy of Bones, in Fifty-Six Plates* (1733; reprint, Philadelphia: W. B. Saunders, 1968), plate XXXVI.

35. Jeffries, "The Naked and the Dead."

36. Thomas Assheuer, "Die Olympiade der Leichen. Der Tabubruch erreicht eine neue Qualität: Gunther von Hagens' Körperwelten ziehen in ein Hamburger Erotik-Museum," *Die Zeit,* 21 August 2003.

37. Von Hagens, "Anatomie und Plastination," 35. In the context of technological media, Body Worlds also offers an incomparable auratic experience.

38. Gunther von Hagens and Stephan Rathgeb, " 'Disneyworld ist doch kein Schimpfwort!' Interview with Gunther von Hagens," *Körperspender-News: Mitteilungsblatt des Bundesverbandes der Körperspender e.V.,* March–April 2001, 3, http://www.koerperspender.de/html/news.htm. Accessed 31 December 2003.

39. Von Hagens, "Gruselleichen," 61.

40. Von Hagens, "Disneyworld."

41. Von Hagens, "Gruselleichen," 45.

42. Von Hagens, "Gruselleichen," 43.

43. As Jane Desmond argues, the production of lifelike, "realistic" specimens is a guiding principle of animal taxidermy. Like plastinated bodies, animal specimens require extensive remaking in order to look "real." Human bodies appear to differ from animal specimens due to beliefs that human bodies represent a being that once inhabited that body. See Jane Desmond, "Displaying Death, Animating Life: Changing Fictions of Liveness from Taxidermy to Animatronics," in *Representing Animals,* ed. Nigel Rothfels (Bloomington: Indiana University

Press, 2002), 162–63, 169. I am grateful to Daniel J. Sherman for drawing my attention to animal taxidermy.

44. Von Hagens, "Gruselleichen," 46.

45. I would like to thank Mark Sandberg for drawing my attention to this.

46. Lorraine Daston and Katharine Park, *Wonders and the Order of Nature, 1150–1750* (New York: Zone Books, 1998), 14.

47. Daston and Park, *Wonders and the Order of Nature,* 276–77.

48. Paula Findlen, *Possessing Nature: Museums, Collecting, and Scientific Culture in Early Modern Italy* (Berkeley: University of California Press, 1994), 403. See Daston and Park, *Wonders and the Order of Nature,* 14–15.

49. Crane, "Curious Cabinets," 75.

50. Carla Yanni, *Nature's Museums: Victorian Science and the Architecture of Display* (Baltimore: Johns Hopkins University Press, 1999), 17.

51. Stephen Asma, *Stuffed Animals and Pickled Heads: The Culture and Evolution of Natural History Museums* (Oxford: Oxford University Press, 2001), 38–41.

52. Asma, *Stuffed Animals and Pickled Heads,* 38–41.

53. Von Hagens offers this explanation on the Body Worlds website, http://www.koerperwelten.de. Accessed 31 December 2003. Also von Hagens, "Disneyworld."

54. Von Hagens, "Gruselleichen," 45.

55. Tiedemann, "Möglichkeiten und Grenzen," 22–25.

56. Tiedemann, "Möglichkeiten und Grenzen," 29–30.

57. "Körperspendertreffen am 1.6.2003 in Heidelberg. Gunther von Hagens empfängt zukünftige Plastinate." http://www.koerperwelten.de/de/pages/specials_heidelberg.asp. Accessed 31 December 2003.

58. "Körperspendertreffen." A similar point about Body Worlds' commemoratory functions is made by Desmond, "Displaying Death," 169.

59. Donald Preziosi and Tony Bennett have drawn attention to this phenomenon. Donald Preziosi, *Rethinking Art History: Meditations on a Coy Science* (New Haven, Conn.: Yale University Press, 1989); Bennett, *Birth.*

60. See comments in Bergdolt, "Unbehagen," 205.

61. Gunther von Hagens et al. "Das Ende der Show," http://www.koerperwelten.com/de/pages/Pressemeldungen_FFM_4.asp. Accessed Sept 26 2004.

62. Susan Ruiz Patton, "Anatomy of Competition: 2 Museums Bid for Bodies," *Cleveland Plain Dealer,* 28 October 2004.

63. In July 2006, each of the venues showing Body Worlds—the Science Museum of Minnesota, the Denver Museum of Nature and Science, and the Houston Museum of Natural Science—showed *The Human Body* at the same time as Body Worlds (see http://www.smm.org/, http://www.dmns.org/main/en/, http://houstonbodyworlds3.com

/index.html?scsrc=bdywldsweb&sckw=wba&sccrtv=200603hmns&scgeo=bw3). The Min-
nesota and Houston museums offered combi tickets (see http://houstonbodyworlds3
.com/imax.html [Houston], http://www.smm.org/visitorinfo/tickets/ [Minnesota]).

64. Representative of religious responses to the Terri Schiavo issue are the views in
this *Houston Chronicle* article, which outlines the respective positions: Tara Dooley, "End
of Life Choices: A Matter of Faith," *Houston Chronicle,* 2 April 2005, 1. An exemplary
overview of the political and religious interest in the Schiavo case is available in Rick
Lyman, Dennis Blank, and Lynn Waddell, "Schiavo in Her 'Last Hours,' Father Says Amid
Appeals," *New York Times,* 26 March 2005. Though religious leaders generally endorsed the
show as early as 2004, in preparation for its opening, articles verifying their approval ap-
peared during the Schiavo era and continue in cities where von Hagens takes his exhibi-
tion. See Susan Ruiz Patton. "Anatomy of Competition: 2 Museums Bid for Bodies."
*Cleveland Plain Dealer,* 28 October 2004; James F. Sweeney. "Amazing Look at the Body;
Advisory Panels Weigh the Ethics of Displaying Real Corpses," *Cleveland Plain Dealer,* 5
April 2005; Tara Dooley, "Science and Ethics: Exhibit Displays Real Flesh and Bones to
Educate about the Body in Motion," *Houston Chronicle,* 24 February 2006; Eric Gorski,
"Body Show Elicits Awe: Cadavars Exhibit," *Denver Post,* 12 March 2006; Jennifer Heldt
Powell, "Museum to Host 'Body Worlds' Show," *Boston Herald,* 28 March 2006.

65. See also Franz Josef Wetz and Brigitte Tag, " 'Körperwelten'-die erfolgreichste
Wanderausstellung unserer Zeit," in *Schöne neue Körperwelten,* 15.

66. Fredric Jameson, "The End of Temporality," *Critical Inquiry* 29 (2003): 711–712.

67. Ibid., 712.

68. Cheselden, *Osteographia,* plate XXXVI. See also Kemp and Wallace, *Spectacular
Bodies,* 44.

69. Jameson, "The End of Temporality," 712–13. Jameson writes, "the problem with
the body as a positive slogan is that the body itself, as a unified entity, is an Imaginary con-
cept (in Lacan's sense); it is what Deleuze calls a 'body without organs,' an empty totality
that organizes the world without participating in it. We experience the body through our
experience of the world and of other people, so that it is perhaps a misnomer to speak of the
body at all as a substantive with a definite article, unless we have in mind the bodies of others,
rather than our own phenomenological referent." Some psychoanalytic analyses of Body
Worlds understand its effect to consist in ensuring a sense that a certain immortality is
achieved. Von Hagens, "Gruselleichen," 62. Von Hagens quotes S. Sarial, "Körperwelten—
Ein Ausstellungserfolg aus psychonanalytischer Sicht," *Zeitschrift für Klassische Psychoanalyse*
16 (1998): 1.

70. Michael Charlton et al., "Was die Menschen an den 'Körperwelten' bewegt," in
*Schöne neue Körperwelten,* 342–56.

71. Von Hagens, "Anatomie und Plastination," 28–29.

72. Brock, Kleinschmidt, and Wagner connect mythmaking to the often observed parallels between von Hagens and the artist Joseph Beuys, whose shamanistic practices and icons (his hat, his story of wartime survival with the Tatars of Russia, his cult of felt and fat) also enact rituals of authenticity. Ninā Kleinschmidt and Henri Wagner, *Endlich unsterblich? Gunther von Hagens—Schöpfer der Körperwelten* (Bergisch Gladbach: Lübbe, 2000), 295–96.

73. See Michael Z. Wise, *Capital Dilemma: Germany's Search for a New Architecture of Democracy* (New York: Princeton Architectural Press, 1998), 23–38, 121–34.

74. Christopher Phillips, "New Art for the Reichstag," *Art in America* 87 (1999): 27.

75. Phillips, "New Art for the Reichstag": 27. On Imperial Germany, see Peter Paret, *The Berlin Secession: Modernism and Its Enemies in Imperial Germany* (Cambridge, Mass.: Belknap, 1980), 9–28, 120–35. On Nazi exhibitions of degenerate art, see Christoph Zuschlag, *"Entartete Kunst": Ausstellungsstrategien im Nazi-Deutschland* (Worms: Wernersche Verlagsgesellschaft, 1995). I am grateful to Daniel J. Sherman for pointing out this connection.

76. Assheuer, "Olympiade."

77. In the 1990s, a series of high profile lawsuits and journalistic studies brought to light the systematic use of steroids and other medical techniques that sought to enhance the performance of GDR athletes. Beyond bodily malformations, cancers, and other increased forms of disease there were several cases of gender and sexuality having been severely affected by the doses of hormones such as testosterone.

78. Didi Kirsten Tatlow, "Dead Body Shop," *The Sunday Business Post,* 5 August 2001.

79. Tatlow, "Dead Body Shop."

80. Beier and Roth, *Der gläserne Mensch.*

81. Charlton et al., "Was die Menschen an den "Körperwelten" bewegt," 330.

82. "Visitor Comments to Body Worlds," Body Worlds website, http://www.koerperwelten.de/en/kommentare.htm. Accessed 5 October 2002.

83. Ho Ai Li, "Body of Evidence: Plastic Fantastic," *Life! The Straits Times,* 13 November 2003. Article posted by Body Worlds at http://www.bodyworlds.com.sg/en/news-01.htm. Accessed 27 June, 2004.

84. Assheuer, "Olympiade." See also Bergdolt, "Unbehagen."

85. Wetz and Tag, " 'Körperwelten,' " 15.

86. Thorsten Meyerer, "Rede anlässlich des Holocaust-Gedenktages am 27.01.2001," website of the SPD Kreisverband Miltenberg, http://www.spd-miltenberg.de/Rede_Holocaustgedenktag.html. Accessed 31 December 2003.

87. Wolfgang Thierse, "Auspracpe bei der Veranstaltung im Deutschen Bundestag zum Gedenktag für die Opfer des Nationalsozialismus," website of the German Bundestag, http://www.bundestag.de/aktuell/presse/2001/pz_010126.html. Accessed 4 January 2007.

88. I am here summarizing arguments I formulated with Andreas Huyssen and Werner Jung that appeared in volume 88 of *New German Critique* on the topic of contemporary German writing since the fall of the Berlin Wall. See Andreas Huyssen, Werner Jung, and Peter M. McIsaac, "Introduction," *New German Critique* 88 (2003): 3–8.

89. Botho Strauss, "Anschwellender Bocksgesang," *Der Spiegel,* 8 February 1993. Martin Walser, "Erfahrungen beim Verfassen einer Sonntagsrede," in *Friedenspreis des deutschen Buchhandels. Ansprachen Anlaß der Verleihung* (Frankfurt am Main: Buchhdl.-Verein, 1998), 37–51.

90. Martin Walser, "Auschwitz und kein Ende," in *Über Deutschland reden,* ed. Martin Walser (Frankfurt am Main: Suhrkamp, 1988), 30–31. The translation is Julia Hell's. Julia Hell, "Eyes Wide Shut, or German Post-Holocaust Authorship," *New German Critique* 88 (2003): 14–15.

91. I am grateful to Evelyn Preuss for bringing this practice to my attention.

92. Hell, "Eyes Wide Shut." See also Amir Eshel, "Vom einsamen Gewissen. Die Walser-Bubis Debatte und der Ort des Nationalsozialismus im Selbstbild der Berliner Republik," *Deutsche Vierteljahrsschrift für Literaturwissenschaft und Geistesgeschichte* 74 (2000): 333–60.

93. Walser, "Erfahrungen," 37–51.

94. Jeffries, "The Naked and the Dead," paragraph 18; Steve Connor, "Body of Criticism Greets Artist's Human Display," *Independent,* 23 March 2002; Rachel Campbell-Johnston, "You've Got to Admire His Guts," *Times* (London), 22 March 2002.

95. Jeffries, "The Naked and the Dead," paragraph 10; "Alder Hey Group's Outrage at Corpse Exhibition," *Daily Post,* 12 March 2002; Tatlow, "Dead Body Shop."

96. The Anatomy Act made bodies of the poor available to anatomists and surgeons if those bodies went unclaimed for forty-eight hours. According to Ruth Richardson, the act was the source of considerable anxiety among the lower classes; Ruth Richardson, *Death, Dissection, and the Destitute,* 2nd ed. (Chicago: University of Chicago Press, 2000), xiii–xvii. Von Hagens referred to the legacy of the Anatomy Act as a way of explaining the British anxieties about anatomical issues. See Jeffries, "The Naked and the Dead," paragraph 19; Lucy Cavendish, "I Will Cut Up My Father, But Even I Couldn't Do It to My Own Wife," *The Evening Standard,* 18 November 2002, 25–26.

97. The British press also referred to von Hagens as "Josef Mengele," but usually only in passing. Jeffries, "The Naked and the Dead," paragraph 10; Tatlow, "Dead Body Shop."

98. Paul Harris and Kate Connolly Berlin, "Trade in Bodies Is Linked to Corpse Art Show: Behind 'Dr. Frankenstein's' Exhibition," *Observer,* 17 March 2002.

99. David Millward, "Health Department Tries to Ban Corpse Exhibition," *Daily Telegraph,* 12 March 2002; Simon Jenkins, "A Bit of a Freak Show, But Where's the Harm?" *Evening Standard,* 21 November 2002; "Alder Hey Group's Outrage at Corpse Exhibition."

100. "Controversial Body Show Not Breaking Any Law," *Belfast News Letter,* 21 March 2002; Ginanne Brownell and Ann Binlot, "Science or Sideshow?" *Newsweek,* 21 March 2002; "MP Condemns 'Ghoulish' Display of Treated Corpses," *Western Mail,* 19 March 2002; "Alder Hey Group's Outrage at Corpse Exhibition."

101. "Leichenspektakel: Professor besteht auf Obduktion," *Der Spiegel,* 20 November 2002, http://www.spiegel.de/panorama/0,1518,223538,00.html. Accessed 20 November 2002.

102. Connor, "Body of Criticism Greets Artist's Human Display."

103. Steve Threadgold, "Body Exhibition Is Education, Not Art," *Daily Telegraph,* 22 March 2002; Gary Grant, "Value of Human Corpse Exhibition," *Times* (London), 27 March 2002. Max Sacker, "Give Death a Chance," *Independent,* 28 March 2002. Jenkins, "A Bit of a Freak Show."

104. One exception is Simon Jenkins, who argued for the show on the basis that Britain "is a free country" and that the half a million visitors who paid to see the exhibition meant it "rated a hearing." See Jenkins, "A Bit of a Freak Show."

105. Steffen Hantke, "Germany's Secret History: Stefan Ruzowitzky's *Anatomie* (*Anatomy,* 2000)," *Kinoeye: New Perspectives on European Film* 1, no. 1 (2001): paragraph 2. http://www.kinoeye.org/01/01/hantke01.php. Accessed 31 December 2003.

106. Stefan Ruzowitzky, "Director's Commentary," *Anatomy,* DVD, dir. Stefan Ruzowitzky (Culver City, Calif.: Columbia Tristar, 2000), DVD.

107. *Anatomy,* DVD.

108. Ruzowitzky, "Director's Commentary."

109. Assheuer, "Olympiade."

110. Ruzowitzky, "Director's Commentary."

111. Sabine Hake, *German National Cinema* (New York: Routledge, 2002), 182.

112. Andreas Nachama and Sven Bernitt, " 'Jetzt kommt der Spaß am toten Körper.' Interview mit Andreas Nachama," *Die Welt am Sonntag,* 11 March 2001.

113. Nachama, "Spaß am toten Körper."

114. This is a point sustained by *Der Spiegel* essayist Henryk M. Broder. Henryk M. Broder, "Gunther von Hagens," Official Homepage of Henryk M. Broder, 23 April 2001, http://www.henryk-broder.de/html/schm_hagens.html. Accessed 31 December 2003.

115. Gunther von Hagens, "Open Letter to Andreas Nachama," *Frankfurter Rundschau,* 22 March 2001. Monika Berger-Lenz, "Körperwelten. Austellung und Einstellungen," *Faktuell,* 4 April 2001, http://www.faktuell.de/Hintergrund/Background116.sthml. Accessed 31 December 2003. Verena Sarah Diehl and Jörg Sundermeier, "Hagens' Leichen," *Jungle World,* 4 April 2001, http://www.nadir.org/nadir/periodika/jungle_world/_2001/15/19a.htm. Accessed 31 December 2003.

116. Von Hagens, "Open Letter."

117. Bennett, *Birth,* 82. See also Macdonald, "Exhibitions of Power," 12.

# PART 2 REPRESENTING DIFFERENTLY

# Meta Warrick's 1907 "Negro Tableaux" and (Re)Presenting African American Historical Memory

W. FITZHUGH BRUNDAGE

Confronting visitors who meandered through the "Negro Hall" at the 1907 Jamestown Tercentennial Exposition, held in Norfolk, Virginia, was a tableau entitled *Landing of First Twenty Slaves at Jamestown*. Meta Warrick (Fuller), a sculptor, had created and arranged twenty-four two-foot-high plaster figures, which re-imagined the shackled, nearly nude, and traumatized Africans who had landed in Jamestown in 1619. In *Landing* and thirteen other dioramas, she gave viewers a chronological survey of the African American experience. Scenes ranged from a tableau of a fugitive slave to a depiction of the home life of "the modern, successfully educated, and progressive Negro."[1] Drawing upon but moving beyond her classical training in Philadelphia and Paris, Warrick applied new capacities for simulation and illusion to the depiction of African American themes. By doing so, she expanded the repertoire of representation of the African American past. Incorporating the lives and concerns of African Americans into the saga of civilization, she turned the historical African American into the centerpiece of the saga, claiming a position the dominant white narrative denied. Her dioramas, which suggested the expansiveness of black abilities, aspirations, and experiences, presented a cogent alternative to white representations of history—by an African American.

With her Jamestown tableaux, Warrick yoked the era's techniques of perceptual modernization to the representation of black history. The dioramas augmented the established tradition of black commemorative celebrations and oratory associated with holidays such as Emancipation Day and the Fourth of July. Not even the most gifted black orators could evoke the full range of historical associations that circumstances demanded and contemporary tastes eagerly sought. Warrick's dioramas complemented the urge, expressed by African American author Sutton Griggs, "to move up out of the age of the voice, the age of the direct personal appeal, and live in an age where an idea can influence to action by whatever route it drifts one's way."[2]

Warrick's tableaux manifested a long-standing and conscious tactic of African American leaders and activists during the postbellum era to use aural and visual means to reach the black masses. Comparatively high rates of illiteracy and poverty among blacks impeded any campaign to impart a sense of collective history and tradition to blacks. Writing in 1874, Rev. Andrew Chambers, an A.M.E. minister from Arkansas, explained that visual displays, which would arouse the unlearned masses and stimulate interest in other forms of commemoration, were the ideal means to educate "our illiterate race." Throughout the late nineteenth century, African American efforts to erect monuments were stymied by poverty, internecine organizational squabbles, and even indifference. But interest in celebratory visual displays persisted among the ranks of black leaders and activists and inspired Warrick and her sponsors at the Jamestown Exposition.[3]

Yet, Warrick's dioramas were much more than just a pragmatic means to instruct the black masses. Warrick and her sponsors adopted the dioramic form in a clear effort to adapt, extend, and experiment with the representational innovations of the era. The very form of her creation, as much as its depiction of the progressive and upward evolution of African Americans, was intended to provide evidence to whites and blacks alike of the modernity of African Americans. As a studio-trained artist, she was familiar with the contemporary transformation of visual culture, especially the proliferation of forms of verisimilitude ranging from dioramas to film. She recognized both the challenge and importance of capturing her audience's attention at a time of dizzying visual experimentation and in a venue rife with competing attractions.

The setting for Warrick's models—an international exposition—placed a premium on representational innovation. During the late nineteenth and early twentieth centuries, world expositions became especially important cultural sites for the dissemination of "new" knowledge and representations of the world. Reflecting the era's emphasis on objects as purveyors of objective truth, fairs promoted all manner of nonverbal forms of experiencing objects. When W. E. B. Du Bois referred to "the usual paraphernalia for catching the eye—photographs, models, industrial work, and pictures" at the 1900 Paris Exposition, he drew attention to the use of visual spectacles to represent reality at worlds fairs. Expositions were occasions for reifying objective reality at a time when, as philosopher Martin Heidegger explains, "the certainty of representation" was in question.[4]

Expositions and museums were perhaps the most conspicuous manifestations of the Victorian compulsion to use physical objects to organize and categorize knowledge. From the London Exposition of 1851 onward, a succession of international expositions fused scientific classificatory schemes with spectacular celebrations of technology, progress, and civilization. Fairs served as venues in which authoritative scientific ideas about evolution, race, and culture were disseminated from academic circles to the level of popular consumption. Sponsors of world expositions, by means of contrived contrasts, attempted to organize the world into representable categories which, not coincidentally, advanced the imperial purpose, strengthened national identities, and inscribed ideas about the essential otherness of "primitive" societies and peoples. More than just an expression of imperialist hubris and curiosity, the ubiquitous ethnographic displays at museums and "authentic" villages of exotic peoples and cultures at expositions, Timothy Mitchell has explained, were the very means through which planners accentuated cultural difference and produced "imperial truth." The rationalizing taxonomy of expositions' organizational schema assimilated African Americans and other "primitive" peoples as objects of spectacle. By intent, then, fin-de-siècle expositions and museums presented human identities as fixed, essential truths, simultaneously categorizing and marginalizing blacks and other colonial peoples.[5]

Technologies of spectacle and representation figured prominently in late-nineteenth-century museums and expositions because they empowered visitors to participate in the reification of categories of knowledge. The seemingly endless rows of precisely organized exhibits encouraged visitors

to conclude that the prevailing ordering of knowledge about the world was self-evidently true and complete. Museum audiences, in other words, did not simply submit to the ideological pedagogy of museums; they were complicit in it. Museums and expositions enabled visitors to teach themselves the truth regarding nature, civilization, and human creativity.

Yet, as Warrick's dioramas underscores, the participation of colonized and "primitive" peoples in expositions created opportunities for African Americans to destabilize this binary classification of civilization and "the other," of modernity and primitiveness. African Americans well understood the importance of how they were represented at worlds fairs. When Du Bois surveyed with satisfaction the 1900 Paris Exposition, he stressed with special emphasis that the "honest, straightforward exhibit" in the Negro Exposition was "above all" made by blacks. As cultural theorist Walter Benjamin observed about film, new modes of representation "in the age of mechanical reproduction" empowered the masses to comprehend themselves for the first time.[6] Warrick's dioramas, similarly, enabled blacks to "see" themselves as the main actors in their own defined world. Whereas "Old South" concessions and anthropological exhibits organized by whites exhibited blacks, Warrick's dioramas "represented" them. The distinction between exhibiting and representing blacks was not just authorship, but also agency. The Jamestown tableaux highlighted blacks' creative capacity, manifest in the very form of Warrick's creation, as well as black agency depicted in the narrative itself. By assuming responsibility for their own representation at expositions, African Americans grappled with the ideological schema that undergirded fairs. Certainly Warrick contested in both subtle and obvious ways the overarching ambitions and assumptions about race, civilization, and progress that found expression at the Jamestown Exposition. Thus, Warrick's dioramas illustrate how the new technologies and discourses of racial and imperial "truth" could be contested even in the setting where they were most powerfully articulated.

Warrick's dioramas, finally, draw our attention to the challenge that African Americans faced when they experimented with various representational strategies to disseminate a counter-narrative of African American historical "truth." For all of Warrick's representational experimentation, her tableaux followed closely, and indeed were constrained by, the conventions of contemporary textual narratives of black progress and history. A preoccupation with

displaying black middle-class respectability, diligence, and cultural refine-
ment foreclosed any possibility that the full range of black lifestyles, talents,
and circumstances could be acknowledged in Warrick's scenes. In this re-
gard, Warrick's envisioning of black life and aspirations was circumscribed
not just by her privileged background but also by the rhetorical tactics inher-
ent in her project. When Warrick set out to depict the black historical expe-
rience, she compressed and homogenized it, almost certainly for purposes
of narrative clarity. Hence, her concern to convey black middle-class re-
spectability through her vignettes was part of a much larger phenomenon of
liberal intellectuals and artists, regardless of ethnic and racial backgrounds,
in late-nineteenth- and early-twentieth-century Europe and America who
projected their concerns and ambitions on the peoples they claimed to rep-
resent. Warrick's work, in this regard as well, was not a "counter-narrative"
per se but instead fit easily with the prevailing grand narrative of social
progress and upward mobility (for whites). Similar interpretative and repre-
sentational tensions were evident in other representations of African Ameri-
can history by blacks during the first two decades of the twentieth century.
Thus, although Warrick faced distinctive challenges as a sculptor when she
set about depicting an ennobling black past, her larger struggle—to use
seemingly objective modes of representation to contest the dominant ideol-
ogy of race and civilization while reinforcing the dominant ideology of middle
class and social progress—challenged her entire generation of black intellec-
tuals and activists.

## Race on Display

Before exploring the range of meanings that Warrick's dioramas conveyed, it
first is necessary to take into account the specific setting in which she staged
her art. The Jamestown fair was just one expression of Americans' insatiable
enthusiasm for exhibitions. Its origins may be traced to the eagerness of Vir-
ginia's white elite to promote sectional reconciliation and economic devel-
opment.[7] Equally important to organizers was the celebration of the state's
colonial heritage, specifically the commemoration of the first permanent En-
glish settlement in the United States. Like the historical displays at the world
expositions described by Walter Benjamin, the exhibits at the Jamestown fair
had the effect of "telescoping the past through the present."[8] Seemingly no

FIGURE 6.1. Designed by W. Sidney Pittman, a black architect who also had designed buildings at his alma mater, Tuskegee, the Negro Building at the 1907 Jamestown Exhibition was a 213-feet-long and 129-feet-wide two-story structure. Although constructed entirely by black workers and contractors, the Negro Building, and the explicit separation of black exhibits in it, offended many blacks at a time when Jim Crow segregation was still a recent innovation. *Reprint of a Jamestown Amusement and Vending Co. postcard.*

display was too mundane to impart lessons about history, progress, civilization, and modernity. Especially rife were assumptions about the nature of historical change and social evolution.

The version of the past extolled by white planners of the exhibition was an unabashed celebration of Anglo-Saxonism. The Association for the Preservation of Virginia Antiquities, a blue blood voluntary association committed to the preservation of the Old Dominion's white past, looked to the fair as an opportunity to disseminate their distinctly conservative mixture of politics and filiopietism. The popular Palace of History at the fair, stuffed with portraits, books, and artifacts, heralded the contributions of white Virginians, as statesmen and warriors, to the nation. Likewise, Anglo-Saxon triumphalism permeated the exhibits staged by the Daughters of the American Revolution, the Colonial Dames, and other self-appointed custodians of the past.

White North Carolinians, for instance, celebrated their state's heritage as the birthplace of Virginia Dare, the first "infant child of pure Caucasian blood," a milestone that "proclaimed the birth of the white race in the Western Hemisphere."[9]

In light of the overriding themes of the Jamestown Exposition, African Americans had ample cause to be suspicious about their place in the proceedings. Certainly the roles accorded to them at earlier expositions offered cause for concern. When whites had acknowledged African Americans' presence in the past, it typically had been in a viciously pejorative manner. At the 1876 Centennial Exposition in Philadelphia, a concession called "The South" offered "a band of old-time plantation darkies who will sing their quaint melodies and strum the banjo before visitors of every clime." At the 1893 Chicago fair, an "Old Time Plantation" display was proposed by Rebecca Latimer Felton, one of the southern representatives on the board of "Lady Managers" of the fair. In an effort to glorify "the slave days of the republic" and to illustrate the contemporary "ignorant contented darkey," the exhibit included two "well behaved" and "real colored folks" chosen by Felton. At the 1895 Atlanta and 1897 Nashville expositions, white businessmen, aided by a minstrel showman, revived the "Old Plantation" concession that had first appeared in Philadelphia.[10]

Even the more "refined" representations of blacks that whites planned for expositions often offended African Americans. At the 1902 Charleston (South Carolina) Exposition, an eight-foot-high sculpture by New York sculptor Charles A. Lopez proposed to portray African American abilities in marble. At the center of the sculpture was a young black woman who supported a basket of cotton on her head. To her left was a young black man, wearing an artisan's apron and equipped with a mechanic's tools, who relaxed by picking a banjo. Moving further around the statue, the spectator encountered a muscular man grasping a plow and leaning on an anvil. Decorating the pedestal were cotton, tobacco, and bananas. To outraged blacks in Charleston, who eventually forced the relocation of the sculpture on the exposition grounds, this depiction of blacks as rustic, muscle-bound laborers was intolerable.[11]

By 1907, blacks understandably were wary of fairs that openly celebrated white supremacy. They resented being insulted by racist depictions while simultaneously being subjected to segregated exposition accommodations.

Blacks had first been allowed to participate, but only in a limited fashion, in the 1876 Centennial. They had fared little better at the 1885 New Orleans exposition. They subsequently had been excluded from the planning of the Chicago World's Fair and were barely represented in its displays. The 1895 Atlanta Exposition, where Booker T. Washington delivered his career-defining "Atlanta Compromise" speech, was the first fair with a building dedicated to African American exhibits. Once the precedent was established, subsequent southern fairs included segregated "Negro Halls." Given these experiences, many blacks agreed with the *Voice of the Negro,* a leading black journal, when it warned in 1907 that any exposition at which the races were segregated and that endorsed the values of white superiority was "a burlesque" that "should be shunned."[12]

Despite the cultural pervasiveness of racism and the injunction to fight the display of such stereotypes, Warrick and other blacks nevertheless succumbed to the temptation to try to use expositions for racial uplift. While ethnographic displays of "primitive" African culture proliferated, no prominent museums devoted space to the systematic display of African American art or historical artifacts. Nor did contemporary black life merit acknowledgment in museums devoted to either natural history or the fine arts. Because of the cultural influence exerted by worlds fairs, they believed that it was essential that blacks represent themselves at them. They especially looked to the expositions as venues in which to affirm their rapid acquisition of civilization to both themselves and whites. R. W. Thompson, writing in the *Colored American Magazine,* observed that critics and skeptics demanded "concrete and tangible proof of all that any people may claim for themselves." "Here [at the Jamestown fair] in the Negro exhibit," he went on, "is granted an opportunity for the race to demonstrate beyond cavil precisely what it has accomplished." These displays would serve as "an accurate time keeper of the progress of the race." Thompson was confident that "the massive aggregation of material" in the Negro Exhibition would demonstrate "the Negro as a constructive factor in the civilization of the age."[13]

Precisely these same ambitions had motivated Giles B. Jackson, a former slave who had risen to the ranks of Richmond's black elite, to propose the creation of a "Negro Exhibit" at the Jamestown tercentennial. Jackson ingratiated himself with Richmond's white elite while working as a servant to several prominent white families in Richmond and as a clerk to a leading white

lawyer. He garnered further favor by claiming to have been Confederate general Fitzhugh Lee's body servant during the Civil War. Establishing himself as Richmond's leading black lawyer, he gravitated toward Booker T. Washington's circle. Jackson envisioned meshing Washington's program of black advancement through economics with the broader aims of the Jamestown Exposition so as to demonstrate "the achievement of the Negro race in America, [. . .] and specially to show what the race has accumulated for the betterment of its condition since 1865." Through such an exhibit, Jackson predicted, the "unjust and unfair critics of the Negroes may be silenced."[14]

Even Thomas J. Calloway was persuaded that exhibitions held promise as pageants of self-representation for blacks. A graduate of Fisk University (where he met his life-long friend W. E. B. Du Bois), Calloway moved easily among militant African American activists. He did not bear the stigma of accommodationism that made Jackson such a controversial figure. Calloway's experience as a Special Commissioner for the "Negro Section" at the Paris Exposition of 1900 (where he first met Warrick) prepared him to be the chairman of the Executive Committee for the Negro Exhibit at the Jamestown fair. Moreover, his role as an officer of the American branch of the Pan-African Organization, which had been founded in London in 1900, and his membership in the American Negro Academy, the leading organization of black intellectuals, enabled him to persuade some prominent African Americans, including Meta Warrick, to support his plans for the Jamestown fair.[15]

It was Calloway's vision, at least as much as Jackson's, that was responsible for the contents of the Negro Exhibit, including Warrick's dioramas. Embracing the era's enthusiasm for spectacular displays of crafts, inventions, machinery, and evidence of educational accomplishments, Calloway and black fair organizers set out to create testimonials to blacks' abilities. Field agents were sent to the states east of the Rockies to solicit exhibits relating to education, "homes," farms, skilled trades, business enterprises, professions, "military life," church life, books, music, art, and "woman's work." One of the few exhibits that the commissioners financed was the "Warrick Tableaux." On 27 February 1907, Calloway and the planning committee contracted with Warrick "to construct in a true and artistic manner a series of fifteen model groups to be so arranged as to show by tableaux the progress of the Negro in America from the landing at Jamestown to the present time." Three months

later, Warrick's dioramas would be installed along with some 9,926 other exhibits in the Negro Department.[16]

The themes of the Jamestown Negro Exhibit, in sum, reflected the same notions of linear historical progress that would be evident in Warrick's dioramas and were pervasive in African American thought at the dawn of the twentieth century. The displays organized black accomplishments within an incremental, chronological narrative that extended from ancient Africa to contemporary America. As early as the 1895 Atlanta Exposition, this emerging narrative convention was literally inscribed in the pediment at the main entrance of the Negro Exhibit there. On one side was a plantation scene of a one-room log cabin, a log church, and the tools of cotton cultivation—synecdoches of black life in the age of slavery. On the other side was depicted African American achievement thirty years after emancipation, including a modern home, an impressive church, and symbols of black artistic and intellectual accomplishment. These tropes appeared again at the Jamestown Exposition where a small windowless log cabin, which was intended to evoke the slave cabins of old, stood juxtaposed with a pleasant modern cottage, representing black home life in the twentieth century.[17] Warrick's own dioramas, of course, were the exhibition's fullest and most elaborate representation of this grand narrative of African American self-improvement.

### Meta Warrick

In a very real sense the Jamestown dioramas were expressions of the milieu from which Warrick herself emerged. Both the form and character of her tableaux reflected the elegantly Victorian and deeply spiritual cultural sensibilities she had acquired while growing up in a comparatively privileged black Philadelphia family. Likewise, her extensive training in fine arts in Philadelphia and Paris, and her standing within the African American cultural elite, made her ideally suited to create the dioramas.[18]

Meta Warrick was born into the ranks of the "Negro aristocracy" of Philadelphia on 9 June 1877. She was the daughter of William H. Warrick Jr., a barber, and Emma Jones Warrick, a hairdresser and wigmaker. The founder of the Warrick line in America had been a white Anglican priest who, after emigrating to Virginia, had married a free black woman. His son, William Henry, worked as a merchant seaman in Portsmouth, Virginia, until the

oppressive racial atmosphere in the 1850s compelled him to move his wife Louisa and their eight children to Philadelphia. There he became a successful steward. Subsequently his son William Jr., (Meta's grandfather) entered the barbering profession and amassed a small fortune through catering and real estate investments. He prospered enough to buy a comfortable home in a mixed race neighborhood of the city and to assume a prominent position among the city's "special class of blacks."[19]

Unlike members of the Warrick family, who boasted that none of their ancestors had been enslaved, Meta's mother was descended from slaves. Her grandfather was Henry Jones, a Virginia slave who had escaped to Philadelphia. There he thrived as a caterer and, on the basis of both his wealth and his sense of social responsibility, emerged as an activist among the city's black elite. Through his membership in the leading abolitionist and "improvement" organizations of the city he befriended William Warrick, whose son married Jones' daughter Emma in 1865.[20]

The Warricks' wealth surrounded Meta and her two siblings with the trappings of Victorian respectability and made possible an education uncommon among Philadelphia's blacks. Meta attended an integrated grammar school and then the experimental Industrial Art School, which mixed traditional academic arts with manual training. Subsequently she progressed to the Girls' High Normal School, where her talent earned a scholarship to the Pennsylvania Museum School of the Industrial Arts in the fall of 1896. She mastered various media, but evinced unusual talent for sculpture. Urged by her teachers, she elected to continue her training in France.

Arriving in Paris in 1899, she came under the influence of painter Henry O. Tanner and sculptors Augustus Saint-Gaudens and Auguste Rodin. Embracing the aesthetic language of the romantic symbolist school of art, she honed her technique by sculpting traditional themes of Western art, particularly those derived from ancient mythology and the Bible. Like other symbolists, she aspired to give expression through art to emotion, mystical experience, and intangible truths. Despite these seemingly abstract aims, she remained committed to using readily recognizable subjects and familiar themes. Yet, following symbolist aesthetics, she eschewed traditions of classical realism and instead devoted particular attention to capturing, in musculature, expression, and pose, the "life spirit" of her subjects. Warrick's exposure to the artistic currents of fin-de-siècle Paris had two especially important consequences: it

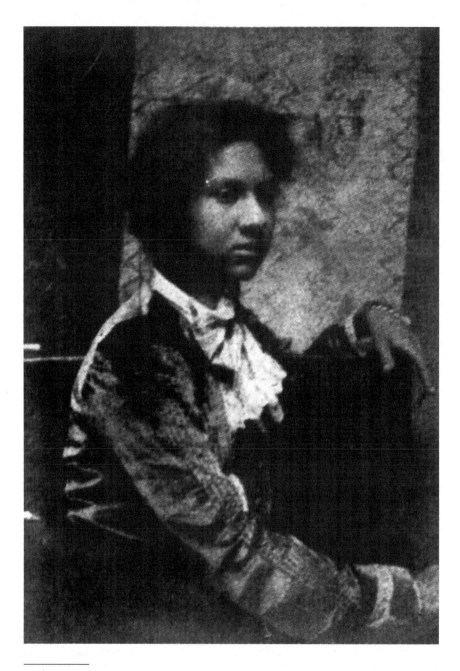

FIGURE 6.2. Portrait of Meta Vaux Warrick (1877–1968) in 1907, the same year she created the Jamestown tableaux. Thirty years old at the time, and boasting training in the studios of Paris, she accepted a commission "to construct in a true and artistic manner" tableaux "so arranged as to show by tableaux the progress of the Negro in America from the landing at Jamestown to the present time." *Reprint from* Voice of the Negro *IV (March 1907): 116.*

encouraged her life-long preference for subjects rich with allegorical potential, and it demonstrated that sculpture need not be limited to the heroic themes and aesthetic conventions that characterized the classical tradition.[21]

Although her experiences in Paris awakened her to the possibilities of sculpture, she shied away from African or African American themes. In 1900 W. E. B. Du Bois, who met Warrick while attending the Paris Exposition, encouraged her to "make a speciality of Negro types." Accepting the suggestion as "well meant," she nevertheless demurred. Her hesitancy to turn to African American themes almost certainly reflected the dilemma African American artists confronted when considering their subject matter. Aesthetic conventions, rooted in both the classical tradition and Western racism, inhibited efforts to fashion representations, especially heroic images, of African Americans. The artistic challenge of depicting African Americans in sculpture was especially daunting. As art historian Kirk Savage has explained, "Making the African American body a monumental subject would alter its marginality, would make African Americans newly visible and historically significant in the physical and cultural landscape." Moreover, Warrick already had acquired a reputation for her perceived "grotesque" renderings of mythical and biblical themes. To apply her creative technique to African American topics ran the risk of having both her creations and her subjects dismissed by white patrons and critics as primitive and bizarre, thereby contributing to artistic marginalization of African Americans.[22]

Circumstances eventually led Warrick to reconsider. During the Paris Exposition, she befriended Thomas J. Calloway, then serving as a commissioner of the "Negro Section" at the exposition. While browsing the exposition grounds in his company, Warrick studied dioramas depicting episodes in Catholic history. Her interest prompted Calloway to disclose that plans were already underway for an exhibition at Jamestown which could include a diorama tracing the history of African Americans from 1619 to the present. During the exhibit, Warrick became intimately involved with still another series of tableaux. Thomas W. Hunster and his manual arts students from the Washington, D.C., Colored High School had created a diorama, but it had been damaged in shipment. Observing Warrick's interest in the form, Calloway suggested that she mend and install Hunster's models. Thus, Warrick found herself working on nine scenes that traced black educational progress since the Civil War. Crafted by African Americans and devoted to African

American themes, the dioramic scenes probably were the first to be displayed at a major exposition. Warrick surely understood the innovative quality and importance of Hunster's work and her own contribution.[23]

Warrick's experiences after her return to Philadelphia hastened the redirection of her artistic interests. Although she had encountered racism during her stint in Paris, she had escaped most of the galling slights that blacks in America routinely endured. Her time in France and the years preceding the Jamestown Exposition coincided with the peak years of lynchings of African Americans, the codification of segregation, and the disfranchisement of southern blacks. She returned to an African American community engaged in strenuous debate about how best to respond to these worsening conditions. For elite blacks like Warrick, the ascendance of the ideology of white supremacy raised vexing questions about their opportunities in America and their proper role within the African American community.

In Warrick's case, she had pursued an education and a career as an artist with the assumption that her identity as a black woman was irrelevant. But the conditions she encountered compelled her to revise her expectations. Her family's tradition of public activism alone might have obliged her to take up the plight of her race. In addition, she surely felt the acute sense of duty shared by privileged blacks. Warrick never spoke of herself as an exemplar of her friend Du Bois's idea of the "talented Tenth," which he developed in an article published in 1903, but in fact she fit Du Bois's description exactly.[24] Her experience as an artist in Philadelphia, moreover, taught her that her art and her racial identity could not be separated. Despite the accolades she had earned in Paris, few white art patrons regarded her as a legitimate artist or were interested in her sculpture.

Consequently, when Calloway offered her a commission of $1,800 to create the dioramas he had proposed seven years earlier, she eagerly accepted. Casting aside her previous refusal to take up African American themes, Warrick grasped an opportunity to reach a potentially vast audience of exposition visitors and to be the first African American sculptor to receive a federal commission.

When Warrick began to create her dioramas in the spring of 1907 she had diverse precedents to draw upon. Her experiences at the Paris Exposition and immersion in the cultural ferment of Paris provided a measure of inspiration. Her familiarity with theater design, especially the dramaturgical

effects of screens and staging, gave her a keen appreciation of the capacity of artistry to create illusions. Her training as a sculptor, as well as her symbolist penchant for allegorical representations, obviously facilitated her envisioning the possibilities of the dioramic form. Most important, she had considerable familiarity with the innovations in natural history and ethnographic displays that Philadelphia museums were then taking a lead in; she, after all, had studied at the art school affiliated with the Philadelphia Museum and was a habituée of it and the city's other museums.[25]

As early as the turn of the nineteenth century, popular "museums" had proven the immense appeal of their wax models and painted illusions. Museum administrators of the late nineteenth century, driven by a "Victorian rage for order," recoiled from the "Barnumesque sideshows" of the bizarre and grotesque that had characterized many museums during the early nineteenth century. Instead, fin-de-siècle museum builders endorsed a rigorously systematic and rational presentation of the known world that made no allowance for the spectacle and chaotic displays favored by their predecessors. Even so, the temptation to harness popular forms of the spectacle to the larger project of using objects to present the world's knowledge proved overwhelming.[26]

Natural historians and museum curators experimented with mounting animals in appropriate landscapes to create an illusion of the natural habitat. By the late nineteenth century, such practices extended to ethnography, a branch of natural history. "Primitive" peoples appeared *in situ,* surrounded by proper ethnographic objects from the overstuffed display cabinets of museums. At the 1895 Atlanta and 1897 Nashville international expositions, for instance, twelve life-sized figures, in "authentic" attire and poses, depicted various types and stages of human development. Such presentations offered patrons a glimpse of "primitive" cultures and vanishing peoples, thereby articulating the dominant ideology: the natural hierarchy of humanity and human cultures.[27]

Warrick undoubtedly knew about such exhibits. Still, the field was ripe for innovation and Warrick did not create her dioramas to merely mimic previous exhibits. Conventions of display had not yet been established, and thus the form was mutable. Lines separating animal and habitat exhibits from cultural and hierarchical tableaux remained ambiguous. In such a context, Warrick's ambition to represent the fullness of three centuries of black history by means

of dioramas moved well beyond the scope of contemporary exhibits, even of ethnographic "life groups."

In fulfilling her commission, Warrick faced daunting prejudice that was built into the forms she wished to use. Extant precedents, ranging from habitat groups to ethnographic models, were not self-evidently suited to tracing and celebrating African American accomplishments. Even seemingly "objective" habitat dioramas were in fact instruments of imperialist, white, male domination. Likewise, so implicated in theories of racial superiority were life group displays that they formed a crucial component of "the epistemology of imperialism." Assembled to plot the location of each human group on the universal scale of social development, ethnographic displays were intended to demonstrate unambiguously that Western civilization marked the highest achievement of social evolution, classifying and naturalizing such categories as primitive and civilized, backward and modern, and so on. An especially glaring example of the arrangement of a display to illustrate such hierarchies was Charles W. Dabney's planned exhibit for the 1895 Atlanta Exposition. As originally conceived, "a series of figures" would portray "the evolution of the Negro from the earliest animals through the ape, chimpanzee and South African Bushman, down to the Negro as he is in this country." In this instance, black protest led to the withdrawal of the proposed exhibit, but elsewhere similar displays took their place in museum and exposition halls.[28]

Warrick not only had to re-imagine dioramas free of such racist emplotment, but she also had to historicize them so that they presented an evolutionary narrative. Not until almost a decade after her miniatures were displayed at the Jamestown Exposition would American museum curators begin to experiment with using dioramas to recreate celebrated events in American history.[29] Until then, ethnographic displays typically treated history and culture as virtually synonymous, drawing few distinctions between the past and present. Most displays presented cultures in a temporal limbo that existed outside of any traditional historical understanding. Warrick, in contrast, highlighted historical change through scenes of the progressive advancement of blacks. The tableaux presented a grand narrative of evolutionary progress from primitive to civilized, from enslaved to free. Five of the fourteen dioramas dealt with the slave era; the remaining nine depicted black life since the Civil War. By beginning her dioramas with slavery, rather than

emancipation, Warrick established the defining influence that slavery exerted on the history of African Americans and America. The subsequent tableaux, whether of a black family homesteading or of a crude schoolhouse, countered racists' claims that freed blacks had retrogressed into criminality, indolence, and barbarism. When viewers reached the last model in Warrick's extended allegory of collective transformation—*College Commencement*—the descendants of the prostrate Africans in the first scene had become well-dressed, erect, proud, able, dutiful, and self-disciplined African Americans.

The narrative logic of her dioramas, progressing from the primitive and shackled Africans of 1619 to the "modern" contemporary black family, presumed that human societies evolved through stages that could be measured against a single criterion of development, or "civilization." In this regard, her dioramas reflected prevailing conceptions of material progress, education, and civilization. Yet, Warrick and her sponsors rejected the conclusion that civilization was a racialized accomplishment peculiar to whites. Rather the achievement of modern civilization was a race-neutral status which African Americans, and peoples everywhere, were capable of achieving. Whereas most whites presumed that centuries would be required to elevate blacks above abject barbarism, Warrick's tableaux would demonstrate that African Americans already were agents of modern progress. [30]

## The Warrick Dioramas

By offering visible evidence—"a theater of proof" as it were—of blacks' progress, Warrick and her sponsors intended her tableaux and the other exhibits at the Jamestown Exposition to demonstrate that African Americans had an understandable and noteworthy history. [31] During a cultural moment when contemporaries were fascinated with replications of reality (evident in everything from literary realism and films to phonographs and boardwalk concessions), these avowedly didactic aims seemed to require the verisimilitude and verity of dioramas, photographs, tableaux vivant, and other visual information and "truth." More than just literal representations of reality, Warrick's dioramas (and models of all kinds) achieved the descriptive, image-making quality of literature and the concreteness of the material world. This synthesis of artifice and mimesis, of literal representations of imagined moments in African American history, illustrates how Warrick's

dioramas brought into focus both what the legitimate subject of history ought to be and how that history should be represented.

Perhaps because of Warrick's rush to complete the dioramas on a short schedule, she left no detailed description of either her planning or interpretation of the dioramas. We have only cursory descriptions of how the tableaux appeared at the Jamestown Exposition. They come to us as a series of photographs scattered throughout the official record of the Negro Exhibition. Yet although much about the organization of the dioramas, and the experience of viewing it, remains unknown, the overarching organizational principles are readily apparent. Warrick established a consistent tone and theme throughout the tableaux, maintaining a representational logic from one scene to the next. Her broadest aims—to chart the progress of her race—are easily discerned. Her specific representational decisions, however, are obscure and open to multiple readings. The apparent ambiguity of and contradictions in Warrick's dioramas present an obstacle to any simple and definitive conclusion about their meaning. But the presence of contradictions in them are the key, not a barrier, to their usefulness for understanding the past.

Almost certainly Warrick intended her tableaux to convey protean, even contradictory, meanings to the various constituencies who attended the Jamestown fair. Warrick and other black exhibitors knew that their audience at Jamestown would include northern whites, southern whites, and blacks from both the North and South. In the racially charged setting of turn-of-the-century United States, and the South in particular, exhibitors faced a daunting challenge of fashioning displays that would not alienate any portion of a public that was divided along fault lines of race, class, and region. The imagery Warrick might have tapped was potentially boundless. Even so, she had to be selective in order to refer to and evoke familiar ideas, myths, and themes that would be legible to her viewers. Through the visual grammar of her scenes, Warrick created a prosaic representation of the ascendant ideology of racial uplift and progressive civilization.

Warrick's scenes of slavery are suggestive of the multiple layers of meaning conveyed by her tableaux. At first glance, the scenes hint that she contrived to repress, or at the very least, to channel narrowly the memories of the ordeal of bondage. The image of slavery called up by Warrick's models was far more reserved than the depictions of servitude that had characterized, for

instance, the speeches and writings of antebellum abolitionists. There was no dioramic equivalent to the vivid, melodramatic descriptions of floggings, murders, rapes, and slave auctions of abolitionist lore. And some of the models conjured scenes that were strikingly similar to contemporary white accounts of slavery. Yet, however restrained her portrayal of slavery's horrors, Warrick's dioramas were no moonlight and magnolia rendition of slavery. Themes of explicit violence and coercion were present in the displays of the arrival of the first slaves in Jamestown, of a fugitive slave hiding from white slave trackers, and of blacks picking cotton while being supervised by a white overseer.

As previously noted, the first tableau concerned the "beginnings of slavery" in Jamestown in 1619. Figures representing twenty African men and women, bound, stripped of clothes, in positions of abject powerlessness and abasement, stood on the dock where a Dutch sea captain had sold them to English settlers. In the background were a stockade, a storehouse, and the captain's ship, receding into the horizon. Both the dress and the untrained hair of the Africans underscored their primitiveness. Warrick compressed into the scene symbols of commerce, empire, and the traffic in humans, thereby reminding whites and blacks alike that "thirteen years after the landing of the white people at Jamestown came the Negro, while not of his own choice or liking." The diorama would seem to have posed the same question that Anna Julia Cooper, an African American writer and feminist, asked in *A Voice from the South* (1892): "Who are the Americans? . . . Who are the absolute and original tenants in fee-simple?" Or as Du Bois quizzed whites in *The Souls of Black Folk:* "Your country? How came it yours? Before the Pilgrims landed we were here."[32]

The second model continued the focus on the role of blacks in the South's and the nation's economic development. It depicted slaves at work in a cotton field on a southern plantation, presumably in the decades before the Civil War. The scene could be interpreted as confirmation of the claim, made by proslavery polemicists as well as Booker T. Washington, that slavery had taught Africans valuable skills, including the work ethic. At least one visitor interpreted the model as depicting "the slaves learning to work." The official history of the Negro Exhibit, similarly, noted that the slaves in the diorama "are properly clothed and show other evidences of increasing civilization."[33] Yet the model also suggested the life-sapping toil that defined the slave experience, in

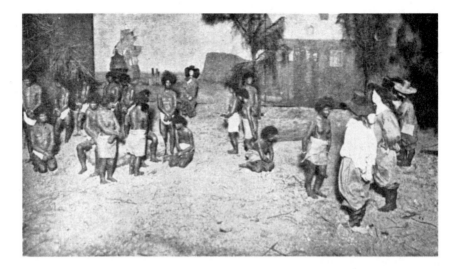

FIGURE 6.3. In the first of her tableau scenes, *Landing of First Twenty Slaves at Jamestown*, Meta Warrick establishes the historical importance of Jamestown for African Americans by highlighting the arrival of Africans thirteen years after the establishment of the colony. Warrick compresses into the scene symbols of commerce, empire, and the traffic in humans. *Reprinted from Giles B. Jackson and D.Webster Davis,* The Industrial History of the Negro Race of the United States *(Richmond: Virginia Press, 1908), 18.*

marked contrast to images of plantation life in the minstrel shows and popular fiction as uninterrupted frivolity.

In the same diorama, Warrick raised the issue of miscegenation through her deliberate use of skin color on the figurines. Whereas the models of the Africans had been painted a dark brown, the laboring slave figurines were "no longer uniform in skin color," thus displaying unmistakable signs of miscegenation. Against a backdrop of strident efforts to assert fixed identities, evident in everything from the era's genealogy fad to ever stricter legal definitions of race, Warrick's models drew attention to the instability of race and the prevalence of racial hybridity in the United States. The models also threw into relief the dialectic of attraction and revulsion that characterized white attitudes toward African Americans; whites enslaved Africans while simultaneously engaging in sexual congress with them. Here again, viewers could read different meanings into this evidence of racial mingling. Was Warrick drawing attention to the sexual exploitation of slaves? Or was she suggesting

that the "increasing civilization" of the slaves was partially the result of the salutary influence of interracial mating? When Warrick drew attention to miscegenation she waded into the turn-of-the-century struggle over the definition of American national character. The newly organized Daughters of the American Revolution and other white patriotic/hereditary societies were then defining the national character in explicitly racialized terms. Anna Julia Cooper, Frederick Douglass, Du Bois, and other blacks vigorously dissented. Rather than privilege "white" blood as the source of American character, they emphasized the nation's history of interracial mixing that eugenicists lamented and many whites vigorously sought to deny. Warrick, in her scenes, joined in emphasizing the nation's longstanding history of biracial intimacy.[34]

From miscegenation and work, Warrick moved on to freedom with *A Fugitive Slave*. Portraying the slaves' hunger for freedom, the model featured a two-man patrol searching for a slave, who was hidden in underbrush. Even though tracked by a bloodhound and armed slave-catchers, the fugitive remained confident that his trail had been destroyed when he crossed the stream that bisected the model's landscape. By summoning the memory of countless runaways (including Warrick's own grandfather) as well as invoking scenes from countless slave narratives, the tableau countered popular depictions of blacks as ideally suited to and content in bondage.

The ambiguity that characterized many of the dioramas was especially evident in Warrick's depiction of the slave/master relationship in the tableau *Defending Master's Home*. Set during the Civil War and in front of a grand Greek Revival mansion, with a humble slave cabin on the horizon of a vast plantation, the diorama, one observer explained, offered a romantic image of "the negro's loyalty to his master in the Civil War."[35] According to the scenario of this model, while the plantation owner was away fighting for the Confederacy, a "poor white" seized the chance to kidnap the master's son. (Apparently no explanation for this curious crime was either provided or needed.) The child's mother, overwhelmed by fear and distress, had fainted into the arms of a faithful black mammy. A grey-haired and proud house slave, armed with a rifle, rescued his master's son and chased off the offender.

The inspiration for this tableau is obscure. Warrick flirted with well-established clichés—of dutiful antebellum slaves uncorrupted by freedom—that suffused Thomas Nelson Page's dialect stories and the gathering movement to commemorate "faithful slaves." Whites had long congratulated

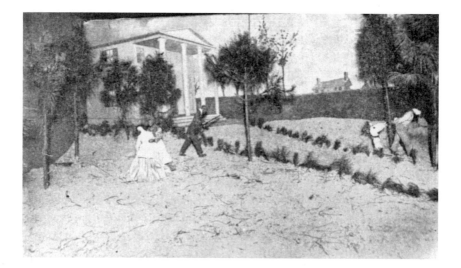

FIGURE 6.4. In *Defending Master's Home in the Civil War,* Warrick provides a complex rendering of the "faithful slave" myth. The tableau depicts a well-dressed house slave foiling the kidnapping of the master's son by a poor white. The plantation mistress collapses into the arms of slave women. The scene may have been intended to recall the intimate bonds that had existed between elite whites and some of their slaves. Yet the scene also turns slaves into historical agents who defended white civilization's most sacred foundations—the home and family. *Reprinted from Giles B. Jackson and D. Webster Davis,* The Industrial History of the Negro Race of the United States *(Richmond: Virginia Press, 1908), 24.*

themselves that the loyalty of slaves demonstrated both the affection that existed between "servants" and masters as well as the civilizing influence of bondage upon Africans. Countless white planter families recounted tales of heirlooms that had been protected from marauding Yankees by loyal slaves. Warrick was hardly alone in invoking the image of the faithful slave; Booker T. Washington and Du Bois both did so despite their differing visions for their race. In the climate of early-twentieth-century America, the figure of the loyal slave offered a more favorable, humane, and complicated representation than the grotesque depictions of freed slaves as sub-human, compulsive rapists in Thomas Dixon's *The Clansman* (1905) and other popular works.[36]

*Defending Master's Home* also may have been intended to recall the intimate bonds that had existed between elite whites and some of their slaves.

Giles B. Jackson, one of Warrick's sponsors, knew firsthand of the advantages that flowed from the ongoing support he received from his former master. Other black leaders, including Du Bois and Washington, agreed that the "better class" of southern whites, comprised of descendants of the old planter elite, was an ally blacks should cultivate. Warrick's model seemingly raised the possibility that white and black elites, who had once shared a sense of obligation and duty to each other, could again be reconciled.

But this tableau deviated in curious ways from the conventions of both the white mythology of slavery and black invocations of the loyal slave. Intentionally or not, Warrick created a vignette that was open to readings that hinted at the extraordinarily complex predicament and motivations of slaves. Like contemporary black orators who recalled that slaves had displayed exceptional loyalty to their masters, Warrick left ambiguous whether the fealty of slaves had been earned.[37] In the tableau, slave heroism affirmed black magnanimity, not white virtue. Warrick's diorama also rendered in miniature a central tenet of the black defense against charges of black criminality; why would blacks rape and murder now when they could have done so easily but had not during the Civil War? The black man in the tableau was the defender of, rather than a threat to, whites. At the very least, Warrick turned slaves into historical agents who defended white civilization's most sacred foundations—the home and family—from the threat posed by menacing whites. Thus, while white viewers may have viewed the tableau as a comforting image of black loyalty, blacks may have seen it as a confirmation of black heroism.

Such black agency was conspicuous in the final diorama of the history of African Americans in the era of slavery. Undoubtedly reflecting her Pennsylvania background, Warrick devoted a diorama to the founding of the Free African Society. With this reference she valorized America's first independent black church, established by Richard Allen and Absalom Jones in Philadelphia in 1787. Allen and Jones, while lay preachers for St. George Methodist Episcopal Church, recruited so many blacks to the congregation that alarmed church officials segregated them into the church's balcony. When the black members refused to accept separate seating, church leaders forcibly ejected them from the church. Undaunted, Jones and Allen began conducting independent church services. Warrick's diorama re-imagined one of these early services at which the two exiled religious leaders ministered in a humble, unadorned blacksmith's shop.[38]

For Warrick, like so many African Americans, the establishment of the Free African Society, which evolved into the African Methodist Episcopal Church, was a signal event because it marked a critical juncture in the emergence of an overt sense of shared African American identity. By recalling this event, Warrick affirmed the role blacks had played in propagating Christian civilization. Moreover, the rise of the AME Church from humble origins to international influence meshed with Warrick's visual catalogue of black advancement. The event had additional meaning for her since she herself was a member of the congregation depicted in the diorama.

Warrick's images of the slave experience were the prologue to ten scenes that depicted African American strivings since emancipation. Warrick exploited tropes common in American popular culture, especially popular illustrations and mythic images of frontiersmen from Daniel Boone to Abraham Lincoln, that charted the transformation of the continent's wilderness into tidy pastures, plowed fields, and picturesque village skylines. Juxtapositions of "before" and "after" scenes—of the rustic conditions endured during slavery and the refinement achieved in freedom—were a staple of representations of black progress at expositions. In this regard, Warrick's models echoed Frances Benjamin Johnston's celebrated photographs of similar scenes, displayed in the Negro exhibit at the Paris Exposition in 1900.[39]

Warrick in particular wanted to display the new-found strength of the black family in freedom. Accordingly, in *The Freedman's First Cabin,* she portrayed a family—a mother holding an infant, a father, a son, and a daughter— as they prepared supper after having cleared a small woodland path and having laid the foundation of their new home. Her figures had escaped the thralldom of slavery, represented by the gloomy and primal forest, for the promise of freedom and a future of civilization, symbolized by the house foundations and the other signs of human refinement in the clearing.

Similarly, she linked freedom, education, and civilization in *The Beginning of Negro Education,* which showed two black teachers, a man and a woman, in a log cabin schoolhouse, calling their black pupils back to class after recess. The diorama recalled the unbounded enthusiasm that freed people had displayed for education after emancipation and celebrated the service of black teachers. The scene underscored the unshakable belief in the power of knowledge and the celebration of learning that were ubiquitous in turn-of-the-century black public culture, oratory, and writings.

Intent on demonstrating blacks' fitness for and record of citizenship, Warrick turned to black military service in *Response to the Call to Arms*. Set in an undefined moment in the recent past, the diorama avoided any explicit reference to the Civil War. Dates and contemporary interest indicates that it was probably a scene from the recent Spanish-American War. In any case, Warrick placed eight black soldiers in the miniature, standing at parade rest, their attention riveted by their black commanding officer. The model was a reminder that African Americans had a history of military service that stretched from the nation's founding through the most recent war. (Indeed, the published history of the Negro Hall at the Exposition made sure that readers understood this point by devoting five chapters to the topic.) Yet even this seemingly simple representation of black Americans' military service was charged with political meaning. Only years prior to the exposition, white southern legislators, in the name of white supremacy, had abolished black militia units, thereby effectively depriving most black men of any opportunity for military service. Even the major Union veterans' organization, the Grand Army of the Republic, had systematically segregated its ranks during the 1890s and the recurring reunions of Confederate and Union veterans pointedly excluded black veterans. And only months before the Jamestown Exposition, the dishonorable discharge of more than one hundred black soldiers for alleged riotous behavior in Brownsville, Texas, had sparked a firestorm of controversy between whites, including President Theodore Roosevelt, who disparaged the abilities of black soldiers, and a virtually united black community, which bitterly resented the unwarranted dismissal of the black soldiers and attacks on black valor. In an age of ascendant imperialism and revived martial spirit in the United States (which the exposition enthusiastically celebrated), black soldiers were virtually invisible in the celebration of war and soldiering; they won no place on the pedestal of civic recognition. Blacks vigorously, if unsuccessfully, contested this systematic denial of their military valor. With this model, Warrick echoed black orators on the Fourth of July and Emancipation Day, as well as black historians such as George Washington Williams, in celebrating black men's record of civic duty, patriotism, and manhood.[40]

Warrick's last six tableaux, set in the present, depicted civilization achieved. In a real sense, these models recreated in miniature the social context out of which emerged the plethora of manufactured goods, handicrafts,

and arts that stuffed the exhibits in the Negro Hall. These scenes were exceptional at a time when sculptural representations of workers of any kind, let alone black workers, were rare. Warrick avoided the exoticized and caricatured images that marred Charles Lopez's controversial sculpture of black workers displayed at the 1902 Charleston Exposition. Instead she domesticated the image of black labor in a manner that was understandable and acceptable to middle-class and elite audiences, whether white or black. The first three—*On His Own Farm, Builders and Contractors,* and *The Savings Bank*—defied stereotypes of blacks as indolent and instead portrayed them as capable contributors in essential areas of the economy. Yet Warrick's own background bounded her ideas of work and workers. She had no firsthand knowledge of the jobs most blacks performed or the conditions they endured. Given her larger aims and her privileged background, she presented a romanticized and allegorical image of black labor. Her sanguine depiction of black occupational mobility, represented by black landowners, tradesmen, and bank clerks, was actually an exercise in nostalgia. She saluted the dignity of labor, but did so while ignoring the powerful forces beginning to drive urban blacks from their trades and rural blacks from the countryside, thereby condemning most black men and women to arduous, unskilled occupations.[41]

Finally, in three models that clearly were capstones to the whole exhibit, Warrick represented accomplishment in "the arts of civilization." First came *Improved Home Life,* set in a neatly furnished parlor in the home of a prosperous black family. While the husband read, his wife was busy with her needlework and their children played on the floor. A house guest, Paul Laurence Dunbar, was seated at a corner table writing. By placing this celebrated black poet and several miniature paintings in the vignette, Warrick demonstrated that the pursuit of beauty and the expression of imagination took their place alongside the accumulation of wealth as an ideal of black family life. In contrast to white presumptions that the acquisition of culture by blacks was dangerous and often destructive, Warrick offered a comforting scene of domestic tranquility.

The virtues of private life and domesticity were not Warrick's only message. We may wonder why Warrick chose to add Dunbar to her depiction of idyllic home life. Perhaps she included the poet simply as a gesture of respect to a lionized and recently deceased fellow artist. Yet Dunbar also was the most iconoclastic and pessimistic black writer of the age. His poetry and fiction

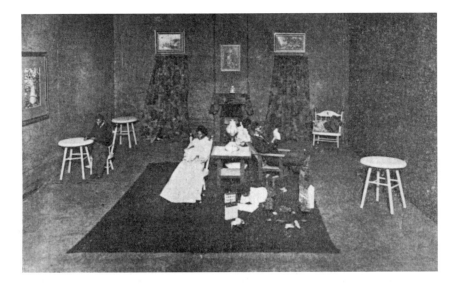

FIGURE 6.5. *Improved Home Life* epitomizes Warrick's focus on black middle-class respectability. While the husband reads, his wife is busy with her needlework and their child plays on the floor. Curiously, Paul Laurence Dunbar, the black poet, is seated at a corner table writing. In contrast to white presumptions that the acquisition of culture by blacks was dangerous and often destructive, Warrick offers a comforting scene of domestic tranquility and propriety. *Reprinted from Giles B. Jackson and D.Webster Davis, The Industrial History of the Negro Race of the United States (Richmond: Virginia Press, 1908), 103.*

called into question many of the assumptions of black progress that Warrick presented in the miniatures. He highlighted the injustices that blacks confronted, exposed the myth of southern paternalism, and reflected on the shortcomings of a program of racial uplift dependent upon material progress and the trappings of gentility. Intentionally or not, by including the figure of Dunbar in her tableau, Warrick provided an opening for ambivalence and skepticism in a scene otherwise suffused with optimism.[42]

Religion and higher education, the essential measures of advanced civilization, were the subject of Warrick's final two scenes. Significantly, in *An After Church Scene,* she returned to less ambiguous themes. She used the sculpture to depict the growth of the African Methodist Episcopal Church and she thus recalled the earlier model of its origins. Instead of a small gathering of worshippers in a smithy's barn, church services now took place in an

impressive church with stained-glass windows and attracted smartly dressed worshipers whose "general appearance" conveyed, in the words of one viewer, "manliness, self-reliance, modest intelligence, and ease of manner."[43] In her ultimate and most elaborate tableau, *Commencement Day,* Warrick paid tribute to black achievement in higher education. At once historical and contemporary, this diorama staged a graduation ceremony at Howard University. Frederick Douglass, the commencement speaker, stood on the common, surrounded by dignified professors, self-confident graduates, and proud parents. Warrick's choice to portray Howard University and Douglass was an unmistakable endorsement of the broadest conception of education and rights for African Americans at a time when industrial education and Booker T. Washington were ascendant. Her aesthetic sensibilities could not be satisfied by the parochial and utilitarian vision for black people offered by Washington. If many of the tableaux could be read as visual affirmation of Booker T. Washington's creed, the concluding diorama suggests that Warrick nevertheless shared Du Bois's conviction about the crucial importance of cultural and intellectual endeavor.

Much about Warrick's retelling of the black past was thoroughly consonant with the racial uplift ideology of her age. The outlines of Warrick's dioramic narrative of black progress were familiar to anyone who had listened to black commemorative orations or who had read any of the burgeoning catalogue of "race histories" or paeans to racial uplift. To a great degree, her allegorical miniatures borrowed and restaged familiar oratorical and literary tropes of black struggle and accomplishment. In place of soothing recitations of arcane data about black educational accomplishments, business investments, and property holding that accompanied most public orations and "race histories," Warrick offered reassuring scenes as a simulacrum of the race's steady advance.[44]

She joined with other black writers and orators in depicting blacks' rapid progress as the consequence of their own will and struggle, rather than of white beneficence.[45] Her post-emancipation scenes were bereft of white figures or symbols of white intervention in black affairs. In this regard, Warrick's dioramas differ in important ways from Frances Benjamin Johnston's celebrated photographs of Hampton Institute and African Americans that had been displayed at Paris and other world expositions. Whereas Johnston apparently tried to erase the racial identity of her subjects in favor of a common

FIGURE 6.6. *Commencement Day* represents the literal and metaphorical culmination of Warrick's tableaux of black progress. The scene depicts a graduation ceremony at Howard University. Frederick Douglass, the commencement speaker, stands surrounded by professors, graduates, and parents. Warrick's choice to portray Howard University and Douglass was an unmistakable endorsement of the broadest conception of education and rights for African Americans at a time when industrial education and Booker T. Washington were ascendant. *Reprinted from Giles B. Jackson and D. Webster Davis,* The Industrial History of the Negro Race of the United States *(Richmond: Virginia Press, 1908), 82.*

national character, Warrick presented a saga of racial autonomy and self-determination. Her scenes were closer to Du Bois's archive of photographs, "Types of American Negroes," that he exhibited at the 1900 Paris Exposition. The diversity of the African Americans depicted and the variety of poses in Du Bois's photographs resisted any simple conception of African American character or identity. Warrick, however, did not represent nearly as broad a panorama of "Negro types" as had Du Bois had and instead presented a relentlessly bourgeois image of black life.[46]

Her belief in the central importance of the rise of the black middle class almost certainly helps explain Warrick's emphasis on the historical significance of otherwise seemingly mundane aspects of African American life. Largely avoiding the exceptional events or heroic deeds of the black historical experience that black orators and historians favored, the dioramas highlighted

the representative and the prosaic. Instead of models depicting, for instance, the black hero Crispus Attucks's death during the Boston Massacre in Revolutionary-era Boston, the Fisk Jubilee Singers performing before the crown heads of Europe, or black soldiers charging up San Juan Hill during the Spanish-American War, Warrick illustrated milestones in the lives of anonymous African Americans. Even so, the title to Warrick's domestic models—The Arts of Civilization—alerted viewers that these deceptively humdrum activities were nevertheless profoundly important. Warrick's transformation of the mundane into spectacle was consonant with the voyeurism of everyday life that characterized late-nineteenth-century culture. The dioramas reflected the erosion of private space evident in contemporary fiction, urban design, and architecture.[47]

Her tableaux encouraged the viewing audience to penetrate the imagined living space of black families, burrowing deep into intimate places normally shielded by Victorian conventions and decorum. Warrick placed nuclear black families at the center of her post-emancipation dioramas. She affirmed that black home life, no less than black public conduct in church, at school, or on the street, conformed to the conventions of propriety. Her emphasis on black civility was more than just a manifestation of her own Victorian upbringing and fastidiousness; because questions of individual and collective integrity had implications for the fitness of blacks to participate in public life, black respectability had unmistakable political import. That she dwelled on domestic scenes as a means to portray black "civilization" demonstrated her recognition that in turn-of-the-century America a crucial measure of one's refinement and respectability was how closely one's life hewed to patriarchal notions of manhood, motherhood, and domesticity. African American domestic life had come under close scrutiny and criticism because of the ways in which Victorian ideologies, especially social Darwinism and evangelical Christianity, linked the private with the public. Hostile whites concluded that black family life contradicted the dictates of civilization and therefore blacks, despite living among the civilized, were doomed to remain a primitive people. Black activists countered that the race's embrace of the patriarchal family demonstrated the triumph of blacks over the legacy of slavery. Summarizing the prevailing wisdom, Du Bois wrote in 1900 that "we look most anxiously to the establishment and strengthening of the home among the members of the race because it is the surest combination of real

progress." Warrick's images of stable, decorous, bourgeois family life confirmed black success at cultivating precisely the sort of Christian home championed by Du Bois and others. But just as was true with her scenes of black work, her preoccupation with displaying black middle-class respectability foreclosed any possibility that she could represent lifestyles that deviated from conventional domesticity.[48]

Warrick's voyeuristic scenes of black domestic life may have presented miniature models of respectable manhood and true womanhood, but she avoided a male-centered historical narrative. Her vignettes presented the black past as a saga of male and female survival and accomplishment. Only the scenes of the runaway slave and of the military muster excluded female figures. In the twelve other miniatures black women engaged in the same range of activities as the male figures. Most contemporary black commemorative celebrations and published "race histories," in contrast, presented manhood itself as synonymous with the progress of the race. Motivated by anxieties about black masculinity, many black men during the late nineteenth century began to reinterpret the whole history of the race in an effort to compile a cavalcade of heroic black manhood. Black men, for example, monopolized the most conspicuous roles in black civic occasions, processions, and histories, leaving only limited roles to black women. While black men sought to embody black masculinity by donning the gaudy finery of the military, or by displaying pride in craft, black women were expected to offer tacit support for the same ideals that black men professed—concerns principally associated with the male public sphere. Whether by intent or not, Warrick's voyeuristic narrative of domesticity challenged not only white depictions of black degeneracy but also black histories that focused exclusively on black men as historical agents.[49]

Taken as a whole, Warrick's dioramic cycle was her effort to interpret the black experience in a manner that contradicted the grotesque and mocking renditions that whites propagated in drama, literature, and popular culture in general. If hurried in execution and ambitious in scope, Warrick's narrative of black freedom was propelled by an internal logic. Much of the narrativity and history invoked by the dioramas lay beyond the immediate visual experience. Neither the scenes themselves nor Warrick's titles conveyed the complex meanings and associations of the dioramas. Presuming that visitors had prior knowledge of the narrative presented in the vignettes, she

relied on this knowledge, along with the ordering of the objects, to unfold dramatic action in the minds of spectators. In this manner Warrick's miniature scenes became stages on which viewers projected, by means of association, a deliberately framed series of actions. The synoptic capacity of dioramas allowed Warrick to present three centuries of African American history as contemporaneous, as coexisting simultaneously in the present. And this underlying narrative logic suggested a distinctive orientation toward the future. Warrick created a purposeful past that linked the struggles of contemporary African Americans with those of their ancestors. The future offered the promise of the fulfillment of enduring aspirations that had been anticipated, inspired, and urged on by the past sacrifices represented in the dioramas.

The contrast between the barely clad and abject slave in the first diorama and Frederick Douglass in the concluding scene was unmistakable. Nowhere in her diorama did she acknowledge the nation's retreat from the promise of Reconstruction or commitment to racial equality. Instead, Warrick celebrated the living struggle of emancipation and projected a present in which the possibilities of her race were bright, or at least open-ended. The cumulative effect of the tableaux contradicted any reinscription of subservience and primitivism on the image of the black body.

### Assessing the Warrick Tableaux

The immediate impact that Warrick's tableaux had on the several thousand whites and blacks who visited the Negro Hall each day during the Jamestown Exposition is difficult to discern. The absence of virtually any record of spectators' responses precludes firm conclusions about any enduring impressions left by the tableaux. Yet, occupying more than 1,500 square feet of prime exhibit space in the Negro Hall, they were difficult to ignore. Further proof of immediate impact appeared in the published accounts of the exposition, including the official fair history, which lauded the dioramas. Recognizing Warrick's creativity, the fair's white organizers awarded her a Gold Prize in the Fine Art category. Negating such praise and notice, however, was the sparse attendance at the fair, which made the exposition one of the least successful international fairs of the era. As though reflecting official lack of interest, when the fair closed in November 1907 the dioramas were disassembled and discarded, proving to be as ephemeral as the exposition itself.

Warrick's participation in the exposition, nonetheless, had far-reaching consequences for her subsequent career. It was a point of creative departure for her, marking her shift away from classical and biblical themes to overtly African American topics. Throughout the remainder of her prolific career, which extended until her death in 1968, she created widely displayed sculptures that dealt with many of the historical themes that she had first explored in her Jamestown dioramas. In 1913, Du Bois requested that Warrick contribute to New York state's celebration of the fiftieth anniversary of the Emancipation Proclamation. She designed an eight-foot-high sculpture entitled *The Sprit of Emancipation.* In it, she depicted an African American couple who, standing under a tree, were nonetheless not safe. Branches, "the fingers of Fate," clawed at them, threatening their tenuous freedom with "the fateful clutches of hatred."[50] Yet, a downward spiral and bathos never marred Warrick's art. Her 1913 statue followed her tableau allegories of 1907. She sculpted no crouching slaves, no beneficent white liberators, no broken shackles. Indeed, she became more explicit in her juxtaposition of pride and danger. In *The Awakening of Ethiopia* (disputed date) she accentuated her subject's non-white appearance and incorporated African motifs, and in *A Silent Protest against Mob Violence* (1919) she depicted lynching and other cruelties endured by blacks. Through narrative sequence and sculptural form she probed themes that would figure prominently in twentieth century African American art, especially Jacob Lawrence's celebrated Emancipation and Great Migration cycles.[51]

Warrick's 1907 creation exemplifies the innovative aural and visual representations of African American history in the first two decades of the twentieth century. Although historians, perhaps reflecting the influence of Benedict Anderson's *Imagined Communities,* have joined literary scholars in emphasizing the importance of print and literacy to the creation of nineteenth century American and African American identity, excessive concentration on texts and literacy obscures a full understanding of visual and aural expression. Warrick's statuary were sites of contestation and properly occupy a place alongside the era's notable non-print representations of African American history, including Bert Williams and George Walker's musical *In Dahomey* (1902), Scott Joplin's operatic celebration of emancipation, *Treemonisha* (1911), Du Bois's elaborate pageant of black heritage, *Star of Ethiopia* (1913), and Oscar Micheaux's incendiary protest film *Within Our Gates* (1917).[52]

As technological and artistic innovations offered new modes of narrative expression, Warrick and her peers engaged in a far-reaching cultural project: the visualization of African American memory. Against a backdrop of "a frenzy of the visible" and an "immense accumulation of spectacles," African American artists experimented with new methods to bring the past into the present, changing the way people experienced their personal past and the collective past. These diverse forms reflected their creators' use of spatial and temporal illusion to excite the visual curiosity of viewers in order to convey historical "truths" that otherwise were ignored in the dominant narrative. Focusing on Warrick's Jamestown tableaux underscores how much conventional binaries of civilization and primitivism as well as of subjectivity and agency were entangled in a field of power and representation that both enabled and constrained the expression of African American historical memory. Alain Locke, writing during the Harlem Renaissance, concluded that Warrick had been stymied in her attempts to represent the fullness and complexity of the African American experience. He criticized her art for wavering "between abstract expression which was imitative and not highly original, and racial expression which was only experimental."[53] Locke's critique remains compelling and relevant to Warrick's Jamestown scenes.

True, she previously had eschewed African American themes. She participated in a segregated exposition that many blacks denounced because it was overseen by the "lick-spittle" Giles B. Jackson. She had adopted the civilizationist ideology, and she likewise presumed that the black masses were an uncouth child-race who had to overcome the legacy of their primitive ancestors and slavery while ascending the ladder of civilization. When she revised the dominant historical narrative by incorporating blacks into the ranks of the civilized, she displayed surprising optimism in its underlying progressive teleology. Her confident representation of idealized "Negro" types and of black economic accomplishments rested on assumptions about class hierarchy and progress that sharply circumscribed her ability to imagine other paths of black cultural development and resistance.[54]

Only around the time of World War I, and especially the Pan-Africanist revival of the 1910s and '20s, did black intellectuals and leaders evince much interest or pride in black common folk. As the grip of social Darwinism, and its corollary of evolutionary racism, loosened, African American intellectuals began to glorify the primitive and to undermine the idea that African

Americans should slavishly submit to the conventions of modern civilization. Earlier assumptions about Africa, black capacities, and civilization—assumptions that Warrick held in 1907—all became subject to revision. While engaging in bolder and more far-reaching critiques of the grand narrative of American civilization than Warrick had envisioned at Jamestown, African American artists and intellectuals would pioneer modernist aesthetics.[55] From Locke's vantage point, Warrick's Jamestown dioramas and early work were at most an obscure and timid antecedent to the cultural ferment of the twenties. But the qualities in Warrick's work that troubled Locke are suggestive of both the possibilities for and the limits of African American historical narration and imagination during a critical period of "perceptual modernization."

At a highly contingent moment, when African Americans were experimenting with new representational strategies, Warrick's tableaux were an early, if tentative, example of African American self-imaging within the dominant domain of racist representation. If she failed to move significantly beyond the extant textual narratives of black progress and history, she did challenge the exclusive authority of white Americans to represent and signify, to embody, either the nation or civilization. Her dioramas challenged what one scholar calls the "visual structures of white supremacy" by simultaneously adopting and subverting conventional turn-of-the-century images.[56] Dismantling the stereotyped and caricatured images of African Americans reproduced in American popular culture, the dioramas recalled the long history of blacks in North America, resisted claims of racial purity by acknowledging the historical reality of interracial reproduction, and offered a teleological narrative culminating in black civilization, not retrogression or criminality. Warrick's contribution was to yoke visual technologies of representation to familiar nineteenth-century literary narratives of African American progress, thereby encouraging viewers to experience firsthand the black ascent of civilization and in effect transforming them into virtual witnesses of black progress. Her tableaux provided a vivid forum in which to establish an alternative black subjectivity through unmistakable representations of black agency. Her version of black progress and civilization, as previously noted, corresponded to a set of ideals which would not long endure unchallenged. Yet her scenes evoked a sense of racial autonomy and self-determination that would persist as a central theme of African American culture throughout the twentieth century.

## Acknowledgments

I am sincerely grateful to Dan Sherman for his support for and interest in this work, and to Ruud van Dijk for his patient and conscientious editorial direction.

NOTES

1. Giles B. Jackson and D. Webster Davis, *The Industrial History of the Negro Race of the United States* (Richmond: Virginia Press, 1908), 205. Meta Warrick did not marry Solomon Carter Fuller Jr., a physician in Framingham, Massachusetts, until 9 February 1909, after the Jamestown Exposition. Consequently, I refer to her by her maiden name throughout this article. Because Warrick's dioramas have been lost, my discussion is based on extant contemporary accounts of them. Various descriptions were published, including Jackson and Davis, *Industrial History of the Negro Race,* which contains both descriptions and photographs of each scene. Other accounts include *The Official Blue Book of the Jamestown Tercentennial Exposition, AD 1907,* ed. Charles Russel Keiley (Norfolk, Va.: Colonial Publishing, 1907), 677; "Historic Tableaux at the Jamestown Exposition," *Southern Workman* 36 (Oct. 1907): 516–17; Helen A. Tucker, "The Negro Building and Exhibit at the Jamestown Exposition," *Charities and the Commons,* 21 September 1907, 726; William Hayes Ward, "A Race Exhibition," *The Independent,* 14 November 1907, 1171–72. For the fullest secondary account, see Judith Nina Kerr, "God-Given Work: The Life and Times of Sculptor Meta Vaux Warrick Fuller, 1877–1968" (Ph.D. diss., University of Massachusetts, 1986), 165–83; for another account, see Brenda Joyce Chappell, "The Consciousness of African American Women Artists: Rage, Activism And Spiritualism, 1860–1930 (Ph.D. diss., Ohio State University, 1993). On the importance of fixed identities to discourses of domination, see Homi Bhabha, *The Location of Culture* (London: Routledge, 1994), 66. On museums and "social conditioning," see Tony Bennett, "The Exhibitionary Complex," *New Formations* 4 (Spring 1988), 73–102; Tony Bennett, *The Birth of the Museum: History, Theory and Politics* (London: Routledge, 1995), 17–58.

2. Sutton E. Griggs, *Life's Demands or According to Law* (Memphis: National Public Welfare League, 1916), 51–52. On the perceptual modernization of the era, see Jonathan Crary, *Suspensions of Perception: Attention, Spectacle, and Modern Culture* (Cambridge, Mass.: MIT Press, 1999).

3. *Christian Recorder,* 3 December 1874, quoted in Mitchell A. Kachun, "The Faith That the Dark Past Has Taught Us: African-American Commemorations in the North and the West and the Construction of a Usable Past, 1808–1915" (Ph.D. diss., Cornell University, 1997), 349. On the challenges to black historical memory, see Elizabeth Rauh Bethel, *The Roots of African-American Identity: Memory and History in Free Antebellum Communities* (New

York: St. Martin's, 1997), 188–91; Kachun, "Faith That the Dark Past Has Taught Us," 234–394; and Kirk Savage, *Standing Soldiers, Kneeling Slaves: Race, War, and Monument in Nineteenth-Century America* (Princeton, N.J.: Princeton University Press, 1997), 89–161.

4. W. E. Burghardt Du Bois, "The American Negro at Paris," *American Monthly Review of Reviews* 22 (Nov. 1900): 576; Heidegger, quoted in Timothy Mitchell, "The World as Exhibition," *Comparative Studies in Society and History* 31 (April 1989): 222.

5. Mitchell, "The World as Exhibition": 222.

6. Du Bois, "American Negro at Paris": 577; Walter Benjamin, "The Work of Art in the Age of Mechanical Reproduction," in *Illuminations,* ed. Hannah Arendt, trans. Harry Zohn (New York: Schocken, 1985), 251.

7. On Jamestown in particular, see Robert T. Taylor, "The Jamestown Tercentennial Exposition of 1907," *Virginia Magazine of History and Biography* 65 (1957): 169–208; Roscoe E. Lewis, "The Negro and Jamestown," *Norfolk Journal and Guide,* 29 June 1957, 11; Idem, 6 July 1957, 9; Idem, 13 July 1957, 9. On expositions in general, see Annie E. Coombes, *Reinventing Africa: Museums, Material Culture, and Popular Imagination in Late Victorian and Edwardian England* (New Haven, Conn.: Yale University Press, 1995); Paul Greenhalgh, *Ephemeral Vistas: The Expositions Universelles, Great Exhibitions and World's Fairs, 1851–1939* (Manchester: Manchester University Press, 1988); Bruce G. Harvey, "World's Fairs in a Southern Accent: Atlanta, Nashville, Charleston, 1895–1902" (Ph.D. diss., Vanderbilt University, 1998); Judy Lorraine Larson, "Three Southern World's Fairs: Cotton States and International Exposition, Atlanta, 1895; Tennessee Centennial, Nashville, 1897; and the South Carolina Inter-state and West Indian Exposition, Charleston, 1901–1902" (Ph.D. diss., Emory University, 1999); Christopher Robert Reed, *"All the World Is Here!" The Black Presence at the White City* (Bloomington: Indiana University Press, 2000); Robert W. Rydell, *All the World's a Fair: Visions of Empire at American International Expositions, 1876–1916* (Chicago: University of Chicago Press, 1984); Robert W. Rydell, John E. Findling, and Kimberly D. Pelle, *Fair America: World's Fairs in the United States* (Washington, D.C.: Smithsonian, 2000), 45–71.

8. Walter Benjamin, cited in Anne Friedberg, *Window Shopping: Cinema and the Postmodern* (Berkeley: University of California Press, 1993), 82.

9. Mary Hilliard Hinton, "North Carolina's Historical Exhibit at Jamestown Exposition," *North Carolina Booklet* 7 (Oct. 1907): 138; on the role of the APVA see James M. Lindgren, *Preserving the Old Dominion: Historic Preservation and Virginia Traditionalism* (Charlottesville: University Press of Virginia, 1993), 123; on the Palace of History, see Virginia State Library, *Annual Report of the Virginia State Library, 1907,* 66–101.

10. Philadelphia quote in Rydell, *All the World's a Fair,* 28; Rebecca Latimer Felton to W. H. Felton, 15 March 1893, Felton Family Papers, Hargrett Rare Book and Manuscript Library, University of Georgia, Athens; on Atlanta and Nashville, see Rydell, *All the World's a Fair,* 87. The fullest account of black participation at the Centennial Exposition is

Kachun, "Faith That the Dark Past Has Taught Us," 244–47, 324–71; plantation scenes at the Chicago fair are described in Reed, *"All the World Is Here!"* 117.

11. William D. Crum, "The Negro at the Charleston Exposition," *Voice of the Negro* 3 (March 1906): 332; Harvey, "World's Fairs in a Southern Accent," 331–32; Larson, "Three Southern World's Fairs," 157–62; William D. Smyth, "Blacks and the South Carolina Interstate and West Indian Exposition," *South Carolina Historical Magazine,* 88 (Oct. 1987), 217.

12. [J. Max Barber], "The Jamestown Imposition," *Voice of the Negro,* 4 (Oct. 1907), 345. The organizers acknowledged the insult of segregation, even while they hailed their freedom from intrusive white oversight. Jackson and Davis, *Industrial History of the Negro Race,* 167. The debate over participation in the Jamestown Exposition filled the columns of the *Indianapolis Freeman* from February to November 1907. On opposition to black participation in previous fairs, see Harvey, "World's Fairs in a Southern Accent," 287–337; Larson, "Three Southern World's Fairs," 165–82; Reed, *"All the World Is Here!"* 21–36; Rydell, *All the World's a Fair,* 84–85; and Ruth M. Winton, "Negro Participation in Southern Expositions, 1881–1915," *Journal of Negro Education* 16 (Winter 1947): 36, 38.

13. R. W. Thompson, "The Negro Exhibit at Jamestown," *Colored American Magazine* 13 (July 1907): 31–32. For similar attitudes regarding the 1895 Atlanta Exposition, see Walter Cooper, "The Cotton States and International Exposition," *Frank Leslie's Popular Monthly* 40 (Nov. 1895): 519. Likewise, the official history of the 1897 Nashville exposition claimed that the Negro exhibits enabled visitors to "measure their [blacks'] strides and determine their progress"; Herman Justi, *Official History of the Tennessee Centennial Exposition* (Nashville: Brandon Printing Company, 1898), 193.

14. In 1903, Jackson chartered a joint stock corporation to oversee the Negro Exhibition. With the support of prominent Virginia politicians, he appealed to Congress for $1,200,000 (two hundred thousand of which was to consist of the unclaimed pensions due deceased black Civil War veterans). Jackson's reputation among many blacks as "a lickspittle" and apologist, however, hindered fund-raising and only $50,000 of stock was subscribed. Meanwhile, Congress allocated only $100,000 of the more than a million that Jackson had requested and only the North Carolina legislature appropriated a modest sum ($5,000) to subsidize the black exhibit. Even the Virginia legislature ignored Jackson's appeals for financial support. Jackson and Davis, *Industrial History of the Negro Race,* 138–84; quotation from 137. On Jackson, see Patricia Carter Ives, "Giles Beecher Jackson, Director-General of the Negro Development and Exposition Company of the United States for the Jamestown Tercentennial Exposition of 1907," *Negro History Bulletin* 38 (Dec. 1975): 480; Patricia Carter Ives, "James and Hulda Jackson of Goochland County, Virginia," *National Genealogical Society Quarterly* 67 (June 1979): 104–106.

15. Louis R. Harlan, ed., *Booker T. Washington Papers,* 14 vols. (Urbana: University of Illinois Press, 1972–1989), 3:177; Alfred A. Moss. Jr., *The American Negro Academy: Voice of*

the Talented Tenth (Baton Rouge: Louisiana State University Press, 1981), 73–74; Thomas Yenser, ed, Who's Who in Colored America: A Biographical Dictionary of Notable Living Persons of African Descent in America: 1930–1931–1932 (Brooklyn: Thomas Yenser, 1933), 210.

16. Jackson and Davis, Industrial History of the Negro Race, 179–81, 188, 204.

17. On the Atlanta pediment, see Winton, "Negro Participation in Southern Expositions": 37. At the 1885 New Orleans exposition, black exhibits incorporated portraits of white and black abolitionists and embroidered images of Haiti's Toussaint L'Ouverture. See Rydell, All the World's a Fair, 82. By the 1897 Nashville Exposition, a separate department in the African American site was required to house the gathered "History and Old Relics." See Harvey, "World's Fairs with a Southern Accent," 321. For descriptions of Negro buildings at the various expositions, see I. Garland Penn, "The Wakening of a Race," in The Cotton States and International Exposition South, Illustrated, ed. Walter G. Cooper (Atlanta: Illustrator Company, 1896), 69; Tucker, "Negro Building and Exhibit," 723–24; Winton, "Negro Participation in Southern Expositions": 36–37, 39–43. These symbols of black progress endured and as late as 1935 teachers in Hampton, Virginia, incorporated them into a lesson plan for third graders. Tamah Z. Richardson, "A Unit of Work for the Third Grade," Virginia Teachers Bulletin 13 (May 1936): 4. On African American conceptions of history, see Kachun, "Faith That the Dark Past Has Taught Us"; David Howard-Pitney, The Afro-American Jeremiad: Appeals for Justice in America (Philadelphia: Temple University Press, 1990), 3–16, 35–52; Laurie F. Maffly-Kipp, "Redeeming Southern Memory: The Negro Race History, 1874–1915," in Where These Memories Grow: History, Memory and Southern Identity, ed. W. Fitzhugh Brundage (Chapel Hill: University of North Carolina Press, 2000), 169–90; Wilson Jeremiah Moses, The Golden Age of Black Nationalism, 1850–1925 (Hamden, Conn.: Archon, 1978), 15–31.

18. Velma J. Hoover, "Meta Vaux Warrick Fuller, Her Life and Art," Negro History Bulletin 60 (March–April 1977): 678.

19. Willard B. Gatewood, Aristocrats of Color: The Black Elite, 1880–1920 (Bloomington: Indiana University Press, 1990), 98. On Warrick's family and early life in general, see "A Negress Sculptor's Gruesome Art," Current Literature 44 (Jan. 1908): 55–58; Benjamin Brawley, "Meta Warrick Fuller," Southern Workman 47 (Jan. 1918): 25–32; Florence Lewis Bentley, "Meta Warrick a Promising Sculptor," Voice of the Negro 4 (March 1907): 116–18; Kerr, "God-Given Work," 1–66; Winifred and Frances Kirkland, Girls Who Became Artists (1934; Freeport, N.Y.: Books for Libraries Press, 1967), 46–50.

20. On the black community in Philadelphia, see Roger Lane, William Dorsey's Philadelphia and Ours: On the Past and Future of the Black City in America (New York: Oxford University Press, 1991); Gary B. Nash, Forging Freedom: The Formation of Philadelphia's Black Community, 1720–1840 (Cambridge, Mass.: Harvard University Press, 1988); Nick Salvatore, We All Got History: The Memory Books of Amos Webber (New York: Times Books, 1996),

9–93; and Julie Winch, *Philadelphia's Black Elite: Activism, Accommodation, and the Struggle for Autonomy, 1787–1848* (Philadelphia: Temple University Press, 1988).

21. The literature on the symbolist movement is vast; among the valuable studies are Robert L. Delevoy, *Symbolists and Symbolism,* trans. Barbara Bray, Elizabeth Wrightson, and Bernard C. Swift (New York: Skira, 1978); Charles C. Eldredge, *American Imagination and Symbolist Painting* (New York: Grey Art Gallery and Study Center, New York University, 1979); Michael Gibson, *The Symbolists* (New York: Abrams, 1988); Pierre-Louis Mathieu, *The Symbolist Generation, 1870–1910* (New York: Skira, 1990); Alan Robinson, *Symbol to Vortex: Poetry, Painting, and Ideas, 1885–1914* (New York: St. Martin's, 1985).

22. Meta Warrick Fuller to Freeman Murray, 5 April 1915, Freeman H. M. Murray Papers, Moorland-Spingarn Research Center, Howard University, Washington, D.C.; Savage, *Standing Soldiers, Kneeling Slaves,* 70; "Negress Sculptor's Gruesome Art"; William Francis O'Donnell, "Meta Vaux Warrick, Sculptor of Horrors," *World Today* 13 (Nov. 1907): 1139–45.

23. Kerr, "God-Given Work," 148; *Report of the Commissioner-General for the United States to the International Universal Exposition, 1900* (Washington, D.C.: Government Printing Office, 1901), 2:381, 408–409, 463–67; Du Bois, "American Negro at Paris": 575; Kerr, "God-Given Work," 97–99.

24. W. E. B. Du Bois, "The Talented Tenth," in *Writings,* by W. E. B. Du Bois (New York: Viking, 1986), 842–61.

25. For brief descriptions of the panoramas, dioramas, tableaux vivant, and other attractions of the Paris Exposition, see James P. Boyd, *The Paris Exposition of 1900: A Vivid Descriptive View and Elaborate Scenic Presentation of the Site, Plan and Exhibits* (Philadelphia: P. W. Ziegler, 1900), 319, 451–52; Friedberg, *Window Shopping,* 84–86; Richard D. Mandell, *Paris 1900: The Great World's Fair* (Toronto: University of Toronto Press, 1960), 64; and Rosalind H. Williams, *Dream Worlds: Mass Consumption in Late Nineteenth-Century France* (Berkeley: University of California Press, 1982), 64–66, 73–78. On visual experimentation in Paris, see Crary, *Suspensions of Perception,* 129; Vanessa R. Schwartz, *Spectacular Realities: Early Mass Culture in Fin-de-Siècle Paris* (Berkeley: University of California Press, 1998), 118–30, 157–76. On Warrick's interest in theater, see Kathy A. Perkins, "The Genius of Meta Warrick Fuller," *Black American Literature Forum* 24 (Spring 1990): 65–72. On innovations in Philadelphia museums, see Steven Conn, *Museums and American Intellectual Life, 1876–1926* (Chicago: University of Chicago Press, 1998), 32–114.

26. Conn, *Museums and American Intellectual Life,* 8–9.

27. On the Atlanta and Nashville displays, see Rydell, *All the World's a Fair,* 100. On habitat displays, see Frank Chapman, "The Bird-Life and the Scenery of a Continent in One Corridor: The Groups in the American Museum of Natural History—A New Method of Museum Exhibition," *World's Work* 17 (March 1909): 11365–74; Irene F. Cypher, "The Development of the

Diorama in the Museums of the United States" (Ph.D. diss., New York University, 1942), 18–47; Frederic A. Lucas, "The Story of Museum Groups," *American Museum Journal* 14 (Jan. 1914): 1–15, and 14 (Feb. 1914): 50–65; Karen Wonders, *Habitat Dioramas: Illusions of Wilderness in Museums of Natural History* (Uppsala: Almqvist and Wiksell, 1993), 106–47. On "life groups," see Cypher, "The Development of the Diorama," 48–80; Curtis M. Hinsley, *Savages and Scientists: The Smithsonian Institution and the Development of American Anthropology, 1846–1910* (Washington, D.C.: Smithsonian, 1981), 83–124; Ira Jacknis, "Franz Boas and Exhibits: On the Limitations of the Museum Method in Anthropology," in *Objects and Others: Essays on Museums and Material Culture,* ed. George W. Stocking Jr. (Madison: University of Wisconsin Press, 1985), 75–111; David Jenkins, "Object Lessons and Ethnographic Displays: Museum Exhibitions and the Making of American Anthropology," *Comparative Studies in Society and History* 36 (April 1994): 242–70; Barbara Kirshenblatt-Gimblett, "Objects of Ethnography," in *Exhibiting Cultures: The Poetics and Politics of Museum Display,* ed. Ivan Karp and Steven D. Lavine (Washington, D.C.: Smithsonian, 1991), 386–443.

28. Conn, *Museums and American Intellectual Life,* 117; Dabney, quoted in Rydell, *All the World's a Fair,* 100. On dioramas as instruments of domination, see Bennett, *The Birth of the Museum,* 95; Donna Haraway, *Primate Visions: Gender, Race, and Nature in the World of Science* (New York: Routledge, 1989), 26–58; Hinsley, *Savages and Scientists,* 89–91, 97–99, 104–109, 112; Jacknis, "Franz Boas and Exhibits," 77–83; Jenkins, "Object Lessons and Ethnographic Displays," 250, 256, 263–66; Schwartz, *Spectacular Realities,* 135–37; Ruth Irwin Weidner, "Gifts of Wild Game: Masculine and Feminine in Nineteenth Century Hunting Imagery," in *The Material Culture of Gender: The Gender of Material Culture,* ed. Katherine Martinez and Kenneth L. Ames (Winterthur, Del.: Henry Francis du Pont Winterthur Museum, 1997), 337–64.

29. Ned J. Burns, "The History of Dioramas," *Museum News,* 1 March 1940, 11–12; Cypher, "Development of the Diorama," 68–77, 87–94; Max Page, *The Creative Destruction of Manhattan, 1900–1940* (Chicago: University of Chicago Press, 1999), 164–70.

30. On race, civilization, and progress, see Tunde Adeleke, *Unafrican Americans: Nineteenth-Century Black Nationalists and the Civilizing Mission* (Lexington: University Press of Kentucky, 1998), 13–30; Gail Bederman, *Manliness and Civilization: A Cultural History of Gender and Race in the United States, 1880–1917* (Chicago: University of Chicago Press, 1995), 1–44; Kevin K. Gaines, *Uplifting the Race: Black Leadership, Politics, and Culture in the Twentieth Century* (Chapel Hill: University of North Carolina Press, 1996), 19–46; Susan Hegeman, *Patterns for America: Modernism and the Concept of Culture* (Princeton, N.J.: Princeton University Press, 1999), 15–65; Louise Michele Newman, *White Women's Rights: The Racial Origins of Feminism in the United States* (New York: Oxford University Press, 1999), 22–55; Wilson Jeremiah Moses, *Afrotopia: The Roots of African American Popular History* (New York: Cambridge University Press, 1998), 96–135, 169–93.

31. The phrase is borrowed from Bruno Latour, "Visualization and Cognition: Thinking with Eyes and Hands," *Knowledge and Society: Studies in the Sociology of Culture Past and Present,* no. 6, (1986): 19.

32. Jackson and Davis, *Industrial History of the Negro Race,* 158; Anna Julia Cooper, *A Voice from the South* (1892; New York: Oxford University Press, 1988), 163; Du Bois, *Writings,* 545.

33. Tucker, "Negro Building and Exhibit," 726; Jackson and Davis, *Industrial History of the Negro Race,* 204.

34. Jackson and Davis, *Industrial History of the Negro Race,* 204; Cecelia Elizabeth O'Leary, *To Die For: The Paradox of American Patriotism* (Princeton, N.J.: Princeton University Press, 1999), 70–90, 110–49; Shawn Michelle Smith, *American Archives: Gender, Race and Class in Visual Culture* (Princeton, N.J.: Princeton University Press, 1999), 136–56; and Robert J. C. Young, *Colonial Desire: Hybridity in Theory, Culture, and Race* (London: Routledge, 1995), 4–5, 142–158.

35. Ward, "Race Exhibition," 1172.

36. Booker T. Washington, *Up from Slavery* (New York: A. L. Burt, 1901), 12–15, 220–21; Du Bois, *Writings,* 383, 485–86, 489. Both Frederick Douglass and Ida B. Wells also invoked the behavior of slaves during the Civil War as evidence of the race's forbearance and magnanimity. See Frederick Douglass, "Why Is the Negro Lynched?" *The Life and Writings of Frederick Douglass,* ed. Phillip S. Foner (New York: International Publishers, 1950), 4:492–506; and Ida B. Wells, *Southern Horrors and Other Writings: The Anti-Lynching Campaign of Ida B. Wells, 1892–1900,* ed. Jacqueline Jones Royster (Boston: Bedford, 1997), 79. See also Savage, *Standing Soldiers, Kneeling Slaves,* 158.

37. For a sampling of accounts of black speeches that described the loyalty of black slaves, see *Savannah Tribune,* 5 January 1889, 13 February 1909, and 10 January 1914; *Atlanta Constitution,* 3 January 1888 and 24 February 1917; *Ocala Evening Star,* 9 January 1900 and 2 January 1901; *Southwestern Christian Advocate,* 3 January 1901.

38. On Allen and the founding of the AME Church, see James Campbell, *Songs of Zion: The African Methodist Episcopal Church in the United States and South Africa* (New York: Oxford University Press, 1995), 3–31; Carol V. R. George, *Segregated Sabbaths: Richard Allen and the Emergence of Independent Black Churches, 1760–1840* (New York: Oxford University Press, 1973); Nash, *Forging Freedom,* 135–43; Albert J. Raboteau, "Richard Allen and the African Church Movement," in *Black Leaders of the Nineteenth Century,* ed. Leon Litwack and August Meier (Urbana: University of Illinois Press, 1988), 1–20.

39. Thomas Crawford's representation of progressive civilization in the United States in the pediment of the Senate Chamber of the U.S. Capitol shares striking thematic similarities with Warrick's dioramas. See William H. Truettner, ed., *The West as America: Reinterpreting Images of the Frontier, 1820–1920* (Washington, D.C.: Smithsonian, 1991), 72.

Another antecedent was James Pressley Ball's 1855 panorama, the *Mammoth Pictorial Tour of the United States Comprising Views of the African Slave Trade*. Ball's panoramas began with views of African villages and progressed to slave ships and the slave markets and plantations of America. Joseph D. Ketner, *The Emergence of the African-American Artist: Robert S. Duncanson, 1821–1872* (Columbia: University of Missouri Press, 1993), 104. On Johnston's photographs, see Smith, *American Archives,* 177–86; Laura Wexler, "Black and White and Color: American Photographs at the Turn of the Century," *Prospects* 13 (1988): 341–90.

40. On discrimination against black veterans and soldiers, see W. Fitzhugh Brundage, "Black Veterans and the Historical Memory of the Civil War," in *The War Was You and Me: Civilians and the American Civil War,* ed. Joan Cashin (Princeton, N.J.: Princeton University Press, 2002); Wallace E. Davies, "The Problem of Race Segregation in the Grand Army of the Republic," *Journal of Southern History* 13 (Aug. 1947): 354–72; Savage, *Standing Soldiers, Kneeling Slaves,* 162–208; Donald R. Shaffer, "Marching On: African-American Civil War Veterans in Postbellum America, 1865–1951" (Ph.D. diss., University of Maryland, 1996), 158–86. On the Brownsville "affair," see Ann J. Lane, *The Brownsville Affair: National Crisis and Black Reaction* (Port Washington, N.Y.: Kennikat Press, 1971); and John D. Weaver, *The Brownsville Raid* (New York: W. W. Norton, 1970).

41. On images of work and laborers in American sculpture, see Melissa Dabakis, *Visualizing Labor in American Sculpture: Monuments, Manliness, and the Work Ethic, 1880–1935* (New York: Cambridge University Press, 1999), 10–34, 62–82, 127–73. Unfortunately, Dabakis has little to say about representations of African Americans. Warrick's conception of black workers matched closely the occupational elite that Du Bois had identified in Philadelphia. Du Bois concluded that those involved in "conducting business on their own account" (including clergymen, physicians, and teachers, as well as those in skilled trades, including carpenters) and those employed as "clerks, semi-professional and responsible workers" constituted the top 15 percent of Philadelphia blacks. W. E. B. Du Bois, *The Philadelphia Negro: A Social Study* (1899; New York: Schocken, 1967), 101–103.

42. On Dunbar and his ambivalent stance, see Dickson D. Bruce Jr., *Black American Writing from the Nadir: The Evolution of a Literary Tradition, 1877–1915* (Baton Rouge: Louisiana State University Press, 1989), 56–98; and Gaines, *Uplifting the Race,* 181–93.

43. "Historic Tableaux at the Jamestown Exposition," 517.

44. For examples, see *Savannah Morning News,* 2 January 1892; *Indianapolis Freeman,* 18 July 1896; *Columbia State,* 2 January 1898; *Raleigh News and Observer,* 2 January 1900; *Raleigh Baptist Sentinel,* 9 January 1908; *Star of Zion,* 29 January 1914; *Richmond Planet,* 9 January 1915.

45. The charge that blacks were incapable of creativity was explicitly made during the Jamestown Exposition when a *New York Times* correspondent alleged that the Negro Exhibit

was filled with the work of "mulattoes" rather than "full blooded negroes." See "Mulatto Negroes and the Jamestown Exhibit," *Colored American Magazine* 13 (Aug. 1907): 87–88.

46. Warrick may have had other reasons for excluding white figures from her models. By doing so, she avoided the problems of positioning whites and blacks relative to each other in the scenes. Too often other artists, when confronted with the challenge of conveying the power and agency of black figures alongside white figures, had rendered the black body as debased and powerless, as "a foil for whiteness." See Savage, *Standing Soldiers, Kneeling Slaves,* 203.

47. On spectacle and late-nineteenth-century culture, see Schwartz, *Spectacular Realities;* on the erosion of private space, see Friedberg, *Window Shopping,* 61–64.

48. W. E. B. Du Bois, *The College-Bred Negro* (Atlanta: Atlanta University Press, 1900), 57. On respectability and domesticity, see Gaines, *Uplifting the Race,* 67–99, 128–151; also see Campbell, *Sons of Zion,* 32–63; Glenda Elizabeth Gilmore, *Gender and Jim Crow: Women and the Politics of White Supremacy in North Carolina, 1896–1920* (Chapel Hill: University of North Carolina Press, 1996), 1–60; Evelyn Brooks Higginbotham, *Righteous Discontent: The Women's Movement in the Black Baptist Church, 1880–1920* (Cambridge, Mass.: Harvard University Press, 1993), 185–230; John F. Kasson, *Rudeness and Civility: Manner in Nineteenth-Century Urban America* (New York: Hill and Wang, 1990), 112–46, 215–56; and Deborah Gray White, "The Cost of Club Work, the Price of Black Feminism," in *Visible Women: New Essays on American Activism,* ed. Nancy A. Hewitt and Suzanne Lebsock (Urbana: University of Illinois Press, 1993), 247–69.

49. For discussions of the struggle over gender roles among African Americans, see Bederman, *Manliness and Civilization,* 45–76; Kathleen Ann Clark, "History in No Fossil Remains: Race, Gender, and the Politics of Memory in the American South, 1863–1913" (Ph.D. diss., Yale University, 1999), 70–120; Gilmore, *Gender and Jim Crow,* 1–60; Higginbotham, *Righteous Discontent.*

50. Freeman Henry Morris Murray, *Emancipation and the Freed in American Sculpture: A Study of Interpretation* (1916; Freeport, N.Y.: Books for Libraries Press, 1972), 55–66.

51. On Warrick's later career, see Kerr, "God-Given Work," 184–362; James A. Porter, *Modern Negro Art* (New York: Dryden, 1943), 77–78, 86–87, 92, 94.

52. Benedict Anderson, *Imagined Communities: Reflections on the Origin and Spread of Nationalism* (New York: Verso, 1991), 163–206. On Williams and Walker, see David Krasner, *Resistance, Parody, and Double Consciousness in African American Theatre, 1895–1910* (New York: St. Martin's, 1997); on Du Bois' pageant, see Blight, *Race and Reunion,* 374–380; on Micheaux, see Pearl Bowser, Jane Gaines, and Charles Musser, eds., *Oscar Micheaux and His Circle: African-American Filmmaking and Race Cinema of the Silent Era* (Bloomington: Indiana University Press, 2001).

53. Jean-Louis Comolli, "Machines of the Visible," in *The Cinematic Apparatus,* ed. Teresa de Laurentis and Stephen Heath (New York: St. Martin's, 1980), 122–23; Guy Debord, *Society of the Spectacle* (Detroit: Black and Red, 1973), aphorism one; Alain Locke, "The Legacy of the Ancestral Arts," in *The New Negro,* ed. Alain Locke (New York: A. and C. Boni, 1925), 266.

54. For thoughtful discussions of the ideological challenges that black intellectuals and activists confronted, see Gaines, *Uplifting the Race,* and Moses, *Golden Age of Black Nationalism.*

55. Mia Bay, *The White Image in the Black Mind: African American Ideas about White People, 1830–1925* (New York: Oxford University Press, 2000), 187–218; Moses, *Golden Age of Black Nationalism,* 220–50; Houston A. Baker Jr., *Modernism and the Harlem Renaissance* (Chicago: University of Chicago Press, 1987); J. Martin Favor, *Authentic Blackness: The Folk in the New Negro Renaissance* (Durham, N.C.: Duke University Press, 1999).

56. Smith, *American Archives,* 183.

# Skulls on Display

## *The Science of Race in Paris's Musée de l'Homme, 1928–1950*

ALICE L. CONKLIN

We have worked for the people, for the education of the people with all our heart. We hope they will respond to our fraternal appeal, that they will understand its full importance.[1] —Paul Rivet, 1938

Here I should like to quote an instance of remarkable success. I refer to the Physical Anthropology Room in the Musée de l'Homme. At first sight, it would appear impossible to take the arid concepts on which is based the classification of peoples, and to make them comprehensible and attractive to everyone. But the intelligence of my good colleagues, MM. Lester and Champion, overcame the difficulty, and there is no room in the museum more visited, particularly on Sundays. The public can see and grasp the most abstruse, the most forbidding secrets of the science of man. All of which shows the public's intelligence must never be under-estimated.[2]
—Paul Rivet, 1948

It was in reading [Boas] that I understood the complexity of ethnology and the interdependence of its different branches. . . . It is thanks to him that I imagined what a true museum of humanity should be, an immense diorama, where the visitor would find the complete tableau of the races, civilizations, and languages of the world. . . . It was also he who made me understand the solidarity that exists between the physical, biological, cultural, and linguistic traits of humanity.[3]
—Paul Rivet, 1958

In 1938, France's preeminent ethnographic museum, the Musée de l'Homme, opened its doors in Paris. Over the previous ten years it had undergone two periods of renovation, and could proudly boast that it was now the most modern of the world's institutions devoted to the display of humankind's cultural and racial diversity. Indeed, as its name suggested, its guiding premise was that the entire natural history of man could and should be known, ordered, and presented to an audience made up of specialists and the masses. Conceived by the eminent anthropologist—and socialist municipal councillor under the Popular Front—Paul Rivet, the Musée de l'Homme nevertheless had another ambition. In the era of the rampant racism of the Nuremberg Laws, the museum's generally left-leaning staff also aspired to carve out a progressive scientific position on the race question.

In this essay, I will explore the complex role played by a particular intellectual community in the halting retreat of scientific racism in France and its empire in the 1930s. There is little question that by the late 1940s and early 1950s, certain Paris intellectuals took a lead internationally in condemning the fallacies of race taxonomies. Under the leadership of Alfred Métraux (Swiss but French-trained), UNESCO issued its famous condemnation of the race principle, including the statement that "race was less a biological fact than a social myth."[4] Claude Lévi-Strauss and Michel Leiris published pamphlets for UNESCO advocating the need for cultural relativism and underscoring the irrelevance of race as a determinant of civilization.[5] Was the ground for such statements already well prepared before the war in the conception and exhibition strategies of the Musée de l'Homme, in which Leiris had taken an active part, and to which Métraux and Lévi-Strauss had sent cultural artifacts from their field research for display? Or were French cultural anthropologists galvanized into action only after the war, due to the atrocities committed by the Nazi regime with the collaboration of Vichy, and the outbreak of dirty colonial wars in Vietnam and Algeria? Did these anthropologists feel by the early 1950s a sense of guilt that they had failed to recognize early the dangers posed by the pre-war misuse of the race concept, a failure that we might in turn link to these ethnographers' complex location inside and outside the empire?[6] Finally, just how definitive was even this rejection of race in French political life in the post-war period?

A number of factors account for my posing these particular questions. No other major ethnographic museum in a world capital opened in the late 1930s,

with the one important exception of the new or renovated Soviet museums.[7] France in 1937 was belatedly hoping to rival other Western countries, which had invested much earlier in the building of such ethnographic institutions; indeed, the creation of scientific collections open to the public had been critical to the professionalization of anthropology as a discipline in Germany, England, and America. The first decades of the twentieth century witnessed a growing questioning among French sociologists and certain anthropologists such as Rivet of the validity of racial classifications as a meaningful way to study human variation. The question of how the Musée de l'Homme, in this context, handled the concept of race became all the more pressing when my research revealed that the museum's original installation included skulls corresponding to specific races throughout the ethnographic galleries. The museum boasted a physical anthropology hall, highlighting the prehistory and evolution of man through the ages as well as the major racial subdivisions of humankind. But most of its exhibition space was devoted to the ethnographic presentation of cultural artifacts, which celebrated the fundamental unity of humankind and the equal value of all cultures. Faced with the humanistic outlook that informed much of the museum's ethnography, and its manifest commitment to impart this outlook to a broad public, how are we to explain these seemingly anomalous "skulls on display" in the rooms devoted to the social and cultural life of individual peoples?

One answer comes immediately to mind. The museum was part of France's Muséum National d'Histoire Naturelle, an institution dating to the eighteenth century, where physical anthropology still had its strong partisans. Rivet, although a physical anthropologist by training, nevertheless defined French ethnology in this period as embracing all facets of mankind: physical attributes, language, and culture. When the Musée de l'Homme opened, it had two assistant directors, one for physical anthropology (Paul Lester) and one for ethnography (Jacques Soustelle). Given this institutional affiliation, the museum's division into two sub-disciplines, and Rivet's background, it would perhaps have been surprising if the older system of racial classification associated with physical anthropology had not found its place in the Musée de l'Homme. The greatest scientific challenges to nineteenth-century notions of racial purity and racial stability came, in the early twentieth century, from the development of biometrics within physical anthropology, and especially from biology in the forms of Darwinism and the rediscovery of Mendelian heredity.[8]

Biometrics seemed to offer new and better tools for measuring race than those used in the past, while the new developments in biology were accepted in France later than in the U.S., Great Britain, and Germany due to the lingering influence of Lamarck.[9] Equally important to the persistence of raciology was the fact that for most of the 1920s and 1930s, the biology of human differentiation was simply unsettled. If many geneticists internationally now understood that race was not the primordial biological category once thought, they had yet to show how heredity interacted with the environment to produce the physical distinctions vital to racial classification. In the face of these innovations and uncertainties, most physical anthropologists everywhere refrained from consigning race typology definitively to the dustbin.

In this context, it is significant that Rivet was not, in fact, alone among liberal scientists in mounting a major exhibition devoted to race typology in the 1930s. As Tracy Teslow has shown, in the late 1920s the directors of the Field Museum of Natural History in Chicago, Henry Field and Arthur Laufer, commissioned nearly one hundred bronze statues and busts from the sculptor Malvina Hoffman for a new Races of Man display, which opened in 1933. The sculptures were incorporated into a redesigned Hall of Man that subtly reinforced notions of a racial hierarchy even as it, too, celebrated the unity of humankind.[10] Teslow is one of several historians who have recently examined the visual processes by which European and American anthropologists from the mid-nineteenth century on constituted racial difference, despite the commitment of some to social equality between the sexes and the races.[11] Founded as a study of difference, anthropology first became "scientific" by rendering visible, through disciplined collection, measurement, observation, and categorization of skulls and skeletons, the immutable racial essences that ostensibly underpinned human diversity. More often than not, curators supplemented these collections with photographs or busts of representative individuals, presented as specific instantiations of generalized racial archetypes whose difference could be read—according to experts—in their very bones. This tendency by anthropologists to embody race difference in a *particular* selection of measurable features was especially evident in France, where the study of the cultural was subordinated to the physical until after World War I. The vast expansion of France's empire from 1830 onward reinforced the tendency to order physical variation in hierarchical terms. After a century of naturalization in authoritative public collections, race typology

had become part of a modern way of seeing (racial) difference in the West generally, and proof of its existence. Along with the complexity of modern biometric and genetic research, this highly developed "visual regime" made it difficult for anthropologists—and not only in France—to challenge the biological reality of race in the inter-war years.[12]

Finally, a number of more short-term practical considerations also helped to shape the new institution's particular choices in the late 1930s. There is never a direct fit between ideology and/or science and museum display, even in the best of circumstances. Poorly endowed from the outset, the Musée de l'Homme had little choice but to draw upon vestigial collections when it set up its "new" installations. The social categories of knowledge, colonial imbrication, and visual practices of these older collections continued to influence the new installations despite Rivet's declared desire to use his museum to combat Nazi racism.[13] From a museographic point of view, it is unclear how contemporaries might have represented complicated ideas about race, when scientists themselves disagreed about how to explain human variation.[14] The Musée de l'Homme's clear pedagogical vocation militated even further against a nuanced presentation of race, since the curators had by definition to limit the amount and simplify the content of any text affixed to their objects. In addition, even as Rivet sought to innovate by bringing science to the people, he accepted uncritically the particular role assigned to museums as knowledge-producers in modern Western society. The objective of exhibits in such institutions was not to demonstrate that scientific truth might be debated among scholars, but to offer a reassuring vision of science as agreed-upon truth. In the late 1930s, the biological reality of race was apparently still "true" enough to warrant its public display, even in an institution whose founders hoped to enroll all in the fight against the misuse of the race concept.

A number of related factors, then, helped to determine the new museum's racialized exhibit of skulls throughout its galleries. Unfortunately, few extant documents illuminate Rivet's exact intentions in his first Musée de l'Homme installations, or indeed exactly what these first installations looked like. Rivet's own scientific views on race are also difficult to pin down, while his commitment to fighting racism was most evident in his political activities in the inter-war years. Given the limitations of the sources, this essay will briefly consider the organization of exhibits of the Musée de l'Homme as well as their provenance. I will then sort through the many strands of scientific thinking on the

race question in France and abroad at the time of the museum's opening.[15] Examining both Rivet's display strategies and his scientific assumptions about how to order human diversity can tell us something specific about the ongoing construction of racialist categories among anti-racist anthropologists at a moment when science had become especially politicized, but also increasingly popularized. The fact that the museum explicitly proposed to initiate the larger public into the latest findings regarding the human experience globally from the dawn of time until the advent of industrialization—but with a particular emphasis on the French empire—makes it all the more urgent to understand how these self-styled scientists understood "race" in this period. Certainly a potential conclusion is that their largely political—rather than scientific—opposition to Nazi racism continued to reify the very object they wished to condemn.

## A Museum Reborn

Before attempting to understand the particular status of race as a scientific concept in the Musée de l'Homme (MH), it is necessary to understand the museum's importance in the institutional configuration of anthropology in France. The "Musée de l'Homme" was the new name given by Rivet to the Musée d'Ethnographie du Trocadéro (MET), which was founded in 1878 but whose collections were suffering by the early twentieth century from considerable neglect.[16] From its takeover by Paul Rivet in 1928 to about 1950, the museum played a pivotal role in the professionalization and institutionalization of anthropology as a discipline in France. French scientists had taken the lead internationally in perfecting the techniques of craniometry from the mid-nineteenth century on, when Paul Broca founded the École d'Anthropologie in Paris. The latter was a mostly private institution that offered instruction but no degrees in all branches of anthropology. By 1914, however, its reputation had diminished greatly, craniometry had reached an epistemological impasse, and the "cutting-edge" study of non-Western peoples had shifted to the Ve section (*sciences religieuses*) of the École Pratique des Hautes Études where Marcel Mauss had been teaching since 1900. Only with the founding of the Institut d'Ethnologie (IE) in 1925 at the University of Paris did anthropology (now renamed ethnology to distinguish it from physical anthropology) gain a toe-hold in the conservative French university system. Although Paul Rivet and Mauss ran the Institut jointly, it was Mauss who did

most of the teaching. The Institut offered a certificate in either the sciences or the humanities that could satisfy the requirements for an undergraduate degree as well as serve as a first step toward a *doctorat ès sciences* or *ès lettres*.

The IE quickly attracted a new generation of maverick young scholars, many foreign, who under the charismatic mentorship of Mauss turned to ethnography and ethnographic fieldwork for a variety of reasons including intellectual curiosity, a sense of adventure, and the desire to understand the exotic so fetishized in the 1920s. Poorly funded and with no prospects of academic jobs given the virtual non-existence of university positions in anthropology in France, these students found in Rivet's museum a laboratory, a library, a peer group, and—most critically—employment throughout their long training and after they had finished their dissertations. It is rare to find a post-war anthropologist in France who did not begin his or her career at the MH. Mauss and Rivet both believed that direct student contact with museum artifacts was an indispensable part of professional training, along with prolonged research in the field. Desperate for volunteers to clean and expand the existing collections, and for a scientifically trained staff on the cheap to reorganize and modernize the museum in keeping with the latest developments of *ethnologie,* Rivet and his first assistant director from 1929 to 1937, Georges-Henri Rivière, put the eager Institut students to work from the early 1930s on. For that decade at least, a rare camaraderie developed among the members of the team that Rivet assembled to run the different museum departments. Eclectic in interests, unevenly ambitious and talented, and of mixed social background, these young people nevertheless found in the overhaul of this seemingly marginal institution a project around which they could temporarily and very enthusiastically unite. The eruption of World War II and the stark choices it presented all French would put this unity to the test; the MH would survive the war with its collections intact, but its professional staff would be torn asunder by professional rivalries, perceived and real betrayals under Vichy, and new directions and opportunities in the social sciences that developed in French universities at the war's end.[17]

This overview might suggest that the MH in its formative and—in retrospect—heroic years was very much the joint product of an intellectual partnership between Rivet and Mauss. Yet although most of the museum's staff regularly attended Mauss's course on ethnographic methods, and several completed doctorates under his supervision, Mauss himself was not directly

FIGURE 7.1. Marcel Mauss at the Musée d'ethnographie du Trocadéro, 1936–1937. *Photo © SCALA, Florence / Musée du Quai Branly, 2006.*

involved in the museum's reorganization. Overseeing this task fell principally to Paul Rivet, a physical anthropologist trained in Broca's methods, who had nevertheless discovered the importance of also studying humanity's different languages and cultures during a prolonged stay in Ecuador at the turn of the century. In 1928 Rivet, by then the leading Americanist anthropologist in France, was elected to the chair in anthropology at the Muséum National d'Histoire Naturelle (MNHN). Located in Paris in the Jardin des Plantes, the MNHN was another extra-university (i.e., non-degree-granting, research-oriented) institution of higher learning specializing in natural history.[18] Every discipline at the Muséum had its own laboratory and research collections; anthropology thus boasted a fine collection of skulls attached to the chair in that field. More often than not, the chaired professor in anthropology also became director of the ethnographic museum at the Trocadéro Palace, although no official rule existed to this effect. Rivet accepted the MNHN chair on the condition that henceforth the two positions would always be joined, thereby endowing the MET with the same scientific credibility that attached to the

Muséum's other laboratories. From his point of view, the collection of cultural objects and the collection of bones were now equally central to the study of man, and the task at hand was to transform the MET into an institution deserving of its newly recognized scientific status.

The MET under Rivet, then, remained principally an ethnographic collection, a "companion" to the MNHN's physical anthropology laboratory. Yet from the outset there were signs that Rivet harbored greater ambitions for this laboratory, ambitions that the physical distance of the MET from the MNHN initially facilitated. Rather than simply renovate the old MET as an ethnographic laboratory, he hoped to transform it into a veritable *ethnological* museum and research center devoted to the study of man's physical and cultural attributes *all in one place*. This became clear when in 1929 he gave priority to building up the MET's library, and insisted that every branch of the discipline be represented in the book collections and journal subscriptions. He also encouraged all existing anthropological societies to give their private libraries to the museum, with some success. In short, without relinquishing the physical anthropology branch of ethnology, he sought nevertheless to "refound" the discipline as a whole by proclaiming that all of its branches were related. Such had been, Rivet insisted, Broca's original definition of *anthropologie,* from which later generations of scientists had mistakenly deviated by focusing exclusively on problems of racial typology. This idea of anthropology as a totalizing and synthetic science was also embedded in the training given at the IE, where in theory every student was initiated in craniometric methods as well as ethnographic ones. When the city of Paris put the MET's staff on notice that the Trocadéro palace was going to be considerably expanded for the 1937 Exposition Universelle des Arts et Techniques, Rivet was suddenly able to realize his ambition. There would be room in the enlarged MET for the transfer of both the MNHN's anthropology laboratory and the IE, not to mention the creation of vast storage areas, a doubling of exhibition space, a disinfection laboratory (for parasites), seminar rooms, a cinémathèque, photothèque, bookstore, and bar. Once authorized to go ahead with these plans, Rivet felt fully justified in rebaptizing his grand edifice the Museum of Man.

The MH thus emerged in 1938, housed now in one of the two refurbished wings of the radically transformed old Trocadéro Palace. Home to the MET since the 1878 Universal Exhibition, the Palace had been, in the words

FIGURE 7.2. Musée d'ethnographie du Trocadéro, Paris 1931. *Photo © SCALA, Florence / Musée du Quai Branly, 2006.*

of James Herbert, "an exotic Hispano-Mauresque relic" clearly at odds with the modernist neo-classicism of the inter-war years.[19] By 1938, the central core of the old building had been gutted, replaced by the commanding esplanade that still oversees the city of Paris. The architects chose nevertheless to preserve the original wings of the 1878 Trocadéro Palace, but sheathed them in new Art Deco façades that gave architectural unity to the entire complex. Modernism prevailed inside the Palais de Chaillot (as the Trocadéro Palace was renamed) as well, since the museum now boasted the most up-to-date technology and a clean presentation of its collections—i.e., spare, well-lit cases, white walls, brightly colored maps, typed commentary, plenty of photographs. It opened to rave reviews and glowing accolades for its dynamic young staff and Rivet and Rivière's combined oversight. To all

FIGURE 7.3. Palais de Chaillot, Exposition internationale des arts et techniques dans la vie moderne, Paris 1937. *Photo courtesy of the Getty Research Institute, Resource Collection.*

appearances, this was a museum with a clear vision of the science it wished to practice.

Yet no description of the museum would be complete without calling attention to a second goal championed by Rivet—that of diffusing as well as producing new knowledge. The museum was not only to function as a sort of scientific Grand Central for all ethnologists, in the hope of once again putting an elitist French science on the map of high intellectual culture nationally and internationally. Equally important for Rivet—and in keeping with his socialism—was the institution's pedagogic mission.

Rivet's principal ambition in the gallery spaces (as opposed to those spaces reserved specifically for research) was to popularize the most human of sciences for a broad public—from school children and workers to the educated middle classes—who had nowhere else to go to see human diversity in general, and the diversity of the empire in particular, presented in a responsible manner. Ethnology did not figure anywhere in the French educational

curriculum, leaving the field wide open to such diverse popular venues as colonial fairs, freak shows, the mass media, and travel and science literature. While anyone in theory could visit the existing ethnographic collections at the old MET, in practice this institution remained the preserve of elites—as did the primitive art exhibitions that became increasingly successful in the 1920s in Paris. Rivet's particular aspiration to educate all strata of French society in the complete history of man predated the rise of Hitler to power, but it came out most clearly after 1935 when Rivet realized he was going to have the opportunity to re-conceive and expand the museum. By then the growing threat of fascism made the task of combating the Nazi abuse of prevailing scientific concepts of race that much more urgent. As Rivet's close associate Rivière put it in January 1937:

> The museum of man is a "museum for man" thanks to which anyone, even the least educated, can come gather an impression of the diverse avatars of our species, and, confronted with the products of so many different races and civilizations, equally valuable given that they are all evidence of humanity, imbibe a bit of that spirit of relativity that is so necessary in our age of fanaticism.[20]

Michel Leiris, one of the curators of the African section, said much the same thing later that same year:

> To promote contact between technicians and the public, to make of the Musée de l'Homme an instrument of popular culture as well as a center for specialists, that is the goal that the director and the personnel have assigned to themselves. . . . It is certain that in our times, one of the most urgent tasks is an extensive diffusion of the anthropological sciences, concrete foundation of a new humanism whose advent no independent spirit can cease to hope for.[21]

## Skulls on Display

That skulls and skeletons had a pre-designated place in the new MH, then, is clear. But what was that place? How did the different branches of anthropology identified by Rivet relate to one another? Did the museum embody a

tacit assumption that race and culture were related, not in the manner proposed by the Third Reich, but sufficiently to legitimate colonial forms of racialized governance? How exactly did the MH anthropologists propose to counter Nazi nonsense about a superior Aryan race—if that was their aim—without giving up the very notion of race typology in the first place? These questions can best be answered by first visiting the museum, then examining Rivet's own scientific writings on race, and finally placing Rivet's work in the larger context of what other avowedly anti-racist scholars were saying on the subject in the 1930s.

Reconstructing the original installations of the MH is a challenge, given the archival lacunae. No exact description exists of the museum's layout in 1938, nor are the photo archives from the era complete. Rivet refused to publish a catalogue at the museum's opening, on the grounds that museum exhibits should be in a state of constant change "to excite [the public's] curiosity."[22] A further difficulty of interpretation is posed by Rivet's belief that "politics" and "science" could and should be kept separate. Rivet most directly condemned Hitler's regime by becoming one of the founding members of the group Races et Racisme—an association of public intellectuals organized in 1937 whose monthly newsletter by the same name was designed to alert the larger public to the atrocities occurring across the Rhine, and to publicize the efforts being made around the world to fight Nazi racism. In Rivet's museum, however, the facts were supposed to speak for themselves—the premise being, as the above quotes from Rivière and Leiris intimate, that the best way to counter the political abuse of racial science was to expose people to what true science had to say about the races of man, human variation, and cultural diversity the world over.

Despite the gaps in the archival record, it is possible partially to piece together the original displays of the MH from press reports, extant photographs, and notes from the weekly meetings held by the museum staff. The museum occupied one of the two central towers of the Palais de Chaillot and the two upper floors and basement of the west wing. The permanent display halls were found principally on the first and second floors of the west wing, and most of the gallery space was devoted to the ethnographic halls organized by continent in which the "material and moral life" of the major ethnic groups was represented.[23] The "official" itinerary through the museum began, however, in the spacious and high-ceilinged foyer. A magnificent sculpted head

from Easter Island greeted visitors, along with a huge globe (*mappemonde*). Together they announced the museum's theme: these walls promised nothing less than an exotic tour of the world. Panels indicating the layout of the museum's rooms first oriented the visitor toward the Anthropology Gallery. Here one discovered the origins of humanity and the distinctive morphological, physiological, and anatomical traits of modern humans, then proceeded to a display of the principal races through skeletons and skulls. The visit of the museum continued with "contemporary man in the five parts of the world."[24] From the Anthropology Gallery (1000 sq. meters), one entered the Black African Hall (500 sq. meters) and its adjoining Madagascar section (50 sq. meters), then proceeded to the White African [North Africa and the Levant] Gallery (350 sq. meters), and the European displays (410 sq. meters), all on the first floor. On the second floor one began in the Arctic Hall (140 sq. meters), proceeded to the Asian Hall (650 sq. meters), then on to Oceania (440 sq. meters), and finally ended the visit with the Americas (1100 sq. meters).[25]

The Anthropology Gallery was designed to instruct viewers on the development of man historically and biologically. Several huge maps of the world lined a wall, one each showing the world's races, peoples, civilizations, political divisions, and languages.[26] For those who cared to think about it, the maps clearly showed that the boundaries between these different categories did not coincide. One case in the gallery showed skeletons of anthropoid apes placed alongside skeletons of man to facilitate comparisons and help "situate . . . our species in the animal kingdom."[27] Another contained fossils of Cro-Magnon man and was part of a larger display of prehistoric remains—for this part of the museum wished to show all the races of man, living and extinct.[28] An important section was devoted to illustrating—and presumably thereby demystifying for the public—the particular physical characters that anthropologists used to classify the various human types, including hair form and hair color, skin color, eye color and eye form, stature, head-form, nasal form, jaw form and lips, and—last but not least—breasts and buttocks. Some cases, for example, showed the differences between the head-forms in the skeleton structure of the different races, complete with skulls and photographs of living men and women belonging to particular races. Easy-to-read text accompanied every object and photograph—a rule followed throughout the museum. Another case had examples and photographs of typical jaw bones and teeth.

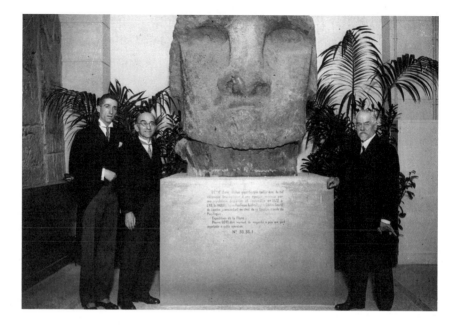

FIGURE 7.4. Paul Rivet and Georges-Henri Rivière in the Musée d'ethnographie du Trocadéro, with Easter Island Sculpture, 27 June 1930. *Photo courtesy of the Musée du Quai Branly. Photo © SCALA, Florence / Musée du Quai Branly, 2006.*

Rather than simply invoke the cephalic index, the latter were explained with the help of diagrams and skulls as well as a display of the anthropologist's "tool kit" used to take measurements. One case highlighted skulls differentiated by sex. The distribution of blood groups throughout the world was diagrammed on a large map.[29]

On the more sensational side, the gallery featured the original plaster cast of Saartjie Baartman, the so-called "Venus Hottentot," alongside her skeleton, as an example of the "racial" trait steatopygia.[30] Photographs of bare-breasted white women side-by-side with more familiar images of naked "primitive" women were included in the case devoted to different breast types. Equally spectacular were cases displaying the stages in the development of the human embryo from eight to twenty-two weeks (a series of embryos in formaldehyde) and the growth of the skeleton of a human being from ages three-and-a-half to five as well as cases with skeletons displaying various human abnormalities and pathologies. Yet more cases were devoted to "trophy heads

and funerary rites." Last but not least, a whole section of the gallery was devoted to each of the three major "races" of the world (Black, Yellow, and White) and their subdivisions. These display cases came complete with skulls, photographs of living examples (male and female), maps indicating where the race in question could be found, and a brief descriptive notice naming the peoples or types who could be so tagged [*rattaché à cette race*].[31] If one followed the installations in numerical order, "*les Noirs*" came first, followed by the intermediate group, "*les Jaunes*." "*Les Blancs*" came at the end of this parade of humankind, clearly occupying the apex of the evolutionary scale.

Although the Anthropology Gallery was not only about racial differences—what then was a single human embryo doing there?—raciation certainly featured prominently as a theme in the endless skeletons and skulls that the museum's staff chose to display there. If we now follow the trail of skulls through the rest of the museum, the first thing to note is that, in the vast ethnographic galleries, their presence is much more discreet. The guiding principle in this part of the museum was to highlight the different ethnic groups peopling each continent, along with the material objects that reflected a particular aspect of their social and cultural life. Although my information here is still incomplete, it appears that the kinds of artifacts chosen to represent particular cultures varied considerably from one geographical area to another. The American collections were rich in Maya and Aztec objects, particularly pottery and sculpture, so one of the dominant narrative modes in that section was historical; contemporary Amerindians of South and North America were nevertheless also represented. Sub-Saharan Africa [*Afrique noire*] was presented principally in the ethnographic present.[32] Here collections had just increased dramatically thanks to Marcel Griaule's extremely well-publicized—and later controversial—Dakar-Djbouti Mission, sponsored by the French government, which crossed West Africa to Ethiopia between 1931 and 1933. The seven members of the expedition aggressively collected several thousand objects to fill out the African holdings of the museum, and these objects figured prominently in the new MH installation.[33] In the North Africa [*Afrique blanche*] section, the curators highlighted the importance of Islam and life in the desert, but urban life was also represented by at least one case. The European collection contained mostly central European folklore represented through costumes. It was particularly poor; France itself was not represented at all due to the 1931 decision to found a separate museum devoted exclusively to the ethnography

of France. The Asian collections were also very uneven, with single display cases of Japanese armor, traditional dress, and Chinese theatre costumes, a section on Tibetan monks, and extensive ethnographic artifacts from the Vietnamese hill tribes. The Oceanic galleries, on the other hand, were more coherent. Dramatic masks and sculptures from Hawaii, New Guinea, the Solomon Islands, and New Caledonia dominated, making spiritual life the focus of that presentation.

To be fair to Rivière and Rivet, this inconsistency in the displays reflected the uneven nature and quality of the collections that they inherited and the limited means at their disposal to amass new ones. When they arrived at the MET in 1928, Rivet and Rivière immediately sought to salvage what they could from the eclectic and deteriorating collections already in the museum—some of which, such as the pre-Columbian American collections, were first-rate—and to replace or supplement these collections as quickly and as rationally as possible. Rivet once again revealed his socialist proclivities by insisting that the museum's new mission was to collect the ordinary objects of everyday life the world over, rather than focus upon acquiring rare pieces of chiefly aesthetic interest. Fiscal reality reinforced ideological imperatives since the museum's acquisition budget remained miniscule. In point of fact, Rivet and Rivière would continue to depend partially on donations from private collectors whose tastes and methods they could not entirely control. But they did quickly realize that the colonies of the French empire continued to offer the MET a cheap and easily accessible source of new acquisition they could plan and supervise, both by sending their students there or by issuing collecting instructions to local French administrators.[34] In light of these various choices and constraints, the particularities of the museum's ethnography become more understandable. Areas of the world under French administration were more completely represented than others—to the point where Rivet claimed that his museum was a colonial one.[35] Yet pre-Columbian America would stay in the MH, despite the fact that no other ancient civilization (Egypt, or China, for example) would figure there. Although this decision was made in part because this was where Americanism had always been housed, there was, indirectly at least, a colonialist logic as well to America's inclusion here. As Daniel Sherman has persuasively argued, the coordinates of the MH's collections—from Ethiopia to Easter Island, from Haiti to Brazil, from the Arctic to South America, sketched "a zone of European imperial

contact," with a distinct preference for illiterate groups or civilizations without significant literary output.[36]

And where did skulls fit in any of these displays of the world's peoples, cultures, and civilizations? Almost every one of these geographically specific ethnographic galleries contained one or more introductory display cases, identifying through text, photographs, and maps a particular people and region, in which one shelf would be devoted to "l'homme." A brief physical description of single or multiple racial types found in this region would figure above one or more skulls; the other shelves of the case typically illustrated a fundamental technique of that same ethnic group. For example, in the American gallery, there was a case on "Mesoamerica" with "maize and manioc" illustrating the shelf below "l'homme" and three shelves in the same case devoted to ceramics.[37] Another case without skulls was devoted to the "races d'Amérique," and explained that modern science had concluded that these peoples had originally migrated from somewhere else. Thus "America was not a cradle of humanity."[38]

The Asia gallery had at its entrance a single case devoted to "les races d'Asie" which contained only skulls.[39] In a portion devoted to the USSR, the rubric "l'homme" accompanied by one or more skulls figured in displays on the Turks, Mongols, and Finno-Ugrians.[40] There were individual exhibits of an Iranian skull and Chinese skulls in another section of the gallery. A whole section of Asia was also devoted to French Indochina, and here too skulls figured predominantly. Skulls accompanied the exhibits on Cambodians, Thais, *Annamites,* and mountain peoples, although one also learned about their traditions, crafts, clothing, and way of life. Some ethnic groups were described, with no accompanying skull.[41] In both the North and Sub-Saharan Africa halls, skulls were displayed as well. The rich sections on nomadic life in North Africa and the Levant featured skulls unobtrusively, always accompanied by man-made artifacts such as weapons and camel saddles, or descriptions of agriculture and commerce. The Sub-Saharan Africa gallery had the most skulls, where they were placed in cases as part of an introduction to a particular people and way of life. The peoples were identified as Negroes [*Nègres*] from East Guinea, South Africa, the French Soudan, North Central Africa, South Central Africa, and the Nile [*Nilotiques*], as well as Nothern and Southern Ethiopians, Haoussa, and Hottentot Negrilloes [*Négrilles*].[42] This greater presence of skulls among the peoples of Africa subtly echoed the

evolutionary racial hierarchy presented in the Anthropology Gallery, in which Africans were implied to be the least developed of peoples.

Neither the geographical classification of artifacts adopted by Rivet and Rivière in the ethnographic sections of the MH, nor the juxtaposition of skulls and man-made objects, was new in natural history or ethnographic museums in France or elsewhere. As Nélia Dias has shown in her definitive study of the MET in the nineteenth century, the classic division of the world by continents had been adopted fifty years earlier by its first curator, the monogenist anthropologist Ernest-Théodore Hamy. Moreover Hamy, before being appointed to the MET, had been in charge of organizing the collections of skulls and skeletons held by the Paris Société d'Anthropologie and the MNHN between 1867 and 1870. Each of these institutions also had smaller collections of ethnographic material. The MET itself included a few physical remains of peoples when it opened its ethnographic collections in 1878. For Hamy, ethnographic information, along with language, comparative mythology, and sociology (among other scientific disciplines) was critical to completing the "tableau of differential characters" which the physical traits of any nation or ethnic group first intimated.[43] The physical and the cultural were thus conjoined, and for each stage of a people's evolution, bones could be matched to man-made objects. In such a system, the skull of the producer of an artifact "naturally" belonged next to the artifact itself, and all of humanity shared the same basic needs and evolutionary trajectory.

As we shall now see, Rivet's own training was very much in the tradition of Hamy and other nineteenth-century physical anthropologists. This continuity surely accounts in part for the particular layout and content of the MH's installations. Indeed it is tempting to argue that when the opportunity finally to bring the ethnographic and physical together under one roof presented itself, Rivet remained as much a prisoner of past ways of thinking about the classification of humanity as he did of the MET's vestigial collections and imperial modes of acquiring them. Yet the scientific understanding of race had shifted considerably since Hamy's first displays, and the manifest dangers of racializing difference had now come to haunt European scientists. Rivet was certainly not indifferent to the dramatically changed political and intellectual context of the inter-war years, or to the positive "difference" his museum could make. Given both developments, it makes sense to consider how Rivet and other leading anti-racist scientists understood the concept of

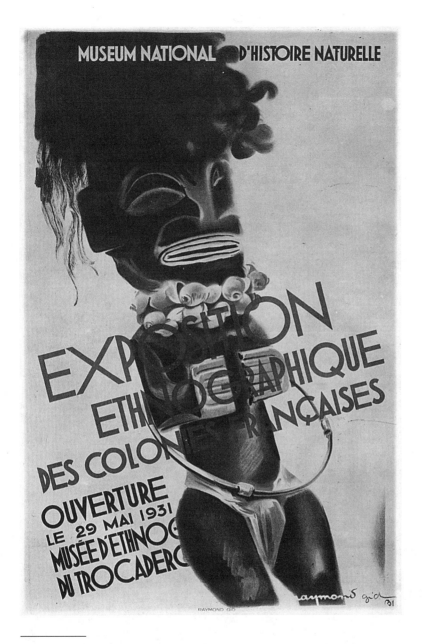

FIGURE 7.5. Poster for the Exhibition on Colonial Ethnography, MET, 1931.
*Photo © SCALA, Florence / Musée du Quai Branly, 2006.*

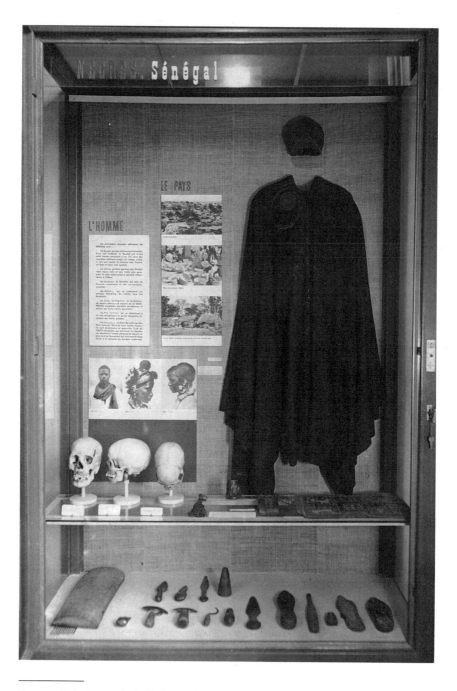

FIGURE 7.6. Case with skulls from Afrique Noire gallery. *Photo © SCALA, Florence/Musée du Quai Branly, 2007.*

race in the 1920s and 1930s before drawing any conclusions about the relative weight of residual scientific paradigms in shaping the MH's installations.

## Rivet's Science of Race

One way into the scientific thinking that underpinned the display of skulls in both sections of the MH is Rivet's own published statements on the question of race. Rivet never treated the topic per se in any real depth, and probably his most comprehensive statement—from which he did not subsequently deviate—can be found in his 1930 article "Les données de l'anthropologie."[44] This article provided an overview of the discipline, both as it existed in 1930 and as Rivet hoped it would evolve. After examining each of the branches of anthropology, Rivet listed the major racial groups of the world and summarized the findings of pre-historians on the earliest races of man (Neanderthal, Cro-Magnon, and so on). Rivet's interest in race was for the most part historical; like many of his generation, he was interested in understanding at what point in human evolution racial variation began, and how the major races came into contact with each other as they spread across the globe. More specifically, as an Americanist and as a diffusionist, he sought to understand the past migrations that peopled the American continents, hypothesizing that South American Indians were descendants of Melanesians who had arrived by canoe. Rivet explained that he had reached this conclusion first by comparing skull forms—to no avail—and then by studying language patterns. His position on racial characteristics was that of the three kinds of facts with which anthropologists *always* had to work, anatomical ones were the least reliable. Two peoples who came into contact almost invariably produced a new mixed people "having characters borrowed from the two peoples who had fused." Given that the original two peoples were already themselves "*métis*" it then became "almost impossible to find in this mix the dominant physical type of each . . ."[45] Languages, on the other hand, rarely fuse at moments of contact between two distinct peoples; one language will persist "in its internal structure [*structure intime*], in its grammar," even if its vocabulary changes. Language was thus a key marker for understanding community of origin. Ethnographic evidence—what Rivet referred to as "civilization: objects, customs, conceptions"—fell somewhere in the middle.[46] Two civilizations often mixed to produce an entirely new type,

again making it difficult to sort out which elements originated with each of the two "parent" civilizations. Yet a people conquered by another rarely adopted new language without also adopting the civilization expressed through that language. At the end of the day, this meant that the three kinds of evidence were always "congruent" [*solidaires*] rather than "independent of each other."[47]

Rivet's insistence that physical characteristics—despite their unreliability—be taken into account when defining a people provides a revealing clue to his attitude toward race. He accepted that one task of anthropology was "the diagnostic [*la diagnose*] of different human races and their distribution among the diverse groups of populations; it corresponds to both *la systématique* and to human biogeography." But he also recognized that anthropologists had erred in the past by relying too heavily on measurements of isolated elements—typically skulls—of single individuals to try to identify a physical type. Anthropologists needed to work comparatively on entire series of individuals within two given populations, in order to decide whether they were dealing with a relatively pure or mixed group. The former were, he acknowledged, extremely rare. They could only be found among peoples who had lived in complete geographic isolation for centuries, if not millennia. It was nevertheless toward identifying such people that physical anthropologists should particularly devote their efforts, since a pure type was much easier to trace in its subsequent migrations than a mixed type. Moreover, the further one went back in time, the easier it was to find well-characterized human types. Indeed, once "all the fossil races are known, it will be relatively easy to trace their descendants in the proto-historic races and in this way reach the modern races." Meanwhile, biologists working on understanding the rules of heredity would surely soon facilitate "the study of mixed populations who constitute the great majority of living humanity."[48]

Rivet, then, was not intellectually opposed to the project of racial typology. But as the above statements suggest, he had increasing doubts about the viability of older methods for determining racial identity, preferring the tools of biometricians, paleontologists, and—somewhere down the line— biologists for sorting out accurately the distinct physical types in the world's modern population. Like many of his generation, he slipped easily from the term "races" to "types," "peoples," and "populations" without distinguishing among them. Rivet did not suggest that skin color, or any other morphological feature, had any necessary connection to culture, although he did accept

that a given "race" might have its own particular "civilization" if this race could be found in a "pure" state. However, since this phenomenon was so rare, anthropologists, he insisted, should always study civilizations comparatively. Only a civilization studied in tandem with the civilizations that surrounded it would reveal "relations, affiliations and . . . the paths by which cultural elements were diffused."[49] In Rivet's science, evolutionary and diffusionist theories of culture were not mutually exclusive, but he never conceded that cultures might develop historically in their own right. Last but not least, however congruent the three kinds of diagnostic evidence at the disposal of anthropologists were, Rivet concluded that language remained the single most reliable one.

Given Rivet's skepticism about what bones could actually tell anthropologists, and his greater interest in the diffusion of languages and cultures, it might appear puzzling that Rivet did not dispense with racial diagnostics altogether, particularly for the modern peoples of the world. Yet it must be noted that no physical anthropologist in pre–World War II Europe or America was ready to jettison completely the system of racial classification inherited from the nineteenth century, either in 1930 or later in the decade when the Nazi menace was fully evident. On the one hand, new statistical tools pioneered by the British biometricians Francis Galton and Karl Pearson in the early twentieth century seemed to offer more refined quantitative methods than craniometry for sorting human beings into discrete racial categories. Rather than settling for simple averages, biometricians analyzed measurements statistically to yield averages, distributions, indices, and frequencies among series. Their work was predicated upon the idea that race was a statistical notion that could not be credibly instantiated in a single individual. This more rigorous approach gave race typing a new lease on life at the turn of the century. Indeed, in the right hands—Boas's famous 1911 study proving the plasticity and instability of the quintessential "racial" marker, the skull, comes to mind—biometrics encouraged anthropologists to explore more carefully the role of environment in shaping human difference.[50]

On the other hand, as noted earlier, most anthropologists internationally had not kept up with the latest findings of genetics.[51] And in the rare cases that anthropologists did turn to biology, they did not necessarily encounter even there an unequivocal rejection of traditional race typology on genetic grounds. In time, of course, biologists would discover that only a small proportion of

genetic differences between individuals correlate with racial type and that no known single genetic differences uniquely define racial groups—hence proving that commonsense notions of race difference are socially and culturally determined. In the 1930s, all of this research lay in the future, and geneticists still tended to accept in theory the biological and anthropological nature of race. What had changed, however, was the willingness of at least some liberal biologists to continue to use the term "race" on political grounds when describing different human aggregates—given both the Nazi abuses to which the racial concept was then giving rise and the fact that their new science did not yet have sufficient data to define race from a genetic point of view.

## "Race": What Is in a Name?

To better understand Rivet's continued use of race typology and the term "race" in his publications and in the MH, a brief survey of what other self-consciously progressive scientists abroad and at home were saying in the 1930s on the subject is useful. In the Anglo-American world, the most important scientific book seeking to educate the public on the misuse of the race concept was *We Europeans,* co-authored by the biologist Julian Huxley and one of Great Britain's most senior and illustrious anthropologists, Arthur Haddon. Faced with the rise of Nazi race propaganda and policy, the two authors deliberately sought to demystify for the public the latest scientific findings on the biology of race as it applied to Europe. The book was divided into two parts. The first part argued that race was hardly definable in genetic terms, except as an abstract concept. The "racial concept," Huxley wrote, was "almost devoid of biological meaning as applied to human aggregates" because of the constant crossing and recombining of populations since Homo sapiens' first appearance, in turn due to his migratory habits.[52] Huxley nevertheless believed that genetic research would eventually produce "frequency maps for all the important genes which distinguish human groups."[53] Until then, anthropologists should continue to do what they had always done: try to come up with a descriptive picture of the visible characteristics of different types.

Huxley, however, did introduce one new element to his conclusions. He insisted that the entirely misleading term "race" be dropped in any mapping of Europeans, for that of "mixed ethnic group," and that the ideal "ethnic" types chosen to represent these groups be acknowledged as just that—hypothetical

ideals that never existed in pure form in the past. In his words, "an ethnic type is a subjective judgment of the normal or ideal characteristics of a component of an existing population."[54] All modern peoples were of mixed ancestry, and "can never be genetically purified into their original components or purged of the variability which they owe to past crossing."[55] These conclusions then paved the way for Haddon, in the second part of the book, to present a fairly traditional view of the major subdivisions of Europe, based on ethnic types. But Haddon too invoked the arbitrary nature of all classificatory systems, reminding his readers that in the face of continuing scientific ignorance "any biological arrangement of the types of European man is still largely a subjective process, and is at best classificatory in a descriptive sense only."[56] As Barkan has pointed out, the most important aspect of *We Europeans* was the attention its authors paid to discrediting fallacious arguments about race. The book made no new claims about what race actually was.[57]

If we return now to France, the most progressive position staked out on the question of race by a biologist seems to have been an article published in 1938 in *La Jeune-République* by a biologist at the University of Poitiers, Étienne Patte, and entitled "Le problème de la race. Le cas de l'Europe passé et présent." Patte also wrote from a self-consciously political stance for a broad audience, and tried to summarize in lay language how modern genetics had dramatically altered past notions of what constituted a race. For him the genetic variety of the human species meant that "the definition of a race does not differ from that of an individual. We must thus define a race as all those individuals possessing the same genetic make-up . . . given the colossal number of different genetic formulae we can say that there are as many races as there are individuals."[58] To those who objected, on the grounds that the black race and the yellow race were clearly different from each other, he replied that all existing racial taxonomies were based on an arbitrary selection of characteristics that appeared to be hereditary, were easy to observe, and seemed to be tied more or less to a specific geographical regions.[59] Patte thus agreed with Haddon and others who maintained that race exists only in our minds. Having thus determined that "in a rigorous sense there is thus neither race nor pure race," Patte nevertheless (like Haddon) proceeded in the remaining section of his article to sketch out a traditional typology of the peoples of Europe (Nordic, Alpine, Mediterranean, Dinaric).[60] The principal difference was that where Haddon and Huxley had preferred to substitute the term "mixed ethnic group" for race, Patte continued

to use the term "race" in its "approximate" or "larger" (i.e., arbitrary) sense. He also accepted the use of the word "type" to designate groups in which "several individuals who are very different genetically possess a very small number of traits in common, which would suggest that they are related, when in fact any such kinship [*liens de parenté*] is extremely weak."[61] But Patte's final summation makes his political position on the race question perfectly clear.

> We have encountered in the course of this short exposé neither a Latin race, nor . . . an Aryan race. These names only refer to languages, peoples, nations or civilizations. . . . We have not even encountered, in the true sense of the word, a single race, since it is only by abusing and simplifying our language that we have identified races in Europe.[62]

In short, scientists who rejected outright the possibility of grouping Europeans into entities called "races" continued to accept a descriptive classification of different populations based on the same selection of physical characteristics that had been used in the past: hair type and hair color, skin color, eye color and eye form, stature, head form, and nasal form. The only invisible genetic descriptor added by most anthropologists in the inter-war years was blood type. Where select inter-war biologists did innovate was by refusing any longer to designate these groups as "races" or by pointing out more forcefully than in the past how subjective this traditional choice of characteristics used to classify human variation was. Of the two options, the former was the more radical, but the second much more common.

Where, then, did Rivet fall on this spectrum? There is no evidence that he personally kept up with new research abroad in genetics throughout the 1930s, although he clearly followed developments in biometrics and blood-typing. Nor were French biologists at the forefront of the field of human genetics. This honor went to the British and the Germans, albeit with very different outcomes in each of the two countries. *We Europeans* was not translated into French until 1947, and despite Rivet and Patte's shared commitment to combat racism, Patte did not move in the same political or scientific networks as Rivet. It is perhaps telling, in this context, that Paul Lester, Rivet's assistant director for the Anthropology Gallery, also co-authored an ostensibly up-to-date book on racial classification, *Les races humaines,* in 1936. In it he claimed that even "if they are never pure, even if they are constantly

changing . . . the human races are different, each having for a time physical and moral characteristics, a marked personality. . . . Some have a taste for music . . . others carry in their blood a taste for war . . ."[63] Lester tempered these statements, asserting that the study of anthropology and ethnography led to a way of thinking that challenged imperialisms and war-mongering.

Paul Lester was not of the same intellectual caliber as Eugène Patte or Paul Rivet, both of whom showed much greater familiarity than he did with contemporary debates about how social and physical factors interacted with heredity to produce human variation. Yet it was Lester who presided over the MH's Anthropology Hall at its opening in 1938. Lester had been put in charge of the MNHN's physical anthropology collection long before it moved to the Trocadéro, and when the collection moved, he moved with it. It is possible that Lester was not Rivet's ideal choice, but it also appears that Rivet shared enough of Lester's basic assumptions about race to make Lester an acceptable steward of the new anthropological laboratory. Clearly the preferred approach among those French natural scientists committed to educating a general public about human variation was to keep the term and the classic division of the "races" constantly in play—and hence on display—even as many questioned the validity of both.

And what was true of natural scientists in France was also true of the social scientists with whom Rivet maintained the closest of contacts. Although Durkheim and Mauss never took race as their privileged object of study, neither was as critical of nineteenth-century raciology as has often been claimed. Recent scholarship has debunked the view that the Durkheimians launched a "scientific revolution" in France before World War I that "quickly and definitively delegitimated biological—and especially racial—explanations in the social sciences."[64] French sociological theory in the inter-war years remained tied syncretically to raciological explanations, even as it sought to emancipate itself from them. As Durkheim himself put it, "race cannot explain social facts but remains, through heredity, a cause of individual behavior."[65] Durkheim and his disciples were not interested, of course, in understanding the behavior of the individual in society, so did not seek to explain how heredity worked to transmit racial traits. But Mauss's own unwillingness to renounce completely the idea of the "sociobiological" must also figure into any attempt to understand why skulls were allowed in the ethnographic wings of the museum in the first place.[66]

## Conclusion

Was, then, the MH "an arsenal," as the admiring biotypologist Eugène Schreider put it in 1939, "where any thoughtful visitor will find impeccable weapons, impartial arguments, and limpid proofs that will allow him to counter, with the serenity that only . . . an impassive science can reveal, . . . the hateful attacks of the enemies of humanity?"[67] Although we have no record of Paul Rivet's views of the galleries when they opened, he may well have shared Schreider's opinion. Schreider was writing, after all, in the final issue of the newsletter *Races et Racisme,* on whose editorial board Rivet sat. The issue was devoted entirely to the MH, identified implicitly as a key site in the battle against the misuse of science and the Nazi atrocities being waged in its name.

Notwithstanding Rivet's limited knowledge of genetics, he had kept up with the extraordinary findings of his friend and acknowledged mentor, Franz Boas. Boas's proof positive that environment and heredity together produced variable populations over time and space profoundly undermined the basis for an older typological classification based on static racial characteristics and types. Yet even Boas continued until his death, in Tracy Teslow's words, "to think of lines of heredity in a broadly typological manner," one that anticipated but did not yet share "a post World War II conception of difference informed by population genetics, and thus rooted in a sense of human variation as permanently shifting, mixing and redistributed across ever-changing populations."[68] Given this apparently unshakeable presence of race typology in the "best" anthropological thinking of the inter-war years, Rivet's galleries were within the pale of responsible science before World War II.

Rivet's science of race alone, of course, does not account for the way the MH organized its collections of skulls; nor do the collections necessarily reflect accurately Rivet's science. A full exploration of the place assigned to race, consciously and unconsciously, in the museum would have to weigh the many institutional, museographic, and disciplinary constraints that also shaped the displays. Since a significant portion of the MH's physical anthropology installations were drawn from older inherited collections, it would be particularly useful to know how the 1938 exhibition of racial types compared to that of the natural history museum at the end of the nineteenth century.[69] From a museographic point of view, it is important to remember that the MH

marked one of France's first scientific museums aimed deliberately at in-
structing the masses, in which everyone agreed that the exhibits had to be
both spectacular and didactic. It thus seems likely that the particular represen-
tation of race in the museum was driven more by the need to simplify and im-
press than by a drive to explain the rather more complex notion that
difference was now best understood as an abstraction that could not be in-
stantiated in any single individual. Moreover, as Schreider's quotation above
suggests, the objective of scientific institutions in this era was certainly not to
highlight scientific debates. Indeed such a confession of disagreement among
scientists might confuse the public as to which scientists in the first place,
French versus German ones for example, to believe. If Rivet's aim was also to
establish the discipline of ethnology on a new footing by creating a modern
museum to house its many branches, here was yet another reason militating
against a more nuanced or conditional representation of the science of race.
What practitioners quarreled about behind the scenes was not yet part of the
public face of science anywhere, not even in an institution whose founders
hoped to enroll in the fight against racism.

If the multiple logics inscribed in the MH's display of skulls were contra-
dictory, and thus difficult to disentangle, determining how these bones were
received by the popular audiences for whom they were in part intended poses
no fewer challenges. The MH was not only or even principally a race gallery,
and without giving equal time to an analysis of the ethnographic galleries of
the museum, it would be impossible to determine the overall understanding
of race and/or culture that a viewer might take away from the museum. Yet
because press clippings were preserved from the opening, we at least know
that only a few journalists writing about the opening of the museum related
what they saw there to the fascist threat. Claude Martial (surely already an
anti-fascist), in the communist daily *L'Humanité,* noted that all savages were
represented in the museum except

> the savage men of the present. A formula should be found to explain
> the forms of neo-paganism that are an exaggerated racial cult. One
> would have to group with the worst fetishizers those obtuse idolot-
> ers who prostrate themselves before the fetish of the fasces or the
> swastika, [and] who had the idea to irrigate steel, in order to harvest
> bayonets.[70]

The writer for *Pratique Automobile* remarked, after his visit to the museum, that

> once again France reveals herself a champion of humanity, by showing by her research, that the deification of Race, a theory which his Holiness the Pope has just condemned, and which replaces charity with egotism, is as absurd as it is iniquitous, and that it is ridiculously pretentious for one race to arrogate the right of looking down on others, and to think that it is the emanation of a so-called divinity created for that sole purpose.[71]

Most of the commentary focused instead on the dazzling profusion of exotic objects, and made only passing reference to the anthropological gallery, and none at all to the skulls in the rest of the museum.

Perhaps this overwhelming focus in the press on the ethnographic displays meant quite simply that race went unremarked, and hence did not matter to many viewers. Such a verdict could then be read as a triumph in itself for Rivière, Leiris, and Mauss's other students in installing the exhibits on humankind's diverse cultures. That Mauss did not fully share Rivet's conviction that all branches of anthropology were necessarily congruent—believing instead that humankind could be studied without any reference to physical type whatsoever—was indirectly suggested by Jacques Soustelle years later. In his 1958 obituary for Rivet, Soustelle paid homage to the idea dear to Rivet that "his" science of man synthesized all branches of anthropology; but he also intimated that such a vision had been limited to their elders, and rendered obsolete by the very war Rivet had so hoped to avoid:

> The powerful ideas of Durkheim had indeed imbued our sociology with an admirable élan, but it became necessary to incorporate into this science the wealth of facts observed directly and to add a temporal dimension through studies and research that plunged into the past. Later on, the encounter and collaboration between Paul Rivet and Marcel Mauss, nephew and successor of Durkheim, would give to French ethnology that openness on the most varied aspects of human reality, that spirit of synthesis that characterized what we could call the School of Paris between 1928 and the Second World War.[72]

Yet a second, more ominous, reading of these skulls' potential impact also seems possible, and as likely. New work on racialized immigration policy in France has stressed continuities not only between the late Third Republic and Vichy, but more disturbingly, between Pétain's regime and post-war governments.[73] As the repopulating of France emerged as a key discourse in the post-1945 Liberation period, experts from a range of fields—medicine, demography, physical anthropology—both rejected any notion that a pure French race (or any pure races) existed, and ranked according to racial type those groups who could be most successfully assimilated. In these rankings biological and cultural differences were conflated, and standard pre-war racial typologies (Nordic, Alpine, and Mediterranean) were transparently transposed onto national ones (Belgian, Swiss, Italian). Nordics, not surprisingly, came out as the most desirable type of immigrant, Arabs as the least.[74] In this context, it is unclear whether essentializing race typologies in the new MH were in fact marginalized either before or after the war, or gained instead a wider lease on life throughout certain parts of French society and the state in these same years, at least in part due to the imprimatur of a museum of "true" science. Rivet's 1948 statement with which this essay opened—that the Physical Anthropology Hall remained the most popular of all the galleries with the public (if not the journalists)—certainly suggests that large numbers of post-war museum visitors would have little reason to think that race was a "social myth" rather than "biological fact."

That Rivet opened the MH to update French anthropology by scientizing ethnography cannot be in doubt. That he also sought to fight the vicious racism of Nazi Germany in the name of modern science, at a time when few intellectuals anywhere were mobilizing against the fascist threat, is equally clear. But despite its Art Deco exterior, streamlined presentation of objects, and humanist declaration of the equal value of all peoples, the classification of races preserved inside the Trocadéro remained startlingly mired in the past. This paradox only serves to remind us how fragile and incomplete the modernist revolution was, when it came to relinquishing scientific racism in a nation that championed empire—before and after the war—in the name of the rights of man.

## Acknowledgments

This paper has been through many audiences, all of whose rigorous readings have, I hope, strengthened it. I would like to thank the members of the history departments at the University of Delaware, the University of Michigan, the Ohio State University, and the University of Houston, as well as the participants in the Center for History, Society, and Culture at the University of California–Davis and the Center for Historical Studies at the University of Maryland for the opportunity to present my work to them and for their stimulating comments. My greatest thanks, however, go to Daniel Sherman and fellow participants in the Museums and Difference conference held at the Center for 21st Century Studies and the Milwaukee Art Museum, 14–15 November 2003, and to Tracy Teslow, Glenn Penny, Owen White, and Geoffrey Parker for their detailed comments on earlier drafts. Research for this project has been supported by grants from the John Simon Guggenheim Foundation, the George Marshall Fund, and the Fulbright Commission.

## NOTES

1. Archives du Musée de l'Homme (AMH hereafter)/2 AM 1 B2/a, Paul Rivet, "Musée des races et des civilisations," *Monde Libre* 1, May 1938.

2. Paul Rivet, "The Organization of an Ethnological Museum," *Museum* 1 (1948): 112.

3. AMH/2 AM 1 B10/c, Paul Rivet, "Tribute to Franz Boas by Paul Rivet," *International Journal of American Linguistics* 24, no. 6 (Oct. 1958): 251–252.

4. Quoted in Elazar Barkan, *The Retreat of Scientific Racism: Changing Concepts of Race in Britain and the United States between the World Wars* (New York: Cambridge University Press, 1992), 341.

5. Michel Leiris, *Race et Civilisation* (Paris: UNESCO, 1951); Claude Lévi-Strauss, *Race et Histoire* (Paris: UNESCO, 1952).

6. The museum received most of its funding from the colonies, but had no "official" relationship with the colonial administration. I have explored these colonial connections more fully in Alice L. Conklin, "The New Ethnology and 'La Situation Coloniale' in Interwar France," *French Politics, Culture and Society* 20, no. 2 (Summer 2002): 29–46. See also the essays collected in Dominique Taffin, ed., *Du musée colonial au musée des cultures du monde* (Paris: Maisonneuve et Larose, 2000).

7. Francine Hirsch, *Empire of Nations: Ethnographic Knowledge and the Making of the Soviet Union* (Ithaca, N.Y.: Cornell University Press, 2005), particularly chapter 5.

8. Physical anthropology had reached an epistemological impasse from within by the end of the nineteenth century, as it became apparent that existing techniques for measuring were incapable of any consistent demarcations between groups. Despite visible

exterior differences between whites, blacks, Asians, and Native Americans, measurement of their skulls and other physical features only yielded contradictory evidence that made formal taxonomy impossible. For French anthropologists' reactions to these problems, see Claude Blanckaert, ed., *Les politiques d'anthropologie: Discours et Pratiques (1860–1940)* (Paris: L'Harmattan, 2001); Jennifer Michael Hecht, *The End of the Soul: Scientific Modernity, Atheism, and Anthropology in France, 1876–1936* (New York: Columbia University Press, 2003); and George W. Stocking, "The Persistence of Polygenism in Post-Darwinian Anthropology," in George W. Stocking, ed., *Race, Culture, and Evolution: Essays in the History of Anthropology* (New York: Free Press, 1968), 42–68.

9. On the reception of Darwinism in France, see William H. Schneider, *Quality and Quantity: The Quest for Biological Regeneration in Twentieth-Century France* (Cambridge, UK: Cambridge University Press, 1990), 6.

10. Tracy Lang Teslow, "Reifying Race: Science and Art in *Races of Mankind* at the Field Museum of Natural History," in *The Politics of Display: Museums, Science, Culture,* ed. Sharon Macdonald (London: Routledge, 1998), 53–76; Idem, "Representing Race to the Public: Physical Anthropology in Interwar American Natural History Museums" (Ph.D. diss., University of Chicago, 2002).

11. See here especially Nélia Dias, "The Visibility of Difference: Nineteenth-Century French Anthropological Collections," in *Politics of Display,* ed. Macdonald, 36–52.

12. I borrow the term "visual regime" from Dias, "Visibility of Difference," 49. Andrew Evans argues that World War I gave racial typing a new lease on life in Germany in the 1920s, as physical anthropologists there measured thousands of European and colonial POWs. Andrew Evans, "Anthropology at War: World War I and the Science of Race in Germany" (Ph.D. diss., Indiana University, 2002).

13. For an in-depth exploration of how a later French museum remained a prisoner of its past collections see Daniel J. Sherman, " 'Peoples Ethnographic': Objects, Museums, and the Colonial Inheritance of French Ethnology," *French Historical Studies* 27, no. 3 (Summer 2004): 669–703.

14. "Accurate" representation would have been difficult under any circumstances, given that race was now understood to be an abstraction that could not be instantiated in any single individual.

15. The history of anthropology in twentieth-century century France has not yet been fully written. There is, for example, no study of the École d'Anthropologie, which Rivet still saw as a rival institution in the 1930s. On the persistence of raciology in France, see Jean-Pierre Bocquet-Appel, "L'anthropologie physique en France et ses origines institutionnelles," *Gradhiva* 6 (1989): 23–34. The emergence of cultural anthropology can be pieced together from Laurent Mucchielli, "Sociologie *versus* anthropologie raciale: l'engagement décisif des durkheimiens dans le contexte 'fin de siècle' (1885–1914)," *Gradhiva* 21 (1997): 77–95;

Jean-Christophe Marcel, *Le Durkheimisme dans l'entre-deux-guerres* (Paris: Presses universitaires de France, 2001); Victor Karady, "Durkheim et les débuts de l'ethnologie universitaire," *Actes de la recherche en sciences sociales* 74 (Sept. 1988): 17–35; Idem, "Durkheim, les sciences sociales et l'Université: bilan d'un demi-échec," *Revue française de sociologie* 17, no. 2 (1976): 267–311; Terry Clark, *Prophets and Patrons: The French University System and the Emergence of the Social Sciences* (Cambridge, Mass.: Harvard University Press, 1974); Filippo M. Zerelli, *Il lato oscuro dell'ethnologia* (Rome: CISU, 1998); Jean Jamin, "L'ethnographie mode d'emploi: De quelques rapports de l'ethnologie avec le malaise dans la civilisation," in *Le mal et la douleur,* ed. Jacques Hainard and Roland Kaehr (Neuchatel: Musée d'ethnographie, 1986), 45–79; Idem, "Le musée d'ethnographie en 1930: L'ethnologie comme science et comme politique," in *La Muséologie selon George-Henri Rivière: cours de muséologie, textes et témoinages* (Paris: Dunod, 1989), 110–21; Idem, "Les objets ethnographiques sont-ils des choses perdues?" in *Temps perdu, temps retrouvé,* ed. Jacques Hainard and Roland Kaehr (Neuchatel: Musée d'ethnographie, 1985), 51–74; Idem, "Le savant et le politique: Paul Rivet (1876–1958)," *Bulletins et mémoires de la Société d'anthropologie de Paris* 1, nos. 3–4 (1989): 277–94; and Daniel Fabre, "L'Ethnologie française à la croisée des engagements (1940–1945)," in *Résistants et Résistance,* ed. Jean-Yves Boursier (Paris: L'Harmattan, 1997), 319–400.

16. On the earlier history of the MET, see Nélia Dias, *Le musée d'ethnographie du Trocadéro (1878–1908): anthropologie et muséologie en France* (Paris: Editions du CNRS, 1991).

17. This summary is based on my research in the Musée de l'Homme archives and on Alice L. Conklin, "Civil Society, Science, and Empire in Late Republican France: The Foundation of Paris' Museum of Man," *Osiris* 17 (July 2002): 255–90. Rivière played a critical role in the earlier reorganizations of the museum. For a recent biography, see Nina Gorgus, *Le magicien des vitrines: Le muséologue Georges Henri Rivière,* trans. Marie-Anne Coadou (Paris: Éditions de la Maison des sciences de l'Homme, 2003).

18. For an intellectual biography of Paul Rivet, see Fillipo Zerilli, *Il lato oscuro dell' etnologia* (Rome: CISU, 1998); Christine Laurière, "Paul Rivet, vie et oeuvre," *Gradhiva* 26 (1999): 109–28; Jean Jamin, "Le savant et le scientifique: Paul Rivet (1876–1958)," *Bulletin et Mémoires de la Société d'anthropologie de Paris* 1, nos. 3–4 (1989): 277–94. On his career as an Americanist, see Paul Edison, "Latinizing America: The French Scientific Study of America, 1830–1930," (Ph.D. diss., Columbia University, 1999).

19. James D. Herbert, *Paris 1937: Worlds on Exhibition* (Ithaca, N.Y.: Cornell University Press, 1998), 13. Herbert sees the esplanade, not the wings, as the chief architectural feature of the new Palais de Chaillot.

20. AMH/2 AM 1B1bis/d, Georges-Henri Rivière, "Dans le nouveau Trocadéro s'ouvrira le Musée de l'Homme," *Les nouvelles littéraires,* January 1937.

21. AMH/2 AM 1B1bis/d, Michel Leiris, "L'Exposition: l'Encyclopédie à la portée de tous," *Avant-Garde,* 14 August 1937.

22. Rivet, "The Organization of an Ethnological Museum," 112.

23. Leiris, "L'exposition."

24. AMH/2AM 1 B2/d, Michel Maubourg, "Le tour de l'humanité," *Echo d'Oran,* 6 January 1939.

25. Fabrice Grognet, "D'un Trocadéro à l'autre, Histoire de métamorphoses" (Paris: DEA de muséologie, Muséum National d'Histoire Naturelle, 1998), 59.

26. Archives du Musée du Quai Branly (AMQB hereafter)/Iconothèque (IC hereafter)/PP0001632; PP0001633; PP0001651; PP000168; PP0094144; PP0094145; PP0094147; PP0094148; PP0094149; PP0094191; PP0094192; PP0094193; PP0094194. The photograph archives of the Musée de l'Homme have been transferred to the Musée du Quai Branly, and a new cataloguing system is being created for the collection. The references to photographs used in this essay follow the AMQB's new catalogue.

27. M.V. Fleury (Eugène Schreider), "Le Musée de l'Homme," *Races et Racisme* 16–17–18 (Dec. 1939): 2; AMQB/IC/PP0001610.

28. AMH/2AM 1 B2/d, R.F.S., "A Museum of Man," *Manchester Guardian,* 14 April 1939; AMQB/IC/PP0001613; PP0001614; PP0001615; PP0094160; PP0094161; PP0094162; PP0094163; PP0094164; PP0094165. See also PP0094175 through PP0094182.

29. AMQB/IC/PP0001582; PP0001596; PP0001609; PP001615; PP0094114; PP0094117; PP0094118; PP0094120; PP0094137; PP0094190. In France, the great popularizer of classifying types according to blood groups in the inter-war years was René Martial. For an extended discussion of Martial's ideas and impact, see Schneider, *Quality and Quantity.*

30. AMQB/IC/PP010027; PP010025; PP0094118. There is by now a large literature on the early-nineteenth-century display of the Khoisan woman Saartjie Baartman, known to the Western world as "The Hottentot Venus." For overviews of the representation of "Hottentots" see F.-X. Fauvelle, "Le Hottentot, ou l'homme-limite. Généalogie de la représentation des Khoisan en Occident, Xve–XIXe siècle" (Ph.D. diss., Université de Paris I, 1999), and Z. S. Strother, "Display of the Body Hottentot," in *Africans on Stage: Studies in Ethnological Show Business,* ed. Bernth Lindfors (Bloomington: Indiana University Press, 1999), 1–61. On the revival of interest in Baartman in 1930s Italy, see Barbara Sòrgoni, " 'Defending the Race': The Italian Reinvention of the Hottentot Venus during Fascism," *Journal of Modern Italian Studies* 8, no. 3 (2003): 411–24.

31. AMQB/IC/PP0094116; PP0094125; PP0001611; PP0001612; PP001617; PP0094112; PP009413; PP0094115; PP0094121; PP0094122; PP0094123; PP0094124; PP0094126; PP0094127; PP0094128; PP0094129; PP0094130; PP0094131; PP0094132; PP0094135; PP0094137; PP0094138; PP0094139; PP0094157; PP0094172; PP0094174; PP0094189; PP0094196; PP0094197; PP0094198. See also PP0094210 through PP0094247.

32. There were some references to a historical past; the gallery included statues and the throne of the nineteenth-century Dahomey kings Glélé and Béhanzin, whom the French defeated, as well as polychrome plaques from the royal palace of Dahomey. Abyssinian frescoes taken by Griaule from an early Christian Church in Gondar also managed to imply that history came to Africa from the West. See AMQB/IC/PP0093262 through PP0093276 and PP009317 through 0093513 for the "Afrique noire" section of the museum.

33. Paul Rivet and Georges-Henri Rivière, "Mission ethnographique et linguistique Dakar-Djbouti," *Minotaure* 2 (1933): 3–5; Jean Jamin, "La Mission d'ethnographie Dakar-Djibouti 1931–1933," *Cahiers Ethnologiques* 5 (1984): 1–179. The young Michel Leiris was among Griaule's associates, and Leiris's 1934 work *L'Afrique fantôme* is both a chronicle and critique of the mission. See Jean Jamin's annotated edition of *L'Afrique fantôme* in *Leiris, Miroir de l'Afrique* (Paris, Editions Gallimard, 1996), 87–869.

34. Conklin, "Civil Society, Science, and Empire," 281–90.

35. AMH/2 AM 1 A 11, Paul Rivet à Edouard Daladier, Président du Conseil, 5 May 1938, no. 825. In his letter to Daladier, then Minister of War, Rivet wrote on the eve of the MH's opening, "but our museum is above all a colonial museum."

36. Sherman, "Peoples Ethnographic," 684.

37. AMQB/IC/PP0090280.

38. AMQB/IC/PP0090277; see also the following photographs of wall panels in the American Gallery: C 53-1429-493; C 40-1671-54; C 40-1675-54; C 40-1676-64.

39. AMQB/IC/PP0093750.

40. AMQB/IC/PP0093771.

41. For cases with skulls, see AMQB/IC/PP0093527; PP0093528; PP0093750; PP0093644; PP0093764. For skulls from French Indochina, see PP0093711 [*Indochine, Montagnards d'origine chinoise*]; PP0093731 [*Indochine, Population Thai*]; PP0093739 [*Indochine*]; PP0093751 [*Indochine, Annamites*]; PP0093752 [*Indochine, Cambodgiens*].

42. AMQB/IC/PP0093323; PP0093335; PP0093342; PP0093347; PP0093348; PP0093349; PP0093350; PP0093473; PP0093479; PP0093480; PP0093490; and PP0093493. I have no photographic evidence of the presence of skulls in the displays in the Oceanic, European, or Arctic sections.

43. Dias, *Le musée d'ethnographie,* 153–55.

44. Paul Rivet, "Les données de l'anthropologie," in *Nouveau traité de psychologie,* ed. George Dumas (Paris: Félix Alcan, 1930), 55–101; see also Rivet, "L'étude des civilisations matérielles; ethnographie, archéologie, histoire," *Documents* 3 (1929): 130–34; Idem, "Ethnologie," in *La science française,* 2 vols. (Paris: Larousse, 1933), 2:5–12; Idem, "Ce qu'est l'ethnologie," in *L'espèce humaine: peuples et races,* vol. 7 of *Encyclopédie française* (Paris: Larousse, 1936), 7:06-1–08-16; Idem, "L'Ethnologie en France," *Bulletin du Muséum,* 2e série (Jan. 1940): 38–52; Paul Rivet and Georges-Henri Rivière, "La réorganisation du

Musée d'ethnographie du Trocadéro," *Outremer* (1930): 138–49; and Paul Rivet, Paul Lester, and Georges-Henri Rivière, "Le Laboratoire d'anthropologie du Muséum," *Nouvelles archives du Muséum d'histoire naturelle,* 62 série, no. 12 (1935): 507–31. These articles tended to repeat the same information, as Rivet sought to publicize as widely as possible his reforms.

45. Rivet, "Les données de l'anthropologie," 58.

46. Ibid., 57–58.

47. Ibid., 60.

48. Ibid., 65–66.

49. Ibid., 66–67.

50. Teslow, "Representing Race," 2, 43–46, and 48–51. See also Barkan, *The Retreat of Scientific Racism,* chapter 3.

51. Barkan, *The Retreat of Scientific Racism,* introduction and part 3.

52. Julian S. Huxley and A. C. Haddon, with a contribution by A. M. Carr-Saunders, *We Europeans: A Survey of Racial Problems* (London: Jonathan Cape, 1935), 144. Also see Nancy Stepan, *The Idea of Race in Science: Great Britain, 1800–1960* (London: Macmillan, 1982).

53. Ibid., 127–28.

54. Ibid., 141. The more radical move here was for a scientist to abandon the term "race"; biologists and anthropologists had long known that all "types" identified in their classifications were hypothetical ones.

55. Ibid., 143.

56. Ibid., 166.

57. Barkan, *The Retreat of Scientific Racism,* 167.

58. Étienne Patte, "Le problème de la race. Le cas de l'Europe passé et présent," *La Jeune-République* 52 (Nov.–Dec. 1938): 16.

59. Ibid.: 17.

60. Ibid.: 22.

61. Ibid.: 25–26.

62. Ibid.: 52.

63. Paul Lester and Jacques Millot, *Les races humaines* (Paris: Payot, 1936), 13–14.

64. Emanuelle Saada, "Race and Sociological Reason in the Republic: Inquiries on the Métis in the French Empire (1908–1937)," *International Sociology* 17, no. 3 (Sept. 2002): 365; see also Owen White, *Children of the French Empire: Miscegenation and Colonial Society in French West Africa, 1895–1960* (Oxford: Clarendon Press, 1999), Gérard Noiriel, *Les origines républicaines de Vichy* (Paris: Hachette, 1999), and Daniel Fabre, "L'Ethnologie française."

65. Quoted in Saada, "Race and Sociological Reason": 380. The quotation is from 1903 and appeared in *Année sociologique.*

66. Quoted in Saada, "Race and Sociological Reason": 381. Mauss used the term in 1934.

67. Fleury, "Le Musée de l'Homme": 5.

68. Teslow, "Representing Race," 166–67.

69. On nineteenth-century collections of skulls and skeletons, see Nélia Dias, "Séries de crânes et armée de squelettes: les collections anthropologiques en France dans la seconde moitié du dix-neuvième siècle," *Bulletins et mémoires de la Société d'anthropologie de Paris* 5, nos. 3–4 (1989): 122–47.

70. AMH/2 AM 1B 2/a, Claude Martial, "Passage douté Musée de l'Homme," *L'Humanité,* 20 June 1938.

71. AMH/2 AM 1B 2/b, *Pratique Automobile,* 1 September 1938.

72. AMH/2 AM 1B 10/c/Rivet, Jacques Soustelle, "Hommage à Paul Rivet," *Voici Pourquoi* 9, 10 April 1958, 22–23.

73. In addition to Saada, "Race and Sociological Reason": 385–86, see Noiriel, *Les origines;* Patrick Weil, *La France et ses étrangers: l'aventure d'une politique de l'immigration, 1938–1995* (Paris: Calmann-Levy, 1991); and idem, "Racisme et discrimination dans la politique française de l'immigration, 1938–1995," *Vingtième siècle* 47 (juillet–septembre 1995): 77–102.

74. K. H. Adler, *Jews and Gender in Liberation France* (Cambridge, UK: Cambridge University Press, 2003), 85.

Dossier

*"Inventing Race" in Los Angeles*

ILONA KATZEW AND DANIEL J. SHERMAN

CHAPTER EIGHT

The exhibition Inventing Race: Casta Painting and Eighteenth-Century Mexico, held at the Los Angeles County Museum of Art (LACMA) from 4 April to 8 August 2004, brought before the public paintings representing racial types and their interaction in colonial Mexico. Its conception, installation, and reception offer a revealing example of an art museum directly confronting issues of difference in a highly diverse community in the early twenty-first century. This dossier includes the following: the museum's press release for the exhibition, the complete didactic text of the exhibition brochure (information on events is omitted), the review of the exhibition by Christopher Knight in the *Los Angeles Times,* as well as a subsequent article in the *Los Angeles Times Magazine* by Gregory Rodriguez, and an edited and abridged version of a conversation between the curator of the exhibition, Ilona Katzew, and Daniel Sherman recorded at the museum on 22 October 2004.

**LACMA Press Release (Excerpts)**

MEXICO'S RICH HISTORY OF INTERRACIAL FAMILIES
REVEALED BY PAINTINGS ON DISPLAY AT LACMA
*Inventing Race: Casta Painting and Eighteenth-Century Mexico*

(La invención del mestizaje. La pintura de castas y el siglo XVIII
en México)
April 4–August 8, 2004
Presented by Univision Communications Inc.

LOS ANGELES—Richly detailed family portraits that celebrate racial mixing among eighteenth-century Mexico's native Indian, Spanish, and African populations have been brought together at the Los Angeles County Museum of Art (LACMA) in the West Coast's first-ever exhibition of a genre known as casta (caste) paintings. Inventing Race: Casta Painting and Eighteenth-Century Mexico, on view April 4 through August 8, 2004 and presented by Spanish-language media company Univision Communications Inc., explores the complex process of mestizaje, or racial mixing, that has shaped life in the Americas.

Curated by LACMA's Ilona Katzew, one of the world's leading authorities on casta painting, the exhibition includes approximately 110 paintings from private and public collections around the world, many on public display for the first time. Included are some of the most accomplished paintings of the genre, such as those signed by the celebrated Miguel Cabrera, the most acclaimed painter of eighteenth-century Mexico, Juan Rodríguez Juárez, José Joaquín Magón, José de Páez, and others. Created as sets of consecutive images, the casta paintings in the exhibition are presented in several complete sets (most have been disassembled over time), which will afford audiences the unique opportunity to see how the images were initially conceived and how the racial combinations were arranged.

"These works are wonderful in their artistic detailing and complexity of subject matter. They showcase an extraordinary chapter in Mexico's history, but at the same time they form part of the larger picture of eighteenth-century Western art," said Katzew, LACMA curator of Modern and Contemporary Art. "Bringing them to a city as ethnically diverse as Los Angeles, with its close ties to Mexico, is especially significant."

The production of casta painting spans the entire eighteenth century. Most sets include sixteen scenes on separate canvases or copper plates illustrating a mother of one race and father of another, with one or two of their children. An accompanying inscription identifies the racial mix of the subjects, such as "From Spanish and Indian, Mestizo" and so forth. In addition to depicting the process of race mixing in colonial Mexico, the paintings also

offer rich samplings of local products, flora, and fauna of the New World, providing a unique glimpse into life in Mexico at that time. The works are key visual documents of a social phenomenon that shaped life in the Americas and bear numerous implications today. They also reveal the great artistic achievement attained by colonial artists and present new genres invented in the colonies that had no equivalent in European art.

Until now, casta painting has received little exposure, although the works were highly popular and avidly collected at the time of their creation. *Inventing Race: Casta Painting and Eighteenth-Century Mexico* charts the development of casta paintings in the eighteenth century, outlining the ways in which their meanings changed according to shifting colonial politics. For example, while early paintings, those from roughly 1700 to 1760, stress the affluence of the colony and embody a collective image of self pride, later works, from about 1760 to 1790, place more emphasis on stratification and the colony's means of production by depicting a host of trades that closely parallel issues raised by contemporary reformers.

By placing casta paintings within their social and historical context, the exhibition shows why the genre was invented, why the subject of interracial families became a topic of a pictorial genre that lasted an entire century, and why the paintings, with their exquisite assortment of objects and detailed renditions, remain as intriguing today as they were in the eighteenth century.

Credit Line:
This exhibition was organized by the Los Angeles County Museum of Art. It is presented by Univision Communications Inc.: Univision 34 Los Angeles; Telefutura 46 Los Angeles; and Univision Radio Los Angeles (KSCA-FM, KLVE-FM, KTNQ-AM, KRCD-FM). ⬢UNIVISION

It was supported in part by a grant from Bank of America.
Curator:
Ilona Katzew, Modern and Contemporary Art, LACMA

Related Publication:
Katzew's upcoming book *Casta Painting: Images of Race in Eighteenth-Century Mexico* (Yale University Press) will be released at the time of the exhibition and sold at LACMA.

LACMA's Collection of Latin American Art

The Bernard and Edith Lewin Latin American Art Galleries, in LACMA West, occupy 4,000 square feet. The galleries exhibit LACMA's finest Latin American art as part of its encyclopedic permanent collection and were named after Bernard and Edith Lewin, who in 1997 gave the museum more than 2,000 works, mostly by Mexican modern masters. With the opening of the Latin American Art Galleries, the generous Lewin gift, and continued expansion of the permanent collection in this area, LACMA has become one of the premier repositories for 20th-century Latin American art in the United States.

About LACMA

Established as an independent institution in 1965, the Los Angeles County Museum of Art has assembled a permanent collection that includes approximately 100,000 works of art spanning the history of art from ancient times to the present, making it the premier encyclopedic visual arts museum in the western United States. Located in the heart of one of the most culturally diverse cities in the world, the museum uses its collection and resources to provide a variety of educational, aesthetic, intellectual, and cultural experiences for the people who live in, work in, and visit Los Angeles. LACMA offers an outstanding schedule of special exhibitions, as well as lectures, classes, family activities, film programs, and world-class musical events.

**Casta Exhibition Brochure Text**

Inventing Race
*Casta Painting and Eighteenth-Century Mexico*
April 4–August 8, 2004

**Inventing Race**
*Casta Painting and Eighteenth-Century Mexico*
Casta ("caste") painting, one of the most compelling forms of artistic expression from Spanish America, illustrates the results of the intermingling of the races in colonial society. The genre emerged in Mexico around 1711 and was popular for about a century. Created by both renowned and anonymous artists, these images open a window on the nuanced complexities of Spanish

colonial life, helping us understand how the concepts of race and race mixing came to assume such important roles in the Americas.

During the colonial period, native Indians, Spaniards born in Spain as well as the New World (the latter known as creoles), and Africans brought over as slaves all populated Mexico. A large percentage of the population was of mixed race—known collectively as castas. Produced largely for a European market, casta paintings reveal the elite's attempt to represent and categorize the process of race mixing.

Most casta paintings were conceived as sets of sixteen scenes painted on either a single canvas or separate surfaces. Each image depicts a family group with parents of different races and one or two of their children. The racial mixtures are identified by inscriptions and the scenes are hierarchically arranged. At the beginning or top are figures of "pure" race (that is, Spaniards), lavishly attired and engaged in occupations or leisure activities that indicate their higher status. As the family groups become more mixed, their social status diminishes.

Many of the compositions and pictorial conventions of casta paintings are based upon European models, which colonial artists knew through imported prints and paintings. These paintings, however, portray a world very different from Europe. In addition to presenting a typology of human races, occupations, and dress, casta paintings picture the New World as a land of boundless natural wonder through precise renderings of native products, flora, and fauna. These scenes underscored the colonists' pride in the diversity and prosperity of the viceroyalty; at the same time, they fulfilled Europe's long-standing curiosity about the "exoticism" of the New World. In this respect, casta paintings portray an evolving sense of Spanish Americans as similar but fundamentally different from Europeans.

## The Culture of Curiosity

Before the "discovery" of the Americas in 1492, Europeans believed the farthest edges of the earth to be inhabited by monstrous races—giants, pygmies, two-headed men, Amazons, and hermaphrodites. Artists created many images, especially as illustrations for manuscripts and printed books, reflecting this fantastical vision. Expeditions of exploration and conquest increased the interest in a larger, previously unknown world and provided fertile ground for the fascination with the marvelous. Spanish, Dutch, and Portuguese

voyages to the Orient, the Middle East, and Africa from the 1550s onward prolonged this interest well into the eighteenth century.

This expanding interest in foreign cultures propelled a gradual increase in texts devoted to the customs of humankind. The constant desire in Europe to receive news from far-flung lands and peoples created a robust market for images of the world's diverse inhabitants. Colonial artists responded by studying these original sources and supplying new images themselves, such as those found in casta paintings.

## The Early Paintings

### Diversity and Creole Pride

By the end of the seventeenth century, a well-defined sense of creole identity had crystallized in New Spain. In 1680, when the renowned creole intellectual Carlos de Sigüenza y Góngora wrote, "admire what is yours instead of what is foreign," he was voicing a sentiment present among a large number of the creole elite. This strong sense of belonging to the land, known as *criollismo,* is essential for understanding the rise of casta painting.

Mexico's racial diversity was legendary, but it also caused great anxiety among Spaniards obsessed with racial purity. Early casta paintings represent an attempt to systematize the complex process of race mixing, thereby creating order out of what was perceived as an increasingly confusing society. Showing the different racial types dressed luxuriously emphasized the wealth of the colony as well as illustrated an integrated and restrained society. Viewed within the framework of creole pride, these early works are careful depictions of Mexican self-identity that distinguished the New World from the Old.

## The Later Paintings

### The Bourbon Reforms and the Enlightenment

The production of casta painting reached its height between 1760 and 1790, coinciding with the implementation of the Bourbon reforms. During this time, the Spanish government looked to strengthen its authority and regain power over its American domains, which had become largely self-sufficient. This era of renewed imperialism was tied to the larger philosophical movement of the Enlightenment, which extolled the power of human reason and the idea of progress. Charles III (reigned 1759–88) and Charles IV (reigned

1788–1808) sought to exploit the colonies to their fullest by levying new taxes and improving management of royal monopolies (including ice cream, playing cards, tobacco, and *pulque,* an intoxicating beverage extracted from the maguey plant). Many of the concerns of the enlightened reformers and intellectuals of Bourbon Spain are addressed in casta painting by including scenes that show a healthy and industrious society with its members engaged in multiple occupations.

Typical Inscriptions on a Set of Casta Paintings
*No. 1  From Spaniard and Indian, a Mestiza is Born*
*No. 2  From Spaniard and Mesitiza, a Castizo is Born*
*No. 3  From Castizo and Spaniard, a Spaniard is Born*
*No. 4  From Spaniard and Black, a Mulatto is Born*
*No. 5  From Spaniard and Mulatto, a Morisco is Born*
*No. 6  From Spaniard and Morisca, an Albino is Born*
*No. 7  From Spaniard and Albino, a Return-Backwards is Born*
*No. 8  From Indian and Black, a Wolf is Born*
*No. 9  From Indian and Mestiza, a Coyote is Born*
*No.10  From Wolf and Black, a Chino is Born*
*No.11  From Chino and Indian, a Cambujo is Born*
*No.12  From Cambujo and Indian, a Hold-Yourself-in-Midair is Born*
*No.13  From Hold-Yourself-in-Midair and Mulatto, an Albarazado is Born*
*No.14  From Albarazado and Indian, a Barcino is Born*
*No.15  From Barcino and Cambuja, a Calpamulato is Born*
*No.16  Barbarian Meco Indians*

## The Invention of Race and the Caste System
Spaniards and creoles used the caste system to rank people according to their purported percentage of white, Indian, or black blood, with its goal to show that certain racial mixings were more positive than others. Because native Indians were considered "new Christians" and thus Spaniards' equals, the system contended that if Indians kept mixing with Spaniards, their offspring could become entirely Spanish on the third generation.

According to this system, the combination of either Spaniards and Africans or Indians and Africans, however, could never become "white" because Africans were associated with slavery and viewed as inferior. This rational is explicitly

articulated through the inscriptions on casta paintings. Each series is divided into three main units—the first group of paintings typically focuses on the Spanish-Indian union, which begets more Spaniards on the third generation; the second group focuses on Spanish-Black unions, and the third on Black-Indian combinations, both of which do not result in more Spaniards.

This artificial way of categorizing people was an attempt to control the reproduction of the colony to safeguard the social position of the Spaniards. During the colonial period there was a great deal of social mobility; Africans and their descendants could attain a high degree of prominence, and not all Spaniards were of higher social status. Nevertheless, the caste system was an attempt on the part of the Spanish elite to create a rigidly structured society and to allocate power and prestige according to how people were perceived.

**Racial Labeling**
Racial labels were common in colonial Mexico and many appear in casta painting. The terms "mesitzo" and "mulatto" were popular from the sixteenth century—mestizo referred to Spanish-Indian unions, while mulatto, originally applied to the hybrid nature of mules, was given to Spanish-Black combinations. *Zambo* or *zambaigo* (meaning "knock-kneed") became widespread to refer to Indian-African unions, but no single term existed to refer to this particular mixture. Other terms gradually appeared in the seventeenth century, such as *castizo* (a light-skinned mestizo, which derives from "casto," or pure) and *morisco* (a light-skinned mulatto, which stems form the word "moro," or Moorish).

By the eighteenth century the names for the castas greatly increased and were not applied consistently. Many names used to describe African-Indian unions, for example, were zoologically inspired and derogatory: *lobo* (wolf), *coyote, albarazado* (white-spotted), *barcino* (used for horses and other colored animals with spots), *cambujo* (originally applied to dark birds), and *chamizo* (in reference to a half-burned log). Others referred to the uncertain origin of specific mixtures, including *tente en el aire* (hold-yourself-in-midair) and *no te entiendo* (I-don't-understand-you), or described a regression in the racial scale away from Spanish ancestry, as in *torna atrás* (return-backwards).

Casta painting is a rich and nuanced pictorial genre that demonstrates the great artistic skill attained by colonial artists, as well as the fascination with

the genealogy of humankind. The works are extraordinarily visual documents of a social phenomenon that shaped life in the Americas.

Text by Ilona Katzew, Associate Curator of Latin American Art, Modern and Contemporary Art, Los Angeles County Museum of Art. This exhibition was organized by the Los Angeles County Museum of Art. It is presented by Univision Communications Inc. It was supported in part by a grant from Bank of America and additional support was provided through a grant from The James Irvine Foundation.

## Los Angeles Times Review by Christopher Knight, 7 April 2004

ART REVIEW Painting the castes of Mexico: Colonial castas, explored at LACMA, imagine a world where order prevails amid miscegenation.

A remarkable new exhibition at the Los Angeles County Museum of Art includes a lovely group of tender paintings by the great 18th century Mexican artist Miguel Cabrera. Each large canvas juxtaposes a serene image of a contented family—Mom, Dad and one or two grinning kids—with unexpected elements of still-life painting. Piles of lettuce, beans and root vegetables, an avocado sliced in half to show its seed or baskets filled with ripe fruit are conspicuously displayed down in the lower right- or left-hand corner. Often, the names of the fruits and vegetables are identified by elegantly written script—chayotes, texacotes, aguacate etc.

Careful script is also written across the top of each. Translated into English, these passages say: From Spaniard and Black, a Mulatto; From Spaniard and Mulatto, a Morisca; From Mestizo and Indian, a Coyote; From Spaniard and Albino, a Return-Backward (a quaint biological locution, referring to something not unlike a recessive trait).

These are castas—or caste paintings—a fascinating but not widely known genre of art that charts the mixing of races in New Spain in the centuries after European conquest. Cabrera's juxtaposition of family groups

with still-life elements—each carefully labeled, like specimens in a scientific display—is an extraordinary artistic invention. Through it, a fabricated hierarchy of racial typing is given the illusion of natural order.

The clincher in this game of scientific "proof" is the painter's convincing naturalist style. If Cabrera's gorgeous craftsmanship couldn't carry off the illusion, the labeling and juxtapositions wouldn't be nearly as convincing. Masterful brushwork renders the sensuous tactility of surfaces, which range from satin and lace to burlap and rope. The luminous elegance of a pearl necklace around an aristocratic woman's throat competes with the shredded weave of rough cotton in a peasant's torn blouse.

Cabrera keeps the space of the pictures shallow, almost like a sculptural relief, so that these sensuously depicted objects crowd the foreground. Elegant linear contours emphasize the organic quality of two-dimensional design. The paintings practically demand to be closely scrutinized. The amiable warmth of the depicted familial interaction is then replayed in your communion with the pictures.

The brilliance of casta painting lies in its astonishing fusion of the touching and the perverse. Human societies invented the concept of race, then constructed complex hierarchies for it. Casta paintings naturalized a thoroughly unnatural phenomenon. They showed what the socially constructed range of possibilities in 18th century Mexico would be.

Spaniards, Indians and Africans are the source material. Castas usually depict 16 combinations of racial mixing. Sometimes a single canvas would be divided into a grid—four across, four down. More often, 16 individual canvases or copper plates would be used to create a large set of paintings.

The first castas date from 1711, and two (attributed to Manuel Arellano) are in the show. Cabrera's apotheosis of the genre came in 1763, in his only known examples.

The last half of the century saw the genre explode in popularity. LACMA's exhibition offers more than 100 individual paintings, including two rare complete sets of images—one by the prolific and gifted sentimentalist José de Páez, about whom little is known; and the other by José Joaquín Magón, who emphasized the sitters' occupations.

Social rank was based on a European standard. That standard was racial—LACMA's show is titled "Inventing Race: Casta Painting in 18th Century Mexico"—but it was also religious. (Male dominance was a given.)

Belief in Christianity was central to a person's stature. Catholic Spaniards were at the top of the heap. Next came Creoles—Spaniards born in the New World. Africans, who had been brought to Mexico in chains as slaves, were at the bottom. In between were Indians, who were religiously sanctioned in an important way.

How? Cabrera, a mestizo (Spaniard and Indian) from Oaxaca, was the best artist in New Spain. On April 30, 1751, he was invited to inspect and certify the miraculous nature of the original image of the Virgin of Guadalupe housed at the basilica just north of Mexico City. There, the mother of God was said to have made herself visible to the Indian peasant Juan Diego, 220 years before; her image was miraculously imprinted onto his cloak.

After inspection, Cabrera swore that no mortal hand had painted the image. A copy was made and sent to Rome. Pope Benedict XIV confirmed the Virgin of Guadalupe as patron saint of New Spain—and immediately, Indians rose in social rank as "New Christians." In late castas, after an Indian mixes with a Spaniard and their offspring continue to mix with Spaniards, the third generation was considered to have become white.

No such dubious honor was available to Africans. In a singular example of tortured logic, their original blackness was widely considered to have resulted from imprinting by a white Ethiopian mother's imagination during conception. She was thinking of a black object, and the result was a black infant. In Cabrera's lovely picture of a Spaniard father and an albino mother, the dark-skinned child—a "return backward"—who is lovingly caressed between them recalls the mother's likely African ancestry.

These boggling layers of cultural fancy unfold in surprising ways throughout the show. For example, only twice is a scene between husband and wife marked by anything less than ideal domestic harmony, and in both cases the put-upon man is a Spaniard, the aggressive woman an African. These works are clearly racist warnings.

Asians, though present in Mexican society, appear nowhere in the casta worldview—for reasons not yet understood.

And Cabrera's picture of a poor mestizo and Indian couple, whose barefoot offspring are given the zoologically condescending name of coyotes, softens the blow of their lowly lot in life by using a composition reminiscent of the Holy Family with the infant St. John the Baptist.

In short, castas are not documentary images, recording for posterity the daily lives of ordinary men and women in 18th century New Spain. Instead they're visual theater—scripted, costumed, set-designed, acted—as befits an art of the Baroque age. The achievement of the show, smartly selected and beautifully installed by LACMA's associate curator of Latin American art, Ilona Katzew, is to denaturalize what Cabrera and the rest so skillfully managed to make seem natural.

Eighteenth century Mexico saw dramatic social transformations—thanks in part to the huge wealth being created in the colony. Silver mining and international trade flourished. Mexico stood at the crossroads of Spain's far-flung empire in the New World and the Philippines. The colony threatened to eclipse the power and authority of the mother country.

Castas were one efficacious way to envision order amid the alarming possibility for colonial chaos. With places for everyone and everyone in their places, domestic tranquillity reigns.

Katzew believes that the casta motif did not emerge as an expression of 18th century Enlightenment ideals, in which cataloging and scientific analyses were highly prized. Convincingly, she argues instead that the form responded to a profound 17th century urge to assert criollismo—Creole pride—a Mexican identity distinct from Spain's.

The curator divided the show into early and late. The early work, which includes exceptional examples by José de Ibarra, Juan Rodríguez Juárez and several anonymous artists, culminates with Cabrera.

Europe provided a market for these painters. Their early reliance on European artistic models is perhaps clearest in a 1715 Juarez [sic] canvas, where the graceful child comes straight from Rembrandt. (Apparently, when a Spaniard marries a castizo—the offspring of a Spaniard and a mestizo—their child is a Dutch Old Master.)

Páez and Magón dominated the late period. They employed symbols of labor and nature's bounty to emphasize an image of colonial productivity. Whimsical decorative elaboration, acute emotional sensibility and flights of extreme pictorial fantasy become increasingly prominent. The casta motif went rococo.

And then, suddenly, it was over. Mexico's 19th century wars of independence overwhelmed the idealized, harmonious social pecking order that casta paintings envisioned and advanced for 100 years.

Disappointingly, LACMA's exhibition does not come with a catalog. But its debut coincides with the publication of Katzew's doctoral dissertation (Yale University Press), which contains richly illuminating scholarship. It's also a shame that "Inventing Race" will not travel. The art of Mexico's colonial or vice-regal period has only been seriously studied in the last several decades, and international exhibitions remain too rare.

Castas in particular have been regarded with some embarrassment, given the racist foundations of the genre. In Mexico you might encounter such a picture here and there in a provincial museum, or maybe at the great Franz Mayer Museum in Mexico City. The huge 1990 traveling show "Mexico: Splendors of Thirty Centuries" wanted to rehabilitate colonial art, but even then only four casta panels were included.

Hiding or ignoring the past won't change it, though, never mind help clarify contested social issues like race and marriage today. A smaller 1996 show (also organized by Katzew) at the Americas Society in New York began the genre's return to light. LACMA's fascinating show—the most complete casta presentation ever mounted, in or out of Mexico—should not be missed.

Credit: Times Staff Writer.

## Los Angeles Times Magazine Article by Gregory Rodriguez, 18 July 2004

An Unsettling Racial Score Card: An Exhibition of Mexico's
18th Century 'Caste Paintings' Is More Cause for Consternation
Than Celebration

Of the many gifts that Mexico has given contemporary American culture, few are greater than the concept of mestizaje—racial and cultural synthesis. After the Spanish conquest of the 16th century, modern Mexico emerged as a fusion of the old and new worlds, an amalgamated nation that is both European and Indian without truly being either.

While interracial sexual unions involving Indians, Europeans, Africans and Asians were common from the early days of the Conquest, intermarriage

became increasingly accepted only in the latter half of the 17th century. In the 18th century, the threatened white elite, fearing this rising tide of castas—the term Spaniards used for the colony's many racially mixed people—devised a caste system to establish status distinctions between the sub-groups in order to divide them and reinforce the Spaniards' sense of their own exclusivity. In part to illustrate the system, elites commissioned paintings of the many categories of castas—a racial score card of sorts.

The Los Angeles County Museum of Art is currently displaying "Inventing Race: Casta Painting and Eighteenth-Century Mexico"—more than 100 examples of the genre, including a rare complete set. The exhibition has a particular resonance here in Los Angeles, which, not coincidentally, shares the distinction of being the most Mexican of American cities and having among the highest intermarriage rates of any city in the United States.

Casta paintings are perverse family portraits. They depict the race of the mother, father and offspring. Works of art and natural history, they also are instruments of racial oppression, the product of a white supremacist ideology that sought to control and provide a hierarchy for rampant racial mixing.

The paintings delineated racially mixed Mexicans according to their distance from the purity of European whiteness. They sought to educate viewers on the social consequences of forging interracial alliances. Certain combinations could help mixed families regain a semblance of whiteness. Others would only lower a family's status. If a woman of Spanish-Indian heritage married an Indian man, her child would be demoted in the social scale and might be labeled as a salta atrás—or a jump backward.

The offspring of these mixed unions—from the mestizos and the mulattoes to the zambos and the chinos—were forced to survive in society's in-between spaces. Deprived of a stable place in the social order and without firm roots in any one heritage, the racially mixed learned to thrive amid social, racial and cultural ambiguity.

Anthropologist Eric Wolf wrote that the mestizo's "chances of survival lay neither in accumulating cultural furniture nor in cleaving to cultural norms, but in an ability to change, to adapt, to improvise. The ever shifting nature of his social condition forced him to move with guile and speed through the hidden passageways of society, not to commit himself to any one position or to any one spot."

For years, scholars believed that colonial Mexicans actually lived according to this intricate system of racial castes. They mistook these paintings as depictions of social reality. But the categories enshrined in casta paintings never came close to reflecting the variety and dynamism of colonial race relations. And while the minority white European elite was obsessed with racial purity, most Mexican commoners were not.

But while widespread mixture made enforcement of a true caste system impossible, the notion of a racial hierarchy did nonetheless influence the nation's self-image. Today the relative absence of dark-skinned actors on Mexican television is a legacy of this tradition. Some Latin American–born advertising executives have imported this prejudice to the United States. Their advertisements routinely feature light-skinned models in campaigns designed to target a Latino population that is distinctly heterogeneous.

Essential to understanding Mexican history, the mestizo consciousness is increasingly influencing visions of the American future. No one has put it better than Mexican novelist Carlos Fuentes when he wrote: "Is anyone better prepared to deal with this central issue of dealing with the Other than we . . . the Hispanics in the U.S.A.? We are Indian, black, European, but above all mixed, mestizo."

Accordingly, Mexican American writers—from Richard Rodriguez to John Phillip Santos—are at the forefront of imagining a racially mixed America. Indeed, it was Mexican American intellectuals who first rejected the English term "miscegenation"—with all its nasty overtones—in favor of the more neutral (or is it celebratory?) Spanish term, mestizaje.

And yet, Mexicans and Mexican Americans rarely acknowledge the dark side of this mixed heritage. Left unexplored are the resentment, the rivalry, the constant jockeying for position inherent in a racially fluid, 500-year-old civilization that has barely begun to congeal. "We are unstable," wrote Mexican philosopher José Vasconcelos. "We are a new product, a new breed, not yet entirely shaped."

Ironically, given the United States' own tragic history of race relations, Mexican Americans have gradually liberated themselves from the pigmentocracy of the mother country. Perhaps the most significant legacy of the Chicano Movement was to remove the shame of brownness.

Unlike Anglo American racism, Mexican racism did not impede or deny racial mixture. But despite its official ideology of celebrating the mestizo, Mexico has yet to overcome the racial arrogance of its elites.

Despite their billing, the casta paintings do not "celebrate" mestizaje. Their original intent was to reveal its dangers, and today they remain unsettling. There is little doubt that the American future will be mixed, and that is a far cry better than the racial segregation of our not-so-distant past. But the casta paintings, products of colonial Mexico, are nonetheless poignant reminders of the struggles that lie ahead here in the United States. While mestizaje will continue to break down racial and ethnic barriers, it will also sow confusion and instability; some identities will be lost while others will be born. We must resist the inevitable efforts to impose order on this chaos.

Credit: Gregory Rodriguez is an Irvine senior fellow at the New America Foundation and a contributing editor to The Times' Sunday Opinion section.

## A Conversation between Ilona Katzew and Daniel J. Sherman, 22 October 2004

**DJS:** The exhibition Inventing Race: Casta Painting and Eighteenth-Century Mexico, and the book that coincided with it, culminate over a decade that you've been working on *casta* painting. You mention in the introduction to your book that you saw an exhibition of *casta* paintings at the Franz Mayer Museum in Mexico City on your way to graduate school in New York in 1990.[1] Did you start graduate school with the idea already of devoting your dissertation to this subject?

**IK:** No, I really didn't. What happened is that I had been living abroad for a long time and I was in a way homesick. So I spent the summer in Mexico before going to graduate school and I just stumbled upon the exhibition and was completely taken by it . . . it was one of those almost epiphany-like moments. . . . And like many things it just was a whole array of coincidences and events that aligned themselves. I went to graduate school at that time at New York University, and it was the first year that they had a visiting professor from Mexico, Clara Bargellini, who was teaching the first course in colonial art ever at the Institute of Fine Arts.

Having seen the exhibition on *casta* paintings and wanting to learn more about them, I took the opportunity to start doing serious research. So the voyage, in a way, started with the exhibition and the opportunity to take a class in that subject.

**DJS:** So it was only after writing a seminar paper that you thought that this might be a possible dissertation topic?

**IK:** Well, I never really knew that it was going to become a dissertation topic, because at the time there was no Latin American art and definitely no Spanish colonial art curriculum at NYU. At some point I even contemplated studying Greek vase painting or Visigothic belt buckles [laughs]. I was very interested in antiquities. We did have one professor there at the time, Edward Sullivan, who is a very well known modernist, who taught extensively, and I did quite a lot of work with him and just found myself taking a whole number of classes in European Old Master painting and French art of the Revolution, constantly trying to look for ways of relating this material back to *casta* painting. Throughout my whole tenure at the Institute it was a thread that just remained there. And by the time I had to make a choice, it was very clear that I wanted to pursue this.

**DJS:** So, you came to LACMA in 2000 as Associate Curator of Latin American Art with responsibility for organizing the museum's first permanent installation of art from Latin America. You were also, as I recall, on your own time, revising your dissertation for publication. How did the idea for a LACMA show on *casta* painting originate?

**IK:** Well, oftentimes people think that exhibition programs are very well charted out and very well planned but things in the museum world also happen in serendipitous ways. We were offered the possibility of acquiring a large collection of *casta* painting from a well-known collection in Monterrey [Mexico]. I brought it to the attention of the head of European Painting, Patrice Marandel, who I know is also deeply interested in Spanish colonial art and has been fascinated with *casta* paintings for a while, and . . .

**DJS:** This was when?

**IK:** It was in 2003. We thought that this might be an interesting possibility to look into and we brought it to the attention of Andrea Rich, who at the time was president and the director of LACMA, and because of her own experience of growing up in Los Angeles and San Diego and having worked at UCLA she immediately connected with the material and was very support-

ive of this prospect. Now what happened is that in order to raise interest within the community and possibly acquire the works we decided that the way to go would be to first have an exhibition devoted to this material. And that's how the exhibition really came about.

**DJS:** At what point did the possibility of financial support from Univision come up?[2]

**IK:** They had sponsored previous shows. In 2000, I was hired to oversee a recently acquired collection of Latin American modernism, mostly Mexican art. This collection, which is the Bernard and Edith Lewin Collection of Mexican Art, was acquired in 1997 before I even came on board. I was hired pretty much to rank the collection, make sense of it, and try eventually to build a more comprehensive collection. And with my appointment, I believe, there was a more concerted effort on the part of the institution to start developing a program devoted to Latin American art. I think that when this opportunity to organize the *casta*s show came about is when everything else really started to kick in. The director looked for sponsorship from Univision and presented a long-term plan of exhibitions devoted to Latin American art to elicit their support.

**DJS:** Now the show here at LACMA, Inventing Race, was the second exhibition devoted to *casta* painting that you curated. What are some of the ways in which it differed from the first one, which was called New World Orders, at the Americas Society in New York in 1996?[3]

**IK:** Well, the show that I did for the Americas Society was really the first more in-depth exhibition on *casta* painting in the U.S. It was a small exhibition that had about sixty-five works, mainly because the Americas Society space is quite small. Because of space limitations, the show only included a couple of complete *casta* sets, which are difficult to find. But it was not only devoted to Mexican art: it also included some paintings of racial types that were done in Peru and Ecuador. The big difference was that the show at LACMA was more than twice the size; it included about a hundred and twenty works and it was solely devoted to Mexican *casta* painting. It was also an opportunity to design the show in such a fashion that it reflected the way I had been thinking about the paintings for a long time, so the scholarly part of the show became very important.

**DJS:** Your book emphasizes the complexity of the colonial context that produced *casta* paintings and gave them meaning, and one of its central

points is that the paintings do not reflect, but construct a reality. Of course wall labels in the exhibition and in exhibition brochures can't reproduce all the nuances of such an argument, and there was no exhibition catalogue—your book was sold at the exhibition, but your book is not a catalogue of the exhibition. Given that in the book you specifically say that you're not particularly concerned with traditional art historical issues like attribution and quality, you couldn't simply let the works available dictate what parts of the argument in the exhibition to emphasize and what to leave out, as might be the case in a more traditional exhibition of a great painter or two. So, how did you decide on the structure and focus of this show? How did you decide how to distill the complexity of your argument into something that that you could convey mainly visually, with some text on the walls?

**IK:** I think that was one of the most challenging aspects of putting the exhibition together. What I was worried about from the get-go is that people would come to the show and understand the paintings on a very superficial level, as actually reflecting a real phenomenon, which is racial mixing, and trying to determine into what category they as viewers belong. This is something that I actually saw happening frequently at the show, in spite of my best efforts to counter that way of interacting with the works. But in the end . . . in the end you can't control a viewer's response, and not everybody's going to read didactics, so you give it your best shot and hope that the people that are interested in getting more informed will come out with all the different nuances that you're trying to present through the didactic material and also the arrangement of the show. Now, the way that I structured the show was first, by providing an introductory room which included some illustrated books from the sixteenth to the eighteenth centuries that set the frame for the exhibition, showing that the tradition of depicting racial types from throughout the world goes back all the way to the voyages of discovery. I very strategically tried to select images that showed how certain books imitated earlier books, so that the notion of stereotype versus realism would be clearly received by the viewers. And I also brought in some books that I thought had a direct impact on the development of *casta* painting, such as Kircher's book on the voyage of some Jesuits to China.[4] In addition to that, there were some *casta* paintings in the introductory room, very generic *casta* paintings, but . . . this is something that as curators we have to deal with, you know, to have the right scale to create

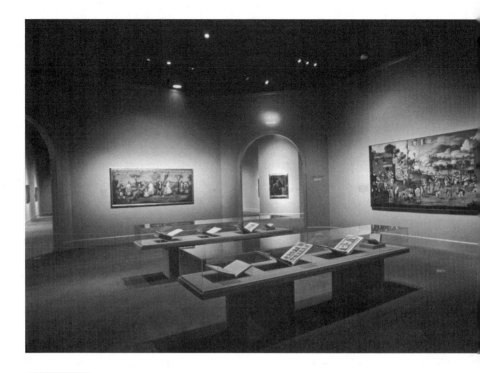

FIGURE 8.1. Inventing Race: Casta Painting and Eighteenth Century Mexico, Los Angeles County Museum of Art, view of the introductory gallery. *Courtesy Los Angeles County Museum of Art.*

a striking first impression. And the other piece that was in that introductory room, which I thought was a key piece, is a seventeenth-century folding screen, which had never been exhibited publicly before, so it was very nice to be able to have it in the exhibition: it depicts an Indian wedding along with some pre-Columbian games that were continued in the colonial period, such as the big flying pole and the famous Moctezuma dance or *mitote*. I thought it was important to include that work to show that the tradition of depicting different racial types within a colonial context is not something that is exclusively an Enlightenment product. I still think that there are a lot of issues around the term Enlightenment. We don't really know what it is or where it starts or where it ends, and you know, we just use it in the most loose of terms. Most of the scholarship about *casta* paintings always treats them as an Enlightenment phenomenon, which I think . . . yes, to a certain

point the genre coincides with some of the issues being brought by the Enlightenment, but . . .

**DJS:** And the screen is late seventeenth-century.

**IK:** And the screen is dated around 1690. It's just one example of several works produced in the colonial era that are already giving a great deal of emphasis to the different types of people that populated the colony.

**DJS:** That was a very striking piece. One of the things that I noticed walking through the exhibition is that if you follow the sequence you laid out, you actually have to pass through that introductory gallery at the midpoint of your visit, more or less, so in other words, you have to go through it twice. Was that deliberate, or did that have to do simply with the space available?

**IK:** In a sense, it was . . . it's both. I mean it has to do, of course, with the planning of the exhibition space, but it was also a deliberate choice to have a kind of a meeting place where you have to go back and forth. It was done with the idea that once as a viewer you immersed yourself more in the exhibition and got more of a sense of what was going on, that issues would keep unfolding throughout the show, and then you would be placed again at the center, at this focal point, and you could start making connections once more.

**DJS:** There was a kind of explanatory table or chart, explaining the various racial categories, and that was at the end of the second gallery, so just before you re-entered the introductory gallery. Why did you decide to place it there, rather than at the beginning?

**IK:** Some of my colleagues asked the same question. It's because I didn't want to serve the topic on a silver platter. I wanted viewers to work a little bit. To start looking—we started the exhibition with the early paintings, which are very different from the ones that were created after 1760. The early paintings are really works that date from roughly 1711 to 1750, and there's a very different discourse that's going on there.

**DJS:** The *criollismo* or Creole pride.

**IK:** Right. And you see that there's much more of an emphasis on clothing, and much more of an emphasis on ostentation and wealth too . . . in a very, very overt way. But at the same time, the inscriptions are on each of the paintings, which tell you how the *casta* system works.

**DJS:** I remember being a little puzzled by the first galleries, because it seemed to me that [the paintings], even though they had these inscriptions,

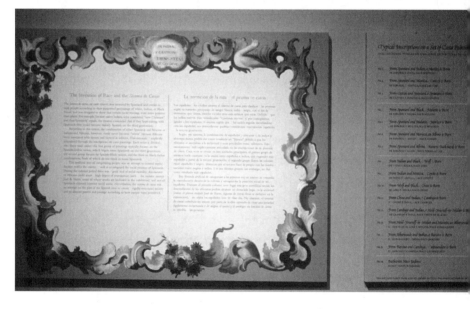

FIGURE 8.2. *Above:* Inventing Race: Casta Painting and Eighteenth Century Mexico, Los Angeles County Museum of Art, end of the third main gallery. *Courtesy Los Angeles County Museum of Art.*

FIGURE 8.3. *Below:* Inventing Race: Casta Painting and Eighteenth Century Mexico, Los Angeles County Museum of Art, didactic materials on the *casta* system. *Courtesy Los Angeles County Museum of Art.*

were less about race and about racial difference, than about something else. I take it that was deliberate: you wanted people to be slightly puzzled, or at least to notice that there were other things going on.

**IK:** It was very deliberate, because a lot of the early paintings are very, very beautiful—they were created by some of the most accomplished artists of the time, Juan Rodríguez Juárez, José de Ibarra, some of the really great masters of the seventeenth and the eighteenth centuries. So you come into those first galleries, and you almost get a sense of . . . "oh, this is a display of really beautiful Old Master paintings." But since you have no idea what the inscriptions really mean, they are tickling you from the very beginning. I wanted people to begin a thought process while they were looking, and then reach a certain point where it became explained, and either it reinforced what they were already processing, or it countered their misconceptions. I intended it as an exercise.

**DJS:** All of the interpretive materials in the exhibition were in both Spanish and English, for obvious reasons. And since you're bilingual, this probably came naturally to you. But it must have also forced you to be even more concise in labeling. In other words, the space that you had available had to be divided in two. Did you see this as a particular challenge, or . . . how did that play out for you?

**IK:** There are certain parameters as to the number of words, which is dictated by our museum's education department. I tend to be somewhat wordy, and . . . [laughs] my word count was somewhat limited. But, having said that, I did have a great deal of freedom to choose what to say and how to say it, and I pretty much did what I thought was necessary. I wasn't limited because the labels were bilingual. I thought that there was too much information to pack into the exhibition, which is already complex by virtue of the subject matter. And because the paintings are conceived of as sets, and oftentimes there were several paintings belonging to the same set, I didn't want to repeat information in labels, so what I did was to create one main label for each set, which in addition to addressing issues present in that cycle, also introduced some larger historical and anthropological notions.

**DJS:** Specific to the particular moment at which that set was created.

**IK:** Exactly. Which if you read, would carry you through the end of the show, because it's information that got compounded. And, issues that I

FIGURE 8.4. Inventing Race: Casta Painting and Eighteenth Century Mexico, Los Angeles County Museum of Art, third gallery with paintings by Miguel Cabrera from the 1760s. *Courtesy Los Angeles County Museum of Art.*

thought could be more potentially interesting to the public, and that I wanted to bring out, those I highlighted in big panels, such as how the *casta* system worked, what the names meant, or the big split between the early works and the later works, or, you know, how this tradition originated in earlier times.

    **DJS:** Could you comment a little on difference in the title in English and Spanish titles [of the exhibition], the English one being Inventing Race, the Spanish being La invención del mestizaje? *La raza* [the literal Spanish term for race] means something very different in Spanish, particularly in Mexico . . .

    **IK:** And here, in Los Angeles.

    **DJS:** And here, sure. I mean, is there a way in which *casta* painting itself is part of the history of the construction of the notion of *la raza*?

**IK:** Do you mean *la raza* in today's terms, associated with the Chicano movement?

**DJS:** No. I guess I mean more in the Mexican context, I mean the monument to *la raza* in Mexico City, and so on, where this is more a post-national phenomenon.

**IK:** I think it's more of a post-national phenomenon, it's a really interesting thing, but at least what I understand from *la raza* is that it's a concept that derives greatly from José Vasconcelos, and the idea of *la raza cósmica,* which has to do with this notion of, yes, of *mestizaje,* but mainly a *mestizaje* that has to do with Indians, with the indigenous component of the equation of whites and Indians.[5] And growing up in Mexico City, I always noticed, and still today when I speak to people, that there's not a thorough awareness that Africans were an integral part of the social development and history of that country. Or Asians. Asians were also there and they don't even feature in *casta* paintings.

**DJS:** And Africans are left out of the National Anthropological Museum [in Mexico City].

**IK:** I think you get very clearly the sense of the position in which Africans were ontologically situated just by looking at *casta* paintings, because they're telling you the story that once you start mixing the blood, then you're going to start receding in the social scaffolding.

**DJS:** It's a biological and social degeneration.

**IK:** Exactly.

**DJS:** It seems to me that the fascinating thing about this pair of titles—and I think it's a theme of your book—is the suggestion that the notion of race itself emerges out of a process of racial mixing. At least the modern, kind of biologistic, notion of race.

**IK:** I'm worried a little bit about those kinds of questions because the issue of the term race is such a complex one. It has been used in different ways throughout history to connote different things. For example, in medieval Spain the term race was used to differentiate commoners from nobleman; it later on became a term associated with religion to distinguish *cristianos viejos* or old Christians from Jews and Muslims.[6] Sometimes people will ask me, well, you know, this was a racist society. Well yes, but that's a twentieth-century sort of interpretation of how racial relations were constructed. "Race," in a way, is more of a recent term, although it

did exist at that time, and I think it needs to be further analyzed depending on what context.

**DJS:** Were there any other significant differences between the English and the Spanish interpretive materials, or were they more or less the same?

**IK:** I think the interpretive materials for the most part were pretty much the same. The big issue that did come up is the issue of race versus *mestizaje*. And you know, there is the word *mestizaje* for example in French, *métissage,* which . . . conveys the same idea that you would convey in Spanish, but there is no such equivalent in English.[7]

**DJS:** Well, the closest is hybridity.[8]

**IK:** Well, hybridity is not exactly the same since it describes the coming together of two separate elements; *mestizaje* suggests a larger and more complex amalgamation of "cultural parts." Besides, you don't want to have a show that's going to be called *Inventing Hybridity,* which would probably be as obscure as *casta* for the broader public, so there are all these notions that come into play. There's the notion of how scholarly and rigorous you want to be with the use of the terms you choose for a title, but by the same token you have to choose a title that's seductive enough to bring people in the door. So, it's a very fine balance. It's not exactly creating a title for a book. It's more creating a title that would have some kind of general appeal as well, or be intriguing enough that people would want to come and see what this is all about.

**DJS:** You spoke in the press release, at least you're quoted in the press release, about the special significance of staging an exhibition of this kind in L.A., which is both the most Mexican of major American cities and one of the cities with the highest intermarriage rates between people of Mexican and non-Mexican descent. Could you elaborate a little on this . . . you said it had special significance, but what is the significance, as far as you could see? Was there a parallel in your mind between twenty-first-century L.A. and eighteenth-century Mexico City, which you described as this very cosmopolitan place, and a kind of nodal point in global commerce and so on?

**IK:** Yes, I think that's one of the most interesting issues that no one has really wanted to articulate clearly. And the easiest thing to do in a press release or to do in a newspaper article, or to just say to the news media, is "oh, you know, here we have these wonderful eighteenth-century paintings

depicting racial mixing, look, you know, something that anticipated our social situation today," when in fact, when you look at the paintings, you have this very dichotomous way of presenting society. On the one hand you have this seemingly familial harmony that is prevalent in the paintings. But on the other hand you have this more "sinister" side which is promoting a caste system through visual representation.

To try to link it to today's situation in Los Angeles does not mean, "oh, look, there was racial mixing in the eighteenth century and there's racial mixing today, so there's been an ongoing trend and it's a good thing." I think that the press tries to give it a positive spin, which is misleading. And again it's a way of oversimplifying information to get people in the door. And racial mixing in a *casta* system is something that's a little too complex sometimes just to convey in a couple of sentences. In other words, yes, there's a great deal of racial mixing, but at the same time Los Angeles is a hugely polarized city and a hugely racist city, where even though Mexicans and Mexican-Americans comprise now about 60 percent of the population, which means that in fact they're not a minority, the mainstream population of the city, or what is perceived to be the white mainstream population of the city, is oftentimes very derogatory towards people who are mixed. So, you've just got to take it a step further. The way things get presented to attract people can sometimes be rather slippery.

**DJS:** Well, I wonder if some of this might have come about because of a desire to avoid controversy, you know, especially in a city, as you say, where there is a distinct racial hierarchy, and where there was, let's not forget, just over a decade ago, serious violence with a strongly racial cast to it.[9] Did you feel any institutional pressure to reduce or avoid the risk of controversy?

**IK:** I did. While organizing the show, when the director first very openly supported the show, knowing, perhaps instinctively more than for sure, how this show would play out with Angelinos, there was especially great resistance, ironically from our education department, particularly because I was always very upfront about the racist content of the paintings. These are very beautiful paintings, but there's a very strong message encoded in them, especially for twentieth- and twenty-first-century viewers. And the education department was . . . in all honesty quite alarmed, thinking that viewers would come out of—especially viewers of either mixed backgrounds or African

FIGURE 8.5. Inventing Race: Casta Painting and Eighteenth Century Mexico,
Los Angeles County Museum of Art, gallery showing series by José Joaquín Magón
from the 1770s. *Courtesy Los Angeles Museum of Art.*

Americans—with a lower sense of self, thinking that it's only whites that are
placed at the top, and that because they're mixed they're placed at the bot-
tom of the social hierarchy. They thought that this would make them come
out of the show feeling belittled, and that it would elicit a huge amount of
controversy. There was also discussion on the part of the education depart-
ment, of suggesting ways to organize the exhibition, the actual physical lay-
out of the exhibition, so that the paintings that were more beautiful, and did
not have scenes of violence, could be toured to different groups. They were
especially concerned about children and teenagers, so the part that was more
racist would be . . . would be censored . . .

   **DJS:** Be left out of the tours.

   **IK:** . . . would be censored from the tour. And it was something
which I completely disagreed with, because the layout of the exhibition is

chronological, and the whole point of the show is to see how these works develop over time, and how the meaning of the works got compounded and shifted according to different historical circumstances. Luckily that did not have to be done in the show, but it was an issue that greatly concerned our education department. I confess that I was somewhat surprised, particularly because, having curated the show in New York, where there's also a great deal of mixture and different types of peoples, there was not one single complaint. In fact it was African Americans who most assiduously came to see the exhibition in New York. And there was a huge African American population who came to see the show in Los Angeles. It's all about how you present a topic. If you're presenting it in a historical context, which is what I tried to explain . . . internally, and you give it historical weight, then you're not promoting the statement that the paintings are dictating in a way, but you're presenting a historical fact. And racism, and the *casta* system, and discrimination are things that have existed . . . it's like deciding not to talk about slavery because you're afraid that African American people will identify with that.

**DJS:** Just to follow up on this—did the education department ask you to change any of the wall labels or didactics . . .

**IK:** No, they didn't. The education department does oversee written material that goes in exhibitions, but in the end I offered them a training session and explained the historical context . . . In other words, I worked with the education department to create a larger awareness of the meanings and the depth of the works. And even though there was initially talk about masking the issue of racial hierarchy and racial content, by bringing a show of this nature to the museum there was simply no way around it. And in the end the education department, despite its concerns, did not meddle with that.

**DJS:** Now, the press release, written by the press office, contained this formulation within the very first line: "richly detailed family portraits that celebrate racial mixing among eighteenth-century Mexico's native Indian, Spanish, and African populations . . . " And so on. You were not happy with that wording, which did actually get picked up in a lot of the press.

**IK:** I wasn't happy because . . . it's qualifying the presentation of a type of material that's much more complex. And even though there is a celebratory

tinge to the early paintings, especially, it's only one aspect of the works. And I knew it was going to be picked up by the media as happy portraits of mixed-race families and that somebody was going to just go after that. But when in fact you continue to read the press release, you do get the sense of how the paintings were done, and it's fairly accurate. But it's typical of the world of journalism to come up with sensational titles that they think might work.

**DJS:** Well, I'm always struck, and I find this in my own archival research on museums, just how often one finds a press release verbatim in publication after publication. They just . . .

**IK:** They just copy the press release.

**DJS:** To go back to this issue of presenting complexity, and historical complexity specifically . . . Racial difference has historically been much more a concern of ethnographic and science museums than of art museums. Not always . . . often in a very insidious way. Your book notes, in fact, that the first set of *casta* paintings to be displayed in a museum was purchased for the French Museum of Ethnography in 1884. But art museums have long had their own systems of classification, most typically by national school, and their own relationship to colonialism.[10]

So, how well equipped are art museums to present issues of difference? Of difference, of racial classification, I mean, and is it a particular problem to present this kind of material in an art museum, as opposed to a historical or an anthropological museum?

**IK:** There are several issues here. There's the issue of Spanish colonial art in general that still fits uncomfortably in mainstream museums, which is just recently being reassessed, and getting more attention with the Metropolitan Museum just recently having done a fairly ground-breaking show on colonial Peruvian art, and the Philadelphia Museum of Art organizing another major show devoted to colonial Latin American art.[11] But issues of quality, as it relates to colonial art, have always been somewhat of a problem. It's not considered to be, by many European art specialists, of the quality or of the stature of . . .

**DJS:** Contemporaneous European painting.

**IK:** Right. Which is an issue that is currently being dispelled, and you've just got to look at works in their own terms and within their own context. Not everything's the same. So, colonial works in general are finding their

way slowly but steadily into mainstream museums. The issue of race, of course—and these paintings that seem very scientific as well—makes them doubly complex, because some of them are of fantastic quality; in terms of colonial art, you have works signed by Miguel Cabrera (fig. 8.4), and by Juan Rodríguez Juárez, and by José de Ibarra, that are wonderful works of art in their own right. But *casta* painting was a genre that proliferated in the second half of the eighteenth century, and there were, in all fairness, copies of copies of copies that are not of wonderful quality. So, for these works to find themselves in a mainstream museum, it's more difficult to justify, if part of what a museum does is . . . well . . . in addition to collecting works from different regions and different parts of the world, is also trying to create certain standards of quality, establishing certain parameters of what goes into a museum and what doesn't go into a museum.

**DJS:** But one of the points of your book is that these works were produced for a large clientele, that they were part of a guild system of production. So the fact that they were copied, and that the motifs reappear in works of what by our contemporary standards are of lesser quality is part of the story you're trying to tell, which goes back to the question I was asking about the particular problems of showing this kind of work in an art museum.

**IK:** Right. And I entirely agree with you because the history of the genre is what it is and copying was part of the tradition; that's why if you can find sets that are of better quality and are the prototypes to go into a mainstream museum, that's wonderful, but on the other hand, connoisseurship is not, in my view, the main point of these works, it's more about what they're representing, and a history of copying is a huge part of that tradition, because it's pointing to a huge demand for these works. Also, some of these paintings were sent back in their own day to cabinets of natural history where they were just one type of work amidst a whole array of works, purportedly representing the entire globe; they were pseudo-scientific, in a way. I think in today's museums they have a place, especially in collections that are already looking to encompass works from the viceroyalties of Spanish America, because of their social and anthropological importance, and because they're telling a story that has many levels. It has an artistic level, it has a racial component, and it also dispels this idea of race being a scientific reality. I don't know if that answers some questions . . .

**DJS:** Well, let me try to get at it in another way. The review by Christopher Knight in the *L.A. Times* seemed to me very thorough, and he seemed to have read your book, and gotten the point—you must have been pleased by that review.[12]

**IK:** Yes, I was, because he got exactly what I was going for.

**DJS:** But then, ten days later, in what I guess is their Sunday arts guide, the review gets distilled to a paragraph, which talks about "the remarkable new exhibition features a lovely group of tender paintings by great artist Miguel Cabrera."[13] There is a little bit about "fabricated hierarch[ies] . . . given the illusion of natural order," but I just wonder whether there's a risk that an art museum presentation of these works will get aestheticized in the critical response, and certainly there's a lot of that in the press, about how beautiful these paintings are—which they are, many of them, and which is a point that you want to make, so that the larger interpretive points get lost. Did you feel that that happened a lot, or . . .

**IK:** There are different types of viewers, and I think that in a way this was not a sort of traditional art historical show where you see the development, for example in a monographic way, of the artist's work through time, and you tie it to biography, and maybe social context a little bit. This was a more challenging show, in the sense that you're confronting a group of works that are extremely appealing. I know that when I first saw the works, I was completely taken by the enormous collection of local objects, beautiful textiles, the food products, the animals. They just grab you in a very . . . visceral way, and it's easy to remain on that level. And if you don't go beyond that aesthetic threshold, then it's no more than a bombardment of objects, and things, and things that if you come from that culture, they immediately appeal to you, so you immediately point, "oh, look at the *chirimoyas*" [a type of fruit], or "look at . . ." You know? And you start engaging with the paintings at the level of "I identify what is being represented." But you don't really understand what is being represented. And I think there was probably a lot of that going on with the people who did not make the effort to go past that.

By the same token, there were people who did go beyond that level and who understood exactly the paradoxical nature of the paintings. I think that's exactly the tension that makes these works so fascinating. On the one hand, they're really beautiful, attractive, compelling works of art, filled with all of these things that you can identify, and on the other, they're telling you a story

about caste and hierarchy that does not really correspond to what you're see-ing on the superficial level, so you're kind of taken aback.

**DJS:** Well, and as you've said earlier, you can't control the way viewers respond in a museum setting. Let me ask you a little more about the critical response. There was an article by Gregory Rodriguez in the *Los Angeles Times Magazine,* near the end of the exhibition run, in which he picked up on the word "celebrate," and used it essentially to re-state the argument of your book, but in a way that tried to imply that it was his idea rather than yours.[14]

But he was not the only critic or observer to draw explicit lessons from the exhibition with regard to the contemporary world. He, for example, criticized the continuing racial arrogance of Mexican elites. And then Miguel Benavides in an online article listed some of the inscriptions and commented that it's sad to say that racial classifications like these are still prevalent in the world today.[15]

You avoid drawing lessons like this in the book. But you must have antic-ipated such responses to the show. And by inviting the performance artist Guillermo Gómez Peña to the symposium you organized in connection with the exhibition, you implicitly drew the show into the present. What did you make of . . . I mean, did anything surprise you, please you, dismay you, about the way those connections got drawn? Between *casta* painting and the present?

**IK:** I guess that one of the fundamental things that I wanted to accom-plish was to get people thinking. And to sort of be able to go through a pro-cess, and come to their own conclusions, and to realize that the issue which to me, as somebody who's been working on race, is fairly obvious (but I guess is not that obvious to many people) is that these notions of hierarchy have existed for a long time, and they continue to exist, in permutated ways, but they exist. That was one of the reasons why, during this international symposium, we decided to divide the symposium into a historical part, and a second part devoted to more contemporary issues.

In his wonderfully amusing performance Guillermo Gómez Peña's whole point was in fact to say that "yes, there all these markers, but every-thing's blurred." He was trying to poke fun at boundaries which are often taken by certain people to mean something very specific, when in fact they can mean any number of things, and that was why his performance was so successful. My idea with doing the show was to make the point

that people for a long time have tried to create categories and pigeonhole people in certain roles and certain classes, when in fact . . . and it is an important reality, but it's also completely artificial. So, I just wanted people to walk out of the show thinking that these notions of classification have been artificially imposed, and continue to be imposed, and to think about how they operate and shape everyday life. That's how I saw it being tied to the present.

**DJS:** When I visited the exhibition, I saw a small group of people—this was in one of the last galleries—a group of people who I took to be Latino, pausing in front of a wall label that discussed the idea that blood mending was not available to blacks. One of the points of your book is that while white or Spanish plus Indian produces *mestizo,* if *mestizos* continue to intermarry with whites, eventually their offspring will become white again. But this doesn't work for blacks. And there was a wall label about this, and one person in the group was reading it in a very emphatic way to the others, saying, "see, if you have any black blood, you're black." Do you have any sense of whether this was characteristic of visitor reactions to the show? They seemed to me much more engaged than in a typical museum exhibition.

**IK:** Well, I myself walked through the exhibition many times, because I wanted to get a sense of what people were saying. And I saw, for example, in one instance, a group of African Americans, who were pointing at the scenes of violence, where a black woman is hitting a Spanish man with a kitchen implement, and blood is gushing out of his forehead. And they were laughing, because . . . the way I read the situation with those viewers is that the situation was so stereotyped and so ridiculous that it induced . . .

**DJS:** Mockery.

**IK:** . . . mockery, and this kind of response was something that was very far removed from what the education department sensed would happen specifically with African Americans, which in my view was a way of infantilizing people, by thinking that they're not able to form a thought by themselves, or to have a thought process that deals with their own history, that it has to be imposed institutionally or they won't be able to make any sense of it. So that to me was very interesting to watch. I also saw people who would go through the paintings, and would try to see where they fit in the racial scale, which greatly bothered me . . . that was in my view the

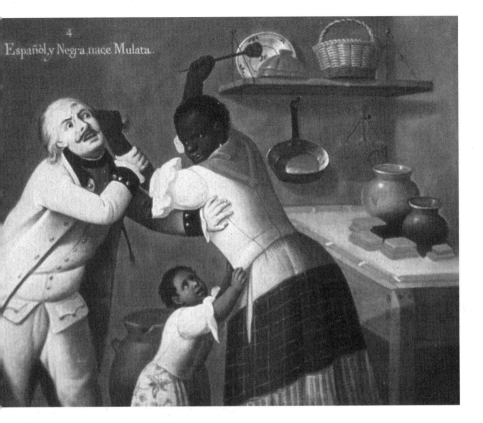

Espanol y Negra nace Mulata.

FIGURE 8.6. Andrés de Islas, 4. *De español y negra, nace mulata (From Spaniard and Black a Mulatto is Born),* 1772, oil on canvas, 59×75 cm. Private Collection. *Published by permission.*

most superficial level of reading the works. I saw other museum patrons who walked through the show, and they would just think "oh, that such a thing could exist," that this racial scale could be so overtly depicted in artistic form . . .

**DJS:** So elaborately.

**IK:** The responses really varied. And I think that as the curator of the show, my only hope is that everybody would come out with deeper knowledge of what they're seeing and read all the labels, but I know that that's not necessarily true. Perhaps a way of conveying this issue of artificiality in the show that would have been more direct for the public would have been

through a video, or creating some small documentary, since people seem to be immediately drawn to television screens..

**DJS:** By scholars, or . . .

**IK:** Well, it could have . . . I don't know, I'm just thinking off the top of my head right now, because it is an important issue. While I do think that it's impossible to control viewers' response, perhaps we could have done something else so that people . . . even those who put the least effort come out realizing that this is artificial and that they're not supposed to try to find their own racial identity by looking at these paintings, and the only way that occurs to me that this could have been done would have been through electronic media.

**DJS:** One of the points you make in the book, and that you try and make in the exhibition—if people are reading the labels and the wall text—is that by the eighteenth century in Mexico, race was only one index of social status. And somatic attributes were only one index of race. You also note in the conclusion that even paint is not equipped to convey what you call the somatic subtleties of the *sistema de castas*. Given the tendency in popular culture to think of, indeed to define, race in visual terms, most basically by color, how can an art exhibition, which is by definition so centered on the visual, convey the non-visual components of racial ideology?

**IK:** That's a tough one, Dan. Yes, I mean, because the paintings in the end cannot even visually create a fixed scale of being, a fixed scale of racial mixing, a fixed scale of anything, so they have to resort to all these different, ancillary elements.

**DJS:** As well as the inscriptions, with the categories that, as you say, get more and more fanciful.

**IK:** Right. Because if you were to see a *casta* painting without an inscription, then the whole notion of racial scale is going to be hopelessly muddled. And that's why the inscriptions are there, and that's why the difference between classes is very clearly rendered through clothing and attributes.

**DJS:** Well, that seems to me, actually that's something that could be done digitally: if you had some time, you know, you could manipulate the paintings visually to take out the various elements, and show how different, or how incomplete they are without . . .

**IK:** Without all these elements. I think that's a really interesting way of thinking about it, because the whole notion of how difference is depicted,

and how today's viewers respond to that, is really at the heart of the matter. And it's a very, very difficult thing to do in a museum, creatively and also in terms of resources and all these real life things that come into play too. But yes, what you're suggesting could have definitely been a way of engaging viewers who don't have a huge attention span to read all the labels to get it more quickly.

**DJS:** I just have a couple more questions. In what other ways might museums address issues of difference and classification? Has your experience with this project given you any ideas about museums' own systems of classification, any do's or don'ts, any sense of how this might develop? I mean you were just mentioning before we started that the structure of the museum is going to be changing, so that, whereas you're now in a department of modern and contemporary art, you'll be in a department that's more geographically defined. How do you think that will affect what you do? I would think there would be both advantages and disadvantages to it.

**IK:** Yes, I think so . . . I think that by dividing material regionally, by having a department of Latin American art, you are imposing an artificial structure, as Spanish colonial art, for example, is more tied to European western art . . .

**DJS:** And contemporary art is completely global.

**IK:** It's completely global, and in fact many artists don't necessarily want to be pegged as Latin American, or Indian, or, you know, Afghani, or American, or anything. It's more of an international circuit. I think that, unfortunately—or fortunately—we're still trying to make sense of knowledge and make sense of objects, and boundaries are not as fluid as sometimes we claim they are, and one way of making sense of the material is by . . .

**DJS:** Maybe boundaries are more fluid than . . .

**IK:** Well, boundaries are more fluid, but in the museum, these fluid boundaries can become even more stringent, by reshuffling collections into areas that may seem more open but in fact are creating more drawers. And I don't know exactly how this can be resolved . . . In the best of circumstances you're able to articulate exactly that fact: that contemporary art is contemporary, colonial art has more ties with European art, and you're honest about the historical circumstances mediating art production, and acknowledging that for the sake of presentation you have created a museum divided by departments, which serves a practical function, but not necessarily

a thorough interpretive one. But I think museums are still working on this, and I don't think the last word has been written or will be written for a long time.

**DJS:** One last question. In the introduction to the book, you situate your first encounter with *casta* painting at a moment, well, we talked about this, in your life when you responded to a nostalgia or longing for sensations of Mexico that you had felt when you were abroad at college. And you then observe that "distinctions among people were ever present but rarely explicitly articulated" while you were growing up in Mexico, so that *casta* painting had a disconcerting effect on you.[16]

**IK:** I was very sensitive to this issue of racial difference from the time I was I was very, very young living in Mexico. I mean I was always very aware that people looked different, and I didn't know exactly quite what to make of it.

**DJS:** Were you aware . . . did you also notice in the media, that the anchorman on the network . . .

**IK:** Well, I noticed that the presidents were always white, I always noticed that. People in positions of power tended to be white, which I always correlated with Spaniards, which in my worldview was mother country, which was power, which was wealth, which is what you want to be. You grow up with these ideas that white equals good equals Spanish equals wealth equals power equals what you aspire to be; even though myself I'm white. But not a Spaniard.

**DJS:** European but Eastern European.

**IK:** Of Eastern European descent. Even though I grew up in that society, it was always something that deeply disturbed me. And I remember . . . in school once, I think I was eleven and we were in a history class. This is something that just stayed with me for a long, long time. It was a class on Mexican nationalism, and the teacher mentioned, you know, the African population in Mexico and how they came over as slaves, and there was this one student sitting at the back of the class, an eleven-year-old kid, completely naïve, who said "well, I don't understand. Why couldn't Africans just be washed with soap? Then they would have been white and none of this would have ever existed." And I will never forget that comment, because it just staggered me that somebody could think that the skin could be washed. Something that for him was such a natural thought process, that you could wash yourself and become white, which is what you should be, and not even

think that that's not possible and who would want to do that? That kind of dislocated vision of the world really stayed with me for a long, long time. . . . And one of the things that greatly disturbs me is discrimination or racism of any type. How certain people can think that they have the right to impose their views or think that they're better than others, for any reason, is beyond my ability to reconcile.

**DJS:** Well, I think that your book and the exhibition make a real contribution to getting people to confront that. And in a way you make the futility, the impossibility of this project of racial classification very, very clear, as well as the way the compulsion to do it is always inscribed in relationships of power and anxieties about retaining power. And I think what has been helpful about this conversation, or illuminating for me, is bringing the power of the museum into the equation, and the complexities of that. It's not easy to negotiate.

**IK:** No, it's not. It's always a challenge.

### Acknowledgments

Daniel Sherman would like to thank Amity McGinnis, for her research assistance and her work transcribing the interview, as well as Megan Knox, curatorial assistant at LACMA, for providing copies of the exhibition press packet and clippings files, for her assistance with illustrations, and for her transcription of the brochure text. Editing of the essay was carried out jointly by Ilona Katzew and Daniel Sherman.

### NOTES

1. Ilona Katzew, *Casta Painting: Images of Race in Eighteenth-Century Mexico* (New Haven, Conn.: Yale University Press, 2004). The publication of the book coincided with the LACMA exhibition, but it is not a catalogue of the exhibition.

2. Univision is a publicly traded, U.S.-chartered Spanish language media company. Its holdings include the largest network of Spanish-language television stations in the United States, radio stations, and a music division. See http://www.univision.net/corp/es/business.jsp or http://www.univision.net/corp/en/business.jsp. Accessed 21 July 2005.

3. See Ilona Katzew, ed., *New World Orders: Casta Painting and Colonial Latin America* (New York: Americas Society, 1996).

4. Athanasius Kircher, *China monumentis, quà sacris quà profanis, nec non variis naturae et artis spectaculis* . . . (Amsterdam: Johannem Janssonium à Waesberge & Elizem Weyerstaet, 1667); for more on this connection, see Katzew, *Casta Painting*, 81–91.

5. See José Vasconcelos, *The Cosmic Race: A Bilingual Edition,* trans. and annotated by Didier T. Jaén, Race in the Americas (Baltimore: Johns Hopkins University Press, 1997; orig. pub. 1979); for more on Vasconcelos, see Gabriella de Beer, *Vasconcelos and His World* (New York: Las Americas, 1966), and Nancy Leys Stepan, *"The Hour of Eugenics": Race, Gender, and Nation in Latin America* (Ithaca, N.Y.: Cornell University Press, 1991), 145–53.

6. See, for example, María Elena Martínez, "The Black Blood of New Spain: *Limpieza De Sangre,* Racial Violence, and Gendered Power in Early Colonial Mexico," *William and Mary Quarterly,* 3rd ser., 61 (July 2004): 479–520.

7. As an example of this equivalence, Serge Gruzinski's *La pensée métisse* (Paris: Fayard, 1999), which focuses on cultural contact and metamorphosis in sixteenth-century Mexico, was published in English as *The Mestizo Mind: The Intellectual Dynamics of Colonization and Globalization,* trans. Deke Dusinberre (New York: Routledge, 2002).

8. The recent scholarly literature on hybridity and racial mixing is vast; some influential works employing or critiquing the concept, or both, include Homi Bhabha, *The Location of Culture* (London: Routledge, 1994); Paul Gilroy, *The Black Atlantic: Modernity and Double Consciousness* (London: Verso, 1993); and Robert J. C. Young, *Colonial Desire: Hybridity in Theory, Culture and Race* (London: Routledge, 1995). A useful collection on the topic is Avtar Brah and Annie E. Coombes, eds., *Hybridity and Its Discontents: Politics, Science, Culture* (London: Routledge, 2000); Leela Gandhi, *Post-Colonial Theory: A Critical Introduction* (New York: Columbia University Press, 1998), offers a concise overview: see especially 130–36.

9. The riots in South Central Los Angeles broke out at the end of April 1992, following the acquittal of white police officers accused of the beating of a black man, Rodney King, the year before.

10. See, for example, Tim Barringer and Tom Flynn, eds., *Colonialism and the Object: Empire, Material Culture and the Museum,* Museum Meanings (London: Routledge, 1998); Dominique Taffin, ed., *Du musée colonial au musée des cultures du monde: Actes du colloque organisé par le musée national des Arts d'Afrique et d'Océanie et le Centre Georges-Pompidou, 3–6 juin 1998* (Paris: Maisonneuve et Larose and Musée des Arts d'Afrique et d'Océanie, 2000).

11. The Metropolitan exhibition, The Colonial Andes: Tapestries and Silverwork, 1530–1830, ran from 29 September through 12 December 2004. Univision was a principal sponsor. The Philadelphia show ran from 20 September through 31 December 2006. Other planned venues were the Antigüo Colegio de San Ildefonso, Mexico City, and the Los Angeles County Museum of Art.

12. Christopher Knight, "Painting the Castes of Mexico," *Los Angeles Times,* 7 April 2004.

13. "Museums: The Essence of Family Life," *Los Angeles Times,* 18 April 2004.

14. Gregory Rodriguez, "An Unsettling Racial Score Card," *Los Angeles Times Magazine,* 18 July 2004.

15. Miguel Benavides, "When Words Are Worth More than Pictures," www.studio international.co/uk/painting/inventing_race.htm, posted 3 August 2004. Accessed 18 October 2004.

16. Katzew, *Casta Painting,* 1.

# Living and Dying

## *Ethnography, Class, and Aesthetics in the British Museum*

LISSANT BOLTON

In 2003 the British Museum opened a major exhibition called Living and Dying. The exhibition, and the new gallery space in which it is displayed, were sponsored by the Wellcome Trust, a research-funding charity. The space will be named for the Wellcome Trust in the long term; this first exhibition, classified as a "permanent" gallery in the British Museum lexicon, will be on display with some changes for five to seven years. Living and Dying does not focus on one particular place, period, or people, but rather uses material from all over the world to explore a specific theme. Created by the British Museum Ethnography Department, it draws on the whole extent of that department's collections, and on the knowledge of all the curators working within it. Living and Dying is an anthropologically informed exhibition drawing on collections from many parts of the world, including Papua New Guinea, the Bolivian Andes, the Pacific Northwest coast of America, the Nicobar Islands in the Bay of Bengal, and contemporary Britain.

Living and Dying was an immensely complicated project in terms both of the curation and delivery of the exhibition itself and of the ideas the exhibition addresses. I was the lead curator for Living and Dying, responsible for the overall content and argument of the exhibition, and for

co-coordinating the participation of nine contributing curators, each of whom worked on a different section.[1] Taking on the lead curator role partway through the planning process, I was responsible not so much for setting the agenda of the exhibition as for reframing and restructuring its core ideas, always a part of exhibition development. From the admittedly partial perspective of one directly involved, the exhibition raises a number of questions about the representation and creation of human difference by and in museums. This paper is less about the exhibition itself, which I do not actually describe in any detail until late in the paper, than about issues that surround it. Several linked issues of difference surrounding the exhibition arise from its status as an Ethnography Department exhibition and from the relationship of the objects displayed in Living and Dying to other collections on view in the British Museum's Bloomsbury Galleries. The axis on which these relationships turn is an aesthetic sensibility linked to the differentials of class.

## The Genesis of Living and Dying

The British Museum was founded in 1753, well before anthropology developed as a distinct discipline, and the ethnographic collections—collections of objects made and used by people throughout the world, primarily in small-scale societies—have had rather a checkered career in the institution. A separate departmental home for the ethnographic collections and for anthropological research was first created nearly two hundred years into the institution's history, in 1945. In 1970 this department separated from the main campus of the British Museum in Bloomsbury and opened as a small museum, the Museum of Mankind, in Mayfair, about a mile from the Bloomsbury campus. In 1997, however, when the departure of the British Library to new premises in St. Pancras liberated significant space in Bloomsbury, the decision was made to close the Museum of Mankind and return Ethnography to the main British Museum site. The museum embarked on a major renovation, opening the Great Court around the Round Reading Room in 2000, and creating a series of new exhibition spaces, many of which were dedicated to the Ethnography Department.

Immediately north of the Great Court is a large gallery, formerly the North Library of the British Library. The renovation of this gallery completes an important north-south route through the entire museum, linking the two entrances. The Ethnography Department galleries were planned to fan around this core space. Three Ethnography galleries opened before Living and Dying, each dedicated to a specific place or culture area—Mexico, Native North America, and Africa. The Wellcome Trust financed both the renovation of the North Library, now known as the Wellcome Trust Gallery (WTG), and the first permanent exhibition to be mounted there. The intention is that the Wellcome Trust Gallery should house a series of conceptually driven semipermanent exhibitions, displaying objects from many parts of the world together. This is something of a departure for an institution that for centuries has based most permanent exhibitions on culture areas and epochs, or object categories such as clocks or money.

The Wellcome Trust is an independent charity, established in 1936 by a bequest made by Sir Henry Wellcome. As well as developing a large pharmaceutical company, Sir Henry had a personal interest in collecting ethnographic artifacts relating to medicine. Separate from the pharmaceutical company

Burroughs Wellcome (now a part of the conglomerate GlaxoSmithKline), the Wellcome Trust funds medical research. As part of its policy of public engagement, designed to raise awareness of the medical, ethical, and social implications of biomedical science, the Trust also funds exhibitions of various kinds and maintains an interest in matters ethnographic. For this project the Trust asked the British Museum to commemorate Sir Henry Wellcome in an exhibition about the history of medicine and/or medical anthropology. The Museum, with the agreement of the Wellcome Trust, responded to this remit by planning an exhibition on cross-cultural perspectives on well-being and health.

Living and Dying was also part of the 250th anniversary celebrations for the British Museum. The BM marked this anniversary by opening two new permanent exhibitions, as well as running several temporary shows. The two permanent exhibitions in a sense span the history of the museum. The first, Enlightenment: Discovering the World in the 18th Century, discusses the Enlightenment era in which the museum was founded, and investigates some of the ways in which the collections were used and organized from 1753 until 1820. Living and Dying, by contrast, offers a view of the world that the museum wishes to present now. During the Enlightenment the starting point for comparison and connection was western Europe. By contrast, Living and Dying attempts to look at many people and places without establishing any as the baseline for comparison and analysis.

The initial formulation of Living and Dying as an exhibition about cross-cultural perspectives on well-being and health was inevitably modified as planning developed. Health and well-being are themselves culturally specific concepts that have a particular salience in contemporary Western society, where the care of the physical body is given considerable attention. In order to take a cross-cultural perspective on these issues, the exhibition uses another formulation: it looks at how people around the world deal with some of the tough realities of life, averting or responding to sickness, trouble, sorrow, and need. It became an exhibition about cosmology. Cosmology sets the parameters by which people understand why things happen, and by which they consider how what happens can be managed. To put it simply: if a cosmology incorporates a belief in spirits, then what happens is likely to be attributed, at least in part, to their actions. If a cosmology incorporates a belief in germs, then at least some of what happens will be seen to be caused by

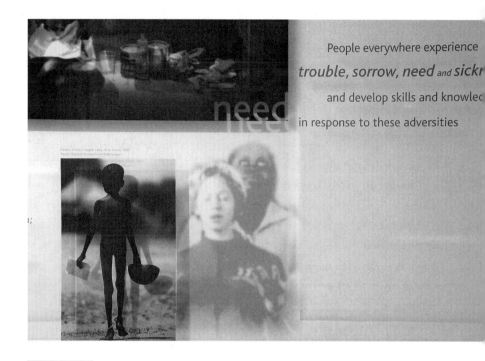

People everywhere experience *trouble, sorrow, need and sickr* and develop skills and knowlec in response to these adversities

FIGURE 9.2. Most of Living and Dying is about solutions and strategies. This is part of the text and image panel indicating some of the tough realities these solutions attempt to resolve. *Photo: ZED Photography. By permission of the Trustees of the British Museum.*

them. Of course, many cosmologies allow for both spirits and germs. The straightforward idea that drives the exhibition is that different people in different places understand and deal with what happens in terms that make sense to them.

The importance of the conceptual focus of the exhibition was underlined once Neil MacGregor took up his appointment as director of the British Museum in mid-2002. MacGregor provides strong intellectual leadership, and he has a number of specific preoccupations. His role is constituted within the cultural framework of Blairist Britain, where image is critical. He faces outwards from the institution, standing for it and presenting it to the media, the government, funding bodies, and the wider intellectual and cultural environment. His starting point in this presentation is that the British Museum, in gathering under one roof objects from many of the

cultures of the earth, past and present, is a museum of the world for the world. He wants the museum to explore what it means to have objects from so many places together—what can be learned and understood through such interactions.[2]

MacGregor thus addresses one of the great dilemmas facing major museums internationally. In the last three decades, largely as a result of indigenous activism in places such as Australia and the United States, the intellectual and physical appropriation of objects has become a way of symbolizing, and marking, cultural identity.[3] Owning objects from other places is now often interpreted, whether a museum intends this or not, as an implicit declaration of cultural appropriation. Inevitably this claim (however unintentional) is contested by other claimants. There is a strand of indigenous rights discourse that proposes that all objects should be returned to their place of origin.[4] For MacGregor, the value of a great collection like that of the British Museum is the extent to which it can be used to reflect on "how the world works as a whole and the different ways it can be understood."[5]

MacGregor's argument represents the latest turn in the long intellectual history of the institution. The museum was founded when there were no other public museums, and has continued until now, when the options for the museum-going public in London are quite overwhelming, and where print media, radio, television, and travel all offer other ways for people to see objects and learn about people and places. Over the last two and a half centuries, through its exhibitions, publications, collections, and research, the museum has interacted with and contributed to wider scholarly and intellectual trajectories and has influenced public understandings on many topics. This role, the riches of its collections, and its connection to British colonial history now make it a museum over which people in many parts of the world wish to exert an influence. The work MacGregor attributes to Living and Dying has to be understood in terms of the convolutions—the interactions and influences—on the museum from both within and without.

## Ethnography in the British Museum

The history of the ethnography collections, like the history of the entire British Museum, is thus a complex interaction between what happened within the institution and wider intellectual developments, some of them influenced

by the museum itself. The BM may now display and discuss the discoveries and collections of Captain James Cook, but Cook himself is listed on the board of principal benefactors that extends along a wall near the entrance, and Cook's discoveries had an impact on the exhibition history of the institution. The museum's founding collection, that of Sir Hans Sloane, included about 2,000 ethnographic objects, which were displayed intermixed with many other things in the style of a cabinet of curiosities. In 1780, after Cook's death in Hawai'i, a "South Seas Room" was established to display the collections acquired during the European exploration of the Pacific: this was the first systematic display of "artificial curiosities" in the museum, and introduced the principle of grouping objects together from similar or geographically close cultures.[6]

In the organization of cabinets of curiosities, the Enlightenment, the founding intellectual influence on the institution, increasingly made use of classification as a technique of display.[7] It was also a period in which people began to consider the diversity of humankind and, increasingly, to privilege the transcendental white male rational subject. As Kincheloe and Steinberg have argued, it was in the context of the European Enlightenment that whiteness "was naturalized as a universal entity that operated as more than a mere ethnic positionality emerging from a particular time . . . and a particular space."[8] The elevation of the rational white male inquirer went hand in hand with the development, through the nineteenth century, of a hierarchical division of the human population into "naturally" unequal races. Many factors may have contributed to the development of the idea of race, but, I would argue, the hierarchialization of races is a cross-over from ideas of class. Race is class internationalized. It developed as an attempt to extend and naturalize social and economic hierarchy across the globe. As George Stocking observes, the idea of race can be seen in part as "a defensive reaction against the idea of equality on the part of groups whose traditionally unquestioned class superiority was being undercut by the social changes of the nineteenth century."[9]

These wider developments are complexly linked to a changing perspective within the museum to its collections. Under the influence of the eighteenth-century antiquarian Johann Winkelmann, transmitted through the collector Sir William Hamilton, the museum "came more and more to adopt the aesthetic that privileged Greek over all other art."[10] The purchase

of the Parthenon Marbles in 1816 led to the reinforcement of an aesthetic hierarchy that valued a naturalistic aesthetic identified above all with ancient Greece. As Ian Jenkins argues, the marbles became the centerpiece of the museum's collections: "The sculptures of the Parthenon, in particular, were presented as the highpoint of human achievement in antiquity. In the subsequent arrangement of the Museum's ever-increasing collections, all other works were seen to lead up to or away from the one supreme moment in ancient art."[11] This arrangement of the collections, as Luke Syson has observed, implicitly associated "ancient Greek perfection and the current 'enlightened' regimes under whose auspices the collections were built up and deployed."[12] They equated the European classical and neo-classical aesthetics, deeming both to be inherently superior.

During the nineteenth century, ideas of evolution, specifically of social evolution, also began to influence the museum and the organization of exhibitions.[13] Building on the elevation of the rational white male, the hierarchies of race began to be seen in terms of an aesthetic expression. The idea that some cultures are more "developed" than others, and the consequent identification of "high cultures," reinforced the aesthetic hierarchy within the British Museum collection, constituting a class system.[14]

In effect, the Department of Ethnography was created by a remaindering process, which reflected these developments. Initially part of a large Antiquities Department, after 1861 the ethnographic collections were, by the creation of new departments for Greece and Rome, Egyptian Antiquities, and Coins and Medals, left in what became the department of British and Medieval Antiquities. In 1921 a Department of Ceramics and Ethnography was created, later renamed Oriental Antiquities and Ethnography. The Ethnography Department took on a separate existence only in 1945, when Oriental Antiquities and Ethnography were separated. The museum's ethnography collections grew throughout the centuries, at first passively, by donation, and then in the nineteenth century under the enthusiastic direction of A. W. Franks, Keeper of British and Medieval Antiquities and Ethnography, by purchase. Ethnographic material was enduringly popular with visitors. The South Seas Room was the most visited attraction in the museum in its time. In the *Synopsis of the Contents of the British Museum* (1808) it is described as "one of the most conspicuous parts of the museum,"[15] and the subsequent Ethnography Galleries were also popular. Much more recently, the ethnography

collections obtained a different kind of popularity when they became the focus of modernist artists and writers such as Henry Moore and William Empson.[16]

Within the museum the Ethnography Department was a kind of miscellany, holding the collections that did not fall into some established material, temporal, or geographical category. It managed anthropological and archaeological collections from North and South America, Australia and the Pacific, Africa, Asia, and parts of Europe, not including material from the ancient world, or from the large-scale societies of Asia. On the whole the ethnography collections represented small-scale and peasant societies, but included the great civilizations of South America. The high culture hierarchism that determined the structure of the British Museum departments was most clearly evident in the division of Asian collections. The Oriental Antiquities Department held largely palace and temple art, while Ethnography managed collections of objects from the humbler sectors of Asian society. While Oriental Antiquities focused on paintings, prints, antiquities, and sculpture, and had an art historical orientation, Ethnography collected objects of all kinds and had an anthropological preoccupation with objects in their social context. Much of the Oriental Antiquities Department collections consisted of stone and ceramic, while Ethnography's Asian collection included objects made of organic and perishable materials such as basketry, wood, low-fired pottery, and cloth.

## The Museum of Mankind

The creation of the Museum of Mankind (MM) in 1970 allowed the Ethnography Department considerable freedom. Although the creation of the Museum of Mankind could be interpreted as a form of high culture hierarchism, banishing the low cultures from Bloomsbury, at the same time the separation freed the department from the issue of comparison. No class differences distinguished MM exhibitions; every culture could be presented as important and valuable in its own right. And, in a broad sense, no class hierarchy separated the visitor from the material on display. There was no call for deference toward what was exhibited, but rather an invitation to respect and to engagement.

The Museum of Mankind focused on producing a series of temporary exhibitions. The museum's visitor numbers, averaging 300,000 per year,

never remotely approached those of the British Museum in Bloomsbury (approximately four and a half million annually), but in fact this worked to the Ethnography Department's advantage. In a small museum that was not a tourist icon, the department could presume visitor interest, rather than needing to snare it. At Bloomsbury, exhibitions focus on objects, presenting them in or out of cases, supported by labels and by some explanatory text panels. Eschewing the reverence of an art museum, the MM emphasized a closer and more experiential sense of life as lived, and addressed both mundane and ceremonial contexts. MM exhibitions from the beginning included reconstructions of contemporary contexts for material culture. Exhibitions depicted, for example, a house in India, a Yemeni market, and a small shop, or trade store, in the Papua New Guinea Highlands.

Not all Ethnography Department staff were anthropologists: some were archaeologists, historians, or art historians. The collection was divided into geographical areas (Africa, North America, etc.), each of which was the responsibility of one or more of these curators. Museum of Mankind exhibitions reflected the disciplinary and research interests of individual curators, as well as the nature of the existing collections. Very often, exhibitions arose directly out of the curators' own research and collecting. Fieldwork in Madagascar led to a Madagascar exhibition, just as Michael O'Hanlon's research in Papua New Guinea led to the much-discussed exhibition Paradise.[17] The immediacy of the relationship between fieldwork and display facilitated the emphasis on reconstruction—the trade store built in the Paradise display was a direct outcome of O'Hanlon's time with the Wahgi in the Papua New Guinea Highlands. This kind of reconstruction was also part of an explicit MM policy. Paradise, like an earlier MM exhibition, Living Arctic, sought to undermine the stereotype "that countries such as Papua New Guinea remain largely untouched by the contemporary industrialized world."[18] The inclusion in the exhibition of "the full range of manufactured goods" used by the Wahgi was also intended to make the point "that the incorporation of Western goods does not determine how they are used."[19]

O'Hanlon's point about the meaning of introduced goods derived from insights then being debated within anthropology. It engaged with research in the anthropology of art and material culture, in this case that of Nicholas Thomas,[20] as well as with work by other Papua New Guinea Highlands specialists. The attempt to undermine the stereotype of pristine cultures arose

from a direct encounter with the visiting public through education programs and observations made in comments books.[21] In a small museum such unmediated responses to academic research and public commentary are relatively feasible. They are much harder to achieve for a major museum competing for visitors with other institutions and entertainments.

The Museum of Mankind's genesis coincided with the appointment of the British Museum's first designer, Margaret Hall, one of whose best-regarded exhibitions was Nomad and City for the Museum of Mankind (1976–78). This exhibition displayed a Bedouin tent and a reconstructed street from a Yemeni market though which visitors could walk to view shops and stalls, redolent with sounds and the smells of spices and incense. A further advantage of being independent was that the Museum of Mankind had its own team of carpenters and technicians, and was able to produce exhibitions with little reference to the resources at Bloomsbury. Exhibitions without significant budgets were able to reuse or redesign furniture from earlier displays. Paradise itself reused curved false walls built for the preceding exhibition that had been intended "to suggest the hills and open spaces of Palestine."[22]

The use of reconstructions, of which, O'Hanlon observes, the MM was a pioneer, is now a less acceptable approach to ethnographic exhibitions.[23] If exhibitions like Paradise depicted the other, and intentionally suggested a radically different significance even for introduced goods, increasingly audible indigenous voices have made exhibitions much more difficult to do well. Beginning with Living Arctic (1987), produced together with the Assembly of First Nations and the National Chief of Canada, the MM worked more and more often in collaboration with curators and traditional owners from the areas treated in its exhibitions.

The way in which indigenous communities have used museums as a means of communicating their concerns to others has had a major impact on the display of ethnographic collections world-wide. Especially in settler societies in Australia, Canada, New Zealand, and the United States, museums are a key context in which indigenous knowledge and practice is made publicly available. Indigenous claims for the right to determine how collections are exhibited have been born partly out of an outrage about how museums have operated in the past. As I have discussed elsewhere, in Australia such criticisms often focused on the presentation of Aboriginal society as existing in a

timeless ethnographic present unaffected by decimating colonial and post-colonial incursions.[24]

The value of indigenous collaboration to museum anthropology has been considerable. It has reinvigorated collections, challenged understandings, opened new avenues for museums to work in, and resulted in many stunning exhibitions. It is part of a world-wide revaluation of cultural difference as equality, which followed the rejection of conventional governmental colonialism during the late twentieth century, and which organizations such as UNESCO have promoted. Ivan Karp and Steven Lavine's influential collection *Exhibiting Cultures*[25] illustrates this kind of thinking. The contributors to this volume make much of the imperative of museums to respond to the concerns of those communities whose collections they display. In the editors' introduction, they observe that "the museum world needs movement in at least three arenas," which they identify as giving populations a chance to exert control, increasing museum expertise in the presentation of non-Western and minority cultures, and developing design strategies that offer multiple perspectives.[26] The British Museum is geographically removed from much indigenous activism and participation in museums, but the Ethnography Department's field-based approach to exhibition production meant that departmental staff were sometimes able to discuss exhibitions with traditional owners during fieldwork.

**Personal Perspectives**

As an anthropologist with a field focus on the western Pacific nation of Vanuatu and as a curator with experience at the Australian Museum, Sydney, and the Vanuatu Cultural Centre, I joined the Ethnography Department at the end of 1999, after the Museum of Mankind closed, to be curator of the Pacific and Australian collections. Inevitably that background has formed my understanding of the nature of exhibitions. Exhibition curation differs greatly in the three institutions where I have worked. This is a function not only of institutional scale but also of political and social contexts. At the Vanuatu Cultural Centre, ni-Vanuatu explore local knowledge and practice both for each other and for tourists. The Australian Museum displays ethnographic collections in an environment increasingly determined by settler-indigenous relationships; there indigenous Australians now have authority over how

Australian collections are presented. In both museums exhibitions are very often underpinned by advocacy-driven objectives such as Karp and Lavine identify. My experience in those institutions taught me to recognize that all exhibitions inevitably reflect their political and social contexts, whether or not their curators intend this.

The role of museums in public education and in influencing public opinion always has to be set against the realities of how exhibitions transmit ideas. Because exhibitions work in three dimensions, their capacity to communicate specific information to any individual visitor is always limited. Not all exhibitions have narratives; indeed, some avoid narrative altogether. Just about all have authored text, but analysis of text never reveals what an exhibition communicates. Rather, communication is a function of the complex interaction between word, object, image, space, lighting, and the unknown visitor. Moving from the Australian Museum and the Vanuatu Cultural Centre to the British Museum and to the Wellcome Trust Gallery project has led me to develop my own theory about how major exhibitions work: that is of the exhibition as iceberg.

Flippant though this sounds, this analogy has been helpful because it raises the question of what is, and is not, visible. In general, most visitors to Living and Dying are likely to leave with the memory of some marvelous objects and images, and perhaps with one or two ideas or facts. But a great deal of research and understanding of both objects and concepts had to be invested in the way the exhibition is organized in order for it to work successfully. This knowledge and research appears to a limited extent in labels and other text, but it also undergirds the three-dimensional structure of the exhibition and of individual cases. As with the iceberg, much is not visible. Most exhibitions make this research and knowledge visible in a catalogue. Unfortunately, as a result of scheduling problems, we were not able to produce a substantial catalogue for Living and Dying.

The other aspect of the exhibition-as-iceberg analogy relates to what the visitor sees. An iceberg, like a mountain, looks different from different angles, and the more you look, the more you learn. Statistics from visitor surveys suggest that the average visitor spends only a few seconds in front of any one case. Visitors are more attentive to temporary exhibitions, which they have often paid to see, but free permanent galleries may receive the museum equivalent of a glance from the rail of a passing ship. What this requires of

exhibition planning and design is an extremely tight structure and strong ideas. Equally, it means that there needs to be a great deal of detail in the exhibition, which the interested visitor can easily find and absorb.

Living and Dying was intended to speak to present political and social contexts. The exhibition thus implicitly contradicts some of the institution's guiding assumptions in earlier centuries. But while no one would now accept a hierarchical evaluation of the British Museum or any other collection on the basis of theories of social evolution, aesthetic hierarchies are subtler and more difficult to erase. The exhibition, as part of the return of Ethnography to Bloomsbury, both required and facilitated that erasure. Approaches and observations that were well established in the Museum of Mankind had to be reaffirmed in Bloomsbury. This is a subtler and more complex working out of the kinds of issues indigenous communities have raised in museum contexts elsewhere, notably in Canada, Australia, and the United States.

## Constraints and Solutions

Almost every exhibition represents what could be achieved within the framework of the constraints placed on it. This was very much the case with Living and Dying. An exhibition driven by an idea rather than by an epoch or area, it has a global reference, displays physically fragile material, was produced collaboratively by a large team, and was constrained by the physical limitations of a space the designer likened to an airport terminal. Its ultimate shape inevitably reflects compromises between the requirements of the funding body, the differing perspectives of participating staff, the restrictions of the time, budget, and space available to it, and the goals of the British Museum as a whole. Curatorially, the greatest tension, as is true of every exhibition, was between the concept and its working out, between what we wanted to communicate and what was possible to achieve. Planning it involved coming to terms with a number of challenges and complications.

The involvement of the funding body was crucial in setting the overall framework for the exhibition, and acted as a constraint to its further development. The Wellcome Trust specified the overall theme of the exhibition, and annual reports were made to Wellcome Trustees as the exhibition plan developed. Initial planning for the exhibition did not attend to the topic—cross-cultural perspectives on well-being and health—in a way the Trustees

found entirely satisfactory. It was my remit as lead curator to find a way forward for the exhibition at this point in the planning process: the focus of the exhibition on how people deal with sickness, sorrow, need, and trouble was devised as a result. A Wellcome Trust official commented to me after the exhibition opened that the Trust itself has an obligation to the Charity Commission to direct its funds in accordance with its charter. An exhibition ranging too far from the focus on the medical, ethical, and social effects of biomedical science could have caused problems for the Trust. Living and Dying met these criteria by addressing contemporary medical responses to trouble and sickness through an art installation in the gallery.

The physical constraints imposed by the British Museum building were also very considerable. Large permanent galleries, without air-conditioning and very often flooded with natural light, designed for the presentation of stone sculpture, are not conducive to the display of fragile materials to contemporary conservation standards. More significantly, the Bloomsbury exhibition style is predominantly that of an art museum, privileging the object in and of itself. BM exhibitions tend to focus on remarkable or marvelous objects, assessed as such in relation both to history and to aesthetics. Objects are displayed without extensive supplementary photographs and graphics, and the museum does not normally create a theatrical context for objects with lighting, design furniture, video, sound, or any of the other media routinely used at the Museum of Mankind. The Sainsbury African Gallery, which opened in Bloomsbury in 2001, draws on the art museum approach. Although it uses small illustrative photographs associated with label text, although the labels are immensely informative, and although it makes use of video, the African exhibition focuses primarily on exceptional objects. It organizes these objects largely by functional category across the continent (textiles together, masks together). Designed by Geoffrey Pickup, who has also designed Living and Dying, it is visually stunning, and it is very successful. It won a major design award, and is popular with visitors.

Unlike the African Gallery, Living and Dying from the beginning related to the presentation of a concept. Although marvelous objects might be, and indeed are, used in the exhibition, it does not focus on objects in and of themselves. At the same time, it was not possible to use the Museum of Mankind reconstruction approach. This was partly because the Ethnography Department was moving away from such a style, but also because, for both institutional

and practical reasons, such an exhibitionary approach is less practical for a permanent exhibition, especially at Bloomsbury. Exhibitions seen by several million visitors a year have to be hardy—well-protected from sticky fingers and other forms of idle damage.

Many visitors who step into the Living and Dying space do so without seeking to see it. Because it is on a major route through the museum, many people are likely to enter the exhibition largely because it is on their path to the Rosetta Stone or the Parthenon Marbles: such visitors have to be entranced into stopping to look at the exhibition. Moreover, since many British Museum visitors have English as a second language, the structure of the exhibition and the language used in the gallery text have to be simple and clear enough to guide them some way into its content. The text thus avoids terms such as "cosmology," aiming to communicate with a simple vocabulary.

The structure of Living and Dying was driven in part by the form of the gallery itself. The Wellcome Trust Gallery is a large space (870 sq. meters, or 9,365 sq. feet), with a very high ceiling (6.3 meters, or 20.66 feet). Ideally an exhibition driven by concepts should have an argument that builds as the visitor moves through space, but this gallery has six entrances and exits, and is a major arterial route: it is not a space that lends itself to linear narrative. No visitor is likely to begin at one entrance, and work his or her way steadily around the whole, so as to leave from the same point. Rather, the intellectual and artifactual content had to be arranged so that it is possible to read it piecemeal—perhaps looking at one section on one transit through the space, and at another at a later stage.

The conceptual starting point is set out in two sections at the principal entrances to the exhibition at the south and north ends of the gallery. Hanging from the ceiling at the southern end of the Gallery is part of the installation The Atomic Apocalypse, created by the Linares family of artists, who work within the Mexican Day of the Dead festival tradition. The installation here comprises the four key figures of the Apocalypse, as outlined in the biblical book of Revelation: War, Famine, Pestilence, and Death. Three horsemen (Famine riding a grasshopper), and the skeleton of Death astride a globe, signal some of the great troubles that face the nations of the earth. But not everyone everywhere deals with difficulty at quite this level of intensity. On the north wall of the gallery two large text and image sections draw together photographs and some poetry, grouped around four words (fig. 9.2).

They are *trouble, sorrow, need,* and *sickness.* These words, drawn from the Anglican liturgy, sum up many of the more ordinary difficulties that are part of most people's lives at one time or another.

The nature of the gallery space necessitated the use of climate-controlled cases for nearly all the objects. The designer, Geoffrey Pickup, created four huge glass cases in the center of the gallery. Just over 5 meters (or sixteen 16 feet) high and 6.3 meters (nearly 21 feet) long, they are designed to themselves disappear so that the objects stand out. These cases are used to explore four aspects of one the central ideas of the exhibition, which is that in many places, the well-being of the wider group is of as much importance as the well-being of individuals, if not more. This communal well-being is often achieved by taking care of relationships important to the whole

group. Each of the four central case studies in the exhibition emphasizes one such form of relational interdependence, while acknowledging that in each case, other dependencies occur. A western Pacific case study looks at the way in which societies without formal leadership systems use both ritual and exchange to build unity, focusing on relationships with each other. A consideration of Native North America looks at dependence on animals, material from the Nicobar Islands in the Bay of Bengal is used to consider relationships with spirits, and objects from the Bolivian Andes illustrate how people manage a relationship with the earth itself.

Against the wall, long cases 4.9 meters (16 feet) high with lighted panels behind, like giant light boxes, display two further sections. These consider how people in different places deal with similar problems. A section called "Life's Ordinary Dangers" considers some of the known dangers and vulnerabilities of life. These are primarily life cycle issues—the dangers of early childhood, of marriage and fertility, of death, and of mourning and loss— illustrated with examples from Egypt, the Solomon Islands, Malaysia, and other places. "Your Life in Their Hands" looks at what people do when sickness and trouble strike. Many people find it hard to accept the inevitability of sickness, trouble, and death, and blame these things on the misdeeds of human or spiritual beings. However, diagnosing who or what is responsible can be a difficult technical exercise, requiring specialist help. This section looks at forms of diagnosis and treatment: divination, shamanism, exorcism, prayer, and diverse medical systems, used in Tanzania, Germany, Sri Lanka, and elsewhere. These cases make considerable use of photographs and other graphics, produced as huge transparencies against the lighted backs of the cases.

In the very center of the exhibition is the installation that turns its lens on contemporary British society. Well-being is a particularly important idea in places such as the United Kingdom and United States today, where it is tied to notions of individual bodily health. Much of British society draws its cosmology from science: it sees most of what happens as comprehensible in terms of the physical world, rather than as a consequence of the actions of non-material beings such as spirits. As a result of this emphasis on the physical, notions of individual well-being have become more and more focused on a scientific or medical understanding of the human body.

*Cradle to Grave,* an art work made by Susie Freeman, Liz Lee, and David Critchley, takes a look at a contemporary British approach to well-being.

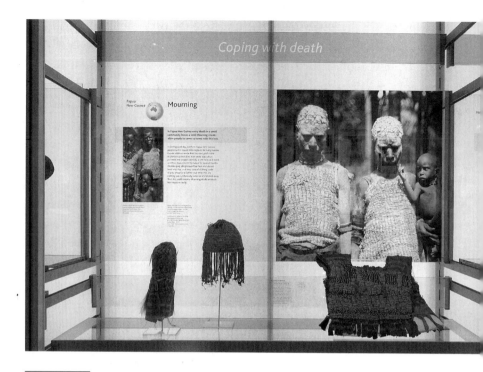

FIGURE 9.4. Part of the "Your Life in Their Hands" section, which addresses forms of mourning in Collingwood Bay, Papua New Guinea. *Photo: ZED Photography.* *By permission of the Trustees of the British Museum.*

Two thirteen-meter lengths of knitted fabric, one for a man and one for a woman, lie side by side. Sewn into small pockets in the fabric is the pharmaceutical prescription history of each individual; examples of all the pills—about 14,000 in each case—that they might take in their lifetimes are presented in sequence. Lying alongside these fabrics, family photographs, documents, and other medical interventions, such as a hearing aid, suggest the progress of the two lives. Based on actual medical records, the installation is a stark demonstration of a specific approach to well-being, which is as distinctive as any in the exhibition. It is estimated that typical British citizens take more than 20,000 prescribed pills per capita over the period of their lifetime. Certain medicines, such as paracetamol and other painkillers, are taken the world over (where people can afford them), but the volume of pill-taking documented here records a

particular focus on the physical body, within the wider context of a life as lived.

The arrangement of the exhibition can be seen as a kind of compromise between the Bloomsbury object focus and the demands of a conceptually driven exhibition. The case studies are the most conventional part of the gallery, in the sense that they focus more on the display of objects. Although we insisted on the inclusion of contextual photographs, these are perhaps not as dominant as the curatorial team would have preferred, but more prominent than suited the designer's object-focused conception. Although the objects used here were chosen for the ideas they illustrate, as much as for their individual merit, in these cases objects are displayed for effect. The theme cases, however, represent the first time in which the museum designed graphics and objects together as a coherent whole.

## Aspirations

Living and Dying involved collaboration and consultation. Many sections of the exhibition were produced either directly in consultation with the originating communities, or at least in consultation with intermediaries, mostly other anthropologists, who acted to a greater or lesser extent on behalf of those communities. This is not to make some grand claim for the exhibition. It certainly does not represent significant indigenous control of content.

Obliquely, however, the exhibition addresses one of the issues that underlie much of the indigenous and community pressure to influence what museums communicate. If ideas of racial inequality have, for the educated at least, long since been dismissed as a false (and pernicious) theory, what underlies them has remained, phrased in other terms. If ideas of race are no longer politically acceptable, ideas of class are a good deal more deeply entrenched. The aesthetic hierarchy by which the British Museum assessed its collections may not be understood in these terms, and it is no longer advocated by British Museum curators, but its influence has nevertheless to be consciously unpacked. In some ways, the Sainsbury African Gallery can be seen as an attempt to meet the other British Museum collections on their own terms, to present the African collection as art, and it does this with panache. Living and Dying does not attempt to meet other collections on these terms, but rather to offer a new approach that steps right over some of

the issues of aesthetic comparison. It aims to show the agency of objects in systems of knowledge and practice—what things mean and how they are used. There are many stunning objects in the exhibition, but they are not there primarily because of their visual interest.

The approach used in Living and Dying involved interpreting the material presented as different solutions to the same shared problems, solutions not necessarily any more strange, although perhaps less familiar, than those a Euro-American exhibition visitor might adopt. The merit of including *Cradle to Grave* is that it makes the familiar strange by using an unexpected lens to look at the visitor's own practice. If the visitor's own practice is also strange, then the exhibition at least suggests that nowhere is necessarily "better" than anywhere else. There are many practical and intellectual difficulties in attempting to look at other people's practice without using any as a baseline for comparison and analysis. Inevitably, people think in terms of their own experience and assume its normalcy, using their experience to assess what other people do. By making the Euro-American visitor look afresh at an aspect of his or her own practice, *Cradle to Grave* undercuts that sense that those practices make sense in a way that others' do not.

It is of course no solution if only Living and Dying adopts this kind of approach while other galleries continue to focus primarily on objects as art: that becomes just another kind of division. In discussions as the exhibition was being developed, Neil MacGregor proposed that Living and Dying should suggest a different set of questions that can be asked of objects, a set of questions the visitor can carry into other galleries in the museum. But of course this objective can be achieved only insofar as other galleries facilitate engagement with those questions. The challenge is to find a way to invite the visitor to respect and engage with the collections within the Bloomsbury environment, just as was possible in the Museum of Mankind. In that sense the core idea in Living and Dying is the affirmation of the value and importance of all the different strategies for life discussed within it.

The exhibition opened in November 2003, and met with a very positive public and critical response. One review affirmed that the "objects speak to us directly about the fears and hopes of the communities who produced them."[27] The *Museums Journal* found it to have "style, wit and an extraordinary ability to provoke thought," specifically making the point that "it is good to see those rich ethnographic collections displayed with such panache in

Bloomsbury."[28] The exhibition won the 2004 Museums and Heritage Award for Excellence for the Best Permanent Gallery. The exhibition has proved popular with visitors.

Living and Dying was, as it turned out, the last Ethnography Department production. Several months after it opened, the Ethnography Department was partitioned in a management-led reorganization, some collections being dispersed to other sections of the institution. A new and smaller department, the Department of Africa, Oceania and the Americas, was created and formally constituted in November 2004. This move resolved the anomaly of the Asian collections by moving the curation of the Asian ethnographic collections into the Oriental Antiquities department, itself renamed the Asia Department. These alterations are part of a larger trend within the institution to organize the collections and the departments on the basis not of disciplines but of geographical regions. It can be seen to some extent as an attempt to overcome the implicit class inequalities in the previous arrangement. It might be argued that this restructuring is an effect of the issues raised by Living and Dying and discussed in this paper, but if so, that connection has not been made explicit. It is not yet clear whether this new structure will be applied rigorously throughout the institution or how it will affect future exhibition development.

Living and Dying does present human cultural diversity, and it attempts to do so without reference to aesthetic assessments of the objects it displays, even while it is designed to look spectacular. It is difficult, for me at least, to assess how successfully it ignores the hierarchies of aesthetic difference taken for granted in British Museum galleries in the past. But to the extent that this objective may be achieved, a new problem arises. When they are displayed as art, objects created in contexts of human suffering and even exploitation can be presented without necessarily engaging with the humanitarian costs of their creation and celebration (as is the case in a number of the British Museum antiquities galleries). But an approach that focuses on the meaning and significance of objects almost inevitably raises these questions, all the more when some of that suffering may have been inflicted using racial inequality as a legitimation.

In Living and Dying we have skirted the fact that everywhere people wreak injustice upon each other. Trouble, sorrow, need, and sickness, not to mention war, pestilence, death, and famine, are very often inflicted upon one

group of people by another, and not exclusively in the context of colonialism, for all that colonialism might be a particularly invidious example. The difficulty of allowing for the infliction of trouble by one group upon another without giving offense to particular interest groups is considerable. In attempting to address the issue of aesthetic sensibilities linked to the differentials of class, we may have raised a new and more intractable problem, how a museum of the world for the world takes into account man's inhumanity to man.

NOTES

1. The core project team for the exhibition comprised Sarah Posey (Deputy Lead Curator), Julie Hudson (Project Co-ordinator), Anna Hughes (Project Manager), Geoffrey Pickup (Lead Designer), and Guy Parks (Architect). The additional contributing curators were Jonathan King, Colin McEwan, Brian Durrans, Ben Burt, Christopher Spring, and Jenny Newell.

2. Neil MacGregor, preface to *Enlightenment: Discovering the World in the Eighteenth Century,* ed. Kim Sloan with Andrew Burnett (London: The British Museum Press, 2003), 6–7, 6.

3. Laura Peers and Alison Brown, eds., *Museums and Source Communities: A Routledge Reader* (London: Routledge, 2003).

4. This position was most recently set out by the indigenous Australian activist, Gary Murray, who said in a radio interview that "all cultural objects and human remains in particular should be returned to traditional owners around the world" (Australian Broadcasting Commission, Mildura–Swan Hill *Morning Show,* 22 September 2004), and somewhat more moderately has said in print that "You go to Britain to see the Crown Jewels, so why would you want to go to Britain to see the bark etchings that come out of Boort [Victoria, Australia] that belong to the Dja Dja Wurrung people?" *Canberra Times,* 28 July 2003.

5. Neil MacGregor, preface to *Enlightenment,* 7.

6. J. C. H. King, "Romancing the Americas: Public Expeditions and Private Research, c. 1778–1827," in *Enlightenment,* ed. Sloan and Burnett, 234–45, 245.

7. Luke Syson, "The Ordering of the Artificial World: Collecting, Classification, and Progress," in *Enlightenment,* ed. Sloan and Burnett, 108–21, 112–13.

8. J. Kincheloe and S. R. Steinberg, "Addressing the Crisis of Whiteness: Reconfiguring White Identity in a Pedagogy of Whiteness," in *White Reign: Deploying Whiteness in America,* ed. J. Kincheloe, S. R. Steinberg, N. M. Rodriguez, and R. E. Chennault (New York: St. Martin's Griffin, 1998), 3–30, 5.

9. George W. Stocking, *Race, Culture, and Evolution: Essays in the History of Anthropology* (Chicago: University of Chicago Press, 1982), 36.

10. Ian Jenkins, "Ideas of Antiquity: Classical and Other Ancient Civilizations in the Age of Enlightenment," in *Enlightenment,* ed. Sloan and Burnett, 168–77, 177.

11. Ian Jenkins, "Ideas of Antiquity," 174.

12. Luke Syson, "The Ordering of the Artificial World," 109–10.

13. David Wilson, *The British Museum: A History* (London: The British Museum Press, 2002), 161; J. C. H. King, "Romancing the Americas," 245.

14. Luke Syson, "The Ordering of the Artificial World," 109.

15. Quoted in David Wilson, *The British Museum,* 44.

16. See for example David Finn, *Henry Moore at the British Museum* (London: British Museum Press, 1981).

17. Michael O'Hanlon, *Paradise: Portraying the New Guinea Highlands* (London: British Museum Press, 1993); James Clifford, *Routes: Travel and Translation in the Late Twentieth Century* (Cambridge, Mass.: Harvard University Press, 1997).

18. O'Hanlon, *Paradise,* 82.

19. O'Hanlon, *Paradise,* 82.

20. Nicholas Thomas, *Entangled Objects: Exchange, Material Culture, and Colonialism in the Pacific* (Cambridge, Mass.: Harvard University Press, 1991).

21. O'Hanlon, *Paradise,* 82.

22. O'Hanlon, *Paradise,* 84.

23. O'Hanlon, *Paradise,* 85.

24. Lissant Bolton, "The Object in View: Aborigines, Melanesians, and Museums," in *Museums and Source Communities: A Routledge Reader,* ed. Alison K. Brown and Laura Peers (London: Routledge, 2003), 42–54.

25. Ivan Karp and Steven D. Lavine, eds., *Exhibiting Cultures: The Poetics and Politics of Museum Display* (Washington, D.C.: Smithsonian Institution Press, 1991).

26. Steven D. Lavine and Ivan Karp, "Introduction: Museums and Multiculturalism," in *Exhibiting Cultures,* 1–9, 6

27. Richard Cork, "World Encyclopaedia," exhibition review, *New Statesman,* 24 January 2004, 40.

28. Peter Lewis, "Death Defying: The Wellcome Trust Gallery, the British Museum," exhibition review, *Museums Journal* 103, no. 12 (2003): 34.

# Museums and Historical Amnesia

## WILLIAM H. TRUETTNER

In 1900, acting on behalf of a generous and farsighted patron, officials at London's Victoria and Albert Museum purchased from showrooms at the Exposition Universelle in Paris an outstanding group of Art Nouveau objects—furniture, ceramics, glass, jewelry, and textiles.[1] One hundred years later, to mark the importance of that purchase, the museum organized a large, stunning Art Nouveau exhibition, surely the most comprehensive effort thus far to investigate the historical and geographical sweep of the movement. Most of the exhibition was devoted to the years (about 1895 to 1910) when Art Nouveau flourished as a pan-European phenomenon. But at the beginning, in several didactic displays, visitors were shown the variety of sources from which, in about 1890, the style emerged. And in the last few galleries, a selection of architectural photographs chronicled the rather abrupt end of the style during World War I.

The exhibition came to the National Gallery in Washington in 2001, where it was shown in much the same way it had been at the Victoria and Albert. And it was accompanied by the V&A catalogue, a lavishly produced book of 496 pages, which included contributions by no fewer than twenty-two prominent scholars.[2] The first part of the catalogue addressed broadly conceived topics such as "The Style and the Age," "Alternative Histories" (surveying

more traditional contemporary taste), and "The Materials of Invention" (show-ing how resourcefully the style had been applied to different media). These were followed by chapters on the geography of the movement, describing the metropolitan centers across Europe and the United States where the style seemed to take hold, but never in quite the same way. These variations in style, brought about by Art Nouveau's encounter with local design traditions, were revealed in a succession of beautifully focused geographical displays, each featuring characteristic objects, interiors, and architectural designs from cities such as Paris, Brussels, Glasgow, Vienna, and New York. The wall texts were, for the most part, concerned with defining the character and appear-ance of Art Nouveau decoration in each of these urban settings, pointing out, for example, that curvilinear motifs were dominant in Paris and Brussels, while a more restrained geometry prevailed in Glasgow and Vienna.

Paris was (and still is) the city most closely identified with Art Nouveau. But Brussels, sometimes slighted, probably deserves to be called the archi-tectural capital of the movement. Numerous public buildings, streetscapes composed of similar façades, and private homes were built in Brussels be-tween about 1890 and 1905, enough to qualify as a minor but important ar-chitectural renaissance. Many of these were designed by Victor Horta, a leading architect in the city, for clients who were prosperous, middle-class professionals.[3] Among them was Edmond Van Eetvelde, a prominent diplo-mat and Secretary of the Independent State of the Congo (Belgium's princi-pal colony), for whom Horta designed a spectacular house, with stylized wall decoration that recalled Congo flora and fauna, in 1894.[4] Other commis-sions came to Horta through a politically active group of Freemasons, whose beliefs set them against the "Royalist" architecture (their term for traditional French classicism) omnipresent in Brussels at that time.[5] Supporting the econ-omy of Brussels in general, and some members of both groups, was money pouring in from the Congo. Much of it went directly to Leopold II, king of the Belgians, and to his friends and business associates, including Van Eetvelde, who held shares in private trading concessions operating in the Congo. These employed native labor to gather and process raw materials (principally ivory and rubber) for export to Europe.

In the Brussels section of the National Gallery exhibition, a short text panel acknowledged the central role of Congo funds in underwriting local architectural projects.[6] But the text went no further, providing specific

information neither on how the Congo managed to produce so much wealth during those years nor on how some of it got into the hands of Horta's patrons in Brussels. Why the text stopped where it did, and left one guessing, is perhaps understandable. Or at least revealing. Art museums have always been reluctant to address these kinds of historical questions, fearful of where they might lead. And this one, especially, would have sent them running for cover. With a little more digging, our text writer would have found that the so-called Congo Free State was neither free nor a state. It was Leopold's private fief, and from it he and his Belgian associates reaped countless millions in profits, but at a terrible cost to the native population of the Congo. During Leopold's reign (1869–1909), the large numbers forced to work for Belgian trading concessions, gathering ivory and rubber in remote parts of the jungle, were so often beaten and tortured that millions eventually died. Estimates of the toll run as high as ten million, which during this period would have amounted to almost half the population of the Congo.[7]

Some would argue, of course, that the National Gallery had no obligation to go beyond what it said in the text—that events in the Congo and the Art Nouveau renaissance in Brussels were, in effect, worlds apart. Others might acknowledge a connection but be quick to say that cultural momentum—the tendency of the style to reproduce itself—rather than an excessive supply of blood money, was the prime cause for such a lively building program in Brussels. And, indeed, it would be easier to make that case than to assign a high priority to Congo profits. Tracing those to determine which of Horta's patrons (except for Van Eetvelde) dealt, directly or indirectly, with Congo concessionaires would be a difficult task. And so would attempts to find out how much these same patrons knew about conditions in the Congo, since Leopold's ministers were adept at covering up the worst of his and their abuses. Moreover, Europe's ruling classes and prominent artists and writers of the period more or less condoned turn-of-the-century colonialism, as long as they could convince themselves that some degree of social benefit accompanied the exploitation of native populations. Joseph Conrad, for example, was appalled by conditions in the Congo, but he considered British imperialism much more enlightened.[8]

The final step in this kind of investigation would be no less difficult. To make clear that its primary aim was scholarship, rather than condemning Leopold's colonial policies, one would have to address the architecture

itself—what meanings it might have had for a cross-section of Horta's patrons, as well as for those who might have benefited from Congo profits.[9] Even without going to such lengths, however, we know that Art Nouveau architecture had certain prescribed social uses. Some patrons, for example, thought of it as modern and progressive, and a complement to new ways of merchandising domestic and personal items to middle-class consumers.[10] That would have led to another use of the style—as a screen, physical and psychological, that served to separate genteel modes of consumption from the raw capitalism that prevailed behind the scenes. Horta's patrons, enamored of the richly decorated interiors in their private homes, must have experienced something similar.[11] Walter Benjamin compared it to the sensation of "dreaming that one is awake." For others it was manifest as a "longing for escape, for renewal."[12] Whatever the response, those who lived in these interiors were often intoxicated by them, eased into a sensory world that may again have distanced them from the economic realities of art patronage.

Oddly enough, Art Nouveau interiors also had a chameleon-like capacity to accommodate the beliefs of an older social and economic order—those who were trying to reconcile past and present.[13] Leopold, who apparently disliked the style, nevertheless commissioned an Art Nouveau pavilion for the 1897 International Exhibition, held in Belgium. Displayed in the pavilion was a wide range of current products from the Congo, as well as several native encampments, each graded according to how much it had progressed from savagery toward civilization.[14] At about the same time, the king had built on his estate at Laeken, outside of Brussels, a greenhouse with four cupolas and a dome in which he created his own miniature Congo. It consisted of a lush tropical paradise, where imported plants and trees, probably arranged in benign, park-like settings, offered a convenient substitute for a colonial possession he never visited.

Even if one doesn't wish to use such methods to investigate Art Nouveau architecture, is there still an issue about the National Gallery text that museum professionals must confront? Or, to ask the question another way, what happens if nothing further is said about the Congo? I suspect our silence will come to mean what it has in the past: that art and architecture so dazzling must have sprung not from the chaos of history but from a so-called golden age (Athens in the fifth century BC, the Italian Renaissance) ideally suited to the production of great works of art. But in the unlikely event there were such times, the turn of

FIGURE 10.1. Victor Horta, dining room of the Van Eetvelde house (1895), with wall designs recalling the flora and fauna of the Congo, Brussels. © 1895, Victor Horta/*SOFAM—Belgium*.

the century would not be one of them. Indeed, those years may reveal themselves as much through conditions in the Congo as through architectural achievement in Brussels. And if that's the case, can we gain some insight by trying to connect them? At the very least, it would seem, we can put to rest the idea that great art appears at moments of exquisite social and political balance. But more to the point, if we believe that Congo natives had a role in helping Horta's patrons realize their cultural ambitions, then the issue of difference lies uncomfortably beneath Belgium's Art Nouveau renaissance.

Adam Hochschild's book *King Leopold's Ghost,* published in 1998, is the most recent indictment of Leopold's role in the Congo. No mention of the book, widely read and well-reviewed in the United States, appears in the catalogue that accompanied the V&A exhibition, published just two years later. Not surprisingly, *Leopold's Ghost* has attracted only grudging attention in Belgium, where the dark side of the king's colonial ventures has usually been excluded from official histories and children's school texts. But just outside of Brussels, officials at the Royal Museum of Central Africa, another of Leopold's diversionary projects, have already instituted changes. On display in the museum in 2003 was a wide range of items representing the Congo: raw material exports, natural history specimens, native art and artifacts, and historical memorabilia, including symbolic statues with names such as *Belgium Brings Civilization to the Congo.* Those caused the newly appointed director of the museum, Guido Gryseels, to acknowledge his dilemma. In an article that appeared in the *New York Times* the same year, he asked, "How do we deal with our colonial past?" Many Belgians, he noted, still resisted change, preferring to see their country's intervention in the Congo as positive and uplifting. And some journalists had cautioned the director not to give in to " 'politically correct' leftist revisionism." Despite the resistance, however, the director has subsequently mounted an exhibition called "Memory of the Congo," a critical update of previous exhibits, with, among other evidence of harsh colonial behavior, unbelievably straightforward photographs of disobedient natives who had suffered hand amputations. Previous museum visitors, the *Times* correspondent observed, had spent their time "oohing" and "aahing" over stuffed animals, rocks, and minerals, without ever learning the "horrific truth" that lay behind the display cases. What they urgently needed, he concluded, was a broader context—presumably composed of the kind of material Gryseels is now showing.[15]

How does such a point of view affect art museums? By now, most museum administrators are willing to group works under broad historical headings, but more critical insights, the kind that dig deeply into the darker, more destructive events of an era, are still out of bounds. And, needless to say, so are attempts to link such investigations directly to works of art, or to read these works for ideological meanings. This happens not because museums wish to deny shifting historical perspectives, or the misdeeds they may uncover, but because they wish to keep art clear of history—the kind that would seem to degrade it. And works of art, many recent scholars have noted, are complicit in this strategy. Even those with an evident critical agenda tend to obscure historical issues and/or gloss the troubling signs of their origin.

At the same time, curators and educators working in museums today are searching for more helpful ways to engage the public, to make works of art come alive as a complex mix of ideas and aesthetic strategies. Many of us believe that art does respond to critical historical issues, but not always in direct, easily detected ways. Making connections between art and history, therefore, requires careful negotiation with, not judgments about, works of art. These negotiations offer new options and insights, new ways for museum audiences to experience a wide range of art objects. But the process starts from a traditional base—a sequence of historical events known to both curators and audiences. From there, with scholarship that "cross-sections" these events, the process moves forward, until works of art, probed from new angles, are made to reveal as many new meanings.

Once projects that connect art and history leave curatorial departments, however, they confront a number of internal and external roadblocks. Those on the inside—trustees, directors, other administrative officers—almost invariably find it safer to present works of art as aesthetic verities, unchanging in their meaning and importance, and uncompromised by historical associations. For the most part, the museums they run seek support from municipal, state, or federal governments whose representatives favor institutions that treat the study of art and history as a record of human achievement. Or they depend on the largesse of wealthy individuals (usually collectors) who believe connoisseurship should be the primary aim of museum scholarship. Challenging that kind of authority, arguing that connoisseurship is only one of a number of tools to probe meaning, rarely makes much headway. For obvious reasons.

The overriding concern of those who administer or support art museums is to preserve the so-called historical innocence of great works of art.[16]

Such beliefs, and the programs that grow from them, leave curators on shaky ground, unsure of how much to press forward with new ideas, and only too aware of the consequences of holding back. When the new galleries of the Peabody Essex Museum in Salem, Massachusetts, opened in the fall of 2003, *New York Times* critic Holland Cotter complimented the museum on the attractive appearance of its permanent collections—an extraordinarily diverse group of objects, American, Asian, and aboriginal, many of which were acquired during the heyday of Salem marine commerce. But interpretation of the newly reinstalled collections, he claimed, failed to "budge the status quo." What seemed to be missing was a search for new meanings—those that might have been revealed when such rich and varied collections were reassembled in spacious new galleries. Exhibition strategies, according to Cotter, focused more on objects as individual art works than on what ideas or historical insights they might convey, as if the two approaches—appreciation of the object versus historical meaning—were somehow unrelated, or, even worse, in conflict. So visitors received a stirring appraisal of the artistic merits of the collections, but learned rather less about what they meant to the merchant seafarers who gathered them, or how they might be understood today. What the installation lacked, in other words, was a more critical examination of the motives of those merchants, who seemed to relish the business of consuming other cultures. In response to minimal efforts to address such historical issues, Cotter observed:

> By choosing to do little, interpretively, with art, you end up by doing a lot to preserve existing ideologies and master narratives, so long in place that we barely notice them. And so, in a professedly agenda-free situation, a museum can talk about exploration without mentioning exploitation, address the theme of leisure without bringing servitude into question, extol the exploits of Salem's globe trotting merchant shoppers without referring to the borderless capitalism and imperialist yearnings they represented. . . . The issue here is not one of political opinion, right or wrong, but of full disclosure, of making the mechanics of persuasion operating in a museum—any and every museum—transparent.[17]

But transparency is anathema to most museums. Fearful that Cotter's standards might require more historical interpretation, they hastily retreat to, as he calls it, the status quo.

Let me now try to collect and sharpen these arguments, using them to investigate scholarship set forth in an exhibition and catalogue produced in 2001 by the Denver Art Museum. The exhibition featured a major and wide-ranging collection of paintings of the American West, gathered over a thirty-year period by Philip Anschutz, a prominent local businessman with investments in natural resources, railroads, cable companies, and entertainment sites. But despite Anschutz's claim that he collected Western paintings because they seemed to "mirror" themes he associated with the development of the West—"a passion for exploration" and "triumph over adversity"—the accompanying catalogue promoted the collection as a survey of masterworks, to some extent unrecognized because Western subjects had little appeal for scholars of mainstream American art. The remedy, author Joan Troccoli maintained, was to replace history—a study of the works in the context of westward expansion—with art history. This would enable scholars and critics to see that so-called Western artists followed the same art historical traditions as those who depicted mainstream subjects. Stylistic comparisons would follow, leveling the playing field and inviting new and more reasonable assessments of quality. The concept of a separate and inferior Western art would gradually disappear, merging into mainstream American art, and artists formerly considered "Western" would rise to the level of more frequently admired mainstream American artists.[18] To examine this theory more closely, we might turn back to issues already raised in this essay, and ask if what the author is trying to do is really possible. Studies in style and connoisseurship, helpful a generation ago to establish the importance of American art, are no longer the only means to accomplish that end. New scholarly approaches, introduced over the intervening years, may do as much or more to strengthen our appreciation of the Anschutz collection.

The treatment of George de Forest Brush's *The Picture Writer's Story* in the Anschutz catalogue is a case in point. *The Picture Writer* is surely the artist's most important Indian image and one of the strongest paintings in the Anschutz collection. But Brush, a maverick of sorts, did not always paint Indians who looked like the Picture Writer. After superb early training in the Paris studio of Jean-Léon Gérôme, he sought the company of

"real" Indians, the Shoshone, Arapaho, and Crow, northern Great Plains tribes whose domestic circumstances were still relatively unchanged by white settlement.[19] Among them he sketched and painted for the next four years (1881–1885). When he returned to the East, however, dividing his time between studios in New Hampshire and New York, he seems to have left real Indians behind. What he painted instead were ideal Indians, like the Picture Writer, and Renaissance-inspired portraits of his wife and family. The heroic form of the Picture Writer, whose descriptive art appears on the buffalo skin behind him, is what we might expect from a student of Gérôme. And its source, familiar to late-nineteenth-century academicians (as well as connoisseurs), is no surprise either; Brush has taken the figure from one of Michelangelo's most imposing works, the *Libyan Sibyl* on the Sistine Chapel ceiling. Both the exhibition and the catalogue placed special emphasis on the borrowing, presumably with some hope that the luster of a great Renaissance artist would transfer to Brush's work. In addition, the catalogue encouraged viewers to see *The Picture Writer* not as a Western (with a capital *W*) picture, but as one that would fit comfortably into mainstream American art.[20]

What happens to make this possible? First of all, the approach obscures the connection, no matter how indirect, between the Picture Writer and the Indians, on or off reservations, Brush might have known or read about. In addition, removing the Picture Writer, artistically and historically, from Brush's own time and associating him exclusively with a past era of art history obscures the vital difference between the Picture Writer and images of "real" Indians. Indeed, the Picture Writer in these circumstances seems to have more in common with the gods and heroes of ancient times, whose form he has magically acquired. And by such magic, the Indian's appearance (and his racial markings) are quietly subsumed into a western (that is, Euro-American) artistic tradition, where he becomes an example of High Renaissance art, carried forward to serve the beliefs of late-nineteenth-century American art patrons. The approach also tells us how the museum establishment takes care of its own. Judgments about artistic merit, encouraged in one way or another by those associated with museums, often spill over into the market place. There such judgments help to quantify the value of a work of art, not as a conscious strategy but as a convenient benefit of the spillover process. For the point of establishing artistic merit, even though it

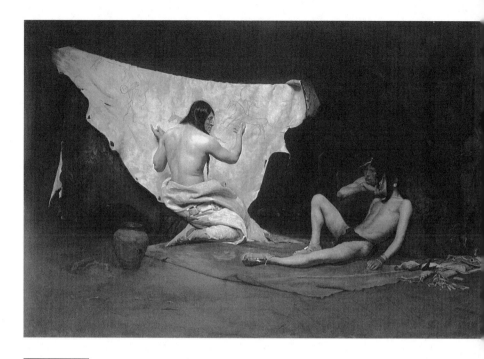

FIGURE 10.2. George de Forest Brush, *The Picture Writer's Story* (ca. 1884), oil on canvas, 24 × 36 in. *Courtesy of the Anschutz Collection. Photo: William J. O'Connor.*

never quite comes out in the open, is to show that we have somehow over-looked Brush, that his work deserves receives greater recognition than it's received. Once that happens, once we assign a new and higher artistic appraisal to his work, the market will frequently respond.[21] But where does that lead us? To an investigation of difference, to a broader, more challenging understanding of *The Picture Writer's Story*? Or to what some might consider a dead end, with art and history once again confined to separate realms?

We might begin by asking what Brush hoped to achieve by representing the picture writer with such heroic proportions. We can probably assume that this was Brush's version of a noble warrior, who in this case explains his military triumphs (or those of his tribe) to two young braves. The subject amounts to a rite of passage—one generation passing on to the next the values and obligations of tribal life, as if they are a key to survival, to perpetuating the race. But why at this moment in time (1884) would Brush choose to

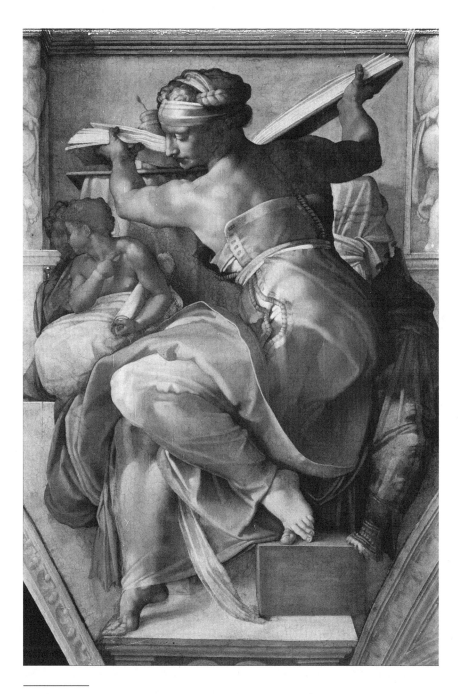

FIGURE 10.3. Michelangelo Buonarroti, *Libyan Sybil* (1511), fresco. Sistine Chapel, Vatican Palace, Vatican City. *Photo: Erich Lessing, Art Resource, New York.*

paint such a subject, when Plains Indians were in such a beleaguered state? Two prophetic events bookend the date of this painting, the Battle of the Little Big Horn (1876) and the Wounded Knee massacre (1891). Both remind us that the Plains Indian Wars continued, unabated, through this period. At Little Big Horn, named for the river in southern Montana where the battle took place, a large force of Sioux outfought the legendary "Boy General," George Armstrong Custer, surrounding and killing every last soldier in his detachment. But for the Indians, their triumph was short-lived. The army tracked them with renewed energy over the next few years, driving most onto reservations or across the Canadian border. Sporadic resistance lasted, however, until 1891, when Army soldiers fired into a group of Sioux Ghost Dancers, including women and children, at Wounded Knee Creek on the Pine Ridge Reservation, South Dakota, effectively ending Indian resistance on the northern Great Plains.

Brush knew of these events and was "heartbroken about how the Indians were treated by the government," according to his daughter Thea Cabot.[22] But if his paintings do not immediately express those feelings, was he, in other ways, trying to sustain Indian life, even as he saw it disappearing? Perhaps that explains why his efforts were not directed at the present but at the past, where he could turn back to a mythic time when Indians, such as the heroic Picture Writer, did indeed rule the Plains. And was that the image that intrigued Brush and his contemporaries—heroic Indians who constantly tested themselves on the battlefield, told here as a quiet recollection but in more strident tones by artists such as Frederic Remington and Charles Russell? Whatever the answers, this kind of Indian did live on, in paintings and bronzes, and on coins, such as James Earle Fraser's *Buffalo Nickel*. And his image came to symbolize an older America, a society of noble warriors whose courage and determination inspired generations of white frontiersmen, up to and including surrogates such as Teddy Roosevelt.[23] But these heroic images also tell us that Brush and his patrons had a remarkable double vision when they focused on Indian life. What they seemed so ready to believe was that noble warriors, who lived in mythic time, had at some point parted company with real Indians, who lived, much less nobly, in the present. There, real Indians languished between the mythic past whites had invented for their ancestors and white civilization, which few Indians could understand and even fewer were encouraged to join.

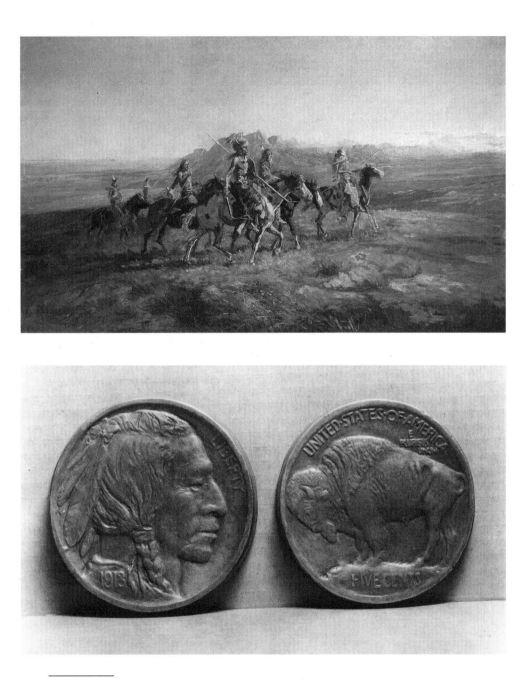

FIGURE 10.4. *Above:* Charles M. Russell, *Sun River War Party* (1903), oil on canvas, 18¼ × 30⅜ in. *Rockwell Museum of Western Art, Corning, New York; gift of Robert F. Rockwell, Jr.*

FIGURE 10.5. *Below:* James Earl Fraser, *Buffalo Nickel,* bronze, 4½ in. diameter. *Photograph courtesy of Kennedy Galleries, Inc., New York.*

Brush's attempt to see the Picture Writer as a premier symbol of America, ancient and enduring, perhaps also reveals an ambition to construct for himself a corresponding lineage. The image of the Picture Writer, practicing his art in native surroundings, was, after all, Brush's effort to reach back to a period long before his time in Gérôme's studio. What he sought to recover was an early or primitive stage of his own impulse to make art. Imaginative comparisons bring this out: the womb-like space that becomes a studio; the buffalo hide that becomes a canvas; the Picture Writer who becomes an artist, or at least assumes a form that associates him with a great artist; and art that becomes a path to a higher life, as one generation passes on its knowledge to another.[24] But for all Brush's earnest efforts to designate the formative role of the Picture Writer (a model who literally becomes a model for early art practice) there is something disturbing about the process. The Picture Writer, struggling to make himself understood, has a long way to go. His studio space, buffalo-hide canvas, and artistic efforts are crude and primitive. Brush's studio accommodations, if a bit rustic, were far superior. And his technique was as accomplished, in its own way, as that any of his more overtly facile Gilded Age contemporaries. Is there, then, an anthropological progression implied? Has Brush moved beyond the artistic skills of the Picture Writer because, over the centuries, white civilization has advanced far beyond the level of the Picture Writer's society? And, if so, does that point to why over the last century the Picture Writer's descendants have been reduced to wards of the government? The treatment of real Indians at the turn of the century was no one's fault, Brush's generation was fond of claiming. Progress was inevitable; history had its own way of deciding who would survive and flourish, and who would not.

This kind of historical subterfuge—the way in which Brush, intentionally or not, reveals his opinions about Indians, past and present—is what most museums are reluctant to address. But such caution has its downside. Only by investigating the Indian issues of Brush's own time—those that he knew about but didn't confront directly—can we begin to understand how *The Picture Writer's Story* engaged Brush's patrons. It did so, we can surmise, by transforming divisive historical issues (differences) into more satisfying and useful narratives. And those become evident not only in the subject Brush chose but in how he proceeded to organize and execute it on canvas.

First of all, as we know, he turned to Michelangelo's great fresco cycle in the Sistine Chapel to find appropriate models. But aside from dictating pose and gesture, they perform other roles in the picture, less obvious but perhaps more meaningful aesthetically. For what Brush, the academic artist, appears to be doing is urging these figures—those he chooses for the Picture Writer and his youthful observers—to tell a deeper, more enduring story. Central to this strategy is the dominating figure of the Picture Writer, along with the passive, subservient appearance of the observers, implying that authority—the obligation to mentor and instruct—resides with the Picture Writer. But the relationship is modified by the way the Picture Writer's heroic proportions are echoed (and perceptibly softened) by the larger shape of the buffalo robe, and by the warm, expressive gaze he turns toward the observers, perhaps his sons, signifying a memory of his own youth. Of the two observers, the one in front, stretched out in almost erotic response to the Picture Writer, has also been taken from a figure on the Sistine ceiling. He is a slimmer, more effeminate Adam, suggesting that what we are witnessing is indeed a rite of passage, the creation (in what can already be seen as an artistic "womb") of a new generation of picture writers, a forecast that this mythic race will continue. But that's not the only way Brush gets this idea across. He uses the forms of the three figures to remind us visually of the transition from youth to age. "Form-less" youth, the slender-limbed young Indians in the foreground, slouching and inert, will in a few more years gain the substance and form of maturity, the model for which is the Picture Writer, who both looks and plays the part as he relates to the youths the exploits of manhood inscribed on the buffalo robe. If we assume that "perpetuating the race" is a theme this picture and numerous other images of Indians at the turn of the century are attempting to convey, those deemed survivors were not necessarily the Indians of Brush's own time. *The Picture Writer* carefully avoids, or navigates around, the more pressing problems of those Indians and instead addresses the need of elite white males to believe in the racial stock of ancient America, and to see that stock, in the form of heroic Plains Indians, as a model for the present, regardless of the then-present condition of Plains Indians. Circuitous as this process may be, Brush helps it along by carefully obscuring the present, not only in the way he constructs his figures but in the space that surrounds them. Though that space lacks historical markings of any

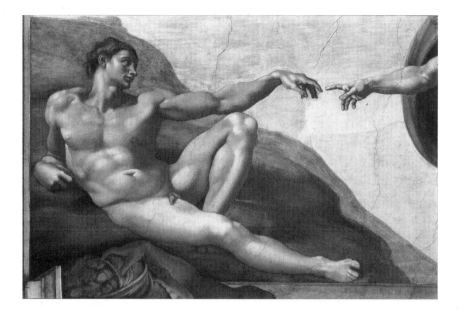

Figure 10.6. Michelangelo Buonarroti, *The Creation of Adam* (1511), fresco. Sistine Chapel, Vatican Palace, Vatican City. *Photo: Erich Lessing, Art Resource, New York.*

kind, one quickly perceives it as ancient and timeless rather than recent and temporal.[25] In the semi-darkness, a studio light fixes the figures against the softly painted shadows behind them. No other hint of the outside world intrudes. The seal is perfect, complete, meant to preserve for all time this mythic image of Indian life.

On one point, I assume, everyone can agree: Brush's aesthetic choices, evident in every aspect of the painting, have been made with considerable skill. But which of these choices are most helpful in trying to rank *The Picture Writer's Story* today? Do we judge Brush on how successfully he adapted Michelangelo's figures to his own compositions? Or do we take another approach, trying to understand how Brush re-used these figures at the turn of the century to convey ideas, shared by his white audience, about Indians and their presumed role in carrying forward the virtues of ancient America? Up to now, my argument has stressed the latter, on the assumption that seeing *The Picture Writer* in a broader context would improve our estimate of its artistic worth. But now let me proceed with more caution. Over the past

decade, art museums may have begun taking history more seriously; at the same time they remain committed to a good/better/best ranking system, assumed to operate in a realm untouched by temporal bias. This creates a dilemma for museum audiences. They are asked to believe that the theories guiding historical analysis and those that determine quality are somehow compatible, when in fact an intellectual universe separates them. The former process attempts to operate within a culturally determined framework; the latter claims complete detachment. Museums complicate the problem further by abandoning history whenever it undercuts connoisseurship, a sure sign that judging quality across the ages is what they still consider their primary mission.

Despite the seeming conflict, connoisseurship does have a role to play in museum scholarship; it can be especially helpful when making distinctions between or within certain finite categories. But when applied more broadly, as a judgment meant to be timeless, it begins to separate so-called masterpieces from the historical circumstances that surround them. Thus Horta's architecture is untouched by association with the Congo, objects on display at the Peabody Essex have no previous existence as global booty, and, closer to home, the Picture Writer and his beleaguered descendants may as well inhabit separate planets. Would more historical exposure improve our understanding of these respective examples? Presumably it would. And would increased understanding translate into greater importance, a higher niche in the artistic canon? Again, probably so. But is that the sole purpose of scholarship, whichever route we take? The point of this argument is not to create a new canon; it is to free us from the old one, to overthrow traditional assumptions about quality and give new scholarship room to breathe. The sooner museums do this, the sooner their audiences will find that aesthetics and history are not adversaries. With the kind of scholarship I advocate, aesthetics and history unite to form meaning. And whatever meaning emerges from this process will help us understand how works of art, regardless of their current status, can engage and enrich our cultural eye.[26]

### Acknowledgment

I am, as always, indebted to Alan Wallach, for generously guiding me through the field of museum studies, and for a helpful critique of this essay.

# NOTES

1. For brief accounts of this purchase, see Anna Somers Cocks, *The Victoria and Albert Museum: The Making of the Collection* (London: Windward, 1980), 88; and Malcolm Baker and Brenda Richardson, eds., *A Grand Design: The Art of the Victoria and Albert Museum* (London: V&A Publications, 1997), 345.

2. Paul Greenhalgh, ed., *Art Nouveau, 1890–1914* (London: V&A Publications, 2000).

3. For a helpful survey of Horta's clients, see Françoise Aubry and Jos Vandenbreeden, eds., *Horta: Art Nouveau to Modernism* (Ghent: Ludion Press, 1996), 117–38.

4. Aubry and Vandenbreeden, *Horta,* 84–85.

5. Greenhalgh, *Art Nouveau,* 275–76.

6. The last paragraph of the text panel reads as follows: "Brussels enjoyed at this time a new prosperity from the wealth it had gained during the Industrial Revolution and Belgium's colonial expansion in Africa. The government promoted the use of ivory by making it available to the city's talented jewelers, and small-scale sculptors, such as Philippe Wolfers. Belgian designers made use of 'exotic' wood from the Congo—particularly Gustave Serrurier-Bovy, who marketed his furniture through showrooms in Brussels and Paris."

7. Adam Hochschild, *King Leopold's Ghost: A Story of Greed, Terror, and Heroism in Colonial Africa* (Boston: Houghton Mifflin, 1998), 225–34. Hochschild's estimate is based on figures from the Congo Reform Association, chartered in England in 1904. More recently, Belgian historians have said such figures cannot be confirmed. They argue instead that in the half century after 1875, the population of the Congo fell by at least 20 percent, due to violence and disease. See Alan Riding, "Museum Show Forces Belgium to Ask Hard Questions about Its Colonial Past," *New York Times,* 9 February 2005.

8. Hochschild, *King Leopold's Ghost,* 146.

9. For a literary investigation of why colonialism "is mysteriously necessary to the poise and beauty of Mansfield Park" (the estate described in Jane Austen's novel of the same name), see Edward Said, *Culture and Imperialism* (New York: Knopf, 1993), 60, 133–62.

10. Greenhalgh, 26; and Aubry and Vandenbreeden, 137.

11. Greenhalgh, 202.

12. See Aubry and Vandenbreeden, 14, 23, and, for Benjamin's quotation, 24.

13. Greenhalgh, 37, 430.

14. Hochschild, 175–76.

15. Craig Winneker, "A Perfect Specimen of Colonial Mythmaking," *New York Times,* 9 August 2003. See also Riding, "Museum Show Forces Belgium to Ask Hard Questions."

16. For the application of these ideas to an earlier era of academic art history, see Carol Duncan, *The Aesthetics of Power: Essays in Critical Art History* (Cambridge, UK: Cambridge University Press, 1993), 135–42.

17. Holland Cotter, "A Bounty in Salem from Globe-Trotters," *New York Times,* 1 August 2003.

18. Joan Carpenter Troccoli, *Painters and the American West: The Anschutz Collection* (Denver and New Haven: Denver Art Museum and Yale University Press, 2000), 12, 18–20. In the early 1990s, when Troccoli was acting director of the Gilcrease Museum, a group from Yale borrowed extensively from Gilcrease collections to organize a traveling exhibition called *Discovered Lands, Invented Pasts* (New Haven, Conn.: Yale University Press, 1992). Prominent Western art and history scholars who wrote for the catalogue took the position that Western art was best understood in the context of westward expansion. Preceding and following the exhibition, historians Richard Slotkin (*The Fatal Environment: The Myth of the Frontier in the Age of Industrialization, 1800–1890* [New York: Atheneum, 1985]), Patricia Limerick (*Legacy of Conquest: The Unbroken Past of the American West* [New York: W. W. Norton, 1987]), and Richard White (*"It's Your Misfortune and None of My Own": A History of the American West* [Norman: University of Oklahoma Press, 1991]) also argued for a historical context for Western art and literature. And Troccoli followed suit in her scholarship on George Catlin, in *First Artist of the West: George Catlin Paintings and Watercolors from the Collection of the Gilcrease Museum* (Tulsa, Oklahoma: Gilcrease Museum, 1993); and in *George Catlin and His Indian Gallery* (Washington, D.C.: Smithsonian American Art Museum, 2002). Seen in that light, the Anschutz catalogue is something of a departure from her past scholarship. My own views on contextualizing Western art first appeared in *The West as America: Reinterpreting Images of the Frontier* (Washington, D.C.: Smithsonian Institution Press, 1991).

19. He must have also spent time with the Mandan. According to an article Brush wrote for *Century Magazine* in 1885, the scene is set in a Mandan lodge "made of poles and mud." That may be, but no details in the picture would encourage such an identification. For more on Brush's Indian paintings, see two publications by Joan B. Morgan: "The Indian Paintings of George de Forest Brush," *The American Art Journal* 15 (Spring 1983): 60–73; and *George de Forest Brush, 1855–1941: Master of the American Renaissance* (New York: Berry-Hill Galleries, 1985), 17–23, and 66 for the Mandan lodge reference.

20. Troccoli, *Painters and the American West,* 78–79.

21. Rising scholarly appreciation of Brush's Indian paintings, for example, has in recent years been matched by higher auction prices. A major example, *The Indian and the Lily,* sold for $4,824,000 in 2004 (see Sotheby's, New York, 1 December 2004, lot no. 36), and *The Picture Writer's Story* sold for $1,707,500 in 1998 (see Sotheby's, New York, 3 December 1998, lot 80). Before 1998, no Brush Indian painting had sold at auction for more than $400,000.

22. Quoted in Morgan, *George de Forest Brush,* 23.

23. See note 19. In the 1885 article, Brush also explains how his fascination with heroic Indians becomes artistic process: "I do not paint [Indians] from an historian's or antiquary's point of view; I do not care to represent them in any curious habits which could not be comprehended by us [meaning, presumably, Brush and other white men]; I am interested in those habits and deeds in which we have feelings in common. Therefore, I hesitate to . . . add any interest to my pictures by supplying historical facts." Quoted in Morgan, "The Indian Paintings of George de Forest Brush": 69–70.

24. For more on the concept of evolutionary progress and how it might have influenced Brush, see Kathleen Pyne, *Art and the Higher Life: Painting and Evolutionary Thought in Late Nineteenth-Century America* (Austin: University of Texas Press, 1996) 2–4, 139–48.

25. See note 19.

26. The following publications, each dealing with ways museums have (or have not) attempted to historicize their collections, have been particularly helpful in preparing this essay: Alan Wallach, *Exhibiting Contradiction: Essays on the Art Museum in the United States* (Amherst: University of Massachusetts Press, 1998); Steven C. Dubin, *Displays of Power: Memory and Amnesia in the American Museum* (New York: New York University Press, 1999); and Charles W. Haxthausen, ed., *The Two Art histories: The Museum and the University* (Williamstown, Mass.: Sterling and Francine Clark Art Institute, 2002). For a broad survey of such literature, see Bettina Messias Carbonell, *Museum Studies: An Anthology of Contexts* (Malden, Mass.: Blackwell, 2004).

# CONTRIBUTORS

**Lissant Bolton** is Section Head, Oceania, in the Department of Africa, Oceania, and the Americas at the British Museum. Both anthropologist and curator, she worked formerly at the Australian Museum, Sydney, and as a post-doctoral fellow at the Australian National University. She also works annually with the Vanuatu Cultural Centre. She is author of *Unfolding the Moon: Enacting Women's Kastom in Vanuatu.*

**W. Fitzhugh Brundage** is William B. Umstead Professor of History at the University of North Carolina, Chapel Hill. His books include *The Southern Past: A Clash of Race and Memory; A Socialist Utopia in the New South: The Ruskin Colonies in Tennessee and Georgia, 1894–1901;* and, as editor, *Where These Memories Grow: History, Memory, and Southern Identity.*

**Alice L. Conklin** is Associate Professor of History at the Ohio State University. She is author of *A Mission to Civilize: The Republican Idea of Empire in French West Africa, 1895–1930,* winner of the Berkshire Prize in History. Her current research, on the professionalization of ethnology in France and its empire between the wars, has been supported by Guggenheim and German Marshall Foundation fellowships.

**Nélia Dias** is Associate Professor at the Instituto Superior de Ciências do Trabalho e da Empresa at the University of Lisbon. Her publications include *Le musée d'ethnographie du Trocadéro (1878–1908): Anthropologie et muséologie en France; La mesure des sens: Les anthropologues et le corps humain au XIX$^e$ siècle;* and, as editor, a special issue of the journal *Terrain* on imitation.

**Ira Jacknis** is Research Anthropologist at the Phoebe A. Hearst Museum of Anthropology, University of California, Berkeley, where he has worked since 1991. He is author of *The Storage Box of Tradition: Kwakiutl Art, Anthropologists, and Museums, 1881–1981,* and of several works on California Indians. His current research focuses on the history of ethnographic representation, especially in the form of museum collecting and display, photography and film, and sound recording.

**Ilona Katzew** is Curator of Latin American Art at the Los Angeles County Museum of Art, where she is responsible for the museum's permanent collection of Spanish colonial, modern, and contemporary Latin American art. She is author of *Casta Painting: Images of Race in Eighteenth-Century Mexico* and *Una visión del Siglo de las Luces: La codificación de Joaquín Antonio de Basarás.*

**Angus Lockyer** is Lecturer in Japanese History at the School of Oriental and African Studies, University of London. He is co-editor of *Japanese Civilization in the Modern World XVII: Collection and Representation* and is completing a manuscript, "Japan at the Exhibition, 1862–2005."

**Andrew McClellan** is Dean of Academic Affairs and Director of Museum Studies at Tufts University. He is author of *Inventing the Louvre: Art, Politics, and the Invention of the Modern Museum in Eighteenth-Century Paris* and *The Art Museum: Ideals, Ethics, and Practice from Boullee to Bilbao,* forthcoming; and editor of *Art and Its Publics: Museum Studies at the Millennium.*

**Peter M. McIsaac** is Assistant Professor of German Studies at York University in Toronto. His publications include *Museums of the Mind: German Modernity and the Dynamics of Collecting* and, as co-editor, a special issue of *New German Critique* on contemporary German literature (2003). He is currently writing a book that situates Gunther von Hagens' Body Worlds with respect to German traditions of German anatomical display and the dynamics of globalization.

**Daniel J. Sherman** is Professor of History and Director of the Center for 21st Century Studies at the University of Wisconsin–Milwaukee. His books include *Worthy Monuments: Art Museums and the Politics of Culture in Nineteenth-Century*

*France; The Construction of Memory in Interwar France;* and, as co-editor, *Museum Culture: Histories, Discourses, Spectacles.*

**William H. Truettner** is Curator at the Smithsonian Museum of American Art in Washington, D.C. Among the influential exhibition catalogues he has edited are *The West as America: Reinterpreting Images of the Frontier, 1820–1920* (1990); *Thomas Cole: Landscape into History* (1994, with Alan Wallach); and *Picturing Old New England: Image and Memory* (1999, with Roger Stein).

# INDEX